Zurich China Egypt Greek Oregli
em Germany Man Ray Cuzco Syria
busier New York South Africa Cuba
Rio de Janeiro Robert Frank Liberi
ntreal Jean Tinguely Pampas Trini
Henri Cartier-Bresson Switzerland
abia Greece Brazil Lebanon Wu S
ael Hans Finsler Suez Canal Trapa
ti Buenos Aires Libya South Korea
esburg J. Robert Oppenheimer N
gentina Kenya Rome Che Guevara
g El Kantara Chicago Pablo Casal
Burri Cape Canaveral Basel Yena
ward Finnegan Pablo Picasso Cair
mann Geneva Saigon Romania Sã
xyo Juscelino Kubitschek Aachen
umenfeld Anwar Sadat Cholon Yv
les Mimi Scheiblauer Milan Pragu
rge Oteiza Bratislava Puno New M
Gasser Leipzig Luis Barragán Par
a Jacqueline Roque Lima Shangha
Hiroshi Hamaya La Paz Roncham

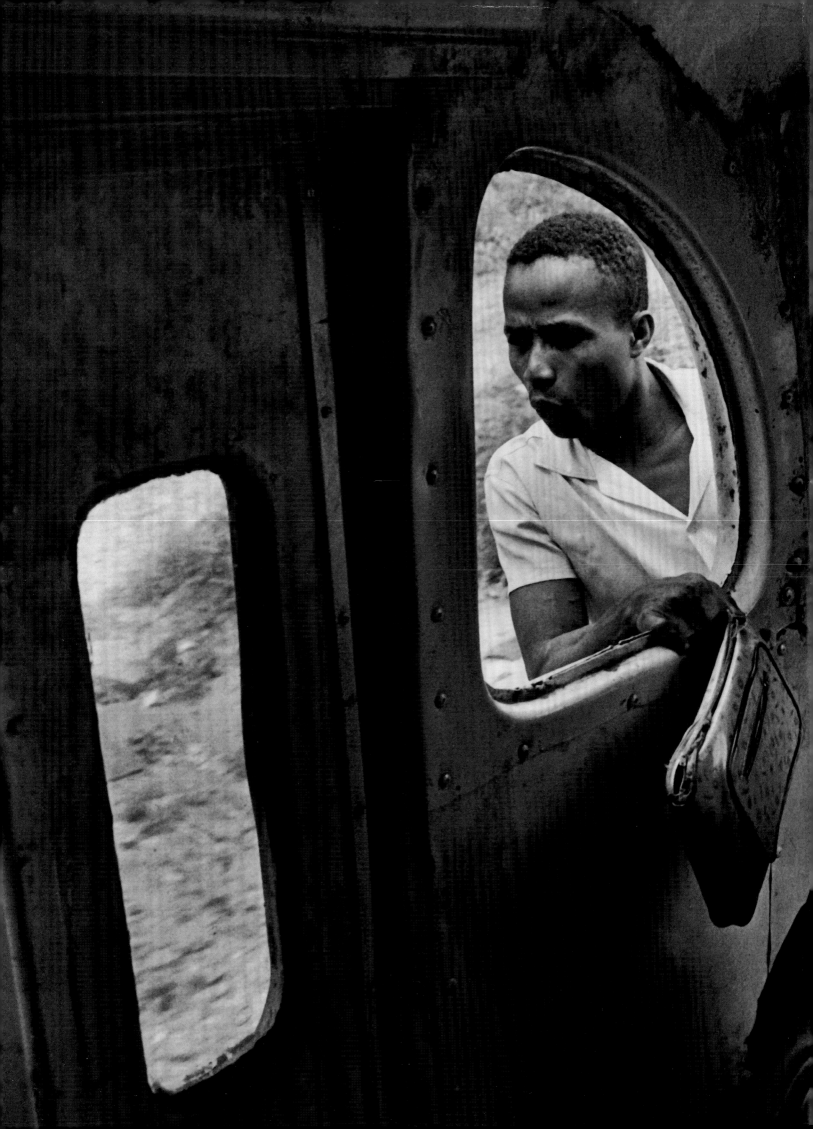

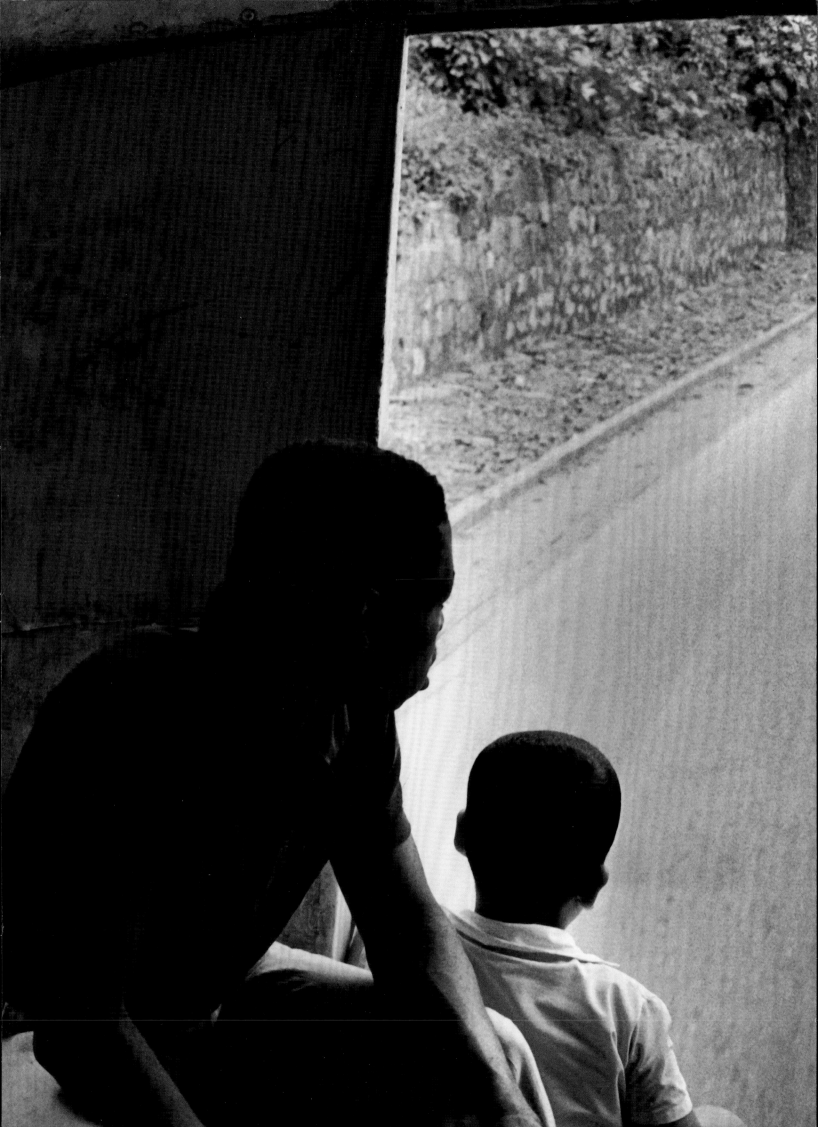

René Burri Photographs

Hans-Michael Koetzle

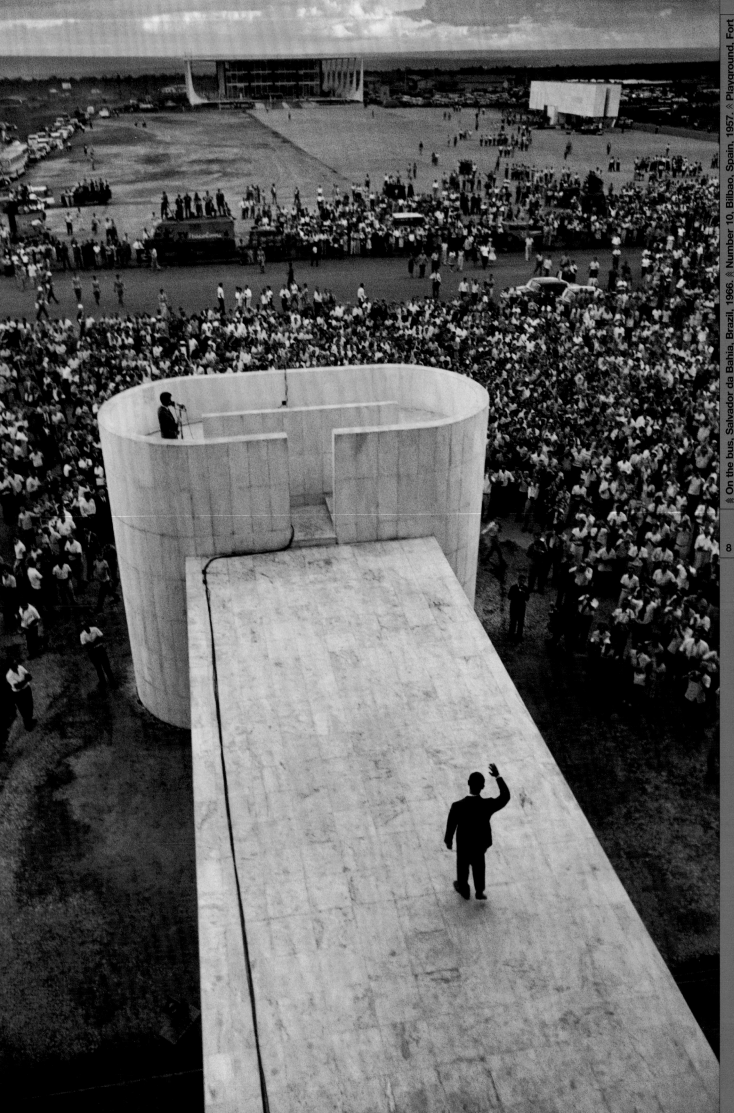

« On the bus, Salvador da Bahia, Brazil, 1966. « Number 10, Bilbao, Spain, 1957. « Playground, Fort Lauderdale, US, 1966. Inauguration of the new capital, Brasília, Brazil, 1960. Juscelino Kubitschek, president of Brazil, on his way to the lectern. It was largely due to his public works programme that the seat of government, designed by Oscar Niemeyer and Lucio Costa was built in only 43 months.

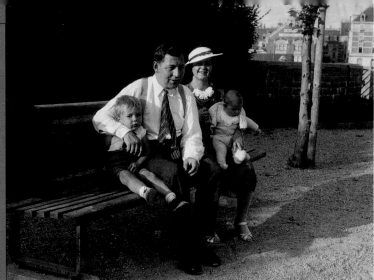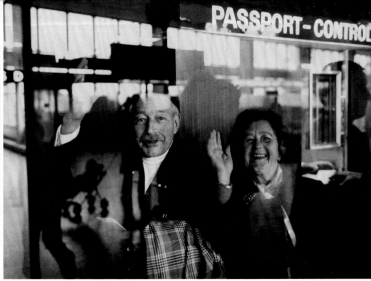

'If you are truly successful in capturing the pulse of life, then you can speak of a good photograph.'[1] In 1984 the first retrospective survey of René Burri's work was published and he chose to call it *One World*. On the book's cover, a hand holds a passport photo in front of many other snapshots. Dozens of faces, but no names. If we look closer, however, we can see that this picture within a picture is of Burri himself. The hand is his hand, the face his face. But what is his message? He wants to intervene in our visual world, deliberately and decisively. With his self-reflective gesture on the cover of *One World*, Burri is counting himself among the sprawling anonymous 'family of man'. Indeed, the conviction that a diverse humanity must learn to share a single world can be seen throughout the book. René Burri's photographs, sketches and collages from almost four decades show poverty, famine and war, prostitution and oppression, racism and violence, revolutions and coups. Portraits, cityscapes, landscapes. Pictures from Europe, Asia and Latin America. By choosing this particular image for the cover of the book, Burri declares that all of mankind is inextricably linked and asks the question: What is the meaning of 'truth' in photography?

Burri would never deny that objectivity and authenticity are worthy ideals. But as a seasoned professional, he knows that photography can only ever be subjective. It is the photographer who chooses the subject and the perspective. It is the photographer who determines the lighting, the background, the ambience, the one who selects the camera and the lens. As Burri well knows, good photographs not only say something about our world, they also reveal something about the person behind the camera. 'What counts,' he has said 'is putting the intensity that you, yourself, have experienced into the picture. Otherwise it is just a

document. But if you are truly successful in capturing the pulse of life, then you can speak of a good photograph.'[2] For the last fifty years, Burri has followed this principle in his travels around the world.

Burri took his first photograph in 1946 at the age of thirteen, a snapshot of Winston Churchill in Zurich (inside front cover). In anticipation of the event, the young Burri took his father's simple Kodak and walked over to Bürkliplatz where Churchill was to give a speech. He pressed the shutter release once, went home and then set the camera aside. In fact, he never used his father's camera again. What can we conclude from this episode? That Burri was a natural talent? The picture was certainly a success from a technical point of view. The completely inexperienced photographer was able to pan the camera with great skill, capturing a striking image of Churchill in the back of his limousine. The episode also reveals his instinct for an important historical moment. Churchill's speech with the immortal declaration 'Let Europe arise!' would remain a topic in the Swiss papers for decades to come.[3] Nevertheless, we can also see that René Burri did not start out as a photography enthusiast. Photography had never been his hobby. But perhaps we can be thankful for this in his case, for too much enthusiasm can sometimes make photographers blind to the critical aspects of their trade. As the propaganda of twentieth-century warfare has demonstrated, the documentary pretence of the photograph and the role that images play in our society must constantly be called into question. Thankfully, Burri has always preferred to place his chosen medium in the spotlight of critical reflection.

By the time Burri entered onto the professional stage in the 1950s, photography's pre-eminence was already under assault by new forms of visual communication,

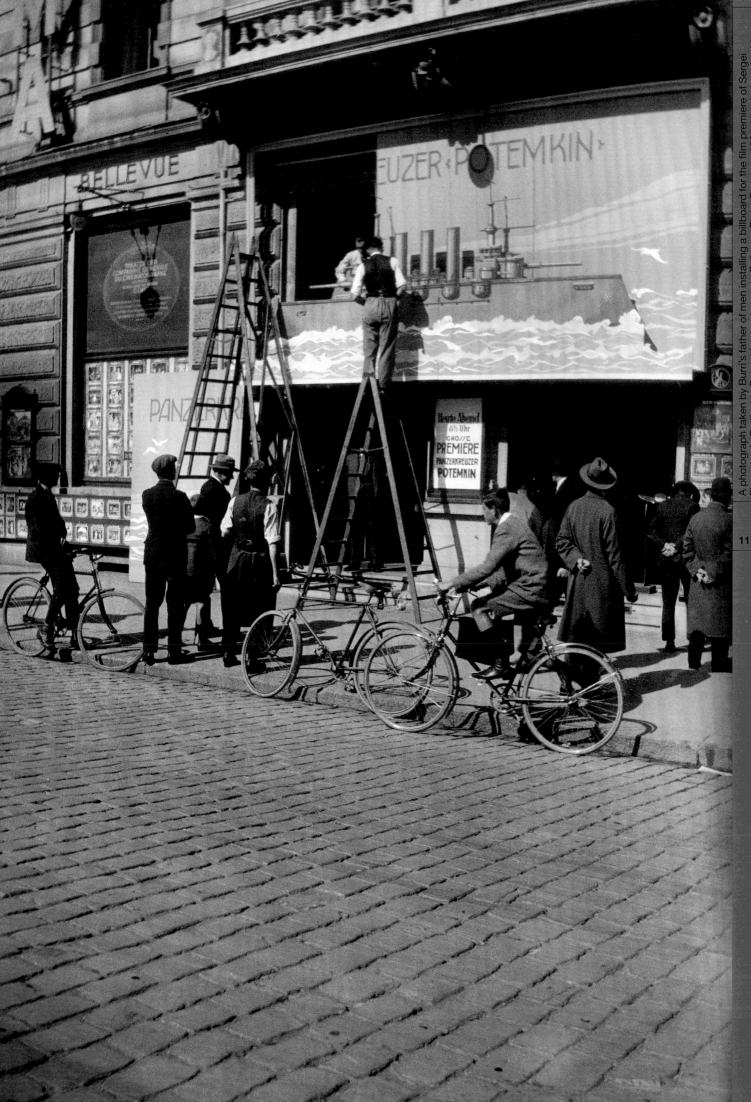

A photograph taken by Burri's father of men installing a billboard for the film premiere of Sergei Eisenstein's *Battleship Potemkin* at a cinema in Bellevue-Platz, Zurich, c. 1931. His choice of subject demonstrates his affinity for the avant-garde movements of the time.

especially television, that were soon to overshadow it. Burri recognized this early on and took the necessary steps. He did not switch over to film, though cinema had always been close to his heart. Instead, he chose to cultivate a style marked by intensely personal statements that went against the spirit of the times. Since then the tide has turned, and greater value is placed now on subjective reportages and commentaries. Today, people want to recognize the individual and the personality behind the photograph. In retrospect, we can see that the young Burri made a courageous and intelligent decision at the very beginning of his career when he chose to work against the grain.

In July 1956 René Burri's first portfolio appeared in the prestigious magazine *Camera.* The twenty-three year old photographer was granted a full nine pages for his work. Editor in chief Roméo Martinez contributed a short biography on Burri and praised him as 'the most promising talent of the young generation of Swiss photographers'.[4] The publication in *Camera* was by no means Burri's first however. After graduating from the School of Arts and Crafts in Zurich, Burri completed his first reportage which was subsequently published in the Swiss magazine *Die Woche* in 1953 (p. 434). In 1955 his photographs also appeared in *Science & Vie, Bunte Illustrierte* and *Paris-Match.* And in 1956 his work appeared for the first time in *Life* magazine, an impressive accomplishment that also served as an admission ticket to Magnum, the legendary photographers' cooperative, which bestowed full membership upon Burri in 1959.

Despite these later successes, Burri's 1956 portfolio for *Camera* is still a remarkable document. It focuses on Burri himself and contains an important statement that is rare for a photographer who so reluctantly speaks about his work in theoretical terms. The young Burri writes:

'When I work for a newspaper, my topic and, above all, my time is limited. So the beautiful and necessary thing about our profession is to occasionally break free and pursue subjects that are of personal interest. Today, when camera shutters rattle from morning to night in every corner of the world, when the film used each day could stretch across kilometres and every continent is lit with the flash of cameras, when images are published in magazines and conserved in archives and on audio tape, we young photographers have to ask ourselves again, "What is our mission?" Today, unlike any other moment in history, the problems of rice farmers in China, automobile workers in America and miners in Germany are, in the end, all the same. The enormous social changes taking place in our age of technology reflected in music, painting, literature and architecture are casting a new face for humanity. Tracing these developments, and conveying my thoughts and images of them, is what I consider to be my job.'[5]

Without a doubt, this statement was a type of roadmap for Burri's later development. It contains everything that would distinguish his later work and casts a critical eye towards the media and its flood of images. Doubts that gave birth to ideas; the will to break away from the restrictions of commissioned work; the desire to create something personal and unmistakable; visionary thinking; and, of course, the idea of one world – a world that the young Swiss photographer immediately set out to explore, yet not in the tradition of Swiss travel photographers such as Walter Bosshard or Gotthard Schuh. These photographers saw it as their duty to bring a touch of the exotic back to the small alpine nation which lacked a coastline, oceans and deserts. Burri, however, was not interested in bringing the world back to Switzerland. Ever alert and curious, he wanted to set

left: **Hans Finsler, Zurich, 1957.**
right: **Alfred Willimann, Zurich, 1953.**
Here we see both of Burri's professors teaching at the School of Arts and Crafts.

13

out into the world and document what he saw without prejudice and with his own unmistakable images.

René Burri was born on 9 April 1933 as the first of two children. A few weeks earlier, Hitler had seized power in distant Berlin. We cannot be certain if Burri's parents felt particularly affected by the National Socialists' victory, but we can assume so. Burri's mother Bertha Haas was originally from near Freiburg in Breisgau. Even though she had virtually become Swiss and could speak Swiss German fluently by 1933, she had maintained close ties to her German home. Born in 1903, she was by all accounts an adventurous and courageous woman who went to Switzerland to work as a maid and a cook as a result of the economic crisis in post-World War I Germany. Burri's younger sister Véronique remembers that 'she was very curious. She wanted to know every-thing – my brother inherited that from her.' Bertha moved from Zurich to Geneva in order to learn French and even for a time entertained the idea of emigrating to the United States. As Véronique remembers, however, 'That was where my father stepped in: "Not if I have anything to say about it!"'[6]

Burri's father, Rudolf Otto Burri, was one of twelve children and is remembered as a 'stolid citizen' of Bern. As a child, his artistic tendencies received little encour-agement, and he eventually became the cook at his parents' inn. He pursued this work with a great deal of imagination and verve. In his spare time, he cultivated his love for the opera and, in later years, photography. He often used his own reflection as a subject, and he took great pleasure in taking pictures of people on the street. One of his photographs shows pedestrians in front of a cinema on Zurich's Bellevue-Platz (p. 11). In the background we can see an advertisement for Sergei Eisenstein's *Battleship Potemkin,* a masterpiece that

would go down in film history. He also enjoyed garden-ing and grew asparagus, herbs and vegetables. Burri says that he can still remember the smell of freshly picked tomatoes and can remember the exotic seafood that his father would occasionally bring home. Oysters, eels and shrimp. 'These smelled different, of the sea,' Burri recalls. 'I didn't want to eat them, but they piqued my curiosity. It was with these things in mind that I took off into the world.'[7]

His childhood in Zurich was sheltered. His daily walk to school took him through a landscape of orchards and ponds where frogs and other creatures were just waiting to be caught. School itself presented no par-ticular problems, though Burri's teachers complained that he used too much paper. Indeed, he could be seen almost every afternoon with his sketchpad and pens. During the war his mother would collect wrapping paper from packages for her young son. As Véronique remembers, 'Burri would lie on the floor and draw, completely lost in his own thoughts. René has always enjoyed drawing.'[8] Increasingly, the war was affecting family life. The lights in Zurich had to be blocked out during air raids on Germany. Food rations and supply shortages dominated everyday life. And there was always the fear of the nearby border. Allied bombers repeatedly flew into Swiss airspace. Once, one of them crashed behind the Zürichsee, an image that Burri recalls as one of his most vivid childhood memories of the war.

Burri remembers his early years in Switzerland as almost claustrophobic. He did not feel oppressed by the political climate but rather by the mountain ranges that blocked his view of the world beyond. Burri remembers, 'I would often hike into the mountains with the boy scouts. At the end of each tour, I would untie

The Trester Club, Zurich, 1951. This legendary club was an outpost of the Existentialist movement, which spread to Zurich from Paris. Propagated by major thinkers such as Jean-Paul Sartre, Existentialism was highly influential among Burri's peers of the time.

Reclining nude, School of Arts and Crafts, Zurich, 1949. Drawing from life in the spirit of a classical academic education was also part of the curriculum at the Zurich School of Arts and Crafts. Burri took this photograph secretly during class.

myself from the rope and storm up to the summit. I wasn't trying to be the first boy to reach it, I just wanted to look beyond the horizon and see the world. Instead, I could only see other mountains. Back then I thought the camera was my only chance to free myself from the confines of the Swiss Alps.'[9]

Everyone in the family was certain that Burri would become a painter or illustrator, and the Zurich School of Arts and Crafts was immediately next door and a first-rate centre of learning. So in early 1949, at the age of sixteen, he began taking basic classes under renowned former Bauhaus teacher Johannes Itten, under whose guidance the Bauhaus philosophy made its way into everyday life at school. 'But nobody really knew what to make of it,' Burri recalls. 'We painted and sketched just like at the Bauhaus academy. At least that's what people said – although fairly disparagingly.'[10] Burri and his fellow students were not particularly kind to Itten. 'But that was his own idea: for the students to "empty themselves".' Or as the art historian Magdalena Droste writes, 'Itten often started his classes with gymnastic and breathing exercises to loosen up and relax his students before seeking to create "direction and order out of flow".'[11]

The introductory courses with Itten lasted for one year and included colour theory and material studies, both of which were of great importance in the early years of the Bauhaus movement.[12] After this year had passed, Burri was supposed to start an apprenticeship in a private graphics studio. His family, never particularly well-off, needed to save money for school. However, when he and his mother went to visit the workshop, they never made it past the building's stairwell. 'It smelled strange there,' Burri recalls. He refused to take up the training and was able to continue his studies at the

School of Arts and Crafts. However, he now had to make a decision about which subject to focus on: graphics, fashion, interior design or photography. As journalist Peter Killer has written in his book on the history of *Du* magazine:

'They led the students through all the departments, and Burri didn't like any of them, not even the photography class with Finsler. The smell of the chemicals stung his nose and forced him to leave the room as quickly as possible. On his way out, however, his eye fell on the photo lamps that stood there with iron feet, grouped together like messengers from another world. They represented Hollywood and the whole history and future of film. Suddenly, it became clear. This was where he wanted to stay.'[13]

Burri has always been enthusiastic about film and loved the cinema as a child. In the 1940s he and his sister made frequent pilgrimages to the local film club. He was also an avid follower of movie reviews on *Bayerischer Rundfunk*, the official radio station of the state of Bavaria. Later in his career, he would create movies of his own. For the time being, though, Burri committed himself to the forerunner of cinema and a technical medium that could also tell stories: photography. His parents were not overly enthusiastic about his new-found interest, and his sister was actually disappointed that her brother wanted to become a photographer. Only a short time earlier, the two children had had their pictures taken by a travelling photographer in the town centre. Was that supposed to be Burri's future? After Burri showed his family around the school, however, explaining the complicated workings of the studio, and even taking pictures of them using artificial light, they realized that there was something special about their son's ambitions.[14]

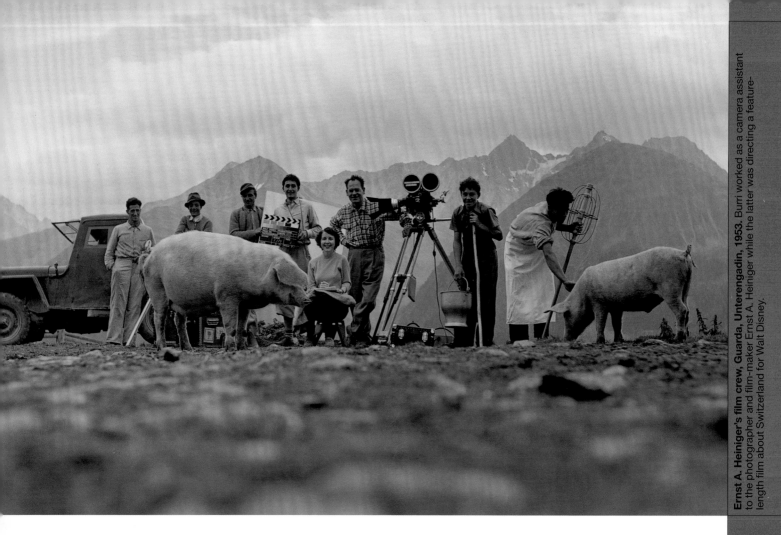

Ernst A. Heiniger's film crew, Guarda, Unterengadin, 1953. Burri worked as a camera assistant to the photographer and film-maker Ernst A. Heiniger while the latter was directing a feature-length film about Switzerland for Walt Disney.

We can see just how little experience Burri had in photography by the fact that he did not pass his first entrance exam. The photography teacher, Hans Finsler, had explained how to use the Leica camera and then sent Burri on his way with a small format film. When Burri returned, they developed and fixed the film together. When they turned the light on, they both had to blink twice. The film was blank. Burri recalls, 'I can still see Finsler looking at me and saying, "Very interesting, René!" His comment was like a slap in the face. I thought it was all over then and there.'[15] Thankfully, Burri was given a second chance by the typography teacher Alfred Willimann, and in early 1950 he began the three-year-long course at the Zurich School of Art and Crafts.

In those days, Zurich was a legendary centre for the study of photography. Hans Finsler had been teaching there since 1932. He was a leading representative of the *Neue Sachlichkeit* (New Objectivity) movement which had helped define photographic discourse in Europe and beyond since the 1920s. He developed his austere material and documentary style when he was in Halle, Germany lecturing at the Burg Giebichenstein School of Design. Finsler became known internationally through pioneering exhibitions such as 'Neue Wege der Photographie' ('New Ways in Photography', 1929) and 'Film und Foto' ('Film and Photo', 1929). It would not be inappropriate to mention Finsler in the same breath as the giants Walter Peterhans and Albert Renger-Patzsch. All three artists had an eye for the 'world of things'. Finsler in particular was fond of reducing his images to bare essentials, a style well suited to his reserved manner. He was a cool and unapproachable man whose every move was dictated by reason. But in a very subtle fashion, he exerted a powerful influence on his students. As one recalls, 'We were all afraid of him.'[16]

Finsler was apparently frugal with both his praise and his criticism. As another student explains, he 'said very little and simply left us alone to "swim"'.[17] The student Jürg Klages remembers that 'he did not interfere while we were preparing a photograph. He gave us a free hand and didn't make comments until the picture was finished. For the most part, we were left to our own devices.'[18] At first glance, it might seem that Finsler had failed to give his students enough direction or the proper orientation. And it is true that Finsler did not ascribe to any particular approach to teaching, writing his photographic credo much later in life.[19] Nevertheless, Walter Binder, one of Burri's fellow students and Finsler's successor, asserts that they were indeed given a certain type of guidance in the form of a 'clearly perceptible climate, or mood' that permeated Finsler's lessons. 'Nothing,' Binder writes, 'was spontaneous. Everything started out as a concept, everything had to be thought out, to be purposeful, to make sense. This began as early as the choice of the object to be photographed: the simpler the form, the clearer and less complicated the object, the more fundamental and universally applicable was the learning process that Finsler had set in motion.'[20]

Clearly, Hans Finsler had rescued a portion of New Objectivity and brought it with him into the post-war period. Of course these post-war years clearly differed from the 1920s which were marked by aesthetic renewal in the spirit of Constructivism. In any case, Finsler's sober view of the world was based fundamentally on reality, on the 'world of things'. However, 'by approaching objects purely through their form,' says Hugo Loetscher of Finsler, 'there began a process of abstraction that restricted itself more and more to aesthetics.' The almost certainly unintentional result

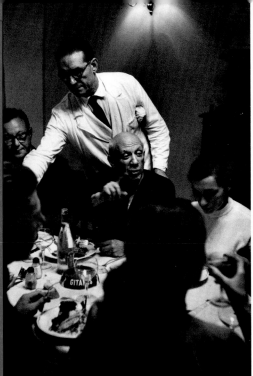

left: **Pablo Picasso at dinner, hôtel du Cheval Blanc, Nîmes, 1957.**
centre: **Magnum photgrapher Chim (David Seymour), Hotel Inghilterra, Rome, 1956.**
right: **Manuel Gasser, Tokyo, 1961.** Here we see the editor in chief of *Du* magazine working on Burri's special issue on Japan.

was that although Finsler 'set out on a search for truth, the path he took eventually led him right past it'.[21]

In many respects, Hans Finsler seemed out of step with the times. In 1946 a prestigious solo exhibition devoted to Henri Cartier-Bresson was staged at New York's Museum of Modern Art. Six years later, Cartier-Bresson's *Images à la sauvette* was published with the English title *The Decisive Moment* and became a guide for generations of photographers to come. And in 1955 one of the most successful photography exhibitions of all time opened: 'The Family of Man', once again at the Museum of Modern Art in New York. In short, people and individuals had become the prime focus of photography. Gestures of reconciliation, especially those with a human face, were in demand after the war, even if they were ideologically problematic because of their cultural, social and political simplifications.[22] But, as Walter Binder remembers, this 'human interest' photography, especially when combined with spontaneity and risk taking, were alien to Finsler:

'In May 1952, [photographer] Edward Steichen and his assistant Robert Frank visited Finsler's photography class. They were looking for photographs to show in the 'Family of Man' exhibition. This was an important moment for Finsler and his students. The most select fruits of their labour were neatly arranged on white paper, ready to be viewed by the two visitors. However, when Edward Steichen came into the room, the famous photographer simply brushed these examples of classical formalist photography aside and said, "I need photographs of people." Finsler was horrified.'[23]

Horrified maybe, but apparently not too proud to modify his thinking on the subject. As Binder points out, anyone looking today in the school's archive will see that the number of reportage photographs increased

considerably after this point.[24] Burri attended Steichen's visit with a Bolex movie camera in hand and made one of his first films, now lost. He can still remember clearly Finsler's dismay at Steichen's gesture. Steichen had not simply criticized Finsler's work but had condemned his entire approach to photography.

Studying under Finsler's strict influence was both a great opportunity for Burri and a personal dilemma. There is no doubt that he received a solid technical education. A feeling for light. A trained eye, without which a large number of Burri's later works would be hard to imagine. If Finsler taught his students anything, it was to use the camera's viewfinder to create order out of chaos, and to discern lines, establish links and rethink the depth of space into a two-dimensional image. 'Finsler taught us to see the architectural aspects of photography,' remembers Burri.[25] Indeed, Burri's well-known photograph *In the Ministry of Health, Rio de Janeiro, 1960* (p. 199) is indebted to Finsler's eye for structures, geometries and strict forms – but it was this same eye that Burri would struggle to free himself from for so long in order to become more spontaneous, to take more risks and to not be afraid of failure.

Thus, Burri's attitude toward Finsler was ambiguous. Like Finsler, he sought out order in things, but he also strove to counter this with a type of anarchy. In the end, these opposing tendencies may very well have prevented Burri from becoming locked into any one style of photography. Burri frequently compares his early photography with the contortions of Houdini; he always found himself trying to escape the fetters of aesthetic norms and rules. When Urs Stahel speaks of the 'Finsler principle' in his excellent essay on twentieth-century Swiss photography, he underscores the importance of a teacher from whose dominance other photographic

giants such as Werner Bischof, René Groebli, Armin Haab, Philippe Giegel and Ernst Scheidegger would, like Burri, have to struggle to emancipate themselves.[26]

Finsler's presence was so strong at the Zurich photography school that a second important teacher is often forgotten: Alfred Willimann. Willimann was the opposite of Finsler, and not only in terms of their personalities. He readily gave his students advice and direction and even helped them realize some of their more complicated projects. Most of all, Willimann introduced his students to graphic techniques that combined typography and photography, called *Typofotos* by the Hungarian artist László Moholy-Nagy. It was with Willimann's assistance that Burri designed two small books that demonstrate the young photographer's early interest in layout and his affinity for the art of Pablo Picasso and the architecture of Le Corbusier.

According to Willimann's obituary written by the school's director Hans Fischli when Willimann died in 1957, he taught his students 'that a photograph was not an end in itself but a part of a larger whole'. Fischli's obituary underscored the lasting importance of a teacher who 'taught his students how to intensify the quality of an image by restricting it, trimming and cropping it, to divide the unending tones between black-and-white into sensitive values and to bring typography into harmony with photography [...] He taught that tension creates counter-tension and showed his students the difference between order and chaos. He was a man whose ability to create was matched by an ability to observe and examine.'[27] Time and again, René Burri paid homage to his highly esteemed instructor, sketching portraits of him or taking shots of him teaching (p. 13).

Burri took his first photographs outside of school while on field trips with his class in Italy, Southern France and Paris in the early 1950s. Years later, Burri would write in *One World* that 'like all photographers, everything began for me in Paris.' The square-format images next to this passage in *One World* are, in Burri's words, 'the first photographs with my Rolleiflex, taken during a trip to Paris with my photography class in 1950', like those published here for the first time on pp. 74–5.[28] This was the heyday of 'humanist photography', a journalistic form of street photography laced with warmth and humour, the protagonists of which included Robert Doisneau, Izis, Willy Ronis and René-Jacques, all of whom had gathered at the banks of the Seine. In Burri's first attempts at the genre of street photography, he was surely inspired by these masters and their emblematic photography books such as *La Banlieue de Paris* (Robert Doisneau, 1949), *Paris de rêves* (Izis, 1950) and *Belleville ménilmontant* (Willy Ronis, 1954). Burri's early pictures of Paris adorn the opening pages of *One World*. A young boy with a baguette; a row of tramps seated on a bench; a mother knitting in the sunshine. We can sense Burri's desire for everyday anecdotes, but also his timidity in approaching people. In five of the six photographs, the subjects have their backs turned to the camera. We can see that Burri was aspiring towards an individual style, but also that he was hesitant to break the rules. The pictures appear static and are a far cry from the radical spontaneity that defines his later work (for example, those images on pp. 110 and 325). Burri recounts:

'When I left school, where we photographed only coffee cups in light, I suddenly had to chase after my pictures. How was I supposed to use my camera when everything was moving, people walking and everything running away from me? I would even call out, "Hey! Stand still for a second!" It took a while before I could

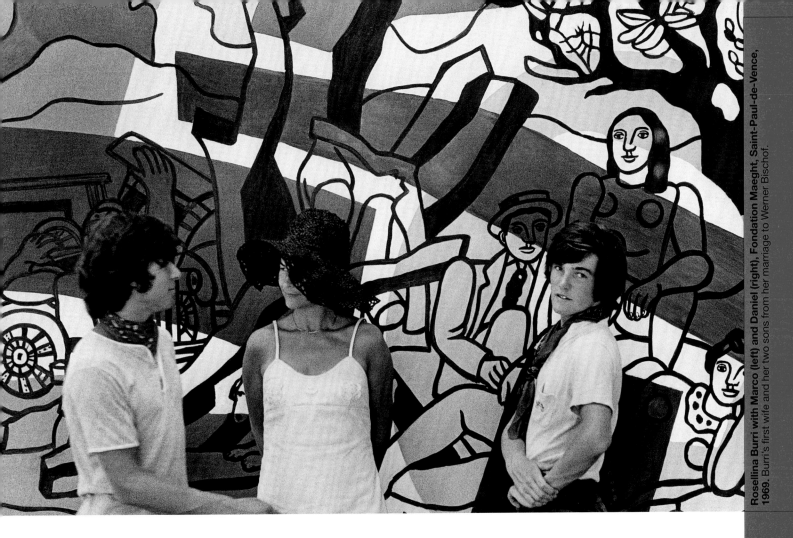

Rosellina Burri with Marco (left) and Daniel (right), Fondation Maeght, Saint-Paul-de-Vence, 1969. Burri's first wife and her two sons from her marriage to Werner Bischof.

move at the right pace, swim with the current. And when it finally did work, the ideal picture would appear on the other side of the street. Pictures are like taxis during rush hour – if you're not fast enough, someone else will get them first.'[29]

Burri's initial training in cinematography can also be traced back to the School of Art and Design in Zurich. During his studies, Burri and the school's Bolex movie camera were virtually inseparable. He even impressed Finsler, who had little knowledge of the medium, with a perfectly cut film about a school trip to Lascaux. After he finished his studies in early 1953, he received a scholarship and shot a documentary film, now lost, about the school. After this, he worked as a camera assistant for Ernst A. Heiniger, who was producing a Walt Disney film about Switzerland. For a moment, it looked as if the cinema would become Burri's new home. Indeed, the film-maker recognized Burri's talent for film and wanted to keep the young employee on his team. But despite the fact that Burri learned a tremendous amount from the experience, he complains that 'everything was too stereotypical, with costumes and such. I felt like we were filming Heidi.'[30] Burri was interested in making his own artistic statement rather than working for an industry that produced films on an assembly line and tailored them to a specific audience. Burri had now come to the point where he had to think seriously about how best to pursue the profession he had learned under Willimann and Finsler.

Peter Killer once referred to Burri as the 'epitome of the restless reporter', thus perpetuating a misconception about the photographer that needs to be addressed.[31] Burri has never thought of himself strictly as a photojournalist, as the 'restless' supplier of transient images meant only to illustrate a particular text. Burri's decision to take on magazine and industry assignments was based on the simple need to make a living. True, he was a professional businessman, who knew how to deliver good, printable stories on time. He would not have been able to survive the competition otherwise. But he also learned very quickly how to turn commissioned work into an opportunity to pursue his own personal projects. In this regard, he was in good company. As Russell Miller writes, 'Henri [Cartier-Bresson], for example, hated assignments. For Henri, a good assignment was an opportunity to make pictures the way he wanted to. Ernst Haas, the same thing.'[32]

More resolutely than any of his colleagues, Burri has lived out the idea of *Autorenfotographie*, or 'author photography'. Klaus Honnef introduced the term in the late 1970s, drawing upon the expression *cinéma des auteurs*. 'Not every photographer,' writes Honnef, 'is also an author, a creative personality who, through his choice of subjects and visual accents, reveals his subjective view of reality.'[33] In much the same way, Stahel describes the early Burri as 'perhaps the only true reporting photographer in Switzerland at the time who clearly understood that the role of photography in reporting was nearing its end. He realized that the truth was no longer to be found in the relationship between reality and its photographic reflection, but rather in a photograph's own inherent truth. Hence he created his own form of "subjective photography."'[34] Magnum photographers may indeed scorn the term 'artist', but of them all René Burri fits the description best. Burri has always viewed the camera first and foremost as a means of personal expression. His pictures reflect his interests, his affinities, his fears, hopes and dreams.

The mid-1950s between 1953 and 1956 were a decisive phase in Burri's career. Burri was a likeable young

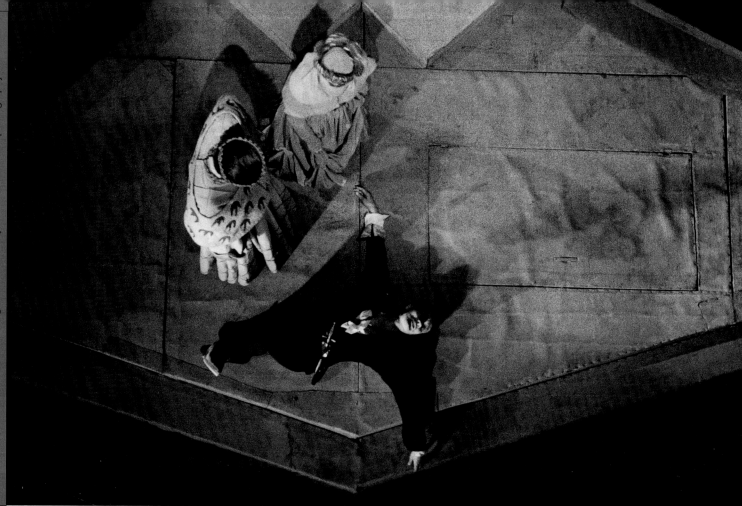

man with an alert spirit and a fresh, friendly personality. As an enterprising beginner, he engaged with verve in what we would nowadays call 'networking'. Burri began to look for contacts, visit editorial offices, make suggestions and pitch stories. In 1953 the legendary Magnum photographer Werner Bischof took Burri's first large publication in the Swiss magazine *Die Woche* with him to Paris and showed it to his colleagues at Magnum.[35] Bischof later wrote Burri a letter, telling him that Robert Capa, Chim (David Seymour), Ernst Haas and Cartier-Bresson had all liked his photographs. As Russell Miller writes, 'Bischof advised him to keep working and promised to contact him when he returned from his forthcoming trip to South America.'[36]

Werner Bischof was never able to fulfil his promise however. In May 1954 he was killed in a traffic accident in the Peruvian Andes. In a sense, Burri took up the baton from Bischof. But this also meant, at least early in Burri's career, taking on the burden of having continually to step out from under Bischof's shadow. It was no accident that he achieved his international breakthrough with the same story that Bischof had shot a decade earlier, that of Mimi Scheiblauer, a well-known teacher of deaf-mute children.[37] Burri was proving that he, too, could do what Bischof had done – and that he could do it differently. The story was on Scheiblauer's innovative school for deaf-mute children in Zurich (p. 21), and it appeared first in the Paris science magazine *Science & Vie*.[38] The *Münchner Illustrierte* picked up the story next, publishing it in May 1955, followed in May 1956 by its publication in the American weekly *Life*.[39] Although Burri's name naturally appeared in all three of these publications, the credits for the story in *Life* magazine read, amazingly, 'René Burri/Magnum'. What had happened between 1955 and 1956?

In 1955 René Burri travelled to Paris to see Picasso whom the young photographer had long admired. He presented himself at Picasso's atelier on the rue des Grands Augustins every day for an entire week, only to be turned away each time by Picasso's relentless secretary. So, Burri says, he 'went to the other side of the Seine, to Magnum. There I found a Spanish lady who looked through all of my pictures in only three minutes and then asked if I had any more. "No," I said. I only had three contact sheets left with me. When I handed them over to her, she became very nervous, looking intently at them through a magnifier, like a jeweller examining a precious stone. She began marking the sheets with a red pen and finally said I should make prints of them and send them back to her.' The young photographer, disappointed, hitchhiked back to Zurich. 'I was sure that it was just a diversionary tactic. But I did finally send the pictures to Paris. Some time later, an envelope arrived. I opened it and there was a copy of *Life* inside. "Strange," I thought, "Magnum has sent me *Life* magazine." I leafed through it and found the pictures from my story with "René Burri/Magnum" printed next to them. I had just turned twenty-three and this was my first Magnum story.'[40]

In a comparatively informal fashion, Burri had become an associate member of a legendary community of photographers. True, their importance has become obscured in the postmodern era with its focus on staged, generated and manipulated photographic art. But in the 1950s, 1960s and 1970s, Magnum was the quintessential photo agency, 'a community of thought'.[41] The cooperative, founded in April 1947, not only represented a position that now exemplifies what we call 'concerned photography', but it also brought under one roof documentary photographers such as George

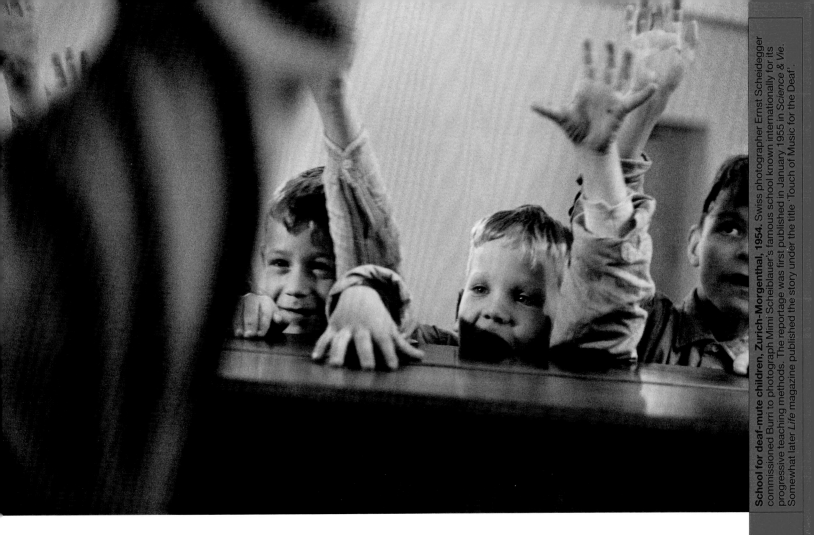

School for deaf-mute children, Zurich-Morgenthal, 1954. Swiss photographer Ernst Scheidegger commissioned Burri to photograph Mimi Scheiblauer's famous school known internationally for its progressive teaching methods. The reportage was first published in January 1955 in *Science & Vie*. Somewhat later *Life* magazine published the story under the title 'Touch of Music for the Deaf'.

Rodger, Capa, Chim, Cartier-Bresson, and later Haas and Bischof, to name just a few. In short, the cream of the crop. 'Membership in Magnum is still one of the highest accolades to which a photographer can aspire,' underscores Russell Miller. 'To be able to add Magnum after your name on a picture credit signifies not only that you have been accepted into an exclusive club, but that the existing members of the club have approved your entry.'[42]

Henri Cartier-Bresson, a generation older than Burri, became the young photographer's second significant mentor. Cartier-Bresson represented the aesthetic opposite of Finsler, whose static view of the world stood in stark contrast to Cartier-Bresson's creative search for the 'decisive moment'. His book *Images à la sauvette* (*The Decisive Moment*) is frequently described as 'the most enduring in photographic literature'. Following its publication in 1952 Cartier-Bresson became something of a godfather to documentary photography, influencing generations of photographers to come.[43] Burri's affiliation with Cartier-Bresson meant, however, that he would have to distance himself from his mentor if he wanted to find his own creative language and survive as an independent photographer. This did not mean disengaging from the left-wing humanistic spirit that held the 'Magnum family' together despite its interior squabbles. Rather, it entailed navigating between the opposing forces of Finsler and Cartier-Bresson in search of his own style. Burri can still remember the anxiety-ridden moments when, as a young photographer returning from an assignment, he was required to show his contact sheets to Cartier-Bresson. When Burri presented to Cartier-Bresson the German first edition of his book *Die Deutschen* (*The Germans*), he had an ulterior motive. The cover was a compound image Burri had created by

combining two sequential negatives, unconventionally cropped to appear as one. Cartier-Bresson looked at it upside-down to examine the structure of the composition and declared it to be good. The fact that Burri's breach of rules went unnoticed was a triumph for the younger photographer. With a hint of quiet pride Burri says, 'That was exactly how I planned to step out of the picture frame.'[44]

The first edition of Burri's *Die Deutschen* was printed in 1962 by the Zurich publishing house Fretz & Wasmuth. A line by the Swiss author Max Frisch supplied the book's motto: 'What I search for in Germany are new horizons in the familiar.'[45] It was published at a time when the written word still possessed a strong authority; exactly half of the 170-page book is filled with literary texts. Photography was not yet recognized as an independent artistic medium worthy of standing on its own without literary confirmation. Burri began to photograph in Germany when he was in his mid-twenties, shooting a number of key images in parallel to his reportages for magazines such as *Bunte Illustrierte* (p. 22). It was only later that Burri's publisher suggested that these photographs be turned into a book. The project itself was conceptualized and edited in collaboration with Robert Delpire, who had courageously published *Les Américains* (*The Americans*) by Robert Frank three years earlier. Those who know Burri well and are familiar with his affinity for French culture, his love of good food and well-groomed hospitality, will ask themselves: Why Germany of all places? Would post-war France not have been just as good a place to do a large-scale documentary? Or even Italy, where it is warmer and the food is better?

Burri however was working within a remarkable tradition of German photography that began with

El Alamein War Memorial, Tobruk, Libya, 1955. On assignment for *Bunte Illustrierte*, Burri flew to Libya to cover the dedication of the monument for the fallen soldiers of Erwin Rommel's Africa Corps. During his stay he also took a number of personal photographs. These would later become part of his masterful photo essay on the Germans, which was gradually beginning to take shape.

the illustrious nineteenth-century photographers Alois Löcherer, Franz Hanfstaengl and Joseph Albert, continued with the emblematic works of August Sander, Hans Retzlaffs, Helmar Lerskis and Erna Lendvai-Dircksens, and which can be found today in the work of Stefan Moses and Derek Bennett and in the twenty-year portraiture project by Gabriele and Helmut Nothhelfer in Berlin, all of which investigate the German people. No people or nation has used the camera so extensively as a means of critiquing its cultural identity. This can be explained, at least in part, by the belated founding of Germany as a nation-state and the resulting need for constant affirmation of its cultural and national identity.

Self-assurance has also played a significant role in Burri's life and work, even if he would never admit it using these words. As mentioned above, Burri's mother came from Germany. German was his native tongue. It was the language of the theatre, which Burri followed passionately in the late 1940s and early 1950s in Zurich, and also the language of the 'new literature' being produced by the writers of Group 47, which was much discussed at the time. Burri's sister confirms that 'René wanted to get back to his roots. Because the Swiss didn't like the Germans, for the most part. That placed him at odds with himself.'[46] This ambivalent attitude towards the Germans can also be seen in the work of the Swiss author Max Frisch. The epigraph for Burri's first book is taken from Frisch, but in an abridged form (probably out of consideration for German readers). In the omitted part of the text, Frisch notes that other relationships of size, such as between Switzerland and Germany, are also reflected in human relationships:

'Many here in Germany hold their heads rather higher than is proper for them and tend to judge themselves by the greatness of their numbers, a form of greatness on which sheep and lice could equally pride themselves; but when one comes on true individuality, this is always freer than in a small country, uninhibited, undistorted, unconstrained; in identical circumstances it tends to expand more richly. It has, one feels, more scope – and in all directions, including the positive ones.'[47]

Frisch confided these thoughts to his diary between 1946 and 1949, around the time when Burri's mother took her two children back to Freiburg, the home she had not seen since the beginning of the war. Véronique clearly remembers how difficult it was for them to obtain a visa for the French zone. Finally, in October 1947 the three of them took a train to Basel. When they arrived, the connecting train to Germany was not there. As Véronique remembers:

'Nobody could give us any information. We couldn't go back, because our visa would have become invalid. We weren't allowed to leave the platform, and there was nothing to eat. We had to wait until the train arrived three or four hours later. When it pulled into the station, we were horrified – the windows were covered with boards and nailed shut. We got on the train and it left the station. The conductor came through with a torch since there was no other light. When we finally arrived in Freiburg, it was night. We came out of the train station and my mother looked around and gasped, 'This can't be!' There was nothing left of the city; the path all the way to the cathedral was a trail of destruction. Everything was reduced to rubble. Mother burst into tears.'[48]

Burri's second trip to Germany was in 1950 when he went to Munich and Ulm on a bicycle tour. This time he had his camera with him and documented his horror at the state of country that, culturally and geographically,

Augsburgerstraße, West Berlin, 1959. The scars of the war; a typical scene in Berlin. This image, with its pronounced graphic qualities, was included in the first edition of Burri's seminal book *Die Deutschen* (*The Germans*).

was not far removed from his native Switzerland, which had been spared from the destruction of war. He took his first photographs in the ruins of Ulm. On the side of the road Burri saw an old man making soup in a battered steel helmet. Burri left his camera in its case this time, but the scene impressed itself on his memory. This was the actual starting point of his four-decade-long examination of the Germans. 'Germany,' Burri explains, 'was a place where certain divisions and boundaries showed up quite dramatically after the war. And that inspired me to do a book – not about France or Italy or some more comfortable location, but a place where contrasting elements were colliding with each other.'[49]

The first edition of *Die Deutschen* appeared in 1962, one year after the Berlin Wall was built. In 1964, it was included as the eighth volume of the *Encyclopédie essentielle* (*Essential Encyclopedia*) by the French publishing house Robert Delpire. In terms of financial success, Burri's photo essay was as disappointing as Robert Frank's *Les Américains* had been four years earlier upon its release. Photography historian Hans Puttnies remembers seeing Burri's unappreciated book for sale at the giveaway price of 5.99 German marks (US$3) at the beginning of the 1970s.[50] Today a copy occasionally finds its way into auction houses and elicits amazingly large bids.

Burri's ability to capture universal truths within the passing moment is something that was only recognized years, if not decades, later. Burri is not satisfied with the mere anecdote. According to Jan Thorn-Prikker, the timelessness of his images is due to the photographer's ability to 'structure pictures to show more than they contain. The symbolic is characteristic of his photographic vision. His pictures are filled with a mysterious meaning that springs from a documentary base. Even though his images are exceedingly beautiful, his symbols never devolve into mere aesthetic objects.'[51] The failure of critics to see the symbolism in Burri's work was, at least in part, due to the lack of competent professional photography criticism at the beginning of the 1960s. Looking back, the naive attitudes of reviewers are astounding in the face of Burri's monumental work, the uncompromising and bold new visual language of which transcended standard magazine photography. The critics could not make it past their surface impressions of the book; they compared Burri's grey photographs with their own view of the world, which in the early 1960s was much more colourful, dazzling and optimistic. The *Hamburger Sonntagsblatt* asked, 'Are we really like that?'[52] And the title of the *Frankfurter Allgemeine Zeitung* review was a curt, 'That Ugly? We think not'.[53] The formal properties of the work, now recognized as a classic of modern photographic literature, were almost universally ignored.

The fact that Burri chronicled the fall of the Berlin Wall in 1989 shows that Germany has remained an important topic for the photographer. In addition to the many revisions he has made to his book *Die Deutschen*, he has been a constant observer of the Germans, both East and West. Burri's Swiss passport undoubtedly helped him gain access to the eastern part of the country. Other photographers had more difficulty. Stefan Moses, who began his study of the Germans in the Federal Republic of the 1960s, was able to add a photo essay on the East Germans only after the fall of the German Democratic Republic's communist regime many years later.[54] *Die Deutschen* is Burri's most substantial project and also the one that has occupied him for the longest period of time. The work perfectly captures the life and customs of the German people in all their variety,

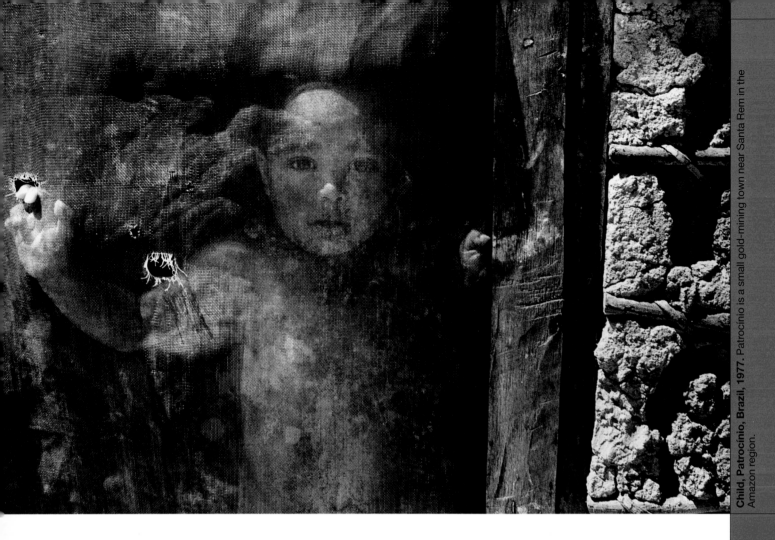

from the East and the West. As such, Burri's master-piece is comparable only to the work of August Sander, even though the two photographers took a fundament-ally different approach to the same subject.

Eleven of Burri's images from the series appeared in the September 1962 edition of *Du* magazine, the Swiss monthly founded in 1941 by the Zurich publishers Conzett & Huber (for example, images on p. 271 and p. 277). From its very beginnings, *Du* magazine has been the most important forum for humanist photo-journalism in Switzerland. Arnold Kübler became editor in chief of *Du* after *Zürcher Illustrierte* ceased publi-cation and his editing job there came to an end. Kübler ordered the magazine to 'emphasize a pictorial and aestheticizing photography' and, in doing so, continued what Urs Stahel once called the 'Kübler line' in oppo-sition to Finsler.[55] According to Dieter Bachmann, the philosophy of *Du* has always involved 'a unique blend of vision and selectivity, of social commitment and courageous design; it printed individual pictures large on the page (there lay its difference from the narrative picture sections of other big illustrated magazines); it had a special love of surprise, of the out-of-the-way event, and the droll; it was unflagging in its attention to detail.' Kübler's philosophy was so influential that his successors, although they differed from him consider-ably in their temperaments and interests, have never strayed too far from his successful example.[56]

Werner Bischof, Robert Frank, Paul Senn and Jakob Tuggener, to name a few Swiss photographers, had already published their work in *Du* by the time Burri made his first appearance in its pages in 1958 (p. 438, no. 1). Burri has continued to publish large-scale photo essays and individual pictures in *Du* up to the present day. His collaboration with the magazine was especially

intense in the 1960s and early 1970s. Working for *Du* proved to be an ideal scenario for Burri. At the time, his budget was tight and any independent travel had to be financed through a reciprocal agreement with Swiss Air. (Burri's photographs frequently illustrated the airline's inflight magazine *Gazette*.) Working for *Du* gave him plenty of opportunities for big stories (for example, the gaucho, Pablo Picasso and Japan), and ample time to design and execute them in a professional manner. Moreover, Burri was able to travel with the magazine's writers. During his most prolific years, his travel colleague was editor in chief Manuel Gasser. Burri also travelled with the Swiss novelist Hugo Loetscher who had a special affinity for photography. Burri's close collaboration and intense dialogue with authors like these created a marriage of text and image that placed *Du* magazine ahead of the competition.

For Burri, the presence of the writer also had the effect of ennobling his work with the camera. The 1950s, 1960s and early 1970s were the heyday of the big illustrated magazines. The written word, and not the photograph, reigned supreme. The job of the photo-journalist was to shoot pictures that would illustrate the text – and nothing more. At least in Europe, today's all-powerful 'art director', responsible for all matters of visual importance, had not yet entered on to the stage. It was the text editors – and only the text editors – who decided which direction a story should take. Photo-graphy was to serve as pure illustration, dishing up bland images of primarily documentary value rather than being showcased as a medium with its own artistic merit. The artistic potential of photography, especially in the context of journalism, was wholly denied. Strangely enough, it was only with the growth of televised news reporting, which pushed the illustrated

Days of the Dead, Metepec, Mexico, 1969. On the 1st and 2nd of November, Mexicans commemorate the dead in the 'Days of the Dead' celebration.

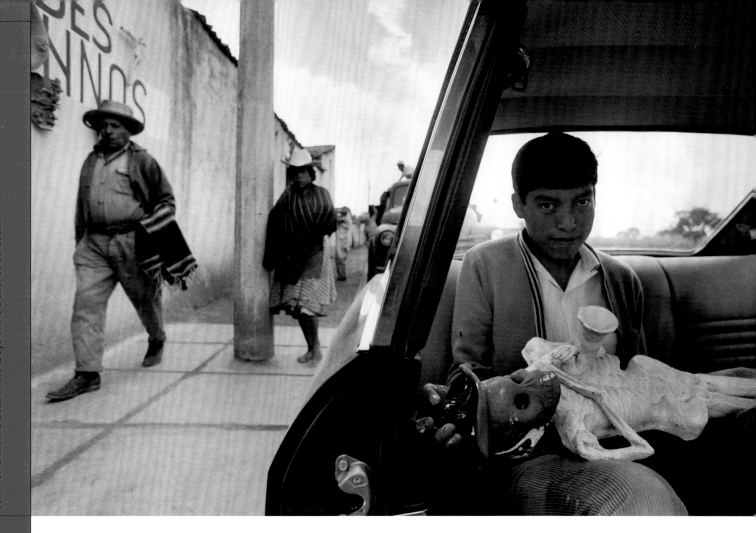

magazines into a crisis of identity, that photographers began to be held in higher esteem.

Burri's contribution to the July 1958 issue of *Du* was 'only' a cover picture (p. 438, no. 1) and two photographs inside the magazine, but by the next year he had made his first major appearance within its pages. A novel written by Ricardo Güiraldes had kindled Burri's interest in the world of the Argentinean gaucho. But Güiraldes' homage to *Don Segundo Sombra* had been written in the 1920s, and no one, not even the Argentineans, believed that the legendary Latin American version of the cowboy still existed. Determined to prove his sceptics wrong, Burri went on a wild journey through the Argentinean pampas – and found the last of the gauchos. Burri has always had a gift for finding topics, and this was just the first of many examples of his boundless energy, determination and commitment to his stories. Many feel that the special issue on the gauchos in March 1959 was Burri's finest reportage for *Du* (pp. 142–7; p. 438, no. 3). But Burri's photographs were also successfully featured in other *Du* special editions, including exclusive reportages on Le Corbusier in June 1961 (pp. 92–7); the island Koh Samui in the Gulf of Thailand in July 1965; Salvador da Bahia in July 1967 (p. 204); and Chicago in May 1972 working with the writer Hugo Loetscher.

Of particular interest is a special *Du* issue dedicated to Japan published in August 1961 (see chapter on Japan; p. 438, no. 2). Long before Japan had been taken seriously or was even noticed as an economic giant by the West, Burri and *Du*'s editor in chief Manuel Gasser were there, reporting on the spot. By avoiding topics such as 'tradition and history', 'architecture and geography', or 'flora and fauna', Gasser and Burri strove to document a new and different Japan, one that was

on the verge of becoming an industrial leader. They drafted the edition together while still in the country, Gasser writing while Burri photographed and worked on the article's layout. Looking today at the layout the two created, it is clear that Burri was very familiar with the rules of Swiss graphic design, especially the halftone screen technique, which had been 'developed for typography in order to achieve optimal readability and memorability'.[57] Clearly, Burri had benefited from Willimann's tutelage and from a three-month work experience in the Zurich studio of designer Josef Müller-Brockmann in 1955.[58]

Du magazine was Conzett & Huber's showpiece and proof of excellence. Photographers could count on serious texts, accurate captions, excellent print quality and detailed credits in prominent locations. Images were never cropped against the will of the artist, and the editors frequently devoted special monograph issues to individual photographers, such as the January 1962 issue 'The Photographer Robert Frank'. The magazine's policies were, however, an exception in a media world that looked upon photography as raw material for putting together series of photos. Henri Cartier-Bresson learned his lesson early and only released his upright and landscape-format Leica photos under the condition that they would not be cropped. Burri, however, did not subscribe to this dogma. In fact, he experimented with cutting and cropping his own photographs. We can see this in the different editions of *Die Deutschen*, in which Burri includes pictures such as *GI on leave* and *Couple kissing*, both Hamburg, 1960 (pp. 278–9), in a markedly narrower format. But Burri went about all of this very pragmatically, shooting his photographs in such a way that the editors would have little leeway to cut them down in size.

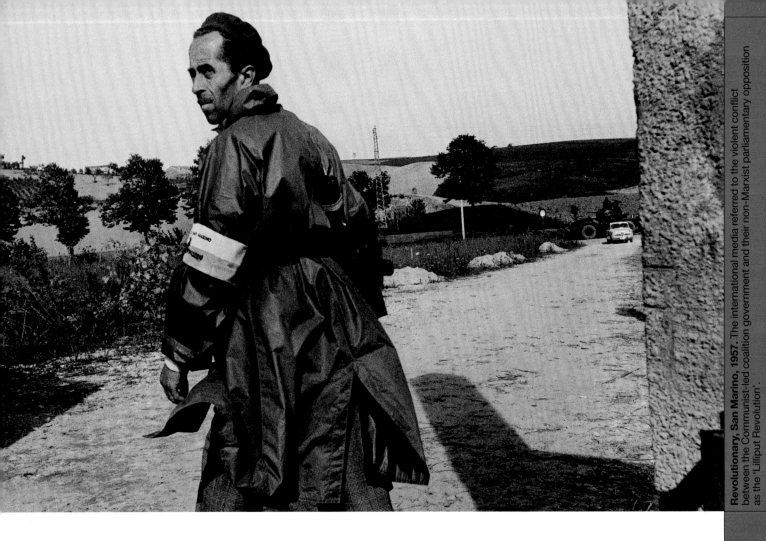

Revolutionary, San Marino, 1957. The international media referred to the violent conflict between the Communist-led coalition government and their non-Marxist parliamentary opposition as the 'Lilliput Revolution'.

The large number of masterfully crafted books and magazine reportages published after 1962 make it easy to forget that Burri was busy travelling around the world from the mid-1950s to the late 1980s, usually on commission for international magazines. Burri completed his first reportages in Switzerland, where he was already in familiar territory. But his horizon quickly widened. As Martin Schaub writes:

'In the appendix to his book *One World*, Burri's travel destinations are listed. It is a long, labyrinthine path. People like us can only follow his trail with our finger on the Atlas: Zurich – we won't mention Zurich anymore, but between the different stations Burri returns time and again to Zurich – Paris, Czechoslovakia, Libya, the Federal Republic of Germany, France, Sicily, Egypt. The photographer is only twenty-three years old. Nîmes, the Seine, Lourdes, the Basque country, East and West Berlin, San Marino, Syria, Greece, Turkey, Egypt, Gaza, Argentina, Bolivia, Peru and Brazil (in a jeep). Now he is twenty-five. Aswan, Luxor, the Nile delta, Cyprus, France, the Federal Republic of Germany, Iran, Iraq, East Berlin, São Paulo, Salvador da Bahia, Rio, Argentina, Geneva. Now he is twenty-seven. Thousands of anonymous people have been immortalized in Burri's photographs; dozens of leading political and cultural figures of the 1950s have let themselves be photographed: Mimi Scheiblauer, Le Corbusier, Picasso, Nasser, Nixon, Frondizi, Tito, Makarios, Eisenhower, Giacometti, Niemeyer, Robert Oppenheimer.'[59]

Although Schaub's timeline does not extend beyond 1960, Burri's virtual travelogue could continue. A quick glance at Burri's nineteen-page résumé, for example, shows that by 1970 he had visited (in chronological order) Japan, Pakistan, Hong Kong, South Vietnam, China, Thailand, Israel, Senegal, Canada, Swaziland, India and Australia – to name just some of the places. Burri once said that 'the camera was a magic wand. It gave me the opportunity to reach places where I could experience new things.'[60] One has to ask, is there a country that Burri has not seen, a culture that he has not explored over the course of his career?

It should be noted that Burri, despite his busy schedule, was never permanently employed by a publishing firm, magazine or editorial office. He was a freelancer, working either on a commission basis or busy with his own projects. The Paris bureau of Magnum on the rue Faubourg Saint-Honoré, and later on the rue des Grands Augustins, was in charge of distribution, ensuring that his individual photographs, photo essays and reportages were placed in the most attractive and lucrative positions possible. Among Burri's most prominent customers were *Life*, *Look*, *Fortune*, *Paris-Match*, *Jours de France*, *Epoca*, *Bunte Illustrierte*, *Stern*, *The New York Times* and *The Sunday Times Magazine*. At the time, the classic illustrated magazine functioned as a shop window to the world, following the motto that *Life* had coined in 1936: 'To see life, the world, to be witness to great events …'[61]

By 1960, news-oriented illustrated magazines were facing tough competition. In her book *Photographie et Société* (*Photography and Society*, 1974) Gisèle Freund describes the impressive lengths to which the illustrated magazine *Life* went to prepare for Winston Churchill's death. The goal was to prove to everyone that the magazine was still a viable medium for covering the news. The reportage on the funeral service was meant to be as current and detailed as possible. 'For this reportage,' writes Freund, 'The story required seventeen photographers, more than forty journalists and technicians, a dozen motorcyclists, two helicopters,

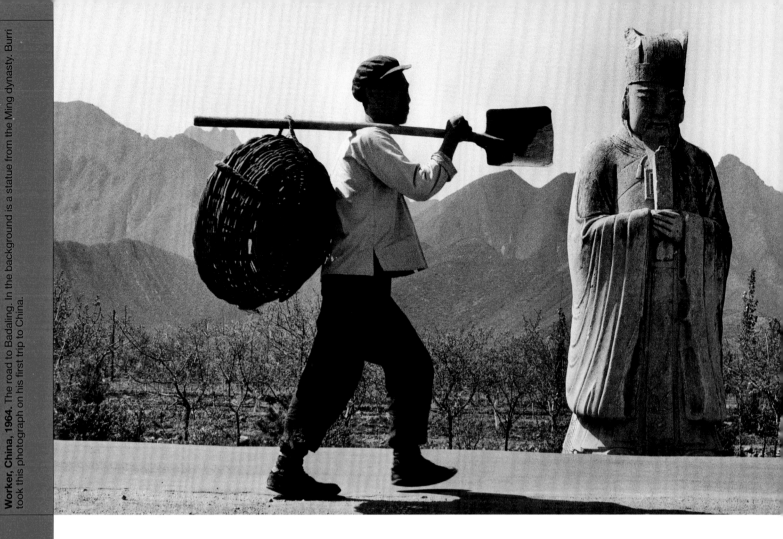

and one DC-8. Two years earlier, a researcher had drawn up a highly confidential list of all that was to happen upon the death of Winston Churchill [...] There was nothing else left to do but to wait for the old lion to die.'[62] As planned, the *Life* special issue on Churchill's death appeared on 5 February 1965. In the end, however, the 'race for relevance was not to be won', as Thomas Hoepker emphasizes.[63] In December 1972, *Life* published its last issue.[64] *Look* had already disappeared from the media marketplace and others like *Jours de France, Réalités* and *Epoca* were soon to follow. The rest mutated into clones of *People* magazine. According to Freund, television 'had become a formidable rival for the magazines. Although the images on the little screen continually disappear, sometimes they bring news so fast that there is no time-lapse between the events and the reporting on them.'[65] The phenomenon Gisèle Freund describes tentatively here – in the mid-1970s – has long since become part of our everyday reality: wars take place live in our living rooms, commentated upon and in colour.

René Burri was able to experience the twilight of the great era of illustrated magazines. At the same time, he became witness to a change in paradigms that has had a lasting effect on our society of communication. He remembers:

'One day, I went to Cyprus. I shot a story about the return of the Archbishop Makarios (p. 32). After that I immediately flew back to Athens with my pictures. Two, three hours later I was sitting in the hotel, writing the captions and packing up the story so that I could send it off. It was for *Paris-Match*. And there I was in the middle of the hotel lobby when the television went on. I was sitting there with my film and saw the exact same pictures that I had just taken. I stood up in front of the

television and said, "Don't watch this! You'll see the story in *Paris-Match* on Monday." They told me to get out of the way and I suddenly realized that I had somehow been overtaken by events.'[66]

Unlike his unsuspecting colleagues, many of whom were pushed out into the cold, Burri recognized the significance of these developments early on. Not that he suddenly withdrew from photojournalism and defected to television or the cinema. True, he made a number of important films, the most significant of which was his insightful 1968 documentary on China. But Burri never abandoned photography. He has always been aware of the qualities of the still picture and its power to become ingrained in our consciousness, to establish memories: As Burri has said, 'A cameraman has twenty-four pictures per second rushing between his fingers. He would give his right hand if he could pin down the picture and hold it still just once.'[67] Perhaps one day we will manage to find a form of journalism that will add to or complement the traditional photo essay with its typically short lifespan. Only then will photojournalism have a chance to survive in this era of moving pictures.

In addition to his immense technical abilities, René Burri's talent lies in his capacity to follow through on big topics and to find stories that closely reflect his personal preferences and special affinities. This has allowed him to maintain his focus over a long period of time and to hold out in the face of great resistance. The story of Burri and Picasso provides a perfect example of this. He first encountered the works of Picasso in the Kunsthaus Zürich (The Museum of Fine Art, Zurich) while still in school. In 1953 he saw Picasso's *Guernica* in the war-damaged Palazzo Reale (Royal Palace) in Milan. Picasso had completed the work in 1937, and Burri, like so many others after 1945, was overwhelmed

by this masterful denunciation of war and indictment of fascism. Burri's photograph of the exhibition reveals his fascination with Picasso and was the starting point of a lifelong interest in the artist and his work (pp. 54–5). To make a portrait of the Spanish master was at the very top of the young photographer's wish list.

We have already mentioned Burri's abortive attempt to visit Picasso in Paris. Three years later, Burri was in San Sebastián, Spain and read in the local paper that Picasso would be attending a bullfight in Nîmes in the south of France. As Burri recalls, 'I drove all night to get there. When I arrived, I looked for the hotel, talked my way past the porter and was met by a chambermaid who called out, "They're all here already!" She led me to a room where a small group of musicians was playing and dancing around a brass bed. There was a man sitting on the bed, busy directing the makeshift orchestra: Pablo Picasso. I asked "May I take a photograph?" and he nodded. That's where it all started.'(pp. 58–9)[68]. This would not be Burri's last photograph of the Spanish artist. And Picasso would not be the last great artist to be examined through Burri's camera. Burri's passion for the world of art provided the backdrop and motivation for countless portraits of artists, actors, musicians, painters, photographers and architects. In 1999, for instance, it was possible to design an entire book using material from his many years of work on Le Corbusier and his architecture (see chapter on Le Corbusier).[69] Early on in his career, Burri explored Oscar Niemeyer's artificial city Brasília, and he formed an intense life-long friendship with the Mexican Luis Barragán. He took portraits of Mario Botta, Jean Nouvel, Renzo Piano and the young Richard Meier. In the 1960s, Burri visited Paris, meeting with Yves Klein and spending a day with Giacometti in his workshop. (It was only later, Burri

admits, that he noticed how Alberto Giacometti himself had come to resemble his angular sculptures, especially his narrowed eyes.) Burri documented the work of his fellow countryman Jean Tinguely over the course of many years. He made portraits of Oskar Kokoschka, and he repeatedly visited and documented exhibitions of Picasso's work.

Of course, as journalists would say, these all sound like 'soft' topics, the kind that are to be found in special interest or art section pullouts. However, reading between the lines of Burri's résumé we also find a life of great adventure, replete with the dangers that all great adventures entail. In fact, in the past fifty years, there has hardly been a war or crisis that Burri has not documented, from the nationalization of the Suez Canal in 1956 to the massacre at Tiananmen Square in 1989. He has followed almost all of the contradictions and antagonisms of the twentieth century: the conflicts between East and West, North and South, rich and poor, black and white.

René Burri knew the dangers inherent in being a reporter. Capa and Bischof had already died by the time he embarked on his first dangerous mission at the age of twenty-three. But Burri sees himself as a political individual and has always been determined to use his photography to contribute to political discourse, although he admits to having 'slipped into the profession unintentionally'. He says, 'I simply wanted to investigate every nook and cranny of the world with my camera, my third eye. And I thought I would have the time. But when I finally made it to these places, something unbelievable always happened.'[70]

In 1956 Burri went to Egypt. Nasser had nationalized the Suez Canal, a provocation with uncertain consequences. The writer Georg Gerster who travelled with

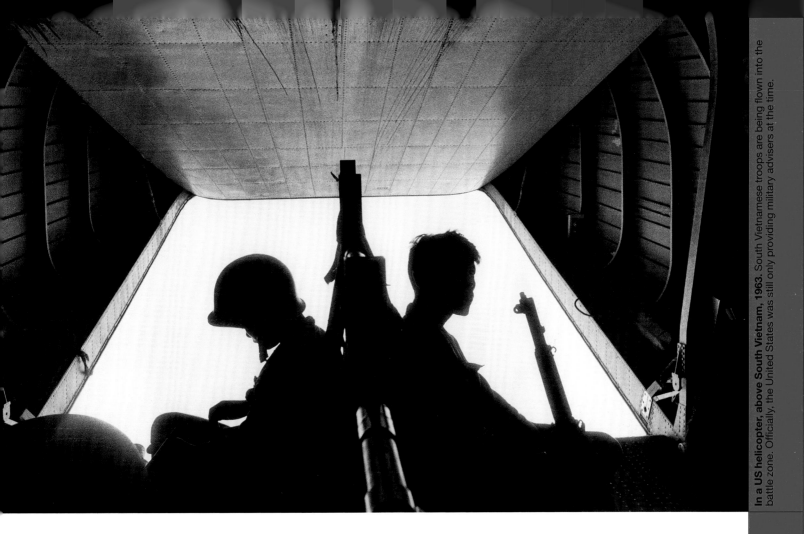

In a US helicopter, above South Vietnam, 1963. South Vietnamese troops are being flown into the battle zone. Officially, the United States was still only providing military advisers at the time.

Burri describes feeling that they were in the eye of the hurricane. On assignment for Zurich's *Weltwoche* and other magazines, Burri also took a number of his own photographs, which convey the surreal quality of the events. 'We made the trip through the canal on a tanker,' writes Gerster, 'the last ship of a convoy that consisted only of oil tankers.' They had hardly set foot on land when Burri was confronted by a soldier 'who unceremoniously loaded his rifle and released the safety catch. A dispute followed, Burri trying in vain to make himself understood and waving about his Swiss passport. The growing crowd of locals became more and more incensed. If the harbour director at Port Said had not intervened, Burri would have been lynched.'[71] Dangerous situations like these are part of a photographer's job but are often forgotten when photographs become 'classics', hanging in galleries and museums to be consumed only on an aesthetic level.

Burri's trip to the Suez Canal in 1956 was the first but not the last time he would report from the Sinai Peninsula. In fact, the Middle East as a whole became a subject of intense interest for the Swiss photographer. This is not surprising when we consider that Burri composed his images with particular attention to depth, both in terms of dimension and content. With its rich history and culture, the Middle East provided the perfect backdrop to the important historical events that were taking place in the foreground. Martin Schaub writes that 'Burri's strength, in addition to his agility and his feel for the prevailing light, is the dynamic composition of depth. Hardly any other photographer is so successful in spontaneously structuring foreground and background in such a dramatic fashion.'[72] This style clearly distinguishes his photographs from the sharply focused, two-dimensional compositions of Cartier-

Bresson. In 1974, Burri captured Richard Nixon and Anwar Sadat as they stood in front of the Pyramids of Giza surrounded by security guards (p. 31). What photograph could better illustrate the attention that Burri has always paid to depth?

It is hardly by chance that continental Europe, China and Latin America are the regions that saw René Burri's most intense photographic activity. Australia was something of an exception, and he seldom travelled in sub-Saharan Africa. He was most attracted to the Middle East with its convergence of great cultures and world religions, both past and present. Repeatedly he travelled to Egypt, Syria, Israel, Palestine, Iran and Iraq, usually on assignment for international magazines. Because he was not American, British or French, he had a particular advantage in these regions. Burri undoubtedly used his Swiss passport more than once to his own advantage. In 1958 he was there to witness the spectacular, if short-lived, union of Egypt and Syria as the United Arab Republic. That same year, chance led him to the secret training camps of Algerian National Liberation Front (FLN) fighters in Egypt, a scoop if there ever was one (pp. 386–7). His photographs were circulated around the world. He also visited Iraq after General Karim Kassem had put a violent end to the monarchy. In Iran he reported on the Dez Dam for *Fortune* magazine (p. 381). And in 1962 he was on assignment for *Vogue* in Lebanon, which back then was sometimes called the Switzerland of the Middle East (p. 374). Almost thirty years later, he returned to find Beirut reduced to a pile of rubble. Almost two decades after he had gone through the Suez Canal on the last permitted oil tanker, he accompanied a commando of international minesweepers who were preparing the waterway to be reopened. During the

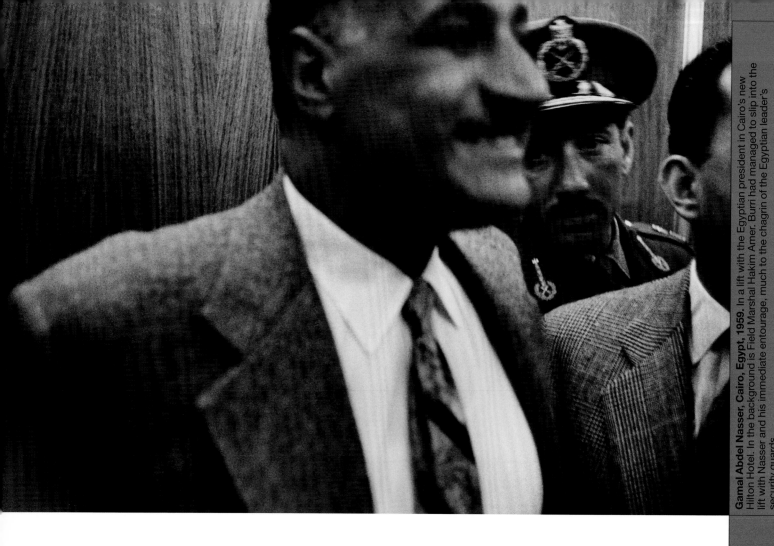

Six Day War, Burri's photographs showed the Russian tanks looking like dead beetles and the downed helicopters like crushed dragonflies (p. 37, p. 392). Burri was there when Sadat celebrated the second success of the Egyptian army in the Yom Kippur War (pp. 390–1). And in 1950, he managed to slip into a lift in Cairo in which Nasser himself was standing (above). The bodyguards were horrified, the head of state amused. And René Burri, as usual, was in the thick of the action.

Burri was able to get close up not only to Syrian president Kouatly but also to Anwar Sadat and the Shah of Persia. The Shah was anticipating fatherhood; his wife, Farah Diba, was pregnant with the long-awaited successor to the throne – a sensation in the boulevard press of the late 1960s. Burri worked alone in Tehran for three weeks, but 'as the birth of the crown prince came closer, dozens of teams from *Time* and *Life* arrived – journalists, drivers and the whole entourage. I sat in my little hotel like a lone fighter.'[73] When the time had come, the photographers were led in groups of ten into the delivery room where a curtain blocked the view of the scene. 'They all had to set up their equipment,' Burri recalls, 'and because I was taller, I went up front and kneeled down in front of the glass pane. Most of them had huge zoom lenses to take a close-up of the baby. But as the curtain rose, it turns out that the baby was lying in a crib directly behind the pane. Everybody rushed to change their lenses, but I had a wide-angle lens already prepared. I managed to take two or three shots before the curtain closed.' Burri sent the exposed film to *Paris-Match*. He did not believe that his reportage was particularly successful until he received a phone call from the Magnum bureau in Paris telling him that his landscape format photograph including the nurse and

treating doctor had merited a full double-page spread in *Life* and also *Paris-Match* (p. 33). After this accomplishment, Burri's 'confidence grew as he realized that success had nothing to do with staying at the Grand Hotel or having drivers. It was luck and also the ability to stand out from the others.'[74]

'A reporter's luck,' Thomas Hoepker once said, 'is always the bad luck of others,' adding the question, 'Could it be that the quiet, but brilliantly photographed story from the life of our next-door neighbour is more fascinating than the juiciest scandal or worst horror?'[75] Those who look through Burri's photo archive, an impressive visual chronicle of the twentieth century, will make an astonishing discovery: there are no corpses. Images of the wounded and the maimed are nowhere to be found. How can this be? Burri was on the Sinai Peninsula. He was in Korea. He was in Vietnam, where he accompanied South Vietnamese helicopter commandos on their missions to the Mekong Delta (p. 29, pp. 308–9). Did Burri not see death? Did he not want to see it? Did he not want to photograph it?

Reporters are supposed to document war, or so the popular mind would have it. Even though everyone knows that their photographs have little or no effect. If they are not misused as propaganda, then they find their way into our living rooms as entertainment for the people who stayed at home. James Nachtwey, perhaps the most widely discussed war photographer today, thinks differently. 'We must look at it. We are required to look at it. We are required to do what we can. If we don't, who will?' he demands.[76] Appropriately, Nachtwey gave his long-term project the title *Inferno*. Here we can clearly see the difference from Burri, who does not subscribe to any sort of apocalyptic mysticism and is profoundly sceptical about what

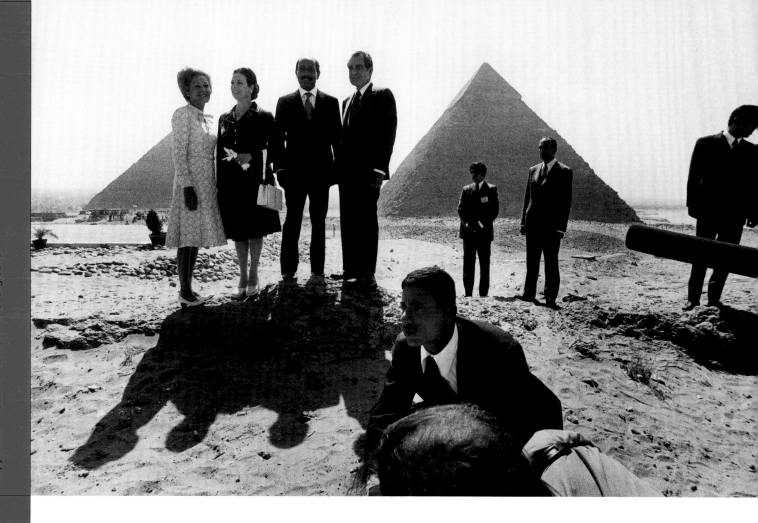

Roland Barthes has called 'shock photos'.[77] Burri knows that it is more important to expose the structures, alliances, connections and interests that make war possible in the first place.

Jan Thorn-Prikker begins his analysis of Burri's war photography by describing a photograph of the desert from the Six Day War in 1967:

'It shows a road criss-crossing the sand and lined with bombed-out vehicles and discarded weapons: a road into nothingness (p. 393). Another image shows two tank-like primeval monsters lost in the desert sand (p. 37). Their canons are pointed at the left and right sides of the picture: weapon-bristling nonsense. A third picture calls the medium of war photography itself into question. It shows war correspondents behind a sand dune at the Suez Canal (p. 444, no. 3). They are sitting, standing and lying in a herd, photographing the columns of smoke where invisible victims are bleeding to death by the thousands. One man is holding his hands to his ears. The image declares that no picture can truly show the essence of war. It makes no sense to speak of immediacy or accuracy when all that war photos really show is the smoke that obscures what is really going on. These Heroes of Nothingness are only perpetuating the false notion that we can be spectators to all wars, wherever they happen to be fought out. Burri's photographs destroy this illusion.'[78]

Burri had already learned from reading the plays of Bertolt Brecht that war eventually devours those who profit from it. His Magnum colleague Capa had trodden on a mine in Indochina; Chim fell on the front line at the Suez Canal in 1956. Burri never shrank back from risk, but he did fear the 'drug' called war, to which he saw countless colleagues become addicted. In 1963 he accompanied a South Vietnamese patrol in 'enormous

helicopters' that were already being flown by Americans (p. 29, pp. 308–9). He recounts:

'When we were about to take off, this guy came running up to us calling, "Stop! Stop!" We pulled him inside and then it was off to the Mekong Delta, where all hell was breaking loose. People were dropped off and there was shooting. It was complete chaos. The man who had come running up was just sitting there, still strapped in. As we flew back, I noticed he hadn't taken his Rolleiflex out of its case. I asked him if he had taken any photos and he replied, "I don't need that any more." He rolled up his trousers to reveal a wooden leg. "Dien Bien Phu," he said. It was 1954 or 1955, and I realized that the man was an addict. He kept throwing himself into battles in order to experience it again and again.'[79]

Action-packed war photography is as alien to René Burri as are images of starving, sick, begging or homeless people in the poorer regions of our world. As Thorn-Prikker writes:

'Burri is successful in the art of working in a precise and documentary fashion without becoming sentimental. One of his images shows a slum in Brazil. In the middle of the picture is a sparsely set table with a pair of glasses, three sets of cutlery, and nothing to eat […] The image summarizes everyday life in the Third World – the lack of food, shortage of housing, overpopulation and a fear of what the future will bring. Burri's convincing precision stems from the casual, the passing, the normal. This picture does not show extreme suffering, agony or murder. Instead it digs down to the root causes of these things.'[80]

Burri has always set ethical boundaries for himself. To some people this might seem like bad journalism or unnecessary self-restraint. To others it might simply appear old-fashioned. But he insists on treating others

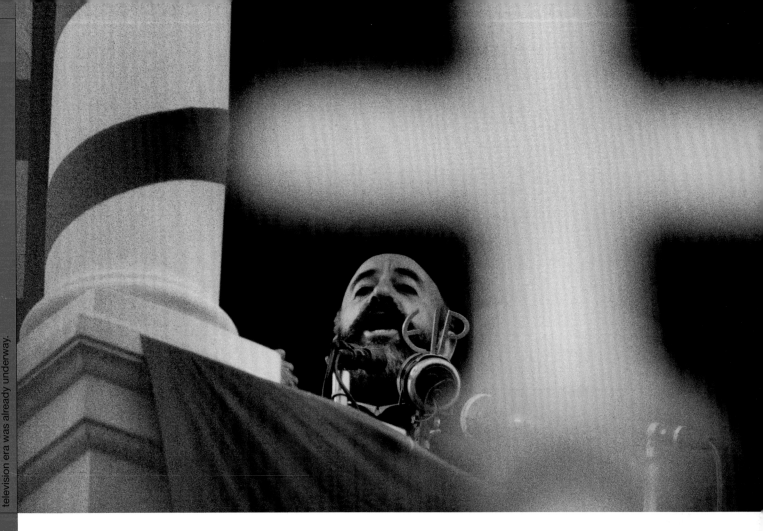

Archbishop Makarios, Cyprus, 1959. Greek Cypriots celebrate the return of Archbishop Makarios, also known as Mihail Mouskos. *Paris-Match* published Burri's photo reportage on 14 March 1959. It was still the heyday of the big illustrated magazines and photojournalism. However, the rise of the television era was already underway.

his equals. He knows that looking down from a safe remove at hunger, sickness, poverty or misery would merely represent a continuation of colonial gestures, as does the term 'Third World'. Those who know how to read Burri's pictures will see the poverty, the under-development, the backwardness. True, these things are not always obvious at first glance. They are coded in a subtle manner and were never intended to feature as double-page spreads in popular magazines. More importantly, they do not degrade the subject. For the act of taking a photograph can, in itself, be degrading. Burri clearly sees the misery in our world, but he does not seek to document it directly with his camera. Burri refuses to 'reduce the powerless to their powerlessness', a phrase used by Neal Ascherson in his criticism of Sebastião Salgado's 'beautiful photos of the poor and enslaved of Africa and South America'.[81]

Because of his strong feelings on this subject, he has refused to take pictures that, though they might have benefited his career, would have exploited the individual being photographed. Burri calls these his 'untaken pictures'. In 1964 he was in China, for example. During a meeting with government officials, 'it was suggested that I come and photograph a gardener.' He refused, but they insisted that this was no ordinary gardener; it was someone who bred orchids. Burri said, 'No, I don't want to take a photo of him.' But then he began to pay more attention. As Burri recalls, 'Someone whispered to me that this gardener was actually the former emperor of China. But I had had enough. I politely thanked them and refused their offer.' Another time, in the woods near St Moritz, Burri ran into the actor Fernandel with his chauffeur and Rolls Royce. Burri recalls that the scene was 'interesting, but somehow sad' and he left the moment unrecorded. Another of his 'untaken pictures'

was in New York in 1959 or 1960. 'A woman wearing a pair of dark sunglasses came down a long side street,' Burri recalls. 'I had my camera with me and lifted it up. She hesitated but continued to come toward me. It was Greta Garbo. Only a few seconds were left for me to decide: should I take the photo or not? I didn't. And just like that, she was gone.'[82] Other 'untaken pictures' include a skeletal arm in the sand of the Egyptian desert. Or Fidel Castro. Years ago, Burri ran into Castro while in Santiago, Cuba. The photographer recalls that 'Castro was standing in front of his hotel and right above his head there was a lit-up sign that read "Exit". I said to myself, "You are not going to take this photo." It would have been too simple, too literal, a picture that everyone would have liked to have taken. Fidel smiled at me and asked "Everything okay?" I answered, "Everything's great."'[83] Clearly, if Burri had taken that picture, it would have become famous overnight.

If there is any common denominator in René Burri's work, it is the fact that his photography is constructive. Burri is more interested in the birth of ideas than in destruction and chaos. He is a photographer of vision who seeks out ideals and utopias. But is there such a thing as a utopia without a revolution? Perhaps this is the source of Burri's interest in China, an ancient culture that, in the mid-twentieth century, was looking for new ways of dealing with hunger, illiteracy and over-population. Burri, however, is not a romantic. He is very aware of the dark side of what, at its core, is a totali-tarian regime. In 1989 he was witness to the bloody massacre of unarmed civilians at Tiananmen Square. But his outlook parallels the metaphor of the glass of water: imperfect, like the world we live in, but half full rather than half empty. His photography thrives on the principle of hope, and his photographs search out great

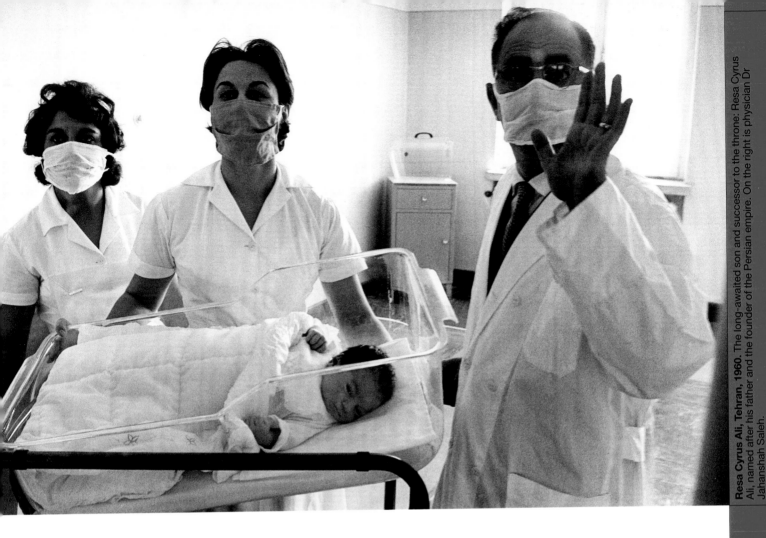

Resa Cyrus Ali, Tehran, 1960. The long-awaited son and successor to the throne: Resa Cyrus Ali, named after his father and the founder of the Persian empire. On the right is physician Dr Jahanshah Saleh.

moments rather than great disasters. As Peter Killer has said, 'Those who see his photographs from thirty years of reporting will never accuse Burri of masking the truth to make it more palatable. Nevertheless, even when they tell of war and death, Burri's photographs have something deeply human about them. There is not one image in Burri's oeuvre that denies the hope of a more civilized world.'[84] Burri documented the creation of the capital city Brasília, a constructed utopia; he has looked over the shoulders of Yves Klein, Tinguely, Giacometti and Picasso – visionaries at work; he has admired built dreams, such as the architecture of Le Corbusier. Burri has worked for the press his entire life, but when he set out to explore the world, he has done so as an optimist, and an individual deeply interested in exploring art and the nature of creativity.

Editor Guido Magnaguagno once said that the casual and passing moment dominates Burri's work. 'Burri,' he asserts, 'does not fix his gaze on the "event" itself, but circles it and examines its context, its surroundings. He shows how events affect their environment and determine people's behaviour. The passers-by of history are given a face. What at first appears to be an enigmatic lack of action becomes, once the sequence of images and ideas comes into focus, a profound description of the state of an era.'[85] Burri's unique visual language cannot be reduced to a simple formula. He has never been seduced into a specific style and has never adhered to a single technique, whether this be the use of coarse graininess, conscious unfocusing, cropped faces, natural light or subtly crossed perspective lines. None of these ever became dogma to Burri, but all of them can be found in his pictures. Burri adapts his style and his formal methods to the occasion. He takes a documentary stance when a topic demands objective

information, and he risks visual experiments in cases where a certain feeling or atmosphere needs to be recorded. Take, for example, New York in the 1960s. Burri was up late one night, working on a film, when the lights suddenly went out. He grabbed his Leica and ran out into the dark streets of the metropolis, photographing a series of ghostly scenes without a flash (p. 28). The only light was the occasional flare of a burning newspaper. Unpublished until now, the series of photographs taken during the blackout would fit well into a discussion of what some would call 'visualism', an artistic approach in photography which deals with visual phenomenon through experimentation. René Burri, however, has never paid attention to this type of jargon. Even before photography was accepted as a valid form of artistic expression, he knew that his best photographs would one day find their way into the annals of great art. Martin Schaub sums up Burri's qualities well when he describes his book *Die Deutschen* as a monument to his 'photographic eye, which though supremely intelligent never fails to capture the human element of a scene.'[86]

If Burri had entered into professional photography a generation or two later, it is quite possible that he would have been able to go beyond his successful commercial colour work and realize his full artistic potential as a colour photographer. He had studied colour theory and his senses were trained in the peculiarities of colour photography through his preliminary course with Johannes Itten, who sensitized his students to colour at the School of Arts and Crafts in Zurich, just as he had done earlier at the Bauhaus. Later in Burri's training, he printed his own dye transfers under Finsler, and as early as 1956 he finished his first colour assignment for *Fortune*. In the late 1950s *Du* began to ask for colour from time to time (p. 438, nos 2–3). *Bunte Illustrierte*,

Burri's most important client at the beginning of his career, became more and more true to its name and let him do colour reportages. The change of culture was sealed in the 1980s by magazines that were firmly dedicated to colour, such as *Geo*. Although Burri is best known for his black-and-white images, his extensive archive is proof that he used colour photography for many decades in the service of international magazines.

Looking through Burri's archive with the eye of an art historian leads to astonishing discoveries. We find pictures that, in their sober view of the banal, anticipate the style of William Eggleston. In other photographs, he distances himself from his subject, taking a minimalist view of the world, much like Andreas Gursky, one of to-day's globally celebrated contemporary photographers. Some of Burri's colour photographs show the irony of American pop culture in the vein of Mark Cohen or Joel Meyerowitz. Many of his images are journalistic, and their delicate balance of colour could compete with those by Carl de Keyzer or Harry Gruyaert, both well-known second generation Magnum photographers. In this latter case, René Burri's colour photography anticipated many tendencies of the later 'New Colour' movement. If anything distinguishes 'New Colour' from other movements, it is the aura of self-confidence that surrounded it. However, the term 'movement' is not entirely accurate. A wide variety of photographers including Stephen Shore, Neal Slavin, Joel Sternfeld and William Eggleston joined together in their expressive use of colour even though their independent artistic personalities differed greatly. The phrase 'New Colour', now broadly accepted, was a third-party term coined by curator Sally Eauclaire for a 1981 exhibition at the Everson Museum of Art in Syracuse, New York. Eauclaire sought to demonstrate that the final break-

through in artistic colour photography had been achieved.[87] And indeed it had, but it had taken a very long time. It is common knowledge that multi-layered films from Kodak and Agfa had already been invented by the mid-1930s, serving as the prerequisite for modern, practical and universal colour photography. This film was expensive, however, as was colour printing, so photographing in colour did not become common in illustrated magazines or among photography amateurs until the 1960s and 1970s. Old prejudices of what constitutes true art also impeded colour photography. The legendary Walker Evans described colour as 'vulgar', and Jean-Claude Lemagny said that 'colour is accidental, black-and-white is existential.'[88] Indeed, when we think of Magnum photography, we most often think of black-and-white images. Like Lemagny, many members of the agency felt that black-and-white embodied the essence of photography.

Burri had an ambivalent relationship with colour from the beginning. On the one hand, he found it disruptive to introduce colour when he was 'building a world in black-and-white'.[89] However, Burri has never been able to resist a challenge. Many of his assignments have been in colour, especially for advertisements, or illustrations for business reports. Over the years, Burri has also used his discerning eye to build a considerable personal collection of colour photographs. His conscious precision distinguishes him from photographers like Ernst Haas, whose increasingly abstract colour works of the 1960s exerted a great deal of influence on amateur photographers. Burri did not follow the colourful and atmospheric style of Haas. Rather, he produced finely crafted, often political images that attempted to address the 'colour problem' on an aesthetic

level. He has never disowned his colour works and included them in both his book *One World* and in the *Photo Poche* book on Burri's work published by Delpire. A close look at the thousands of slides in Burri's archive shows his eye for the world of everyday and popular culture. Walker Evans might have said that colour was vulgar, but he followed his comment by adding that colour is also the ideal medium 'for depicting vulgar subject matter'.[90]

In 1989 Burri travelled to Moscow for a meeting between Ronald Reagan and Mikhail Gorbachev. It was a historic moment and a big media event, with no fewer than 6,500 journalists present. Some even brought along ladders so they could get a better view. There were security forces, barriers and other restrictions. Burri realized it would be impossible to take a meaningful picture in this controlled environment. As soon as he dared to step out of the prescribed area, a security guard grabbed his arm and shoved him back in line. In the 1950s in Cairo, Burri had been the only Western reporter who dared to follow Nasser and Kouatly into the mosque on the eve of the historic union between Egypt and Syria. But today, distinguishing oneself from the crowd has become increasingly difficult, if not impossible, in our age of indirect censorship.

Burri's colour reportage on the Reagan–Gorbachev meeting is one of his last. Recently, he made a portrait of his older friend, colleague and mentor, Henri Cartier-Bresson, on commission for the US magazine *Vanity Fair* for a portfolio honouring Cartier-Bresson's ninety-fifth birthday. Now Burri seldom uses his camera. He has settled down, partly due to his young wife and son Léon Ulysse, but also because too many pictures in his archive are still waiting to be discovered. Burri has set up a studio in the Passage Piver in the eleventh arrondissement of Paris. The room itself is only a few square metres in size and is stuffed with books, magazines, catalogues, cardboard boxes full of photographs, contact sheets, photocopies and prints from all stages of his career. Tacked on the wall are a series of pictures: the skyline of New York, a pensive Picasso, a proud Che Guevera, photos of friends and family, Robert Frank with a cigarillo, Yves Klein in his studio, Jean Tinguely. To reflect and bring memories back to life is also a form of travel; to reveal what is buried is a form of adventure. This small studio is where our 'one world' is stored, the world that René Burri set out to explore and document over five decades ago. Now, after opening the boxes, bags and albums with Burri and assembling his remarkable story here, we can turn the page, and explore his world.

Above the altiplano, Bolivia, 1958. This photograph was taken during Burri's first trip to Latin America. Burri left Europe for six months and explored Argentina, Brazil, Bolivia and Peru, among other countries.

Endnotes

Quotations that appear in the introduction have been translated by the publisher into English where no published English original exists.

1 Burri, *One World: Photographien und Collagen 1950–1983*, edited by Rosellina Burri-Bischof and Guido Magnaguagno, Bern: Benteli, 1984, p. 163. Magnaguagno suggested the catchy title.
2 Ibid.
3 See *Wir Brückenbauer: Wochenblatt des sozialen Kapitals*, no. 41, 9 October 1996, p. 5.
4 Roméo Martinez, 'René Burri', *Camera*, no. 7, July 1956, p. 296.
5 Ibid.
6 Véronique Burri, interview with the author, 23 February 2003, Zurich.
7 René Burri, interview with the author, 25 November 1996, Paris.
8 Véronique Burri, interview with the author, 23 February 2003, Zurich.
9 Interview with Burri, 'Moment! Das Lebenswerk des Magnum-Photographen René Burri: zusammengerechnet höchstens vier Minuten', *Süddeutsche Zeitung Magazin*, no. 43, 24 October 1997, p. 22.
10 René Burri, interview with the author, 12 December 2002, Paris.
11 Magdalena Droste, *Bauhaus 1919–1933*, Cologne: Taschen, 2002, p. 25.
12 Ibid., p. 28.
13 Peter Killer, 'René Burri: Träumende Reporterunrast', in *Du: Die Zeitschrift der Kultur 1941–2001*, Zurich: Du/Transmedia AG, 2000, p. 73.
14 Véronique Burri, interview with the author, 23 February 2003, Zurich.
15 René Burri, interview with the author, 11 December 2002, Paris.
16 Sissy Bolliger-Lang quoted in Klaus E. Göltz, et al. (eds), *Hans Finsler: Neue Wege der Photographie*, Leipzig: Edition Leipzig, 1991, p. 46.
17 Anita Niesz quoted in Göltz 1991, p. 51.
18 Jürg Klages quoted in Göltz 1991, p. 51.
19 See Hans Finsler, 'Das Bild der Photographie', *Du*, no. 3, March 1964, pp. 2–54 and also Finsler, *Mein Weg zur Fotografie: 30 Aufnahmen aus den zwanziger Jahren*, Zurich: Pendo, 1971.
20 Walter Binder, 'Erinnerungen an Hans Finsler', in Göltz 1991, p. 43.
21 Hugo Loetscher, *Durchs Bild zur Welt gekommen: Reportagen und Aufsätze zur Fotografie*, Zurich: Scheidegger & Spiess, 2001, p. 37.
22 See 'Die große Familie der Menschen', in Roland Barthes, *Mythen des Alltags*, Frankfurt/Main: Suhrkamp, 1964, pp. 100–2.
23 Walter Binder in Göltz 1991, p. 44.
24 Ibid.
25 René Burri, interview with the author, 11 December 2002, Paris.
26 Urs Stahel, 'Fotografie in der Schweiz', in Urs Stahel and Martin Heller, *Wichtige Bilder: Fotografie in der Schweiz*, Zurich: Verlag der Alltag, 1990, p. 148.
27 Hans Fischli, 'Zum Andenken an Alfred Willimann', in *Neue Zürcher Zeitung*, 1 April 1957, p. 14.
28 Burri 1984, p. 8.
29 Interview with Burri, 'Moment! Das Lebenswerk des Magnum-Photographen René Burri: zusammengerechnet höchstens vier Minuten', *Süddeutsche Zeitung Magazin*, no. 43, 24 October 1997, p. 22.
30 René Burri, interview with the author, 12 December 2002, Paris.
31 Killer 2000, p. 73.
32 Russell Miller, *Magnum: Fifty Years at the Front Line of History: The Story of the Legendary Photo Agency*, London: Secker & Warburg, 1997, p. 106.
33 Klaus Honnef, 'Es kommt der Autorenfotograf: Materialien und Gedanken zu einer neuen Ansicht über die Fotografie', in Gabriele Honnef-Harling and Karin Thomas (eds) 'Nichts als Kunst ...' Schriften zu Kunst und Fotografie, Cologne: Dumont, 1997, pp. 152–82.
34 Stahel 1990, p. 160.
35 '13 sehen unser Land in 7 Tagen', in *Die Woche: Neue Schweizerische Illustrierte Zeitung*, no. 39, 21–27 September 1953.
36 Miller 1997, p. 127.
37 See Marco Bischof (ed.), *Werner Bischof 1916–1954: Leben und Werk*, Bern: Benteli, 1990, p. 38 ('In der Taubstummenschule von Mimi Scheiblauer, Zürich, Schweiz 1944')
38 'Les enfants sourds-muets peuvent apprendre la musique', *Science & Vie*, January 1955, pp. 94–9.
39 'Sie lernen hören mit den Händen', *Münchner Illustrierte*, no. 19, 7 May 1955 and 'Touch of Music for the Deaf', *Life*, 1956, pp. 95–7.
40 René Burri, interview with the author, 25 November 1996, Paris.
41 Miller 1997, p. 15.
42 Ibid., p. xi.
43 See Andrew Roth, *The Book of 101 Books: Seminal Photographic Books of the Twentieth Century*, New York: PPP Editions, 2001, p. 134.
44 René Burri, interview with the author, 25 November 1996, Paris.
45 The epigraph is taken from Max Frisch, *Sketchbook 1946-1949*, New York/London: Harcourt Brace Jovanovich, 1977, p. 254.
46 Véronique Burri, interview with the author, 23 February 2003, Zurich.
47 Max Frisch, *Gesammelte Werke in zeitlicher Folge: Werkausgabe in zwölf Bänden*, vol. 4, Frankfurt/Main: Suhrkamp, 1976, p. 697.
48 Véronique Burri, interview with the author, 23 February 2003, Zurich.
49 Quoted in Hans-Michael Koetzle, 'René Burri: Die unbekannten Deutschen', *Leica World*, no. 1, 1997, p. 27.

After the Six Day War, Sinai Peninsula, 1967. A view of the Russian-made Egyptian tanks destroyed during the Six Day War.

50 Burri 1984, p. 85.
51 Jan Thorn-Prikker, 'René Burri: One World', broadcast review, WDR (Westdeutscher Rundfunk), 1984.
52 Sonntagsblatt (Hamburg), 24 February 1963.
53 Frankfurter Allgemeine Zeitung, 23 May 1963.
54 See Stefan Moses, Abschied und Anfang: Ostdeutsche Porträts 1989–1990, Ostfildern bei Stuttgart: Hatje Cantz,1991. Moses' study of Germans is entitled Deutsche and was first published by Prestel in 1980.
55 Stahel 1990, p. 148.
56 Dieter Bachmann, 'Dauer im Wechsel: Die Zeitschrift du und ihre Fotografen im Verlauf eines halben Jahrhunderts', in Dieter Bachmann and Daniel Schwartz, Der Geduldige Planet: Eine Weltgeschichte: 255 Fotografien aus der Zeitschrift 'Du', Zurich: Schweizer Kulturstiftung, 1996, p. 278.
57 Thilo Koenig, 'Information statt Persuasion: Werbung und Plakatgestaltung mit fotografischen Mitteln', in Thilo Koenig, Michael Koetzle and Christiane Wachsmann, Objekt + Objektiv = Objektivität? Fotografie an der HfG Ulm 1953-1968, Ulm: HfG-Archiv, 1991, p. 95.
58 The Zurich graphic designer Josef Müller-Brockmann is considered one of the great defenders of the aesthetics of screen printing. See Josef Müller-Brockmann, Raster-Systeme für die visuelle Gestaltung: Ein Handbuch für Graphiker, Typographen und Ausstellungsgestalter, Stuttgart/Heiden: Niggli, 1988.
59 Martin Schaub, 'Zeichen der Zeit: René Burri: 33 Jahre Fotografie', in Tages Anzeiger Magazin, no. 2, 14 January 1984, p. 18.
60 Brigitte Ulmer, 'Ich dachte, Burri, du spinnst', in Cash Extra, no. 49, 5 December 1997, p. 68.
61 See Marianne Fulton, Eyes of Time: Photojournalism in America, Boston: Little, Brown & Company, 1988, p. 131.
62 Gisèle Freund, Photographie und Gesellschaft, Reinbek bei Hamburg: 1980, p. 150–1.
63 Thomas Hoepker, 'Fotojournalismus im Zeitalter des totalen Fernsehens', in Bernd Bosch et al., Fotovision: Projekt Fotografie nach 150 Jahren, Hanover: Sprengel Museum, 1988, p. 20.
64 Last issue appeared on 28 December 1972. Since 1982 Life has been available as a monthly illustrated magazine.
65 Freund 1979, p. 161.
66 Quoted in Hans-Michael Koetzle, 'René Burri: Die unbekannten Deutschen', in Leica World, no. 1, 1997, p. 27.
67 ibid., p. 24.
68 Ibid.
69 See Arthur Rüegg, Le Corbusier: Photographs by René Burri/Magnum, Boston: Birkhauser, 1999.
70 René Burri, interview with the author, 12 January 2003, Paris.
71 Georg Gerster, 'Augenschein in Suez', in Die Weltwoche, no. 1188, 17 August 1956, p. 3.
72 Martin Schaub, 'Pressephotographie nach 1945', in Schweizerische Stiftung für die Photographie (ed.), Photographie in der Schweiz von 1840 bis heute, Bern: Benteli 1992, p. 232.
73 René Burri, interview with the author, 12 December 2002, Paris.
74 Ibid.
75 Hoepker in Bosch 1988, p. 20.
76 Quoted in Hans-Michael Koetzle, 'James Nachtwey: War Photographer', European Photography, no. 72, winter 2002/2003, p. 13.
77 Barthes 1964, pp. 55–8.
78 Thorn-Prikker 1984, p. 5.
79 René Burri, interview with the author, 1 March 2003, Paris.
80 Thorn-Prikker 1984, p. 4.
81 See Verena Lueken's discussion of Susan Sontag's book of essays Regarding the Pain of Others in Frankfurter Allgemeine Zeitung, no. 97, 26 April 2003, p. 39.
82 René Burri, interview with the author, 1 March 2003, Paris.
83 Burri 1997, p. 24.
84 Killer 2000, p. 74.
85 Burri 1984, p. 19.
86 Schaub 1984, p. 19.
87 See Sally Eauclaire, The New Color Photography, New York: Cross River Press, Ltd., 1981.
88 Quoted in Gabriel Bauret, Color Photography, Paris: Éditions Assouline, 2001, p. 11.
89 René Burri, interview with the author, 12 December 2002, Paris.
90 Quoted in Thomas Weski, 'The Tender-Cruel Camera', in Hasselblad Foundation (eds), The Hasselblad Award 1998: William Eggleston, Göteborg: Hasselblad Foundation, 1999, pp. 9–10.

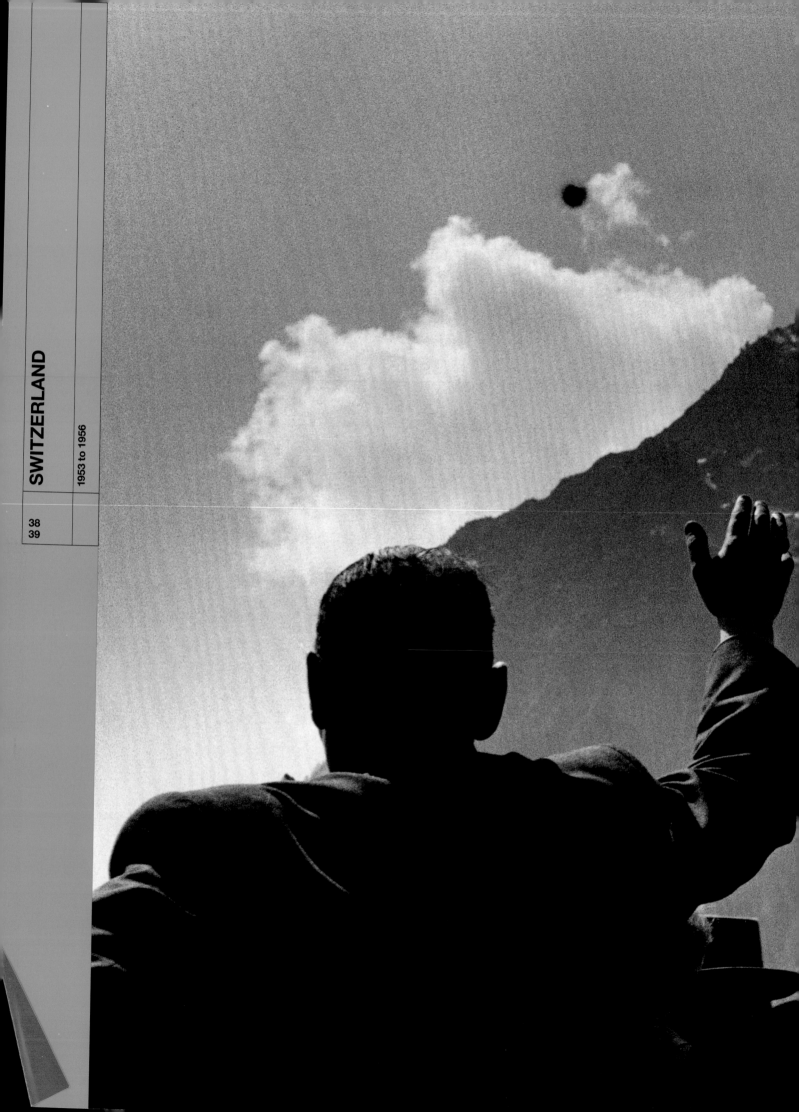

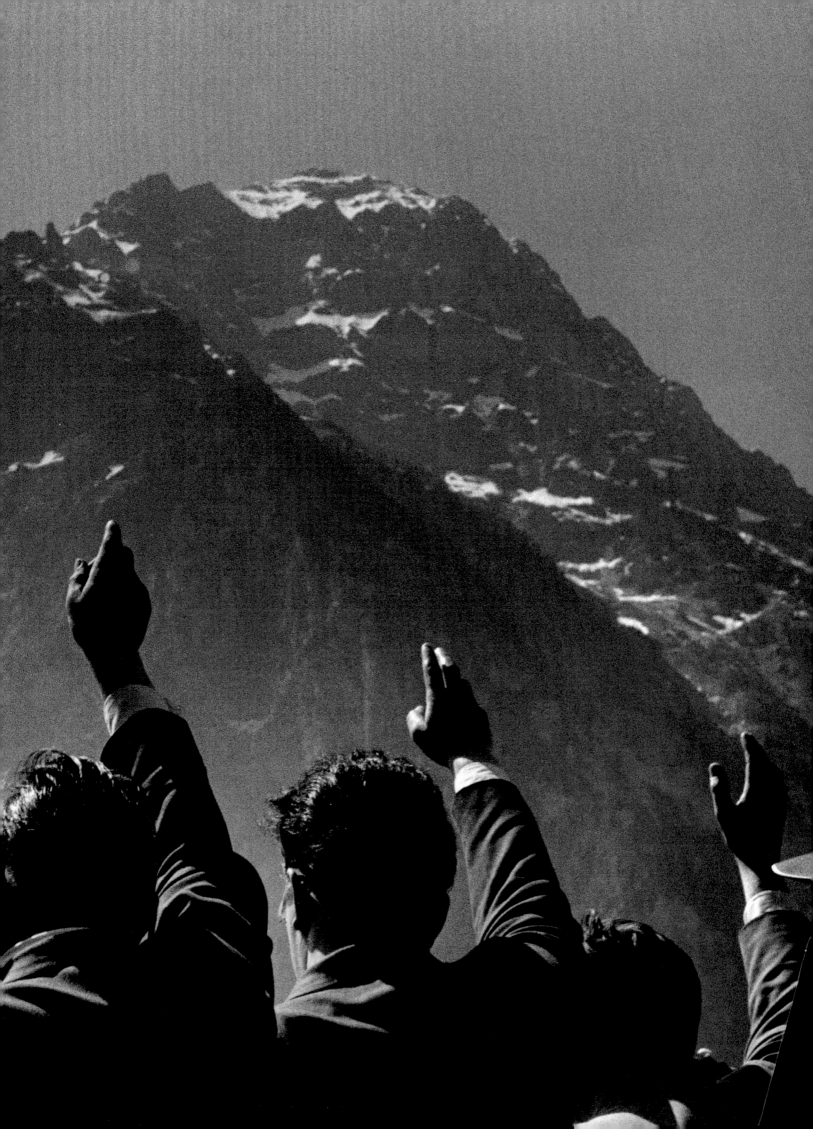

René Burri's first photographs were taken in his native Switzerland, but the alpine nation has never been the primary focus of his work. This is quite different from the photographer Paul Senn, whose 1943 book *Bauer und Arbeiter* (*Farmers and Workers*) is centred around the idea of a Swiss homeland. Burri clearly chose a different path. When he fixes his gaze on Switzerland, he actually looks right through it in his search for a wider perspective.

This can be seen in a number of his earliest assignments. In September 1946 he took his first photograph. He was only thirteen years old, gifted at painting and drawing but hardly someone who could be described as an amateur photographer. In fact, the most avid photographer in his family at the time was his father. It was he who gave his son a simple Kodak camera and sent him to Bürkliplatz, where the former British prime minister Winston Churchill was to give a speech that would go down in history. As it turns out, Burri took a remarkable picture of Churchill standing in the back of his open limousine (inside front cover). At first glance, the unassuming, small format print with a deckle-edge typical of the time would hardly seem to mark the beginning of a career in photography. However, if we look more closely, two things stand out: first, Burri's skill at panning the camera at just the right shutter speed – not something that just anyone could have done; and second, his instinct for an event that was of far more than just local importance.

Interestingly, the young Burri never used his father's camera again. His decision to become a professional photographer was a compromise solution made much later on. Burri wanted to go into cinema, but at the time Switzerland did not offer an appropriate educational institution for the study of film. So in the autumn of 1949 Burri began his studies at the School of Arts and Crafts in Zurich. There he studied under Hans Finsler and Alfred Willimann, two important photography teachers who would introduce him to the field. Finsler, whose style was based on the

functionalist aesthetics of the 1920s, played a particularly influential role in Burri's development.

Equipped with curiosity and an alert eye, and always with a camera, Burri started right away with his first assignments both in and around the school. Here we can already see his attempts to counter Finsler's 'straight photography' with a more subjective approach. However, it would take years for Burri to liberate himself from his teacher's sober formalism, so distant from the human interest of French photography. But this was just another step in his growth as a professional photographer.

Burri's first publication was in the thirty-ninth volume of the magazine *Die Woche* in 1953 (p. 434). It was a cover story featuring American students in Switzerland. In 1955 he gained an international reputation with his reportage on Mimi Scheiblauer's school for deaf-mute children in Zurich that was published in *Life* magazine. A year later, *Discovery*, a supplement of the magazine *Modern Photography*, showcased a graphically structured image taken by Burri from the roof of a recruit school during roll-call (p. 43). In 1959 a more comprehensive feature story appeared in the same journal. In it, the author notes that Burri had 'clearly made progress' and was 'now working in twenty-two different countries'. Indeed, at the age of twenty-six, the young Swiss photographer had become an international reporter and citizen of the world.

Sharpshooters, Jura mountain range, 1954. Burri began his compulsory military service in 1954 at the age of twenty-one after finishing his photography studies. He used his Leica to photograph a manoeuvre in the Jura by the sharpshooters company of the Aarau military school with whom he was stationed. The composition of the images is clearly an homage to Robert Capa.

Military school, Aarau, 1954. A view of the courtyard in the Aarau barracks. With permission from his superiors, Burri photographed the troops on their daily routine. One photo from the series (not shown) was published in November 1956 in *Discovery*, the supplement of the US magazine *Modern Photography*.

43

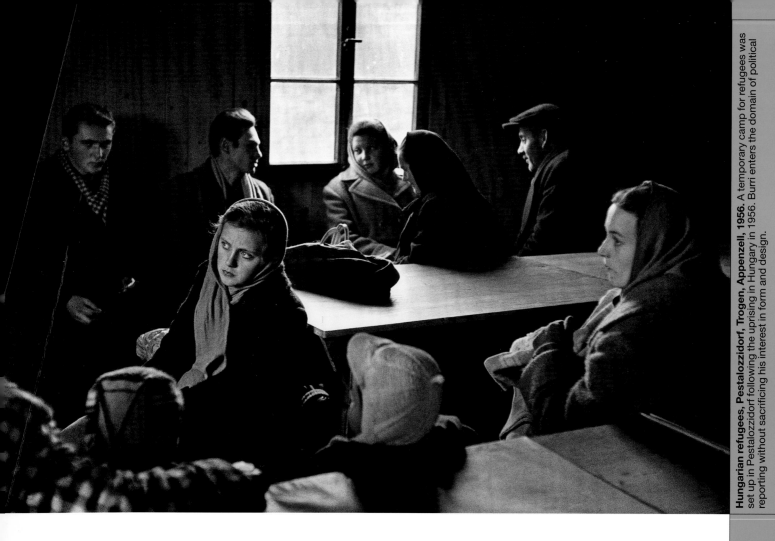

Hungarian refugees, Pestalozzidorf, Trogen, Appenzell, 1956. A temporary camp for refugees was set up in Pestalozzidorf following the uprising in Hungary in 1956. Burri enters the domain of political reporting without sacrificing his interest in form and design.

Man with saw blade, Pestalozzidorf, Trogen, Appenzell, 1956. This man was also a refugee in the Pestalozzidorf camp. More than 200,000 people left Hungary after the uprising.

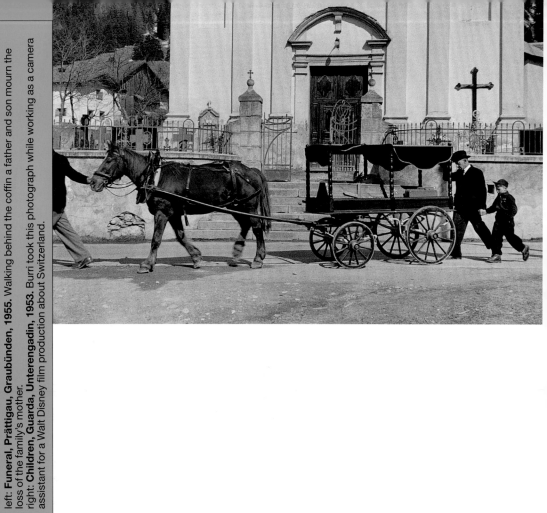

left: **Funeral, Prättigau, Graubünden, 1955.** Walking behind the coffin a father and son mourn the loss of the family's mother.
right: **Children, Guarda, Unterengadin, 1953.** Burri took this photograph while working as a camera assistant for a Walt Disney film production about Switzerland.

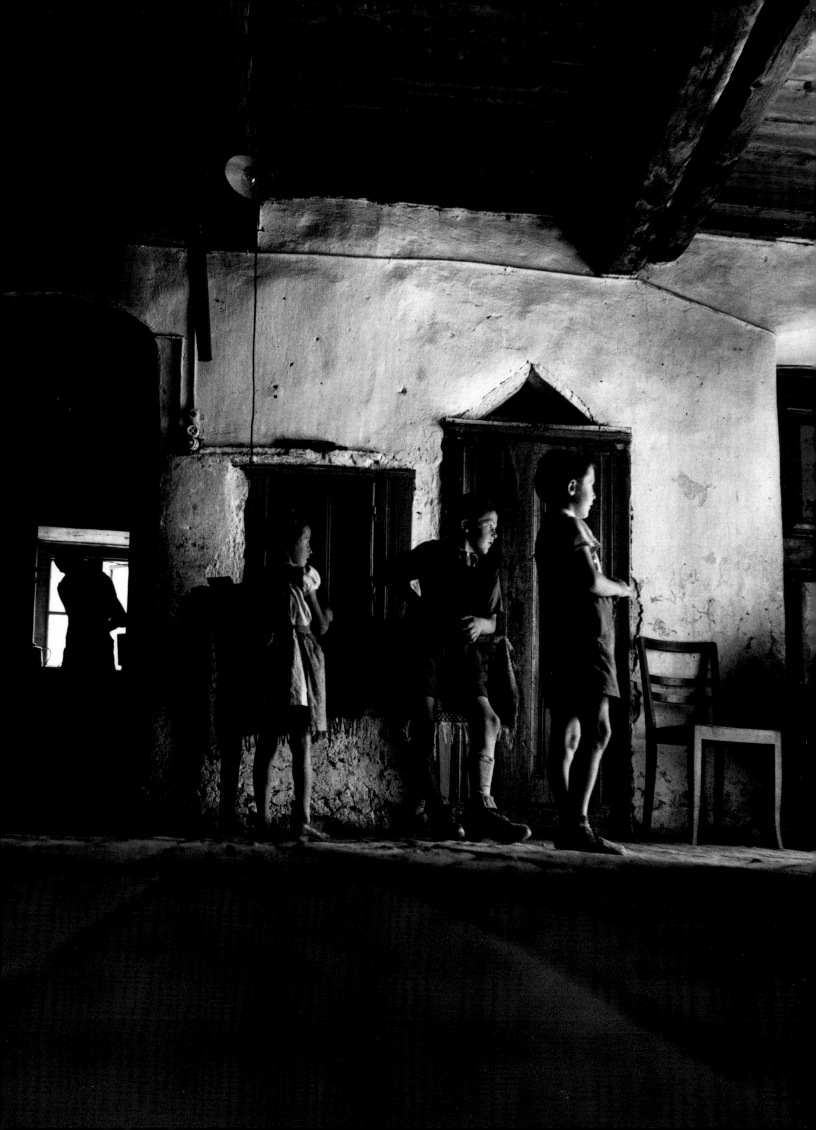

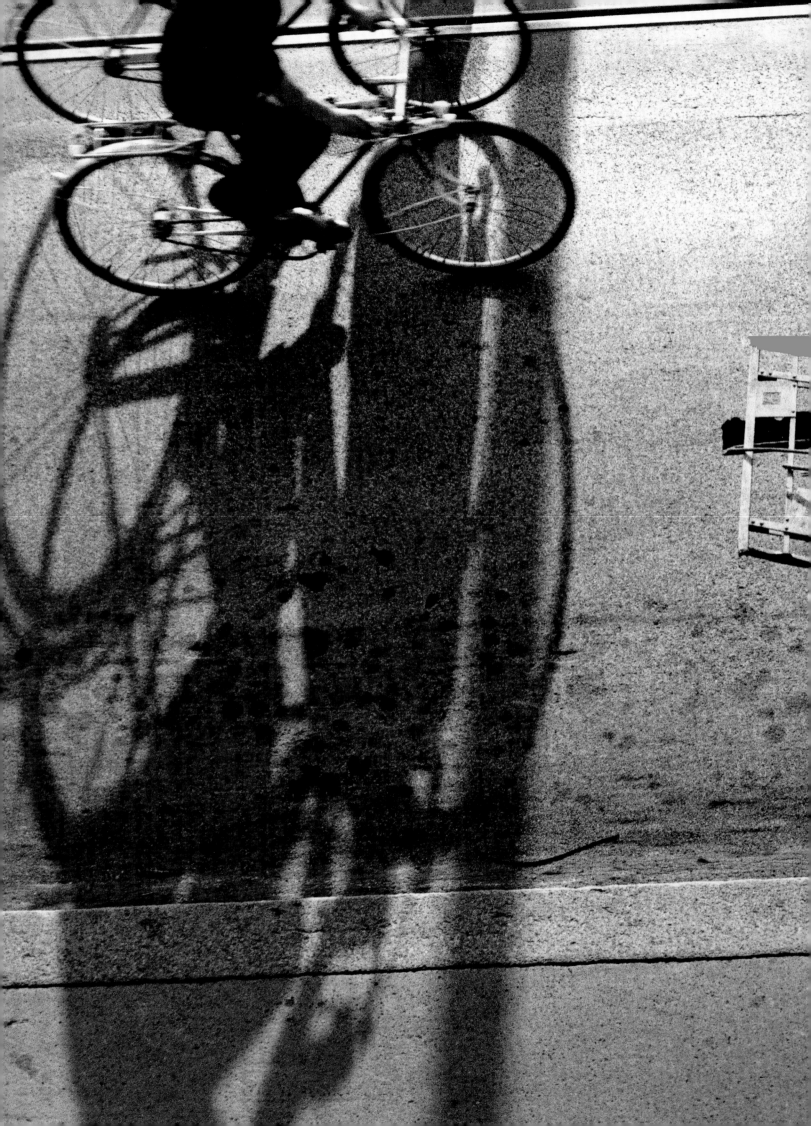

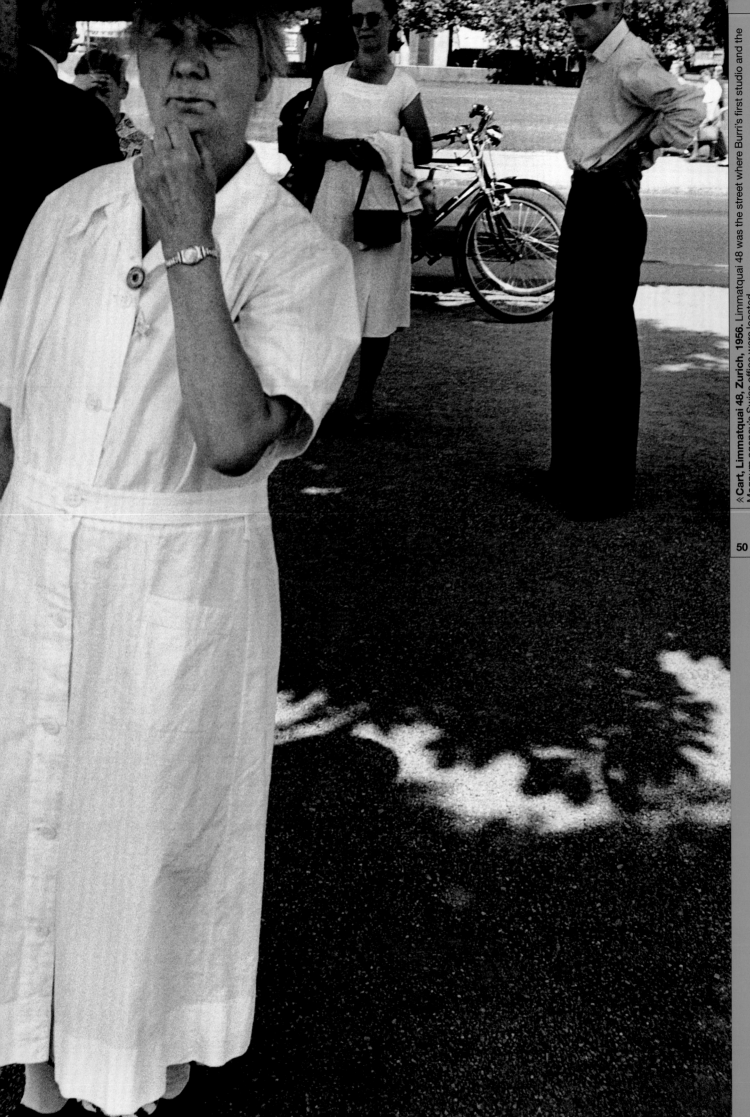

《Cart, Limmatquai 48, Zurich, 1956. Limmatquai 48 was the street where Burri's first studio and the Magnum agency's Swiss office were located.
Woman, Bellevue-Platz, Zurich, 1956. A woman listens intently to a speech. Not far from the lake, a forum for public debate had established itself along the lines of Speaker's Corner in London.

Street cleaner, Bahnhofstraße, Zurich, 1956.
≫ **Hermann Geiger, Sitten/Sion, Valais, 1956.** The airfield in Sitten/Sion served as a base for the renowned air rescue pilot Hermann Geiger. Together with his wife, Geiger revolutionized the system of air rescue in Switzerland.

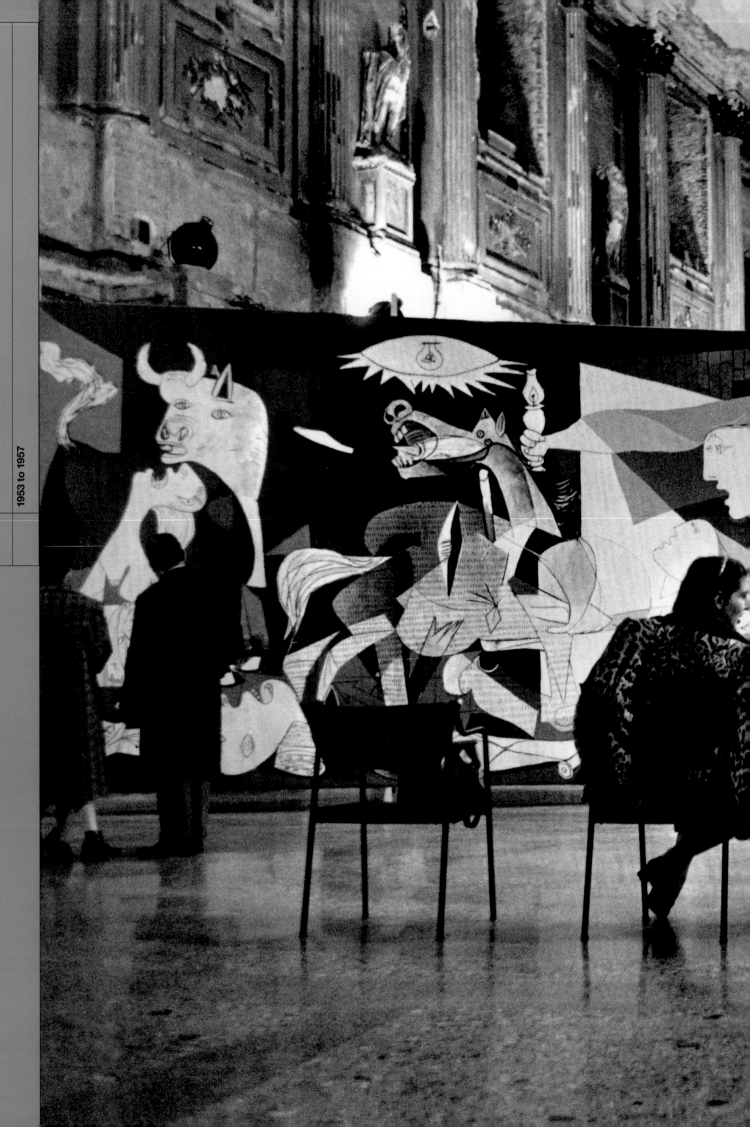

The relationship between Picasso and Switzerland is a topic that could fill volumes. As early as 1911, Picasso's works were being shown in Lucerne, and his first major retrospective outside of a gallery was presented by the Kunsthaus Zürich in 1932. The museum used the occasion to buy *Guitar on a Pedestal Table* (1915), for which the artist offered a large discount.

René Burri's life-long love of Picasso began when he was still in school and first visited the Kunsthaus. If asked who has influenced him the most in the fifty years of his career, Burri would say – without hesitation – 'Picasso'. In fact, meeting Picasso, the 'incarnation of the paintbrush' as journalist Marco Meier has called him, was an early goal for the aspiring photographer. In 1955 Burri spent an entire week knocking at the gates of Picasso's studio on the rue des Grands Augustins in Paris, only to be spurned day after day. His requests to meet with the painter were dismissed with a haughty, 'You want to see Picasso? In his atelier? No, I don't think that will be possible.' Burri was left to content himself with visiting exhibitions of the artist's work.

Burri, like many others, was absolutely overwhelmed by Picasso's political masterpiece *Guernica*, which he saw for the first time in 1953. He collected his impressions in a small, unembellished book designed together with his teacher, Alfred Willimann. Of the three copies they made, Burri lent one to Picasso. The gallery owner Daniel-Henri Kahnweiler served as messenger, first delivering the gift and later bearing bad news: Picasso had lost the book. Regardless, Burri's enthusiasm for Picasso did not abate. In 1960 he visited the momentous Picasso retrospective exhibition at the Tate Gallery in London, and in 1966 he saw an exhibition of sculptures in New York. Both times he documented the reaction of visitors to the works of art – something that would be practically impossible in museums today.

In the end, however, it was chance that brought Burri and Picasso together. Or perhaps it was the

same 'journalist's luck' with which Burri has so often been graced. In the summer of 1957, Burri got into trouble with Franco's secret police in San Sebastián. While standing in a café, recovering from the encounter, he read in the local newspaper that Picasso was expected the next day for the bullfight in nearby Nîmes. Burri crossed the Pyrenees by car that very night. Upon arriving in Nîmes, Burri's search for the painter led him to the hôtel du Cheval Blanc. He could hear music and, before he knew what was happening, a chambermaid led him into a small room full of people. At the centre of the action was Picasso, sitting in bed – laughing, singing and clapping. Burri asked if he could take some photographs. Picasso nodded (pp. 58–9). The evening extended into dinner, and Burri was invited to round off the number of guests at the table, which was thirteen (p. 17). He was also present the next day when Picasso gave his valuable watch to the celebrated bullfighter Antonio Ordoñez.

Burri encountered Picasso again later in 1957, while on assignment for *Du* magazine. This time they met in Picasso's private home and atelier near Cannes, the Villa La Californie. According to Manuel Gasser, the editor in chief of *Du* at the time, Burri was received warmly and with a charming intimacy. Burri made a portrait of the artist close up. He also photographed Picasso with his children (pp. 64–5) and wife Jacqueline Roque (p. 67). Burri was so pleased to have finally gained access to his hero that he did not even ask about the book he had made after seeing *Guernica*.

Just as Henri Cartier-Bresson had found his ideal in Matisse, Burri was inspired by Picasso, the more political of the two great painters. Picasso's actual medium, as Eduard Beaucamp once stated, was the endless development of ideas and permanent stream of shifting styles, tonal variations and transformations – in his words, 'the inexhaustibility of the possible'. Burri's lasting impression of Picasso was of a man of unswerving momentum and perpetual invention, fed by curiosity and energy. The two men would not meet again. Picasso died on 8 April 1973.

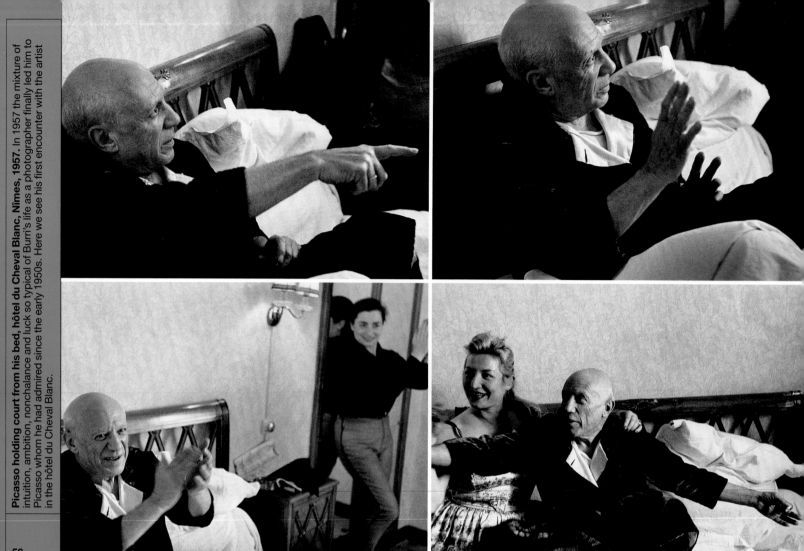

Picasso holding court from his bed, hôtel du Cheval Blanc, Nîmes, 1957. In 1957 the mixture of intuition, ambition, nonchalance and luck so typical of Burri's life as a photographer finally led him to Picasso whom he had admired since the early 1950s. Here we see his first encounter with the artist in the hôtel du Cheval Blanc.

Picasso in bed, hôtel du Cheval Blanc, Nîmes, 1957. From the middle of his bed, Picasso is directing a small group of musicians. He gave Burri permission to take photographs with a simple nod of his head.

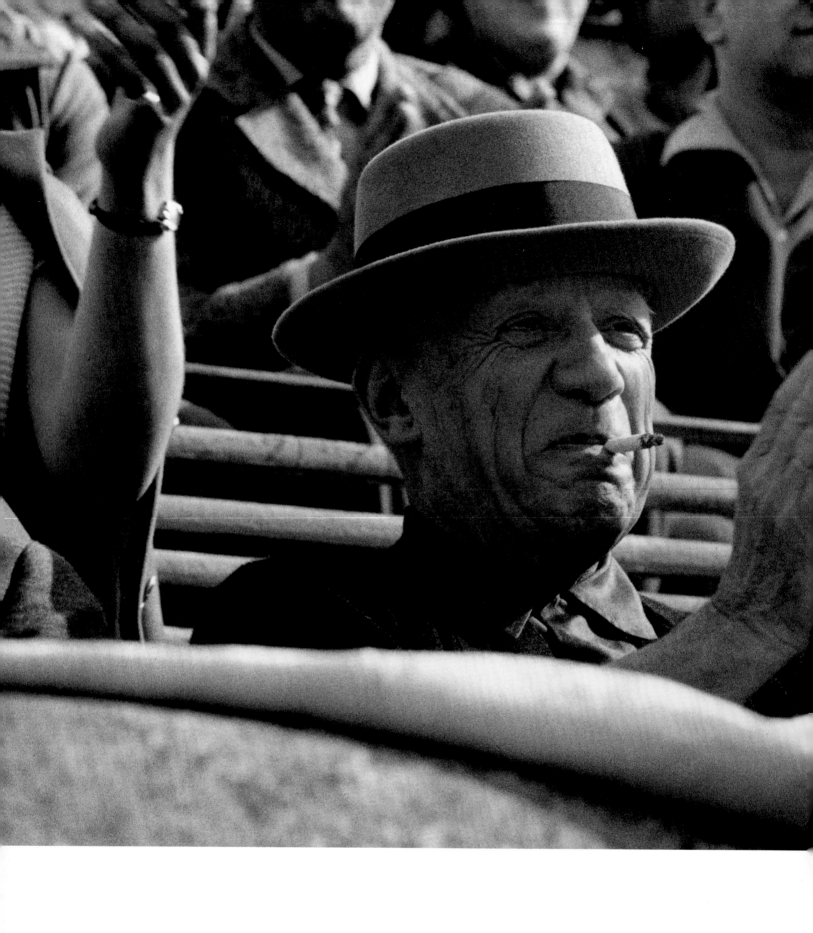

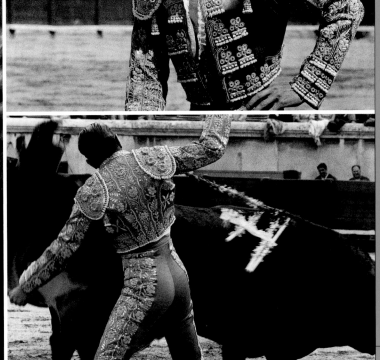

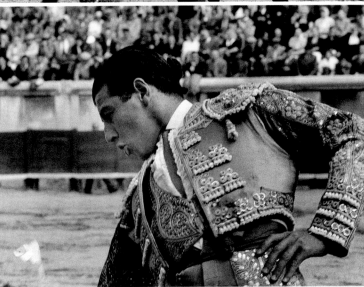

left: **Picasso at a bullfight, Nîmes, 1957.** The national newspapers had reported that Picasso would attend the bullfight in Nîmes, which helped Burri track down the artist he so admired.
right: **Antonio Ordoñez, Nîmes, 1957.** The legendary bullfighter was born in the city of Ronda in Spain.

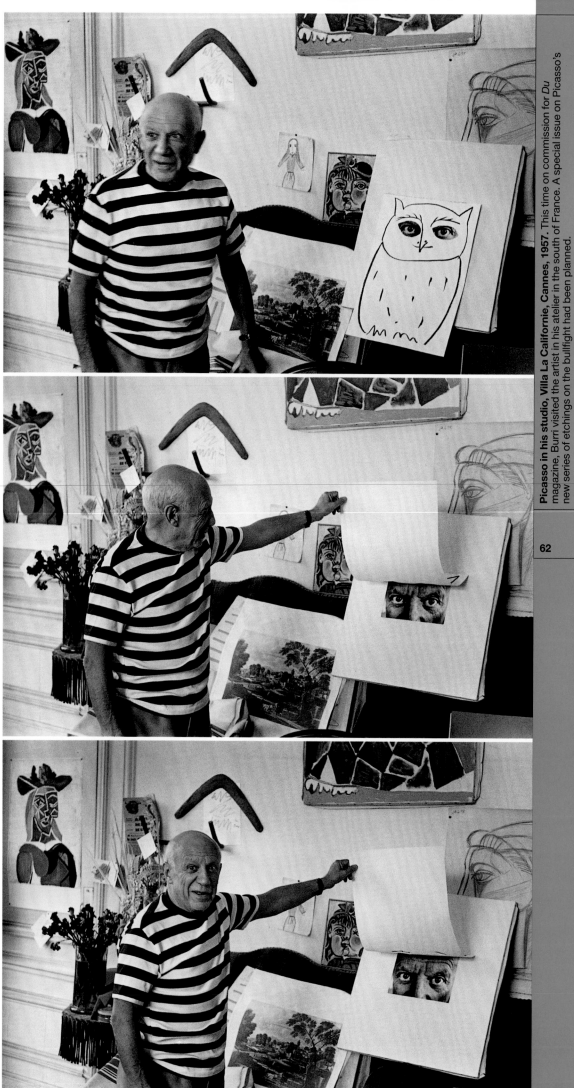

Picasso in his studio, Villa La Californie, Cannes, 1957. This time on commission for *Du* magazine, Burri visited the artist in his atelier in the south of France. A special issue on Picasso's new series of etchings on the bullfight had been planned.

Picasso as a cowboy, Villa La Californie, Cannes, 1957.
≫ **Picasso with his children, Villa La Californie, Cannes, 1957.** At the table are Jacqueline Roque's daughter Catherine (far right), and Picasso's daughter Paloma (foreground) and son Claude (centre left) from his relationship with Françoise Gilot.

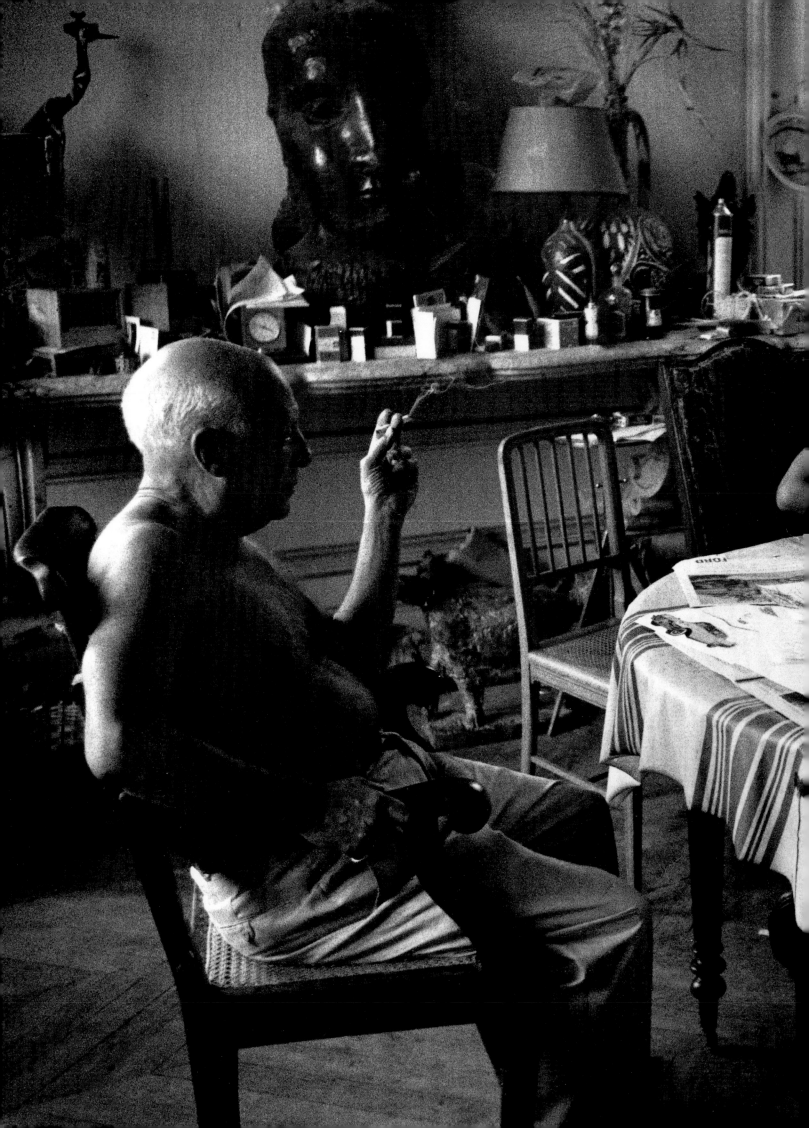

Picasso relaxing at home, Villa La Californie, Cannes, 1957. In 1955 Picasso bought the belle-époque villa La Californie near Cannes. In the background is an oil painting by his son Claude depicting a bullfight. The dedication reads 'Pour mon papa chéri' ('For my darling Father').

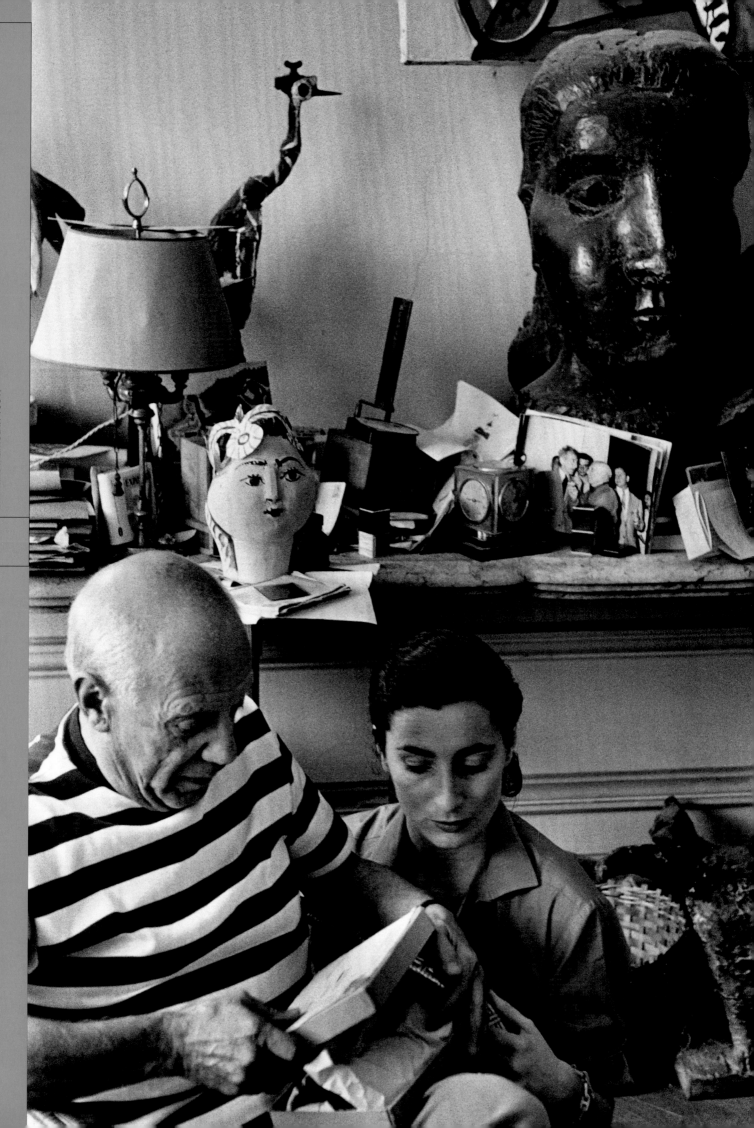

Picasso and Jacqueline, Villa La Californie, Cannes, 1957. Picasso with his wife Jacqueline Roque whom he married in 1961.

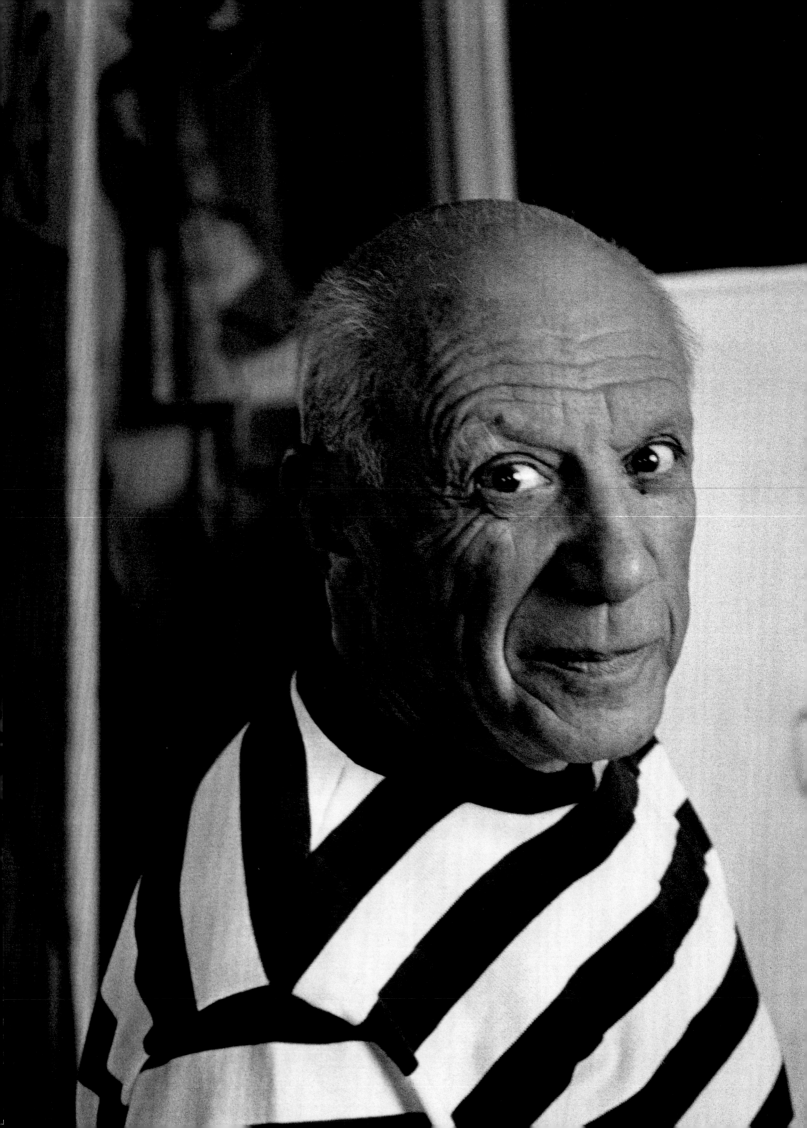

Pablo Picasso, Villa La Californie, Cannes, 1957. Picasso's atelier was relatively open to outsiders which allowed Burri to take his photographs freely. The Lucerne art dealer Siegfried Rosengart and his daughter Angelika were also present at the time this photograph was taken.

68
69

« **Banquet of the chevaliers du Tastevin, Beaune, 1959.** Each year the local winegrowers would come together to auction wine, with proceeds going to the famous medieval charity hospital and church Hôtel-Dieu in Beaune.

René Burri has always had a special relationship with the French. He is intrigued by their complexity and admires the quiet anarchy in everyday French life. Given this affinity for the culture, it seems only natural that Burri moved to France in the early 1990s and has lived there ever since. If Germany gave Burri literature, then France furnished him with images. Burri harbours a passion for French painting, French photography and, above all, French film. As a young man, Burri wanted to become a film director. However, there was no school for film in the 1940s and 1950s in Switzerland, so he decided to study the forerunner of cinema, photography. He found it fascinating because, like film, it was a technical medium that could tell stories.

Twentieth-century photography can be divided into two main tendencies. In Germany, *Neue Sachlichkeit* (New Objectivity) represented the more experimental and reflective approach, which dominated the period between the wars. In France, there emerged humanist photography interested in everyday scenes of street life. Its influence extended into the 1950s and early 1960s, gathering internationally renowned advocates such as Henri Cartier-Bresson, Robert Doisneau and Edouard Boubat. There is no question that Burri felt most attracted to the French aesthetic. But in the end, his art was influenced by both the human interest of the French and the strict formal production of the Germans. The German style was communicated to Burri by his teacher, Hans Finsler, who had moved from the Burg Giebichenstein School of Art and Design in Halle, Germany to teach in Zurich.

Notwithstanding the German impact on his early style, Paris remained the city of choice for the young Burri. It was the 'capital of photography' – home to internationally acclaimed magazines such as *Paris-Match* and *Jours de France*, as well as headquarters for the prestigious photography agencies Rapho and Magnum. In 1950, Burri and other students of Hans Finsler and Alfred Willimann went to the City of Lights for the first time. He used the fresh surroundings

to continue searching for his photographic ideal and his own style. The pictures Burri took with his Rolleiflex during this initial visit attest to the influence of his German teachers and their formal principles, founded in part on the Bauhaus-related philosophy of Burg Giebichenstein.

In 1955 Burri visited Paris once again. By this time, his reportage on Mimi Scheiblauer's school for deaf-mute children had already been published in the magazine *Science & Vie* (p. 21). The photographer used this visit to the French capital to pick up his contact sheets. He also applied to be in Magnum, where his reportage on Scheiblauer's school made such a strong impression that he was accepted shortly thereafter as an associate member. Burri's attempts to contact his hero Picasso were less successful, however. The painter's secretary at the rue des Grands Augustins was unrelenting and would not permit Burri to meet with the artist. While disappointing, it left him with plenty of time to explore the city with his camera. This was a turning point for Burri. Pictures from the market at the Porte de Clignancourt (pp. 78–81) mark his conversion from the old Rolleiflex to a Leica, a more dynamic apparatus. His unique artistic signature begins to emerge in these pictures. They demonstrate Burri's own visual language, created independently of his role models.

Burri's contribution to French and, in particular, Parisian photography is unmistakable. He departed from the already clichéd anecdotal street photography of Doisneau and took a novel approach to the city. Above all, Burri's camera has illustrated Paris through its artists. Produced over the course of five decades, portraits of Picasso, Le Corbusier, Giacometti, Yves Klein, Tinguely and others reflect the faces of René Burri's France.

≫ Chairs in the Tuileries, Paris, 1950.
≫ Eiffel Tower, Paris, 1950.
Burri explores the 'capital of photography' on a school field trip with Finsler and Willimann. Burri's photo studies are clearly influenced by late 1920s and early 1930s avant-garde photography.

Railway, Paris, 1950. In the 1950s the railway was still an important theme in photography. Burri took this photograph near the Gare de l'Est during his photography school field trip to Paris.

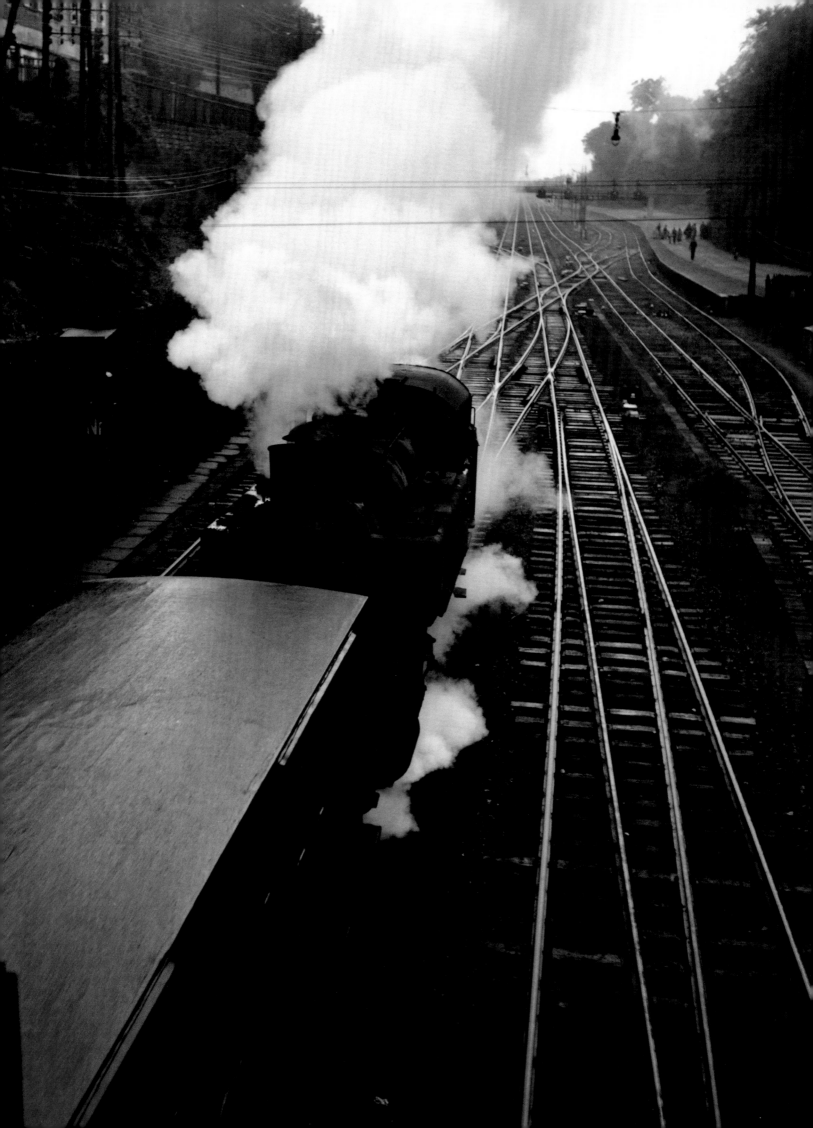

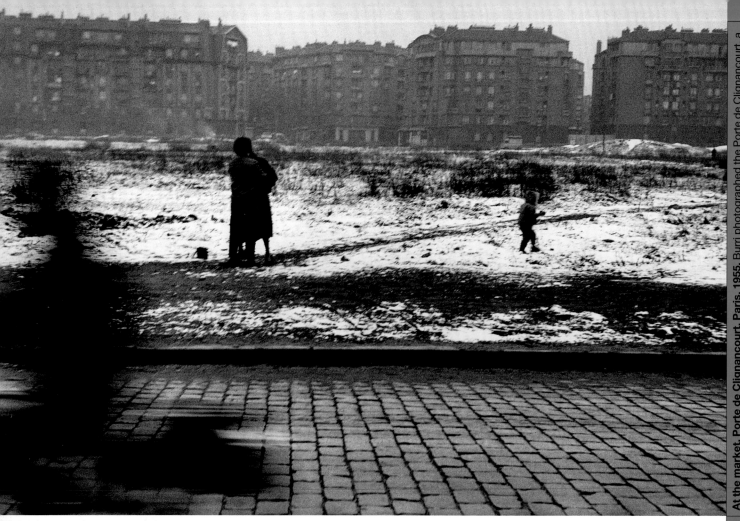

At the market, Porte de Clignancourt, Paris, 1955. Burri photographed the Porte de Clignancourt, a famous flea market in the north of Paris, while hitchhiking. Burri planned the trip so that he could introduce himself at the Magnum agency and visit the revered Pablo Picasso. In between he had time to photograph the city.

Shoe stall, Porte de Clignancourt, Paris, 1955.
≫ **Baskets, Porte de Clignancourt, Paris, 1955.** Interestingly, Burri largely avoided narrative or documentary photographs of the stalls and people in favour of more ambitious and formal aesthetic studies.

Models on steps, Paris, 1950. Taken on Burri's field trip with the photography school. Armed with his Rolleiflex and Leica, he profits from an unknown fashion photographer's shoot on the banks of the Seine.

《**Model in Yves Klein's studio, Paris, 1961.** Burri photographed this model in the painter and performance artist Yves Klein's studio, located at 9 rue Campagne-Première in Montparnasse. Klein died in 1962.
Nude study with white chiffon, Paris, 1991.

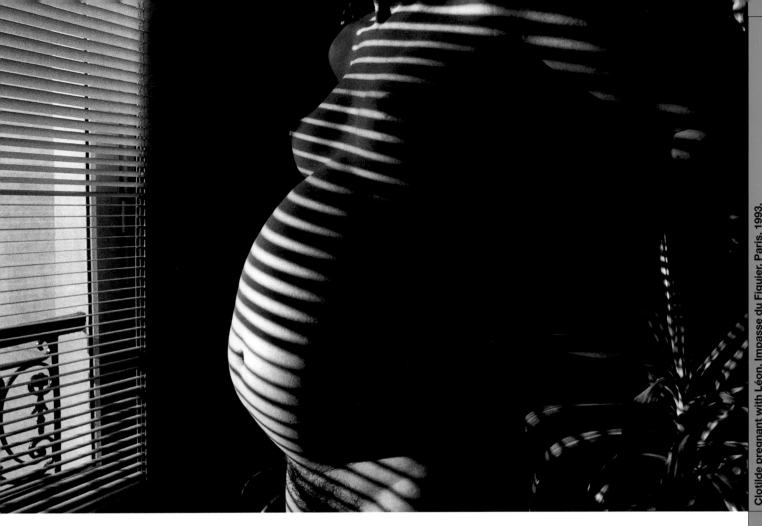

Clotilde pregnant with Léon, Impasse du Figuier, Paris, 1993.

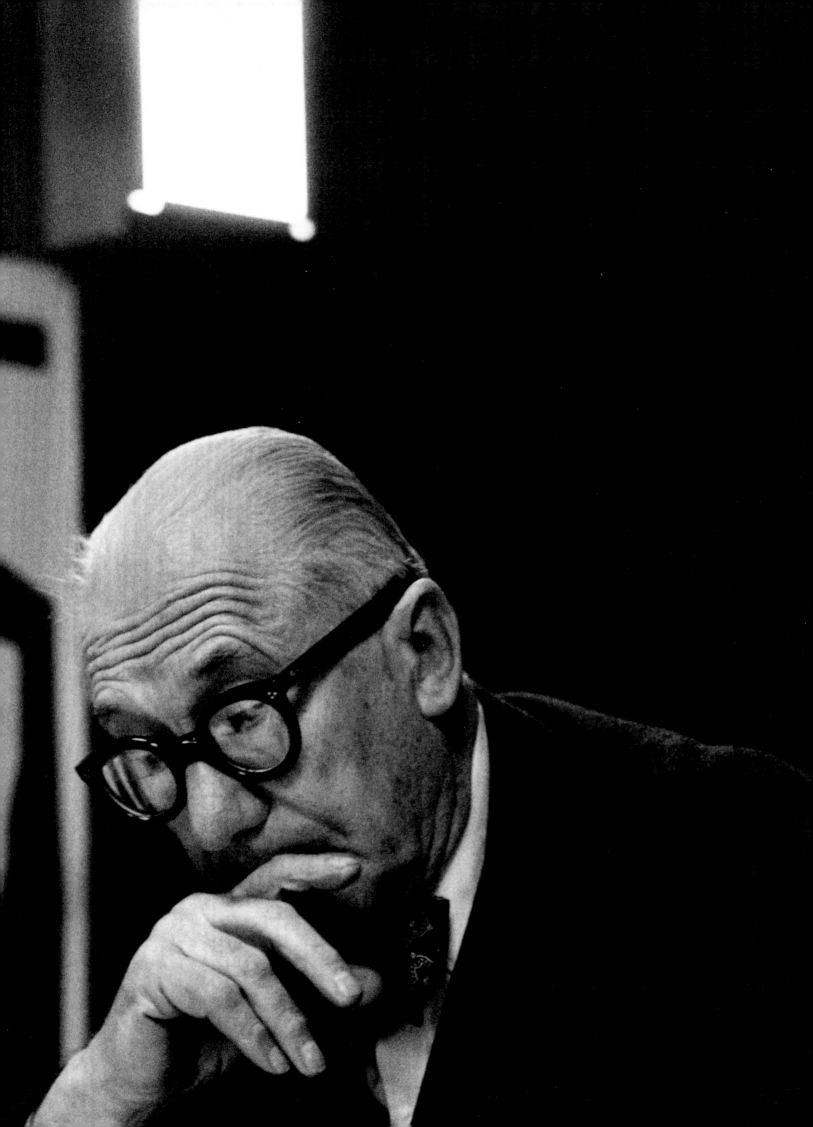

Architecture is a built environment. A good building embodies an idea; a great building is the incarnation of a vision. René Burri showed an early fascination with visionary architecture. Not the least bit interested in illustrating lifeless business portfolios, he related to great architecture as a chronicler. He wanted to accompany a building throughout its life, tracing its evolution from the initial stages of planning and development to its completion and daily use. Burri perceived architecture as a social and political enterprise. This principle directed Burri's attention to Oscar Niemeyer, creator of the modern capital city Brasília, and to Le Corbusier, master and myth of twentieth-century architecture.

The young photographer was especially inspired by Le Corbusier. Today, Burri is considered one of the authoritative interpreters of the Swiss architect along with photographers Albin Salaün and Lucien Hervé. At least three thousand of Burri's negatives concern Le Corbusier and his work. Unlike Hervé and his uncommissioned work, Burri did not use Le Corbusier's architecture as a pretence for developing his own stylistic formula. While Lucien Hervé had a tendency towards the abstract, Burri's ambitious photographs attempt to convey the intellectual, social, political and aesthetic processes that are part of a building's life. As architectural historian Arthur Rüegg notes, Burri is interested in architecture as part of a larger story, and his photographs on the subject are 'visual histories'.

He was still a student at the School of Arts and Crafts in Zurich when he first encountered the work of Le Corbusier in 1950. One day he decided to hitchhike to Marseille with his friend Serge Libiszewski to see the Cité Radieuse. Although still under construction during his visit, the building impressed him considerably. He took a few pictures of its most distinctive features and later used these images in a collage for Alfred Willimann's class. It was Burri's first homage to the great architect. Nine years later, he again visited the Cité Radieuse, now

completed and full of life. With irony and a good dose of humour, Burri's photographs show how the visionary building had developed into something quite different from what its architect Le Corbusier had originally intended.

Four years earlier, in 1955, Burri had chronicled the completion and consecration of the famous pilgrimage destination, the chapel of Notre-Dame du Haut in Ronchamp. This material was included in his first large publication in the illustrated magazines *Die Weltwoche* and *Paris-Match*. In 1959 Burri accompanied the architect on a visit to the construction site of the monastery of Sainte-Marie de la Tourette in Eveux-sur-l'Arbresle, where his photographs assessed the building's well-conceived form. That same year, Burri visited Poissy, where the neglected and decaying Villa Savoye became the subject of a sensitive photographic exploration. And not surprisingly, when a tour was given of Le Corbusier's last creation, the Pavilion in the Zürichhorn Park designed for gallery owner Heidi Weber, Burri could be seen among the crowd.

In the last decade of Le Corbusier's life, Burri became what Rüegg calls the architect's 'congenial chronicler'. He had formed a close relationship with the man himself, often visiting him at his atelier in the rue de Sèvres. Once, Burri was even invited to Le Corbusier's private studio outside the city centre in the rue Nungesser-et-Coli. When he arrived, it was morning and the door to the studio was open. Le Corbusier, dressed casually in a checked cotton shirt, was painting and initially paid no attention to him. Burri entered quietly. He slowly approached the architect, taking photographs with every step (pp. 102–3). Suddenly, Le Corbusier woke from his reverie and exclaimed, 'Ah! You're here!' Had Le Corbusier noticed Burri's entrance and intentionally kept working? Or was he truly startled when he finally noticed Burri's presence? Whatever the case, the intimate exposure to the architect was a unique gift to the young photographer.

≫ **Consecration of the Notre-Dame du Haut, Ronchamp, 1955.** The congregation listens to a sermon as part of the consecration ceremony of the chapel on 25 June.

91

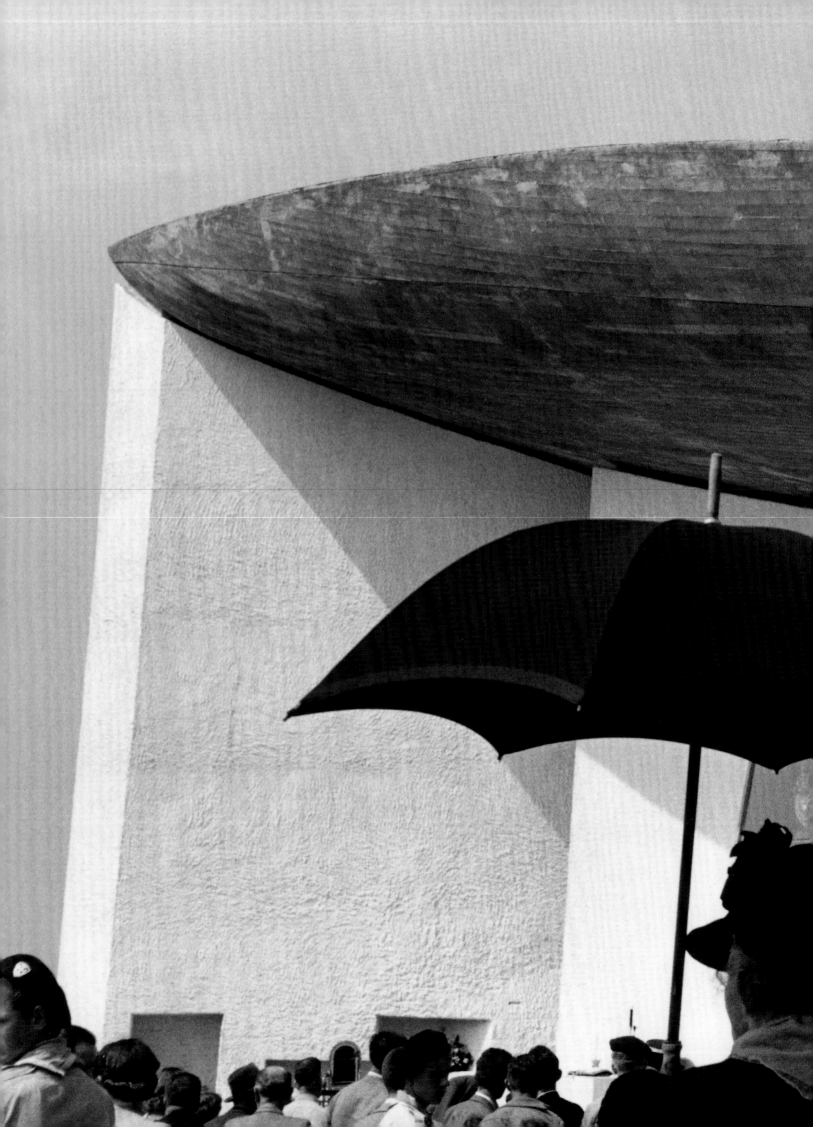

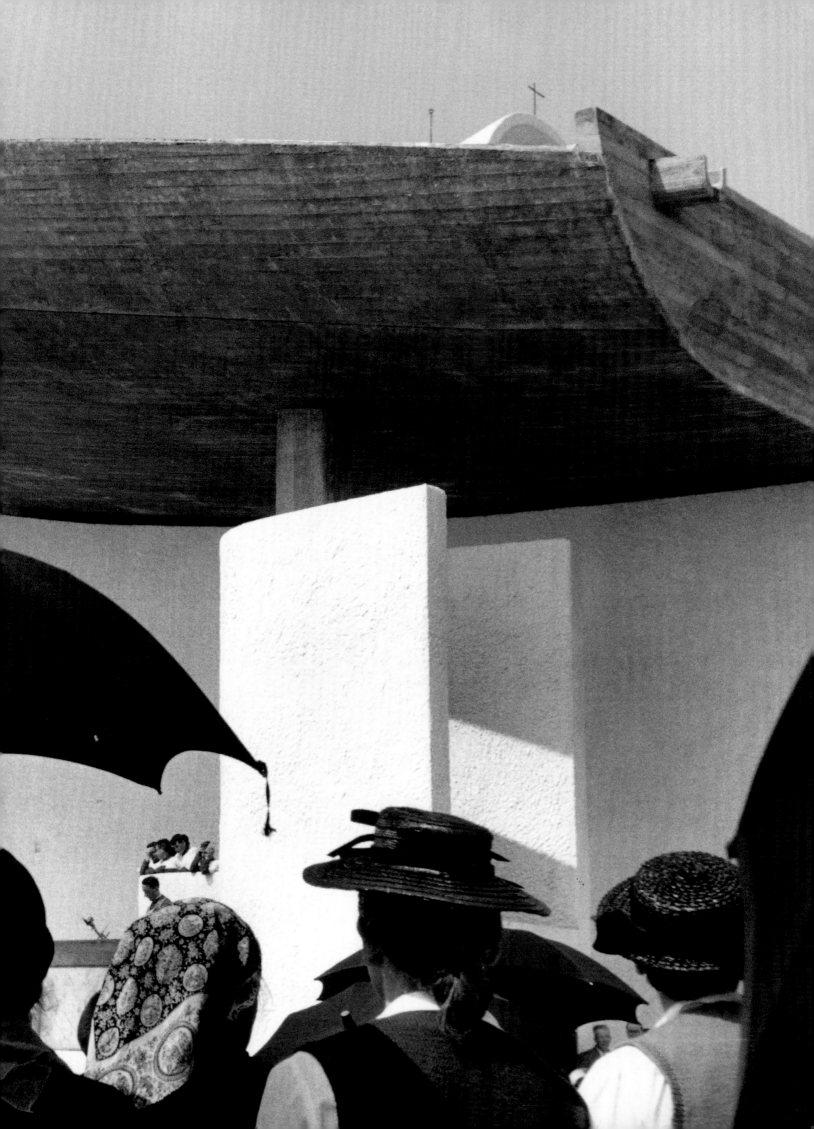

Candles, Notre-Dame du Haut, Ronchamp, 1955. Probably the most beloved of Le Corbusier's buildings, the chapel was built, in the words of Arthur Rüegg, 'just as one would expect of a great architect, with one quick wave of his hand'. It is surely one of the most well-known religious buildings of the modern age.

Shell of the Chapel, Notre-Dame du Haut, Ronchamp, 1955. The chapel, seen here without its stained glass windows, was built on the ruins of a chapel destroyed in 1944.

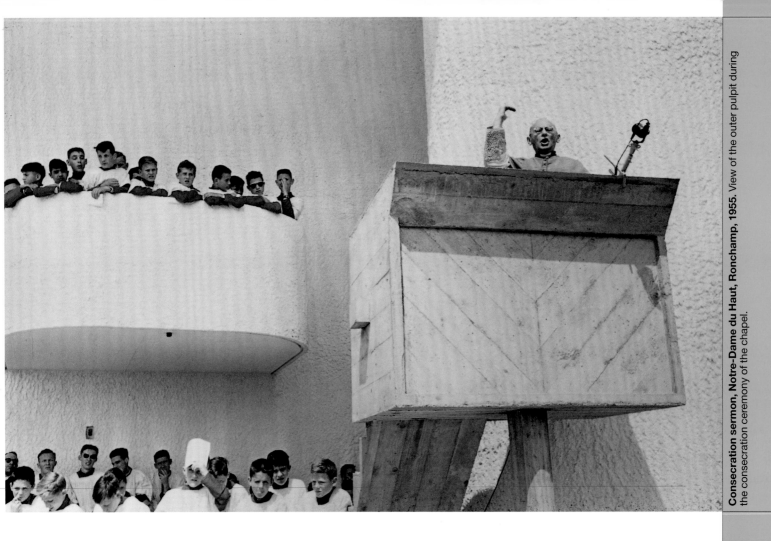

Roof detail, Notre-Dame du Haut, Ronchamp, 1955. According to the architectural historian Arthur Rüegg, the roof of the church was based on the form of a crab's shell.

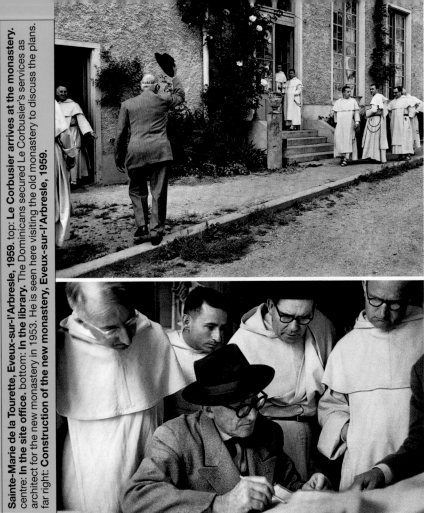

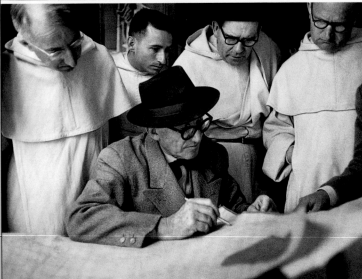

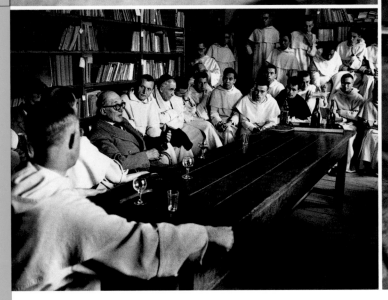

Sainte-Marie de la Tourette, Eveux-sur-l'Arbresle, 1959. top: Le Corbusier arrives at the monastery. centre: **In the site office.** bottom: **In the library.** The Dominicans secured Le Corbusier's services as architect for the new monastery in 1953. He is seen here visiting the old monastery to discuss the plans. far right: **Construction of the new monastery, Eveux-sur-l'Arbresle, 1959.**

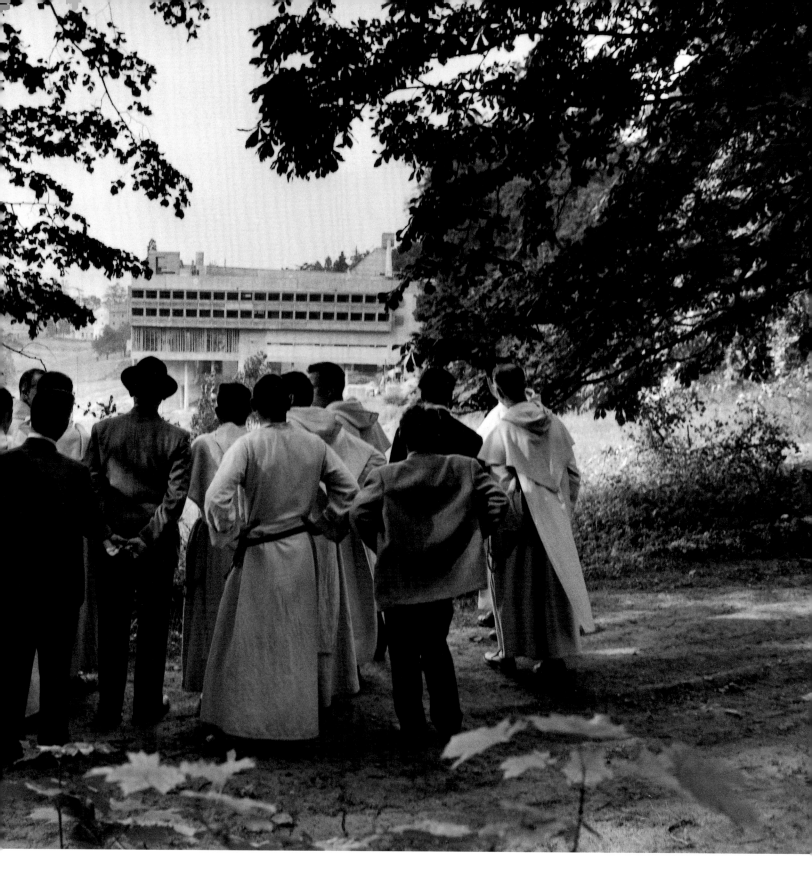

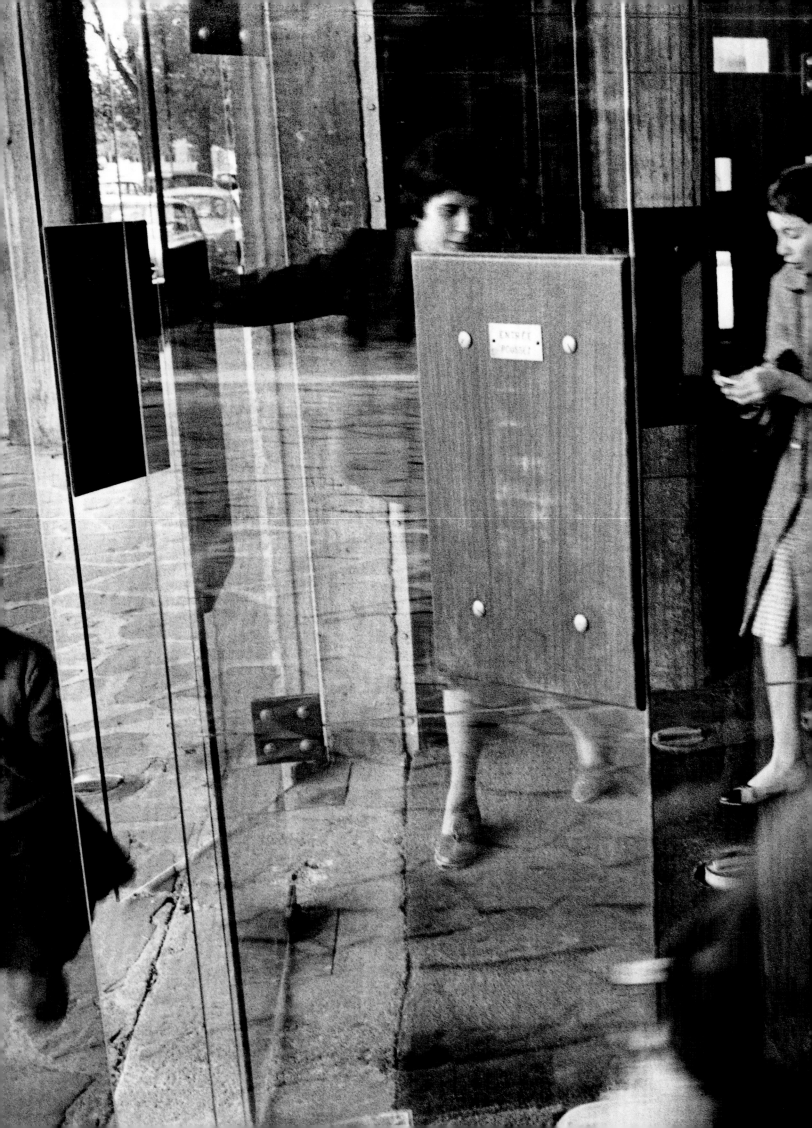

Entrance of the Cité Radieuse, Marseille, 1959. Burri first visited the building in 1950, two years before it was completed.

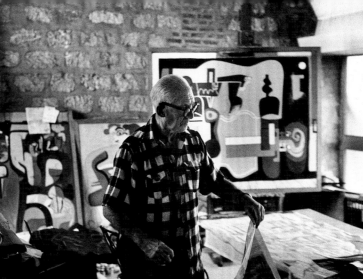

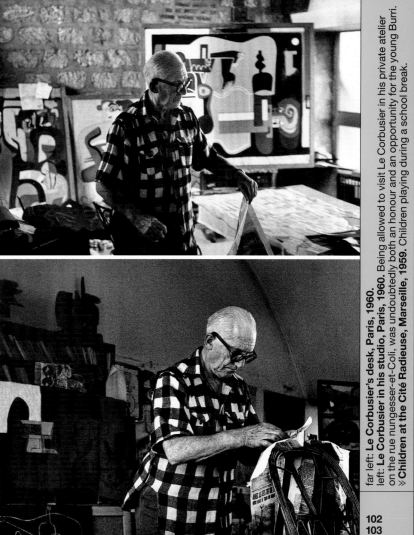

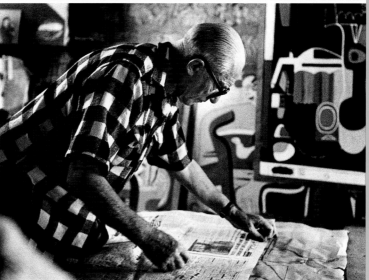

far left: **Le Corbusier's desk, Paris, 1960.**
left: **Le Corbusier in his studio, Paris, 1960.** Being allowed to visit Le Corbusier in his private atelier on the rue nungesser-et-Coli, was undoubtedly both an honour and an opportunity for the young Burri.
≫ **Children at the Cité Radieuse, Marseille, 1959.** Children playing during a school break.

102
103

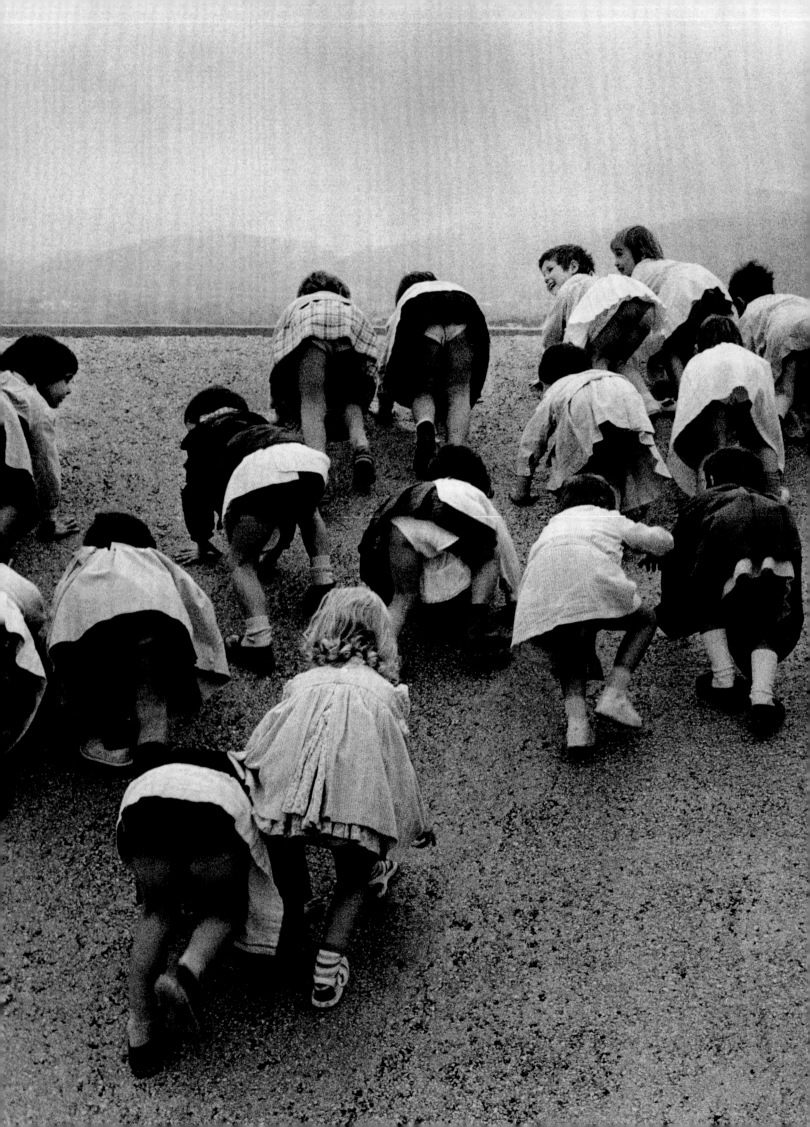

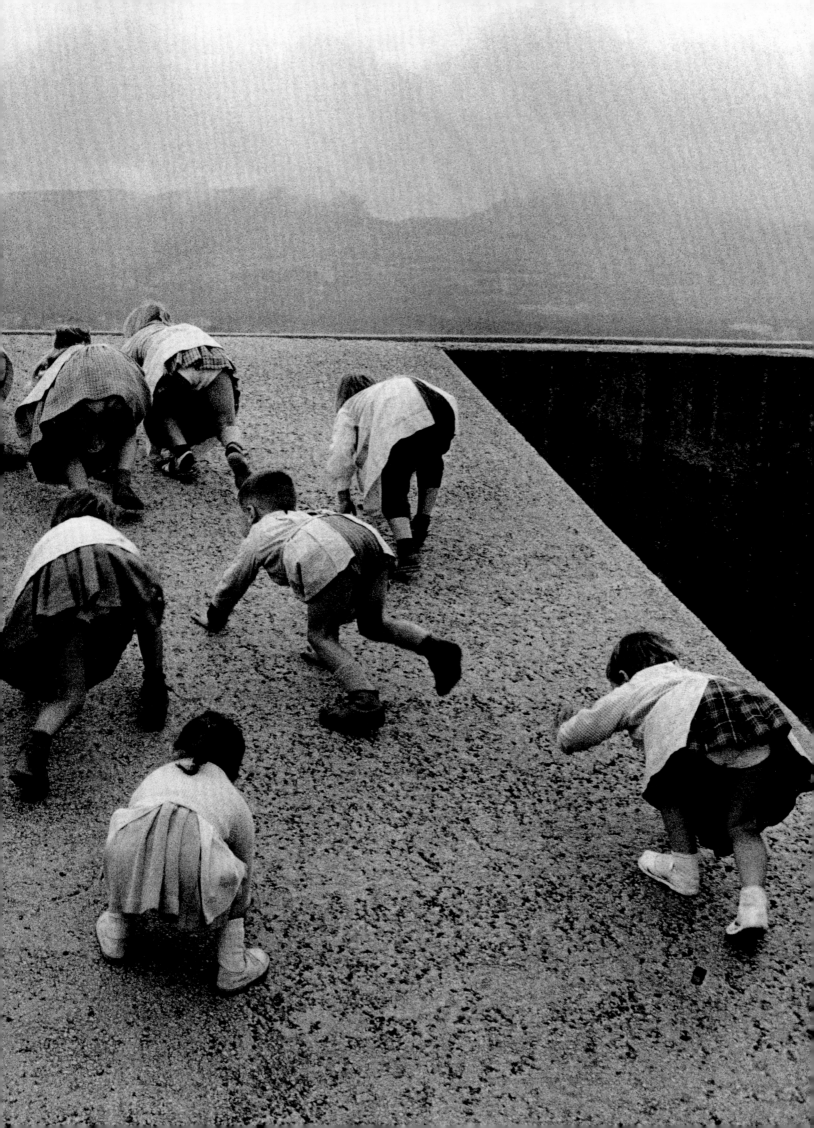

René Burri has never thought of himself strictly as a photojournalist, and was never content to deliver merely illustrative photos to the press. Perhaps he considered himself a reporter at times, but only in the sense that Burri always returned from his assignments with a host of pictures, stories and information – the more exotic, the better.

The world in the 1950s and 1960s was not as accessible or as familiar as it is today through the media and ease of travel. At the beginning of Burri's career, travelling to strange and distant lands was not only a job, it was also an adventure. As a child he had collected stamps from every country imaginable. Exploring remote continents and cultures as an adult was a natural extension of his inherent curiosity about the world.

The 1950s and 1960s were a period of extensive travel and substantial reporting for Burri. In addition to North and Latin America, he created photographic accounts of the Near and Middle East, China, Japan, South Korea and Vietnam. Even though Europe's accessibility and familiarity lacked the allure of these exotic destinations, Burri certainly did not overlook the continent during these years. Though Burri was kept occupied at the time by his sizeable photo essay *Die Deutschen*, Italy became for him the subject of intensive photographic research for several weeks in 1956. Only twenty-three years old, Burri had entered a photo competition hosted by the Zurich paper *Die Weltwoche* and won a weekend in Florence. Along with his wife Rosellina, Burri used the opportunity to investigate the south of the Italian peninsula and Sicily in their Volkswagen. In Burri's own words, he simply wanted 'to discover and investigate things'. He travelled with no official assignment and no financial backing but carried with him an alert eye and adventurous spirit. What we have today are several small reportages on Italy as well as a number of individual pictures – all meticulous in their artistry. While the former are primarily set in rural areas, the focus of his individual pictures is Italy's larger cities.

At the time, Italy was still overshadowed by the end of the war and was awaiting economic recovery. It was the Italy of old, a country on the outskirts of Europe. Many of its citizens were leaving the country, either forever or to become temporary so-called 'guest workers' elsewhere. The gritty neo-realism of Italian film captured the atmosphere of these years with an oppressive accuracy, as did Bruno Barbey's famous photo essay *Les Italiens* (*The Italians*). Subjects such as sea-salt production in Trapani (pp. 118–19) and tuna fishing in Favignana (pp. 120–1) may seem trivial when compared to the global crises and conflicts that Burri would soon encounter through his work, but far from perceiving these ordinary subjects as banal, Burri recognized that the localized struggles of everyday life symbolized larger conflicts, even if they appeared less spectacular than the 'real' problems in the world. He has always searched for and uncovered the epic simplicity of daily scenes in his pictures, many of which, like *Steps, Leonforte, Sicily, 1956* (p. 116), have gained the status of universal icons.

The individual photographs that Burri took in Italy have a two-dimensional quality that is atypical of his style. They are reminiscent of the works of other photographers such as Henri Cartier-Bresson. *In the street, Imperia Oneglia, 1956* (pp. 114–15), for instance, shares many common elements with Cartier-Bresson's photograph *Salerno, Italy, 1953*. Burri's unique eye, however, produces images that are more complex and that vibrate with unspoken tension. Burri had become a mature photographer, confident in his creative powers.

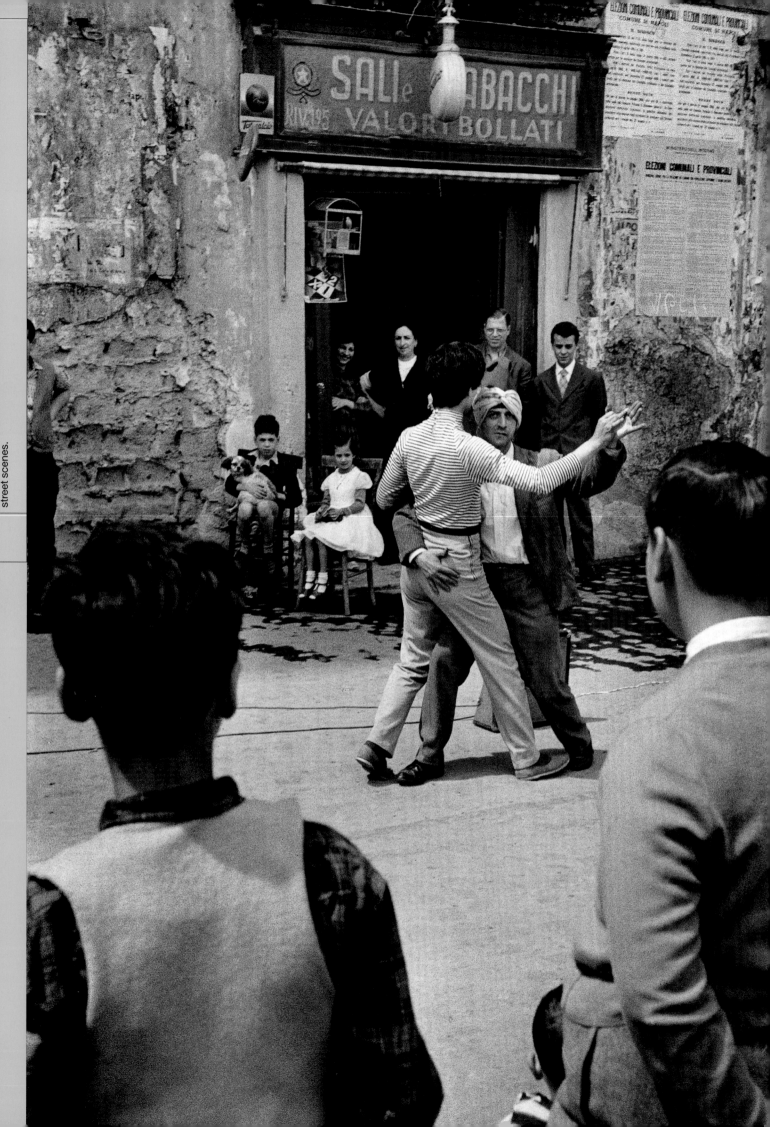

Street theatre, Naples, 1956. On his way from Florence to Sicily, Burri stopped in Naples. He was not on assignment but took these photographs out of curiosity and the pure joy of recording everyday street scenes.

Watching the street entertainment, Naples, 1956. Mixing with people, taking photographs from within the crowd, putting a finger on the pulse of life: these were hardly a part of the Finsler school which was devoted to sober images of objects. Burri's trip to Italy in 1956 certainly opened up a whole range of new possibilities.

Street scene, Gubbio, 1956. The town is known for a race that has been held there since the Middle Ages, and which still takes place today. Burri created a small photo essay on the race during his stay.

112

Stazione Termini, Rome, 1956.
》 **In the street, Imperia Oneglia, 1956.** Burri visited Adrian Wettach, better known as the clown Grock, on a commission for *Bunte Illustrierte*. In his old age, Grock had retired to Imperia Oneglia in the Italian Alps.

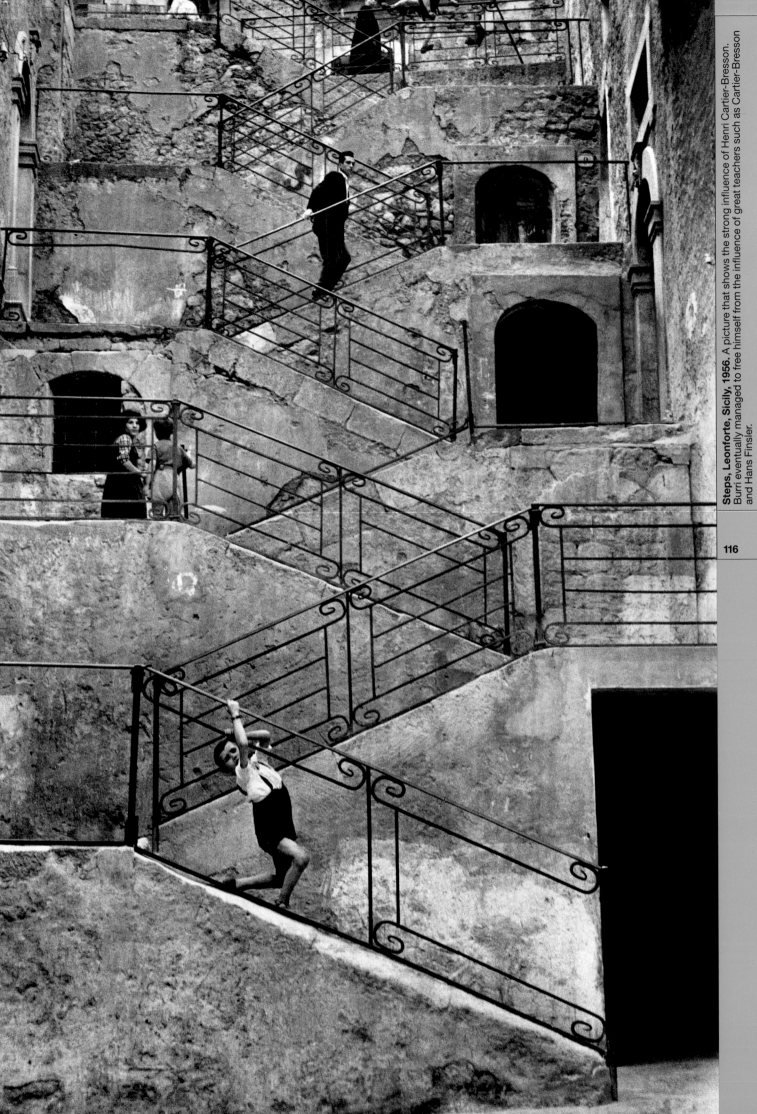

Steps, Leonforte, Sicily, 1956. A picture that shows the strong influence of Henri Cartier-Bresson. Burri eventually managed to free himself from the influence of great teachers such as Cartier-Bresson and Hans Finsler.

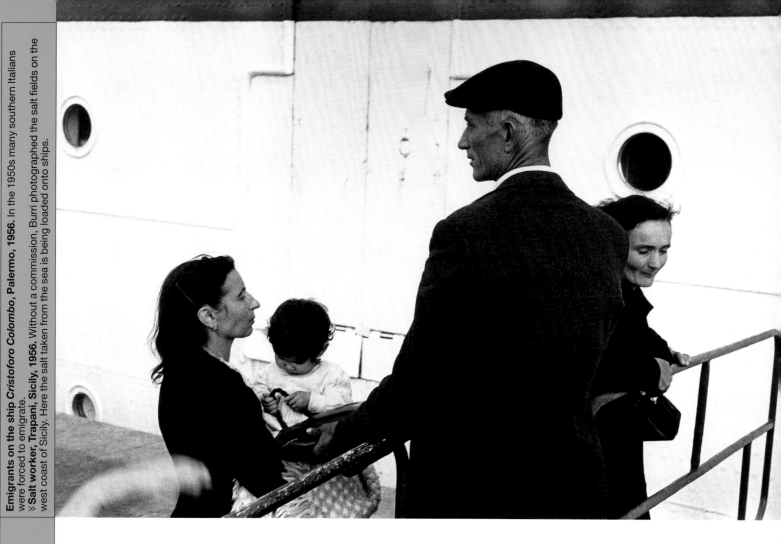

Emigrants on the ship *Cristoforo Colombo*, **Palermo, 1956.** In the 1950s many southern Italians were forced to emigrate.

≫ **Salt worker, Trapani, Sicily, 1956.** Without a commission, Burri photographed the salt fields on the west coast of Sicily. Here the salt taken from the sea is being loaded onto ships.

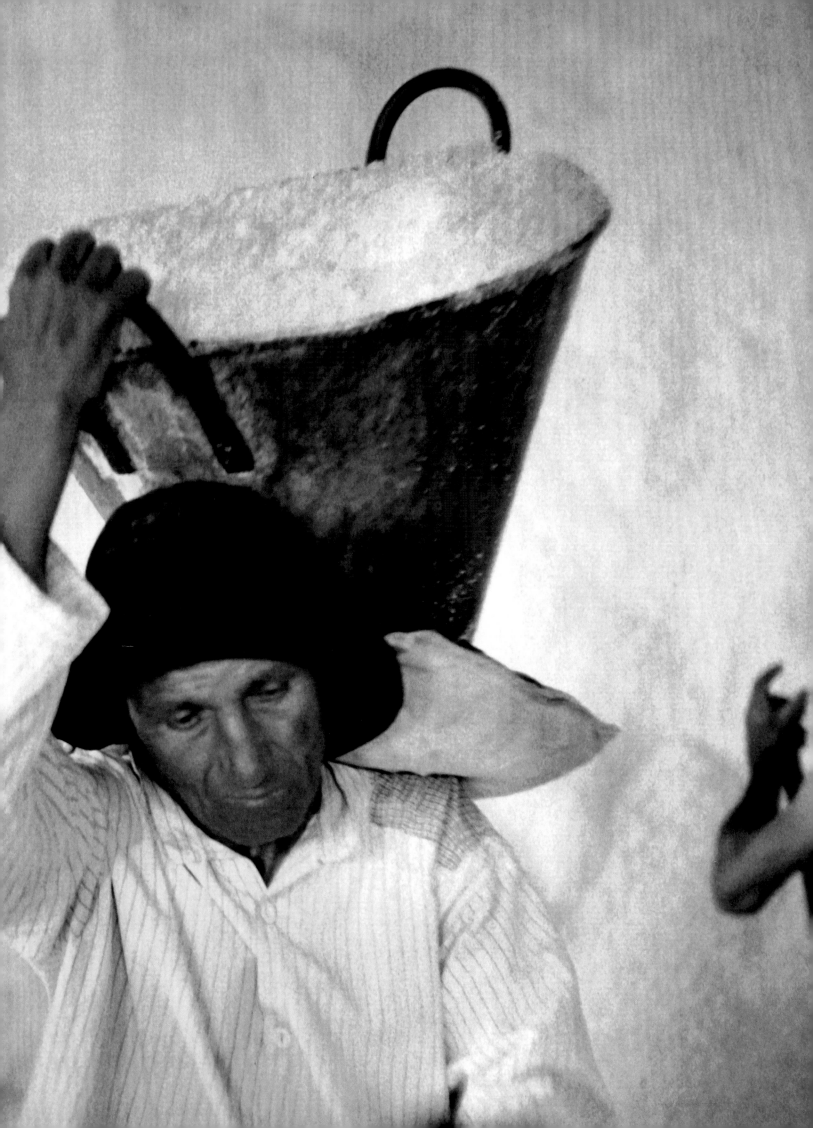

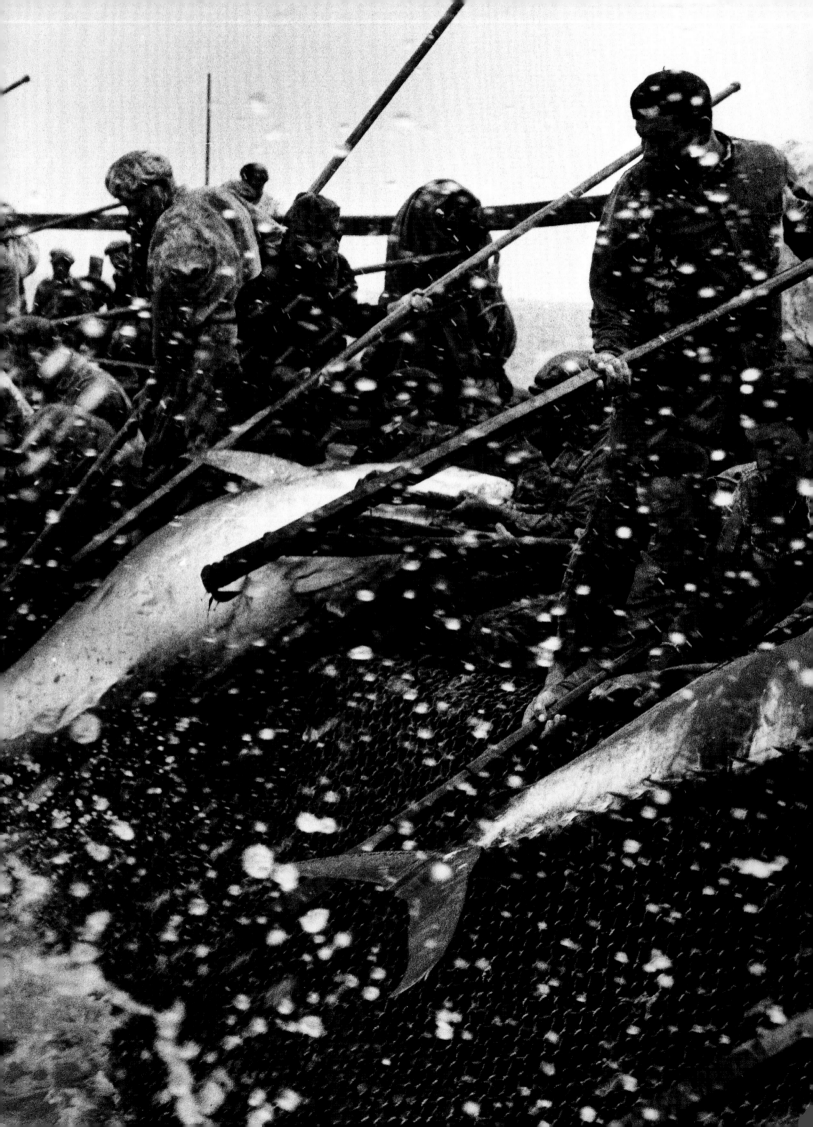

Tuna fishermen, Favignana, 1956. The arrival of great shoals of tuna was the year's biggest event for the fishermen of Favignana island. They would observe them over a period of weeks before positioning their nets so that the fish would swim straight in.

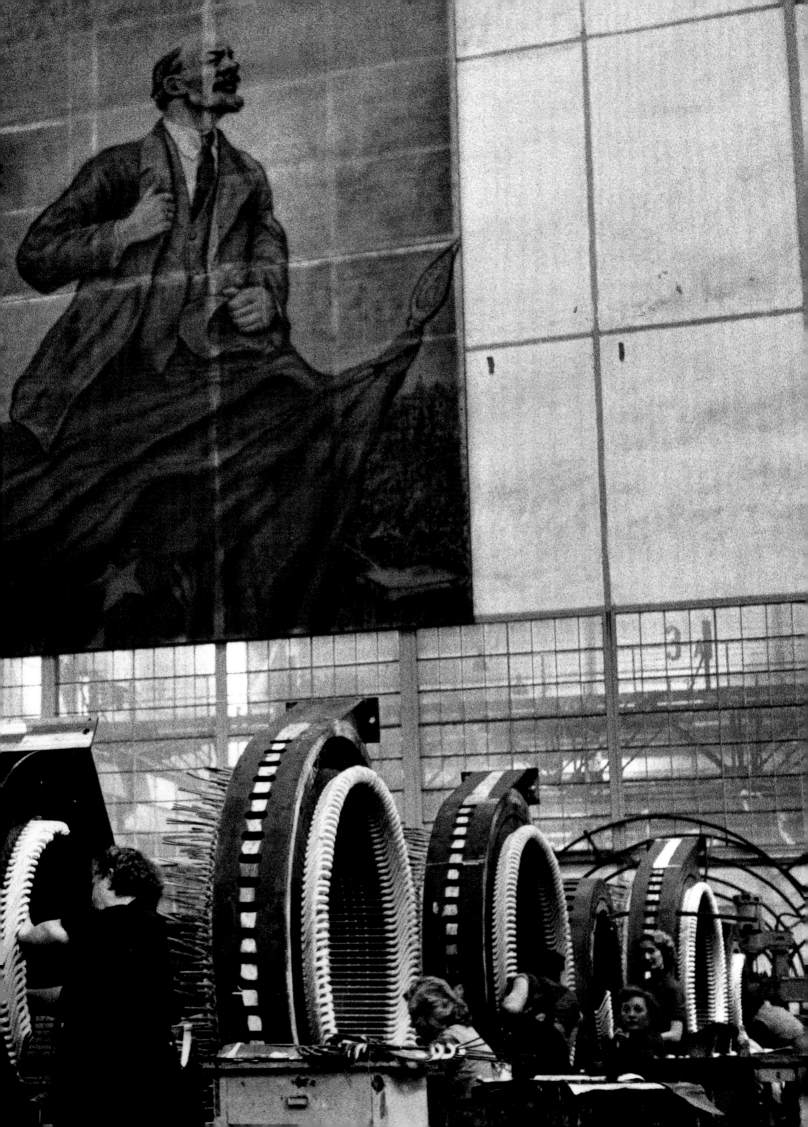

In the mid-1950s René Burri visited Czechoslovakia no fewer than three times. It was a stone's throw from West Germany where Burri went frequently on assignment for *Bunte Illustrierte* and international newspapers. But even though the country was so near, it was also impossibly removed for most Westerners. The border known to history as the 'Iron Curtain' kept Czechoslovakia at an inaccessible distance.

Beyond this boundary lay the Eastern bloc. Its very name suggests an absolute togetherness, a political monolith that the countries united under the roof of Communism never actually became. Poland remained distinct due to its powerful and influential Catholicism, while Yugoslavia and Romania both attempted to divorce themselves from Moscow's authority, each in its own way. And for a few weeks in October 1956, Hungary was successful in pulling off the straightjacket of post-Stalinist socialism.

Many prominent photojournalists documented the Hungarian Uprising, the bloody end of the regime of Hungarian prime minister Imre Nagy in the autumn of 1956. Among them were Rolf Gillhausen for *Stern* and the Magnum photographer Erich Lessing. Burri, however, was not able to enter the country. His view of Hungary and its failed revolution remained an outsider's perspective. He positioned himself at the border near Rohrschach and later in Pestalozzidorf in Trogen, Switzerland. There Burri photographed the arrival of refugees from Hungary, documenting a journey that over 200,000 people would undertake.

Though it seemed unlikely that other Eastern European nations would attempt democratic reform after Hungary's disastrous example, it seemed equally improbable that the failed uprising would leave Hungary's neighbours completely unaffected. Following his intuition, Burri set out for Czechoslovakia at the end of 1956 to see what he could find. Once again, his Swiss passport and its promise of neutrality would prove to be an advantage. This was in fact his third trip to Czechoslovakia, the Eastern European nation that Burri had explored more intensely than

any other. In 1955 he and a friend had travelled in an open-topped sports car from Zurich to Prague and then far into Slovakia where, Burri recalls, they were 'stared at as if they were the devils from the world of capitalism'. He made his second visit in the summer of 1956. This time he was on assignment for *The New York Times* reporting on the Skoda factory, which produced tanks, ammunition and cars (pp. 122–3). He describes it as a 'quite difficult time: we were constantly under surveillance'. Undisturbed work was impossible, whether in the factory or on the streets, where he would normally search for and find his uncontrived, uncensored images. Burri recalled in certain situations that it was difficult even to lift up his camera, not to mention take the actual photographs. Nevertheless, Burri was able to find his pictures, photographing topics that went beyond the scope of his original assignment. He captured an industrial complex at night and the countryside near the border. Burri's determination led to his arrest, but the Swiss embassy was nearby and intervened effectively.

Burri's examination of Czechoslovakia may be more modest than his photo essay on the Germans. Yet it is no less insightful, no less profound and no less precise in its artistry. The photographs possess a sad, grey poetry. With a backdrop of ubiquitous propaganda, Burri describes everyday life in a country that had lived under dictatorship since the late 1930s. He offers visual proof of the country's stagnation, more evident in the countryside than in the city. He witnessed and recorded a bleak era. The Prague Spring in Czechoslovakia's distant future was as yet unforeseen, and the collapse of the Soviet Union was even more removed from the reality of these years. The country was devoid of public protests, and if there were to be a revolution, Burri was told, it would first be announced in the pages of the *Rude Pravo*.

Hotel guest, Prague, 1955. Burri's pictures are known for their depth of composition. Mirrors or reflective surfaces are often employed to help increase the sense of space.

Children, Prague, 1956. In the wake of the Hungarian Uprising of October 1956, Burri embarked upon his third trip to neighbouring Czechoslovakia.
≫ **Stalin monument, Prague, 1955.**
≫ **Socialist mural, Bratislava, 1955.** Taken during Burri's first trip to Czechoslovakia.

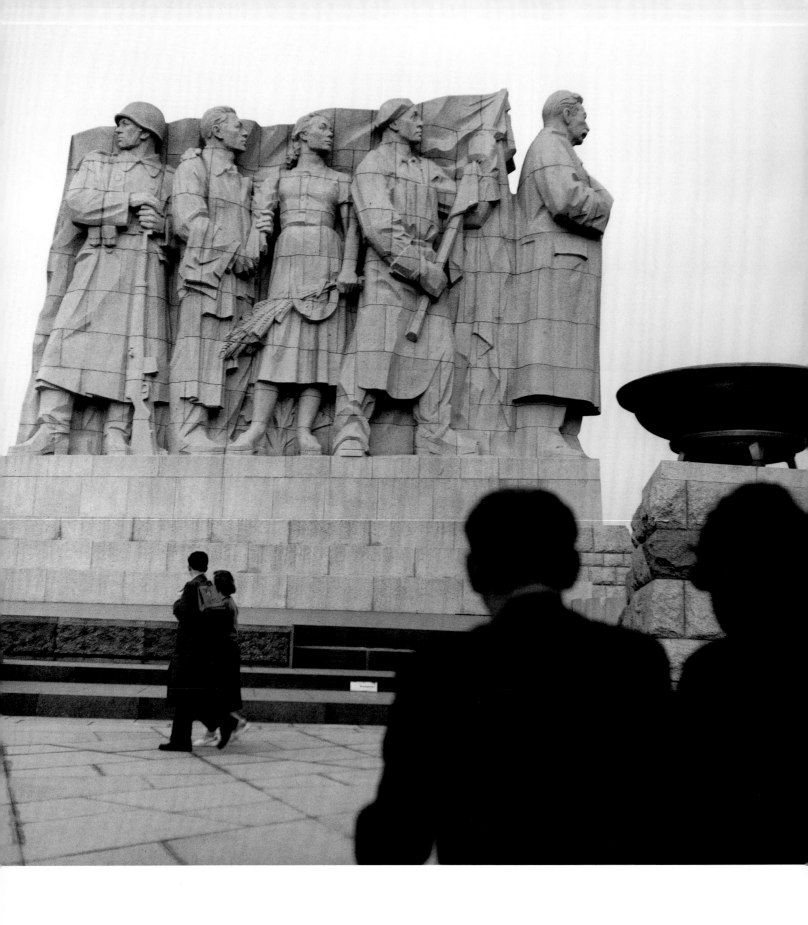

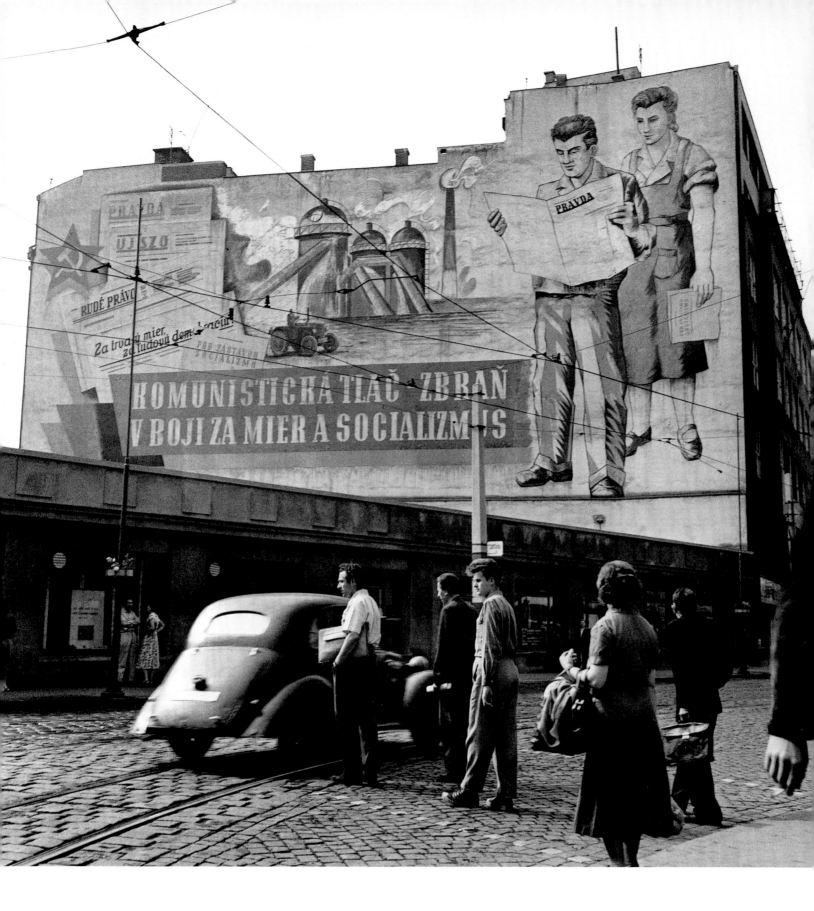

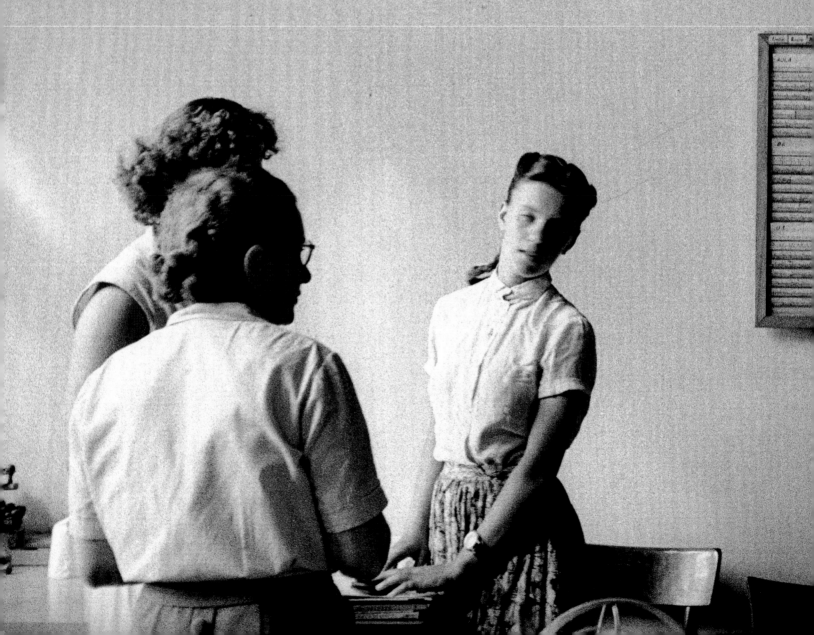

Office in the University of Bratislava, Slovakia, 1955. On the wall is, among other things, a copy of Picasso's *Dove of Peace.*

Cobbled street, Prague, 1956. Taken on Burri's third trip to Prague immediately after the October Hungarian Uprising. The big question was, would the protests spread to neighbouring communist countries?

Still life, southern Bohemia, 1955. Hans Finsler was without doubt the one who opened Burri's eyes to compositions such as this still life with beer and schnapps.

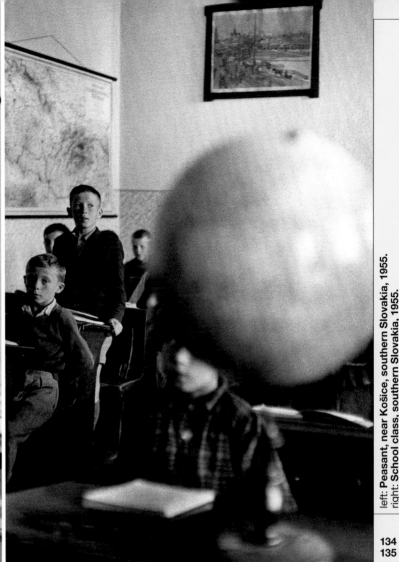

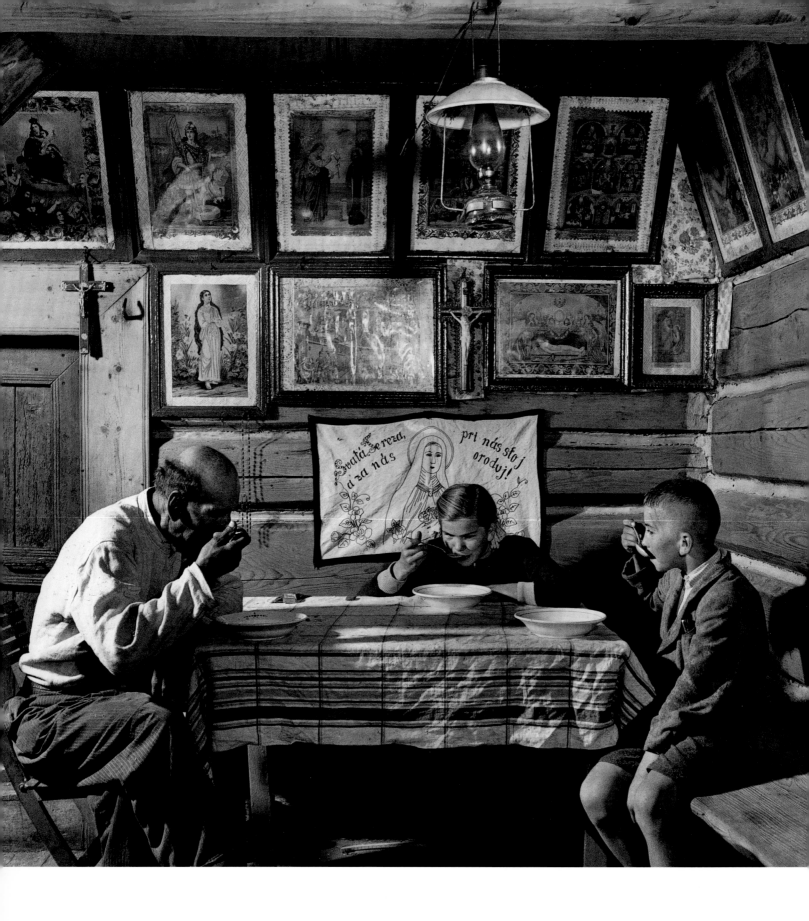

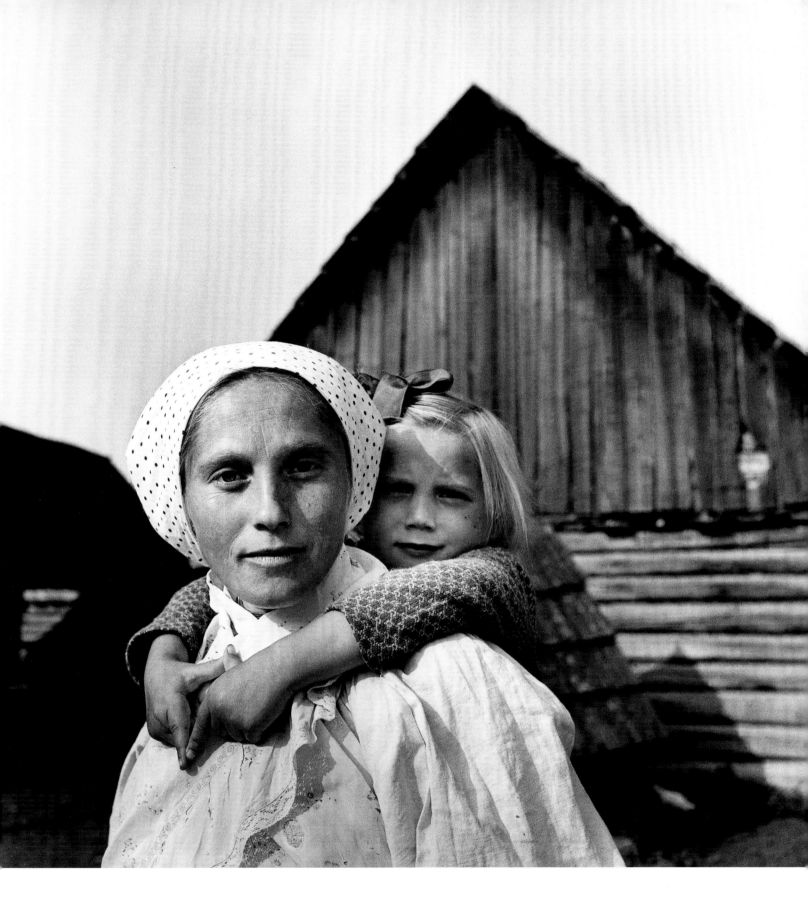

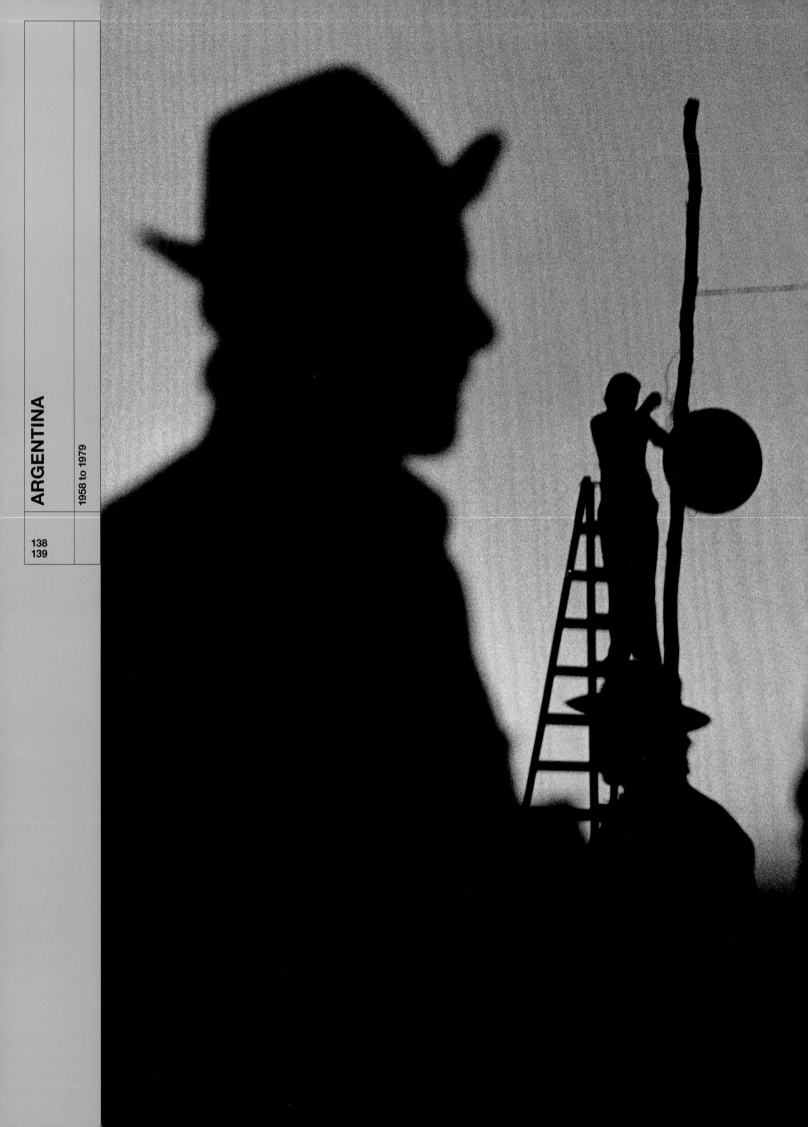

« Gauchos at work, the Pampas, 1979. Twenty-one years after Burri made his first photo essay on the South American gaucho, a series that had become legendary in the meantime, German *Playboy* commissioned the photographer to seek out and photograph the gauchos once again.

In 1958 René Burri was nominated to become a full member of the Magnum agency at its annual general meeting in Paris, but a majority of the members voted against him on the basis of his youth. Understandably disappointed, Burri simply vanished – and reappeared in Latin America.

One of his destinations was Argentina. A country seventy times larger than Burri's native Switzerland; a country with a sweeping coastline; and a country that is largely flat – as flat as Switzerland is mountainous. Perhaps this was the source of his fascination with the South American country. New and unfamiliar landscapes have always enthralled Burri. Take, for example, his first trip to Libya at the age of twenty. He enjoys recounting his first impressions of the lowlands near Tobruk, where he went on assignment for *Bunte Illustrierte* to photograph an event in honour of war victims of El Alamein (p. 22). When Burri first landed in Tripoli, it was night and he saw little of the striking scenery besides the barracks that housed the international journalists and media representatives. In the light of the next morning, the spectacular and wholly unfamiliar landscape made an indelible impression on him. The never-ending horizon was uninterrupted by walls, hills or mountains. An electricity wire stretched endlessly across the vast space, forming a perfect model of perspective into the distance. Burri let out a cry of surprise into the unknown desert panorama, shocking his more veteran colleagues.

As his photographs from Argentina in 1960 show, the never-ending horizon can also possess a haunting sense of anxiety. On a tip from a journalist friend, Burri travelled to Adolf Eichmann's hideout on the outskirts of Buenos Aires. It was a site of great historical importance, abandoned and in disrepair. Shortly before Burri's arrival, the famed Israeli intelligence officer Isser Harel had tracked down the former Nazi leader and put him under surveillance before removing him from the country. Through Burri's subtle visual handling, the terrain adopts Beckett-like

proportions; his photographs describe a no-man's-land marked with an incongruous touch of introverted German homeliness (pp. 148–9). He photographed the unassuming place from a deliberate distance. A view through the windows of the bungalow reveals an unexpected and strangely unsettling glimpse of old German, pre-war culture. Other photographers would have gone into the building, but he maintained his distance. Perhaps the sign of a true Magnum photographer?

René Burri has repeatedly drawn inspiration for his photography from world literature. In the mid-1950s he was reading a beautiful Manesse edition of Ricardo Güiraldes's *Don Segundo Sombra*, a hymn to the culture of the Argentinean gaucho. When the novel was first published in the 1920s, the concept of the gaucho had changed from that of a ruffian adventurer to a 'romantic fellow' and 'real man'. At the same time, the gaucho had all but vanished from everyday Argentinean reality. He had been frozen into a literary metaphor, a symbol of the proud and romantic outcast who was, as described by Brian S. Kingson, 'independent and individualistic'. Representing freedom, lyricism, resistance to tyranny, and a robust passion for horses and women, the gaucho was thought to exist only as a symbol.

This did not discourage Burri. With boundless energy and initiative, he sought out and found the last of the gauchos in the distant Pampas. He accompanied them with his camera for a number of weeks, observing them closely as they worked with their animals. The culture exposed in these photographs is untroubled by any dependency on material goods or modern conveniences. The resulting photo essay 'El gaucho' ('The Gaucho') is a document of great anthropological interest. It was René Burri's most intense work to date and appeared in *Du* in 1959 (pp. 142–7; p. 438, no. 3), the same year his membership of Magnum was finally confirmed.

》 **Horse training, the Pampas, 1958.** Burri was inspired to seek out the gauchos by Ricardo Güiraldes's book *Don Segundo Sombra*.
》 **'El gaucho', the Pampas, 1958.** *Du* provided Burri with the opportunity to research the myth and reality of the South American cowboys.

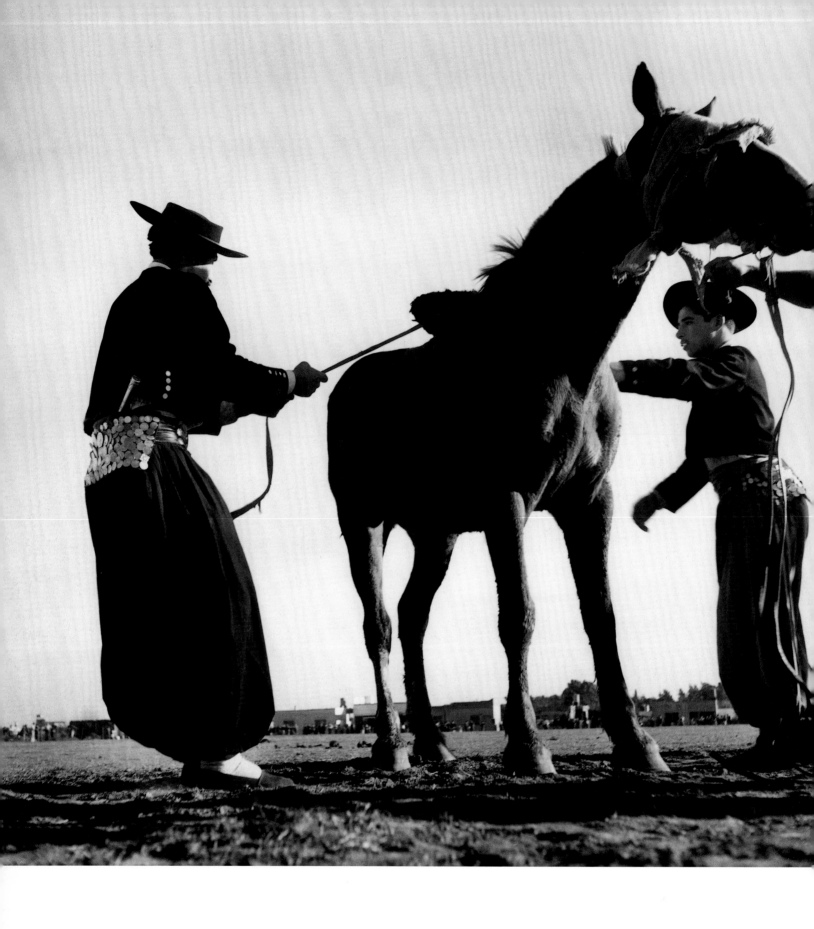

« Saddling a horse, the Pampas, 1958. Burri did not merely collect impressions but investigated the culture of the gauchos with something approaching an ethnographer's accuracy.
Cattle, Buenos Aires, 1958.

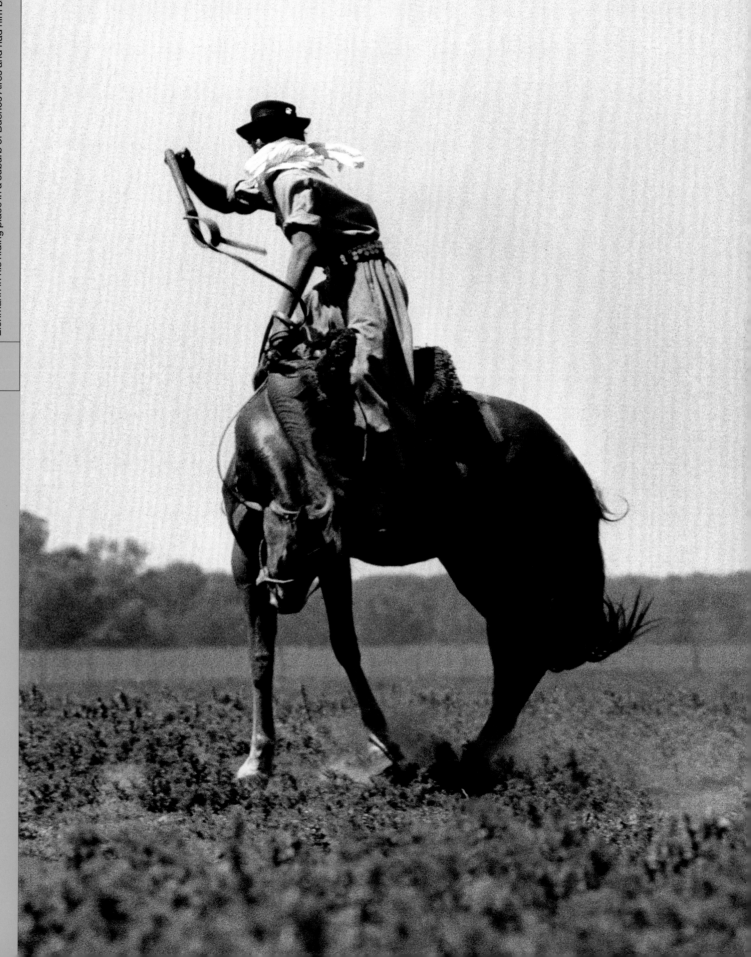

Breaking in a horse, the Pampas, 1958. A gaucho breaks in a wild horse.
» **Adolf Eichmann's hideout, Buenos Aires, 1960.** Isser Harel, the Israeli intelligence officer, found
Eichmann in his hiding place in a suburb of Buenos Aires and had him brought to Israel to be tried.

Military parade, Buenos Aires, 1958. The democratically-elected president Arturo Frondizi ended the authoritarian rule of the Peron era. Years later the so-called 'Mothers of the Plaza de Mayo' brought attention to the fate of their family members who had disappeared during the military dictatorship.
≫ **Newspaper boys, Calle Florida, Buenos Aires, 1958.**

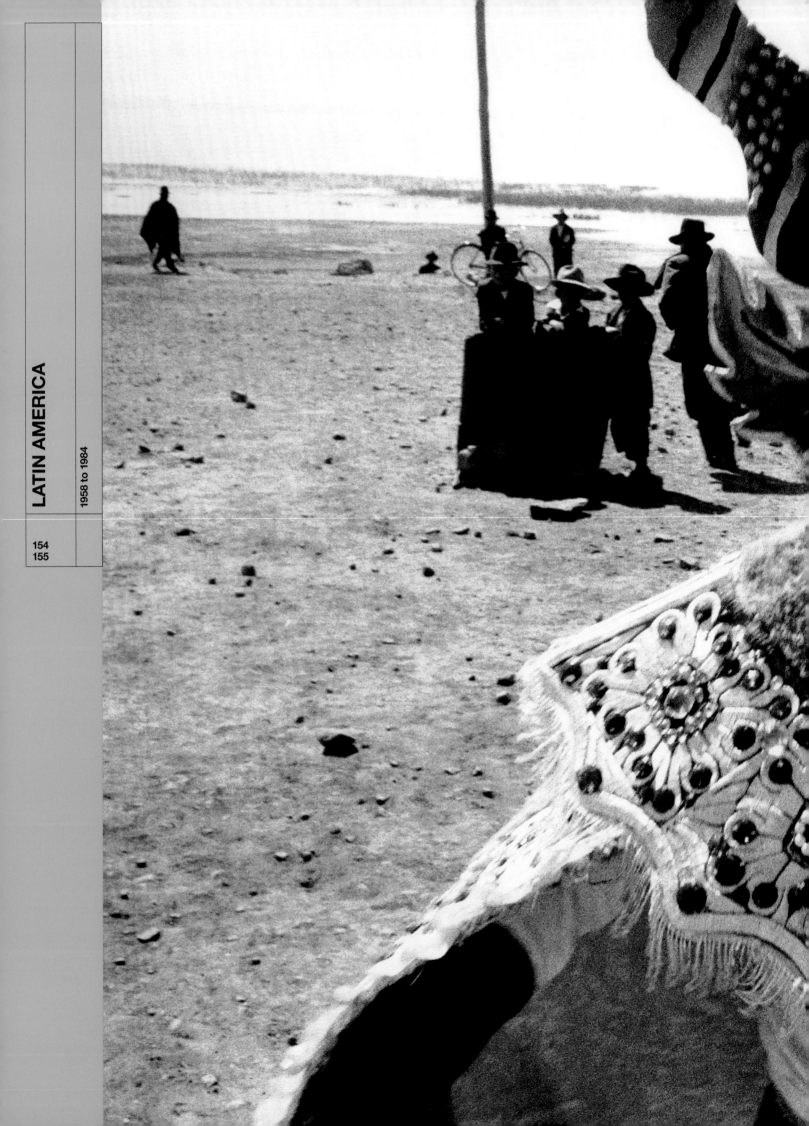

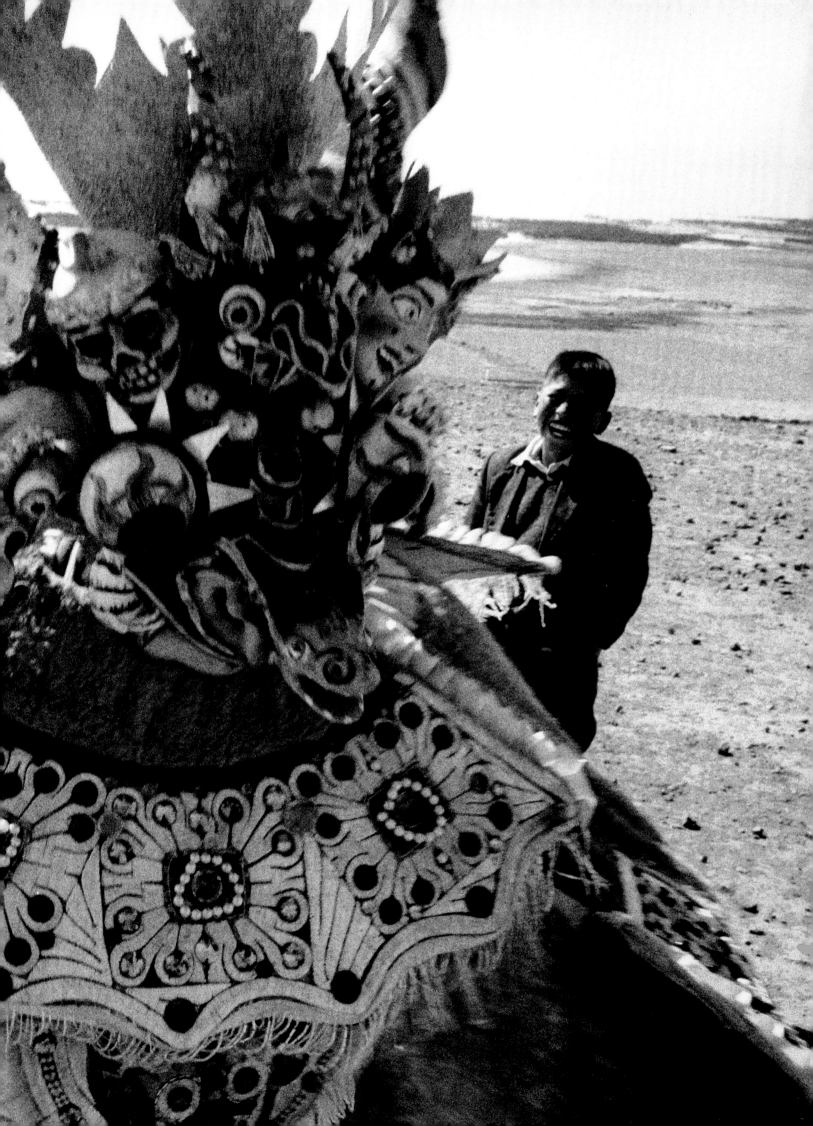

When René Burri left for his first trip to Latin America in 1958, he knew very well in whose footsteps he was following. Werner Bischof, also from Switzerland and, like Burri, a graduate of the School of Arts and Crafts in Zurich, was a member of the Magnum group. Some of Bischof's best-known photographs were taken in Mexico and Peru in 1954, including his famous *Flute Player, On the Road to Cuzco*. The image is undoubtedly one of the most popular motifs in post-war European photography.

Bischof was a role model for Burri, who was seventeen years his junior. But independent-minded and bursting with creative energy, Burri soon felt the need to step out from under Bischof's shadow. Thus, it was against images like the *Flute Player* that Burri began to develop his own, distinctive artistic personality. He must have felt justified in this approach when he received a letter from Bischof himself. The elder photographer wrote that he had shown Burri's work to Capa, Chim, Haas and Cartier-Bresson, 'and they all liked it'. Tragically, Bischof had a fatal accident in the Andes shortly thereafter, and Burri must have wondered about his chances of being 'knighted' as a member of the Magnum group after his advocate's death. Burri had been named an associate member of Magnum in 1955 on the strength of his first publication in *Life* magazine. He was due to be elected a full member three years later, but this did not happen for a further year.

Burri travelled through Latin America for six months. Why Latin America? The answer can be found in a 1967 issue of *Du* dedicated to Salvador da Bahia, the 'dethroned capital of Brazil'. In the introduction, author Hugo Loetscher writes that 'it took three centuries to give birth to the city. Portuguese Europe, black Africa, and the native Indians created South America as their stage'. Indeed, what applies to Bahia on a small scale can, with certain reservations, be said of Latin America as a whole. It is a melting-pot of cultures and ethnic groups. The interaction of disparate elements has always been of special interest to Burri, and he

found himself immersed in such an environment during his trip. It should also be noted that, during these six months in Argentina, Peru, Brazil, Bolivia and elsewhere, Burri completed a number of lucrative industry assignments, such as one for the French oil prospecting consortium Schlumberger.

Equipped with a list of important people and good contacts, Burri went searching for new topics, new stories and new inspiration. At the heart of his research was the hunt for the Argentinean gauchos (previous chapter), the legendary adventurers who had all but disappeared from everyday life.

In Brazil, Burri discovered the beginnings of Brasília, the bold capital city designed on the drawing table. Years later he would return to record its completion. This first trip to Latin America was the beginning of a lifelong affinity for the region. In 1968 Burri photographed the Olympic Games in Mexico City. And in 1969 he met Luis Barragán for the first time, an architect whose style was located somewhere between sparse modernism and Latin American sensuality, and who inspired a lasting fascination in Burri. His photo series on Che Guevara's Cuba (see chapter on Cuba) and his city portraits of São Paulo (pp. 192–3, p. 198) and Rio de Janeiro (p. 199, inside back cover) are also products of his initial exposure to these cultures. In all of his travels, Burri found the opportunity to explore the pulse of everyday life. Uncontrived and alive, these images represent bold aesthetic experiments. One thing is certain, though. In all of his photographs, René Burri is always searching for himself.

Woman wearing hat, Potosí, Bolivia, 1958. Burri embarked on his first extended trip to Latin America in 1958. Potosí, a silver-mining town roughly 4,000 metres above sea level, attracted him not least because of the remarkable hats worn by the women there.

158

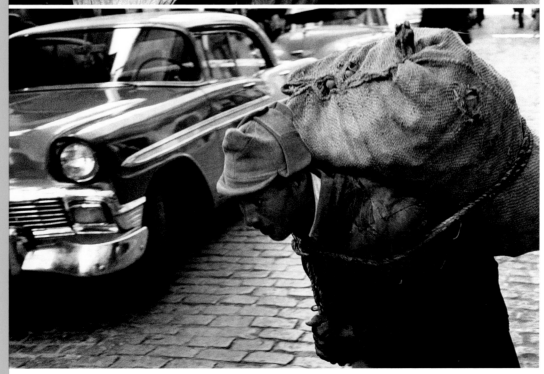

On the train, Machu Picchu, Peru, 1958. The ancient Inca city of Machu Picchu was 'discovered' in 1911 by American anthropologist Hiram Bingham.

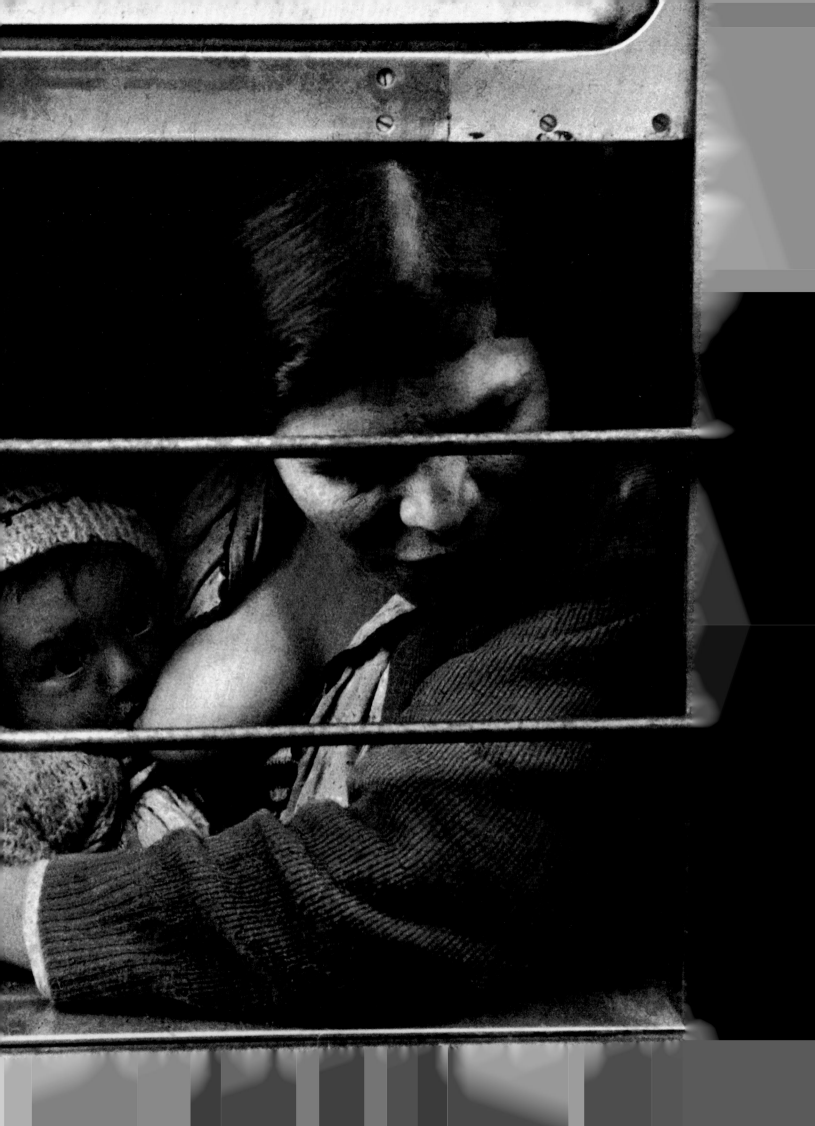

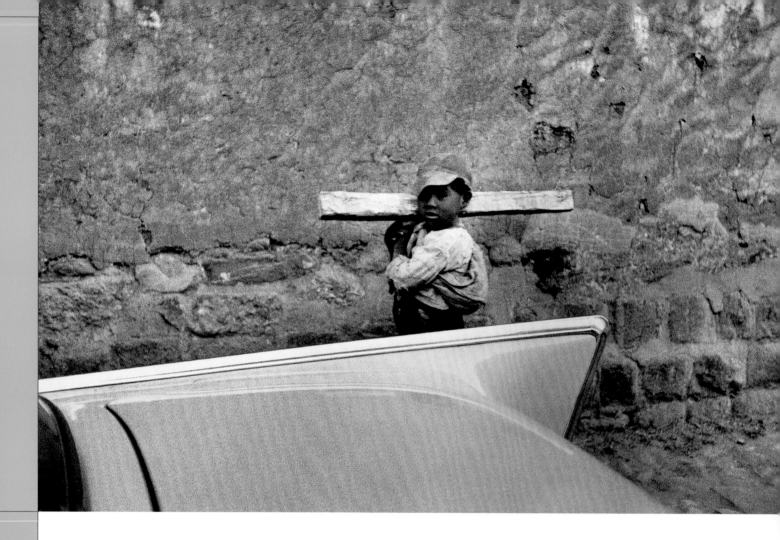

Local boy, Cuzco, Peru, 1958.

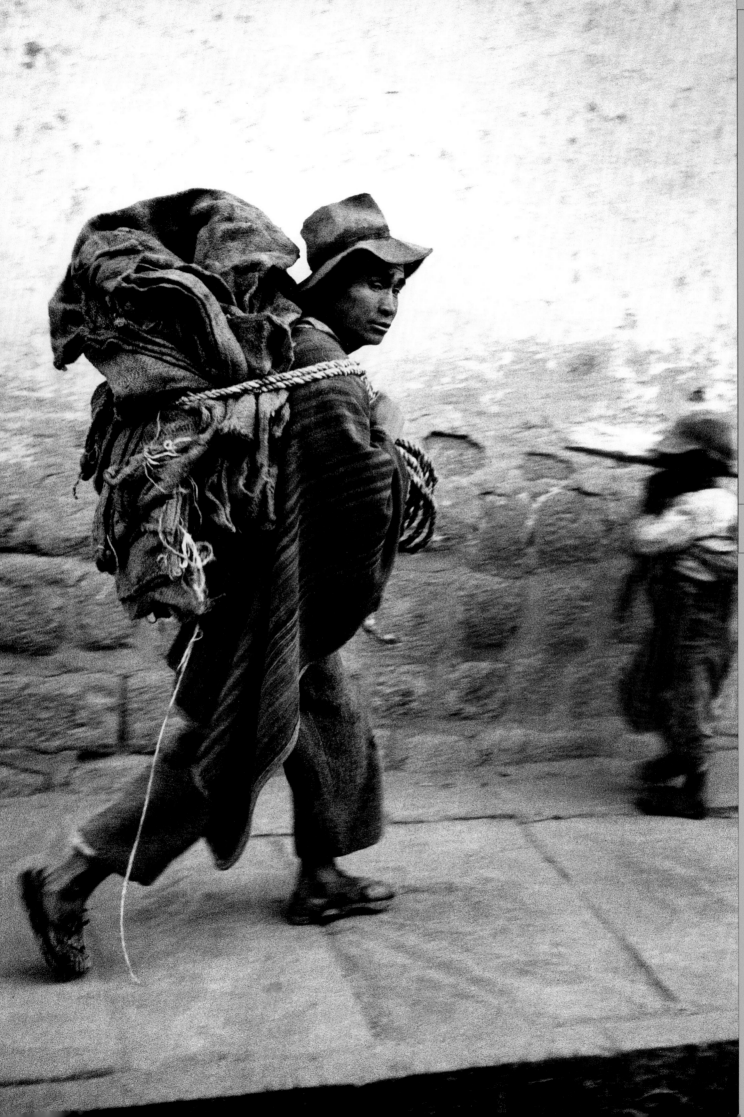

Local, Cuzco, Peru, 1958.

Villager, Puno, Peru, 1958. This man is taking part in a local bullfight.

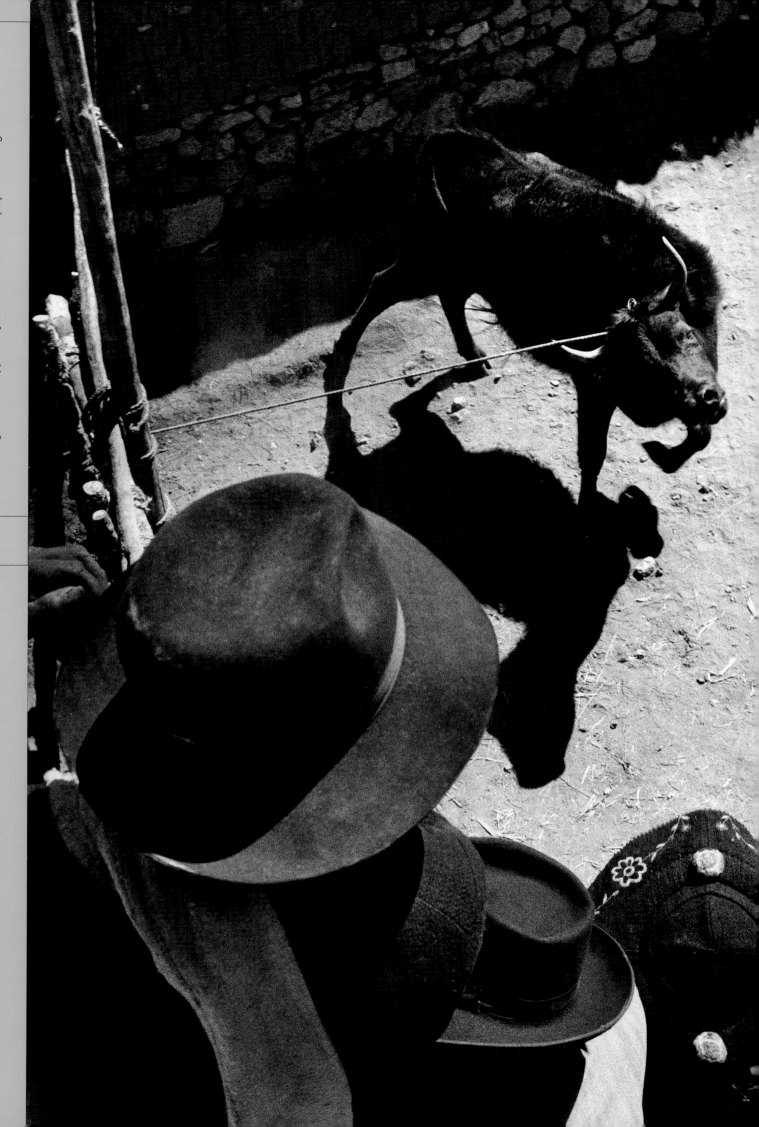

At the bullfight, near Lake Titicaca, Peru, 1958. According to tradition, the bull is not killed, but rather the bullfight offers an opportunity for the local men to display their courage.

left: **Bonfires at Indian festival, Taxco, Mexico, 1958.** It was pictures like this that first made Burri famous as an art photographer, someone concerned with formal and aesthetic issues rather than reportage alone.
right: **Carousel, Lima, Peru, 1958.**

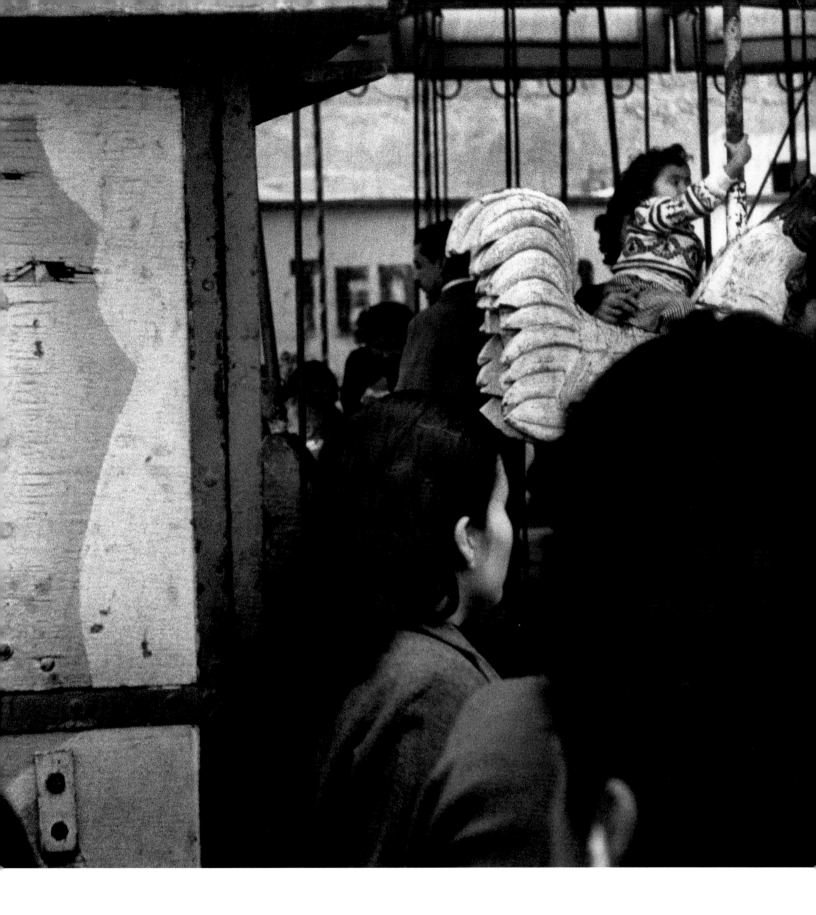

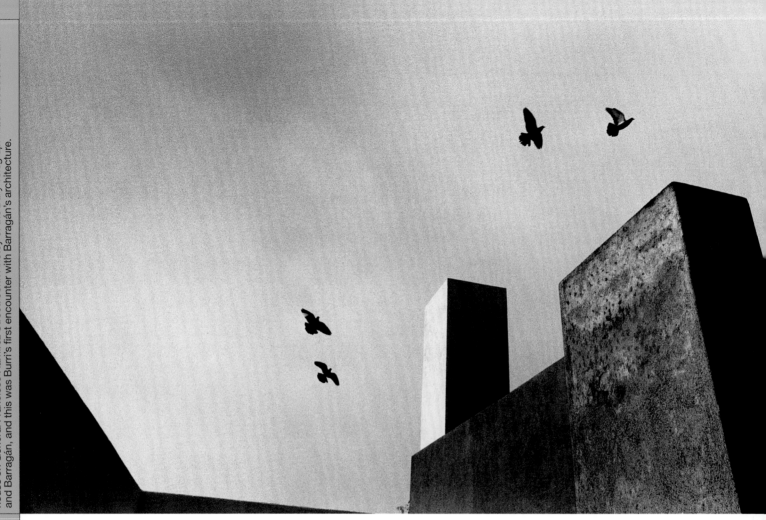

Tower by Luis Barragán, Mexico City, 1969. Together with his friend the painter Mathias Goeritz, Barragán conceived and built a group of painted concrete towers as the 'gateway' to a new satellite city on the edge of Mexico City in the 1950s. This photograph was taken from inside one of the towers with Barragán in the doorway.

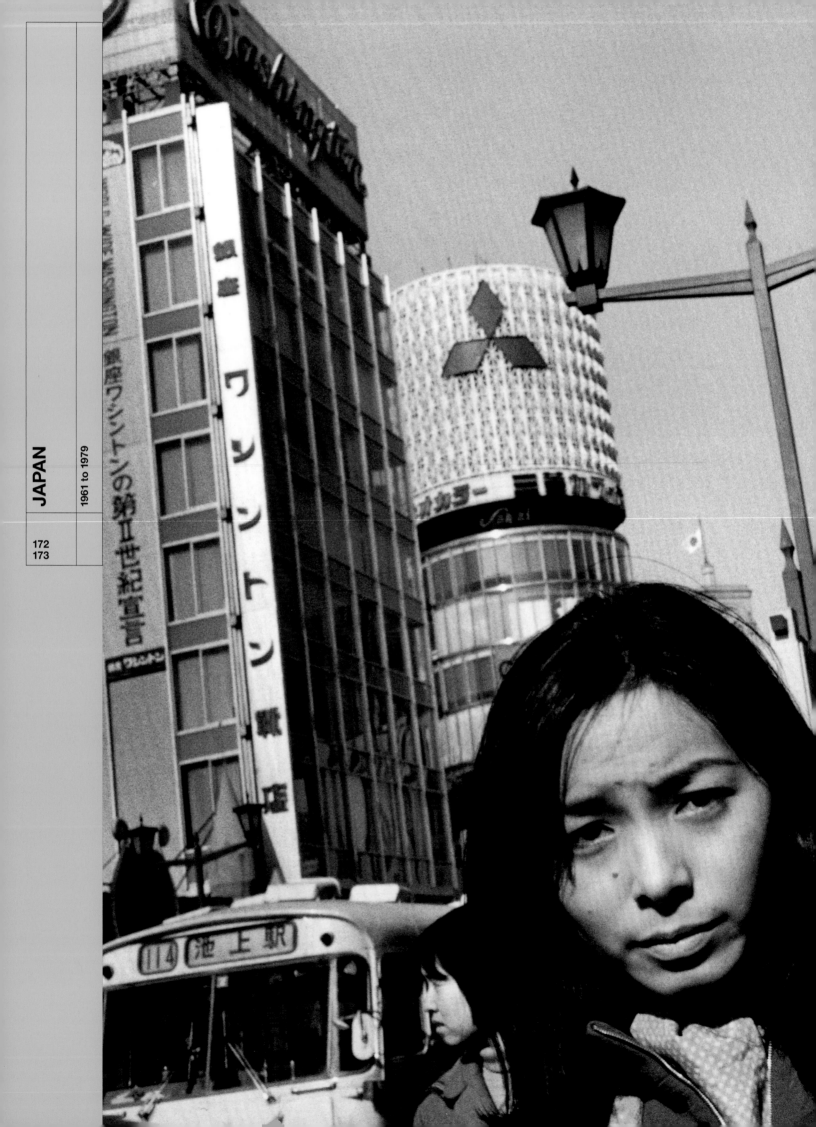

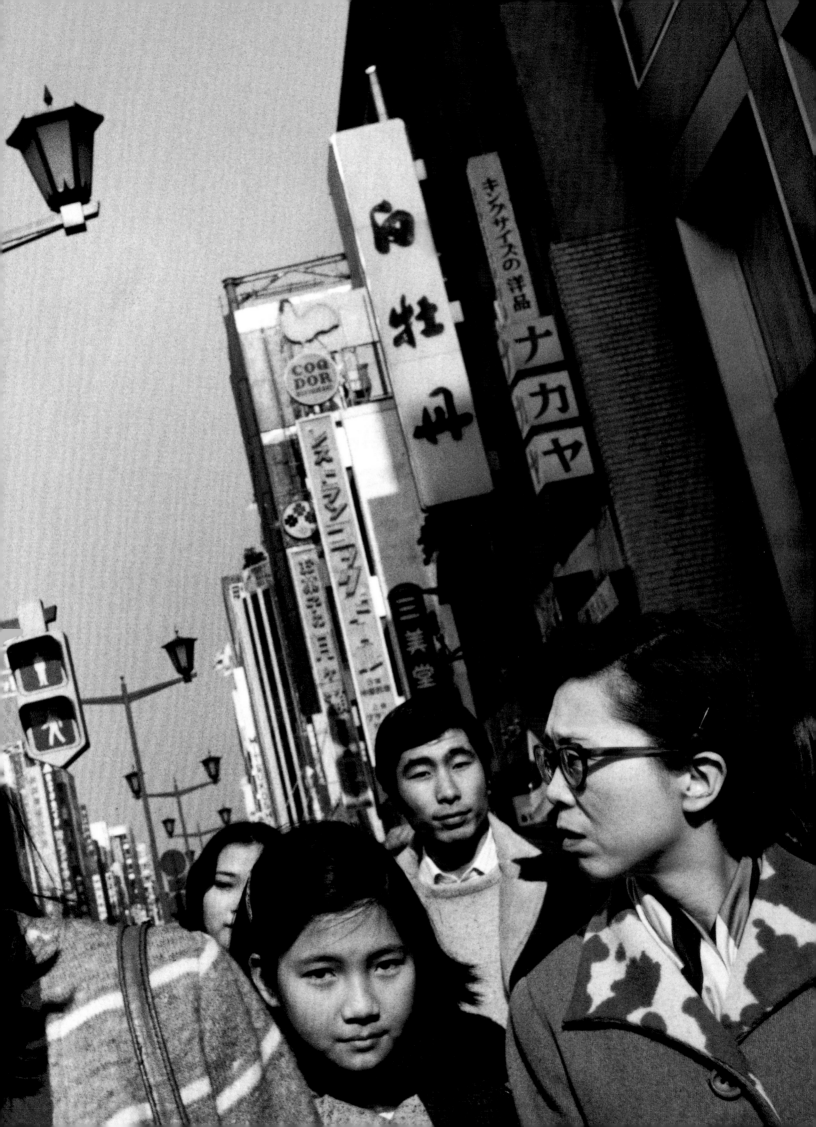

« **Pedestrians, Ginza, Tokyo, 1970.** Eighty-five per cent of the city was destroyed in World War II.

From a European perspective, Japan was still a distant land in 1961, isolated geographically, psychologically and culturally. However, it was also a country in the midst of dramatic change, poised to become an economic giant. This development went virtually unnoticed in the West, which after World War II had not felt the need to take Japan seriously. Undoubtedly this was also one of the reasons for Japan's sudden and seemingly miraculous economic success.

Du magazine felt compelled to report on Japan earlier than other publications. 'Japan at Work' was the title of the special Japan issue of the magazine that appeared in August 1961. Publishing an entire issue on the one country emphasized the importance that the editor in chief, Manuel Gasser, placed on Japan. He resisted turning the reportage into a collection of Far East clichés, and instead focused on Japan as a country on the verge of becoming a modern industrial leader. As he well knew, Japan's success was not merely the product of chance. It was the result of a range of deeply human qualities: diligence, ambition, work and discipline. At the beginning of the issue, Gasser writes that 'the Japanese sign for "work" is a combination of the symbols for "person" and "motion". It is precisely this picture of people in motion, in action, that impresses itself upon any visitor to this country.'

Burri and Gasser had travelled to Japan earlier that same year. Although Burri was well travelled by this time, it was his first visit to the island nation. It was also his first trip together with an editor. Burri and Gasser complemented one another perfectly. The success of their project was in no small part due to their personal cooperation, permanent dialogue, joint research and the immediate feedback that their companionship fostered. For Burri, the presence of the writer had the effect of ennobling his work with the camera. This was still the time when writing, and not photography, was considered the more dignified art. Although many now speak of the 'visual century', the written word, and not the photograph, was still

king of the press at this time. Images were supposed to accompany text, not the other way around. Following this productive trip Burri became fond of travelling together with the writers working on his particular assignments.

During this first stay in Japan, he was greatly helped by his Magnum colleague and friend Hiroshi Hamaya (p. 414), who turned out to be an invaluable scout for the project. Moreover, he was able to use Hamaya's laboratory to develop his films and produce the first rough prints. The draft layout created here by Burri and Gasser remained essentially unchanged in the final version. When completed, the Japan special consisted of twenty-three black-and-white and seven colour photographs, plus a colour cover depicting a steelworker in the Kawasaki factory (p. 428, no. 2).

In the accompanying text, Manuel Gasser reveals his amazement at a people who do not have a word for 'leisure', who eat raw fish and, in a singular fashion, are able to combine simplicity and sophistication. Burri expresses this same amazement in his images. He approaches the culture with curiosity, but also with respect. It may have been foreign to him but he did not simplify it or portray it as merely 'exotic'. For Burri, who had progressed far beyond the conventional type of travel reportage in his formal and aesthetic style, it was important to emphasize the common rather than the divisive elements between cultures. (This philosophy of a common human destiny is a clear theme that runs through his later book *One World*.) Concluding the reportage, Manuel Gasser writes, 'The more time you spend with the Japanese and the deeper you delve into their manner of thinking and way of life, the more you realize that everything here is the same as what you left back home.'

» **Mask vendor, Tokyo, 1961.** The occasion for René Burri's first trip to Japan was an issue of the magazine *Du* called 'Japan at work'.

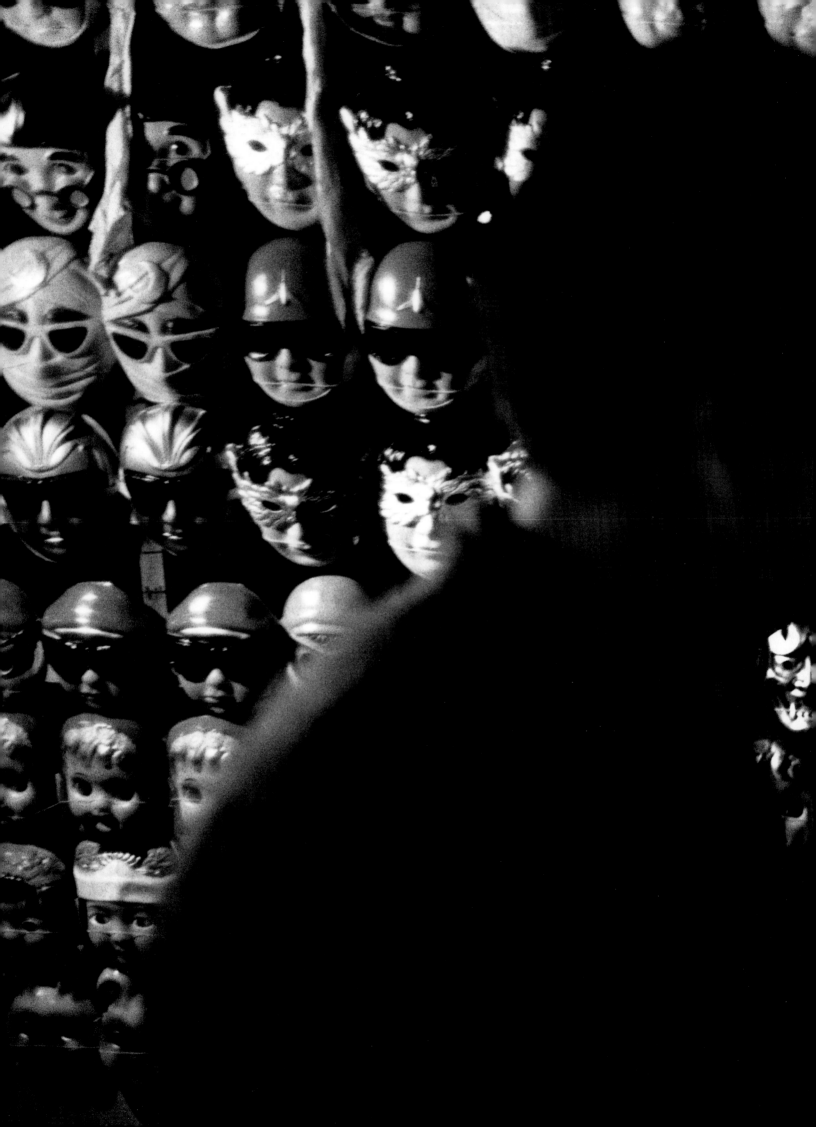

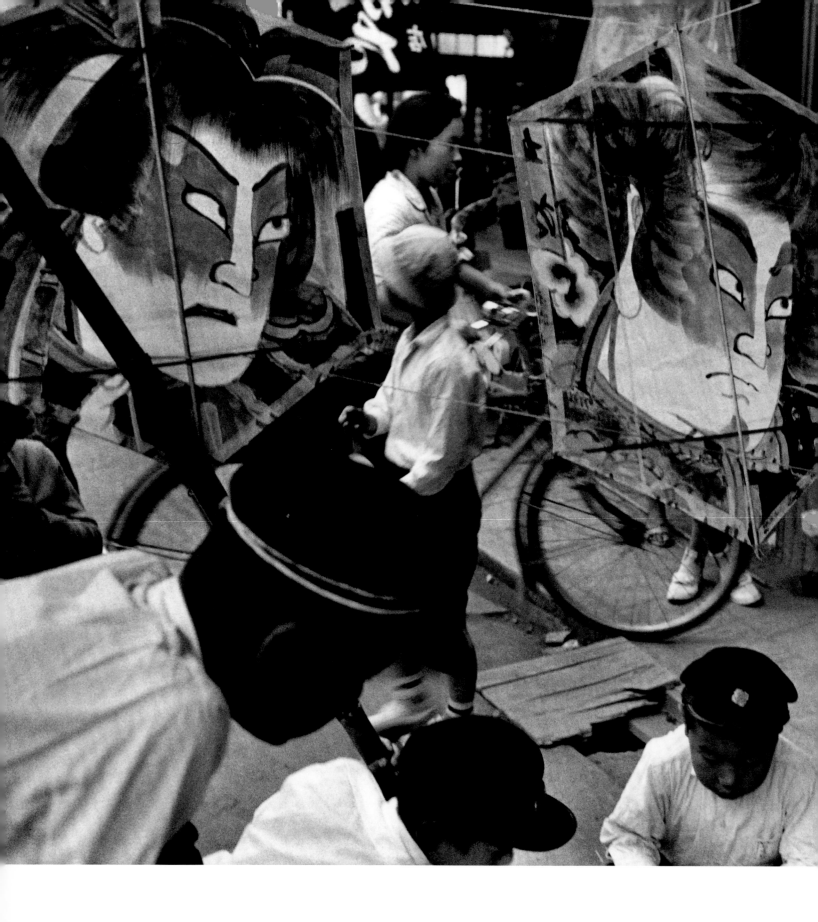

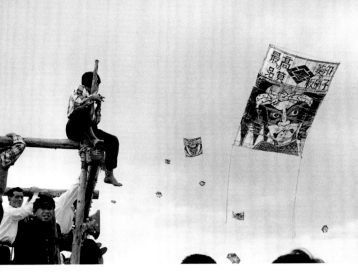

left: **Kite painting, western coast of Japan, 1961.**
right: **Kite flying, western coast of Japan, 1961.**
Every year the traditional kite festival takes place in the bay of Honshu during the spring storms. Here the kites are being painted before they are made to crash into the river as part of a competition.

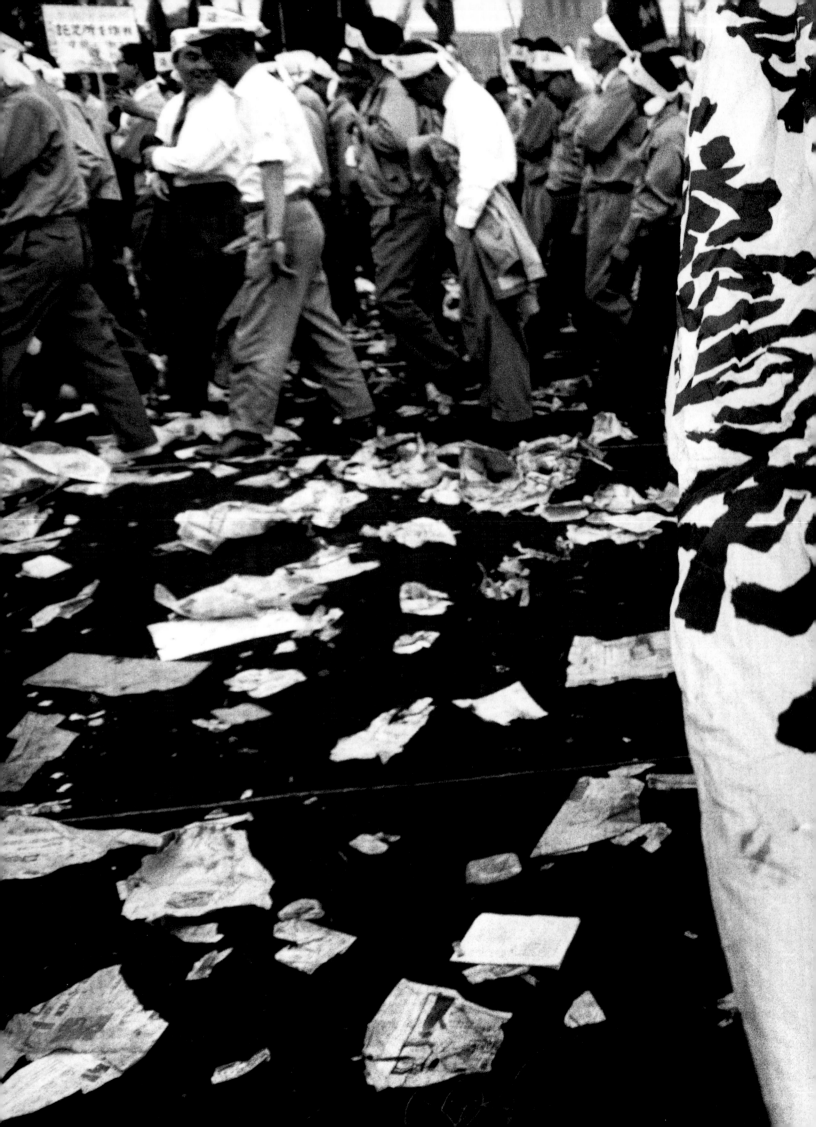

May Day demonstration, Tokyo, 1961. The commission from *Du* seems to have encouraged Burri to take unusual pictures – this is an unconventional take on a group of demonstrators. The Japan issue included a vertical variation of this photograph.

left: **Street scene, Ginza, Tokyo, 1961.**
right: **Wedding, Tokyo, 1970.** What drew Burri's attention was the fact that these newlyweds chose Western rather than traditional Japanese dress.

182
183

Passionate embrace, Tokyo, 1979. This nightclub patron in the Akasaka district is obviously having trouble leaving his hostess.

Dancer, Tokyo, 1961. A dancer in the Niki Gekki, a nightclub similar to the Folies-Bergère in Paris.

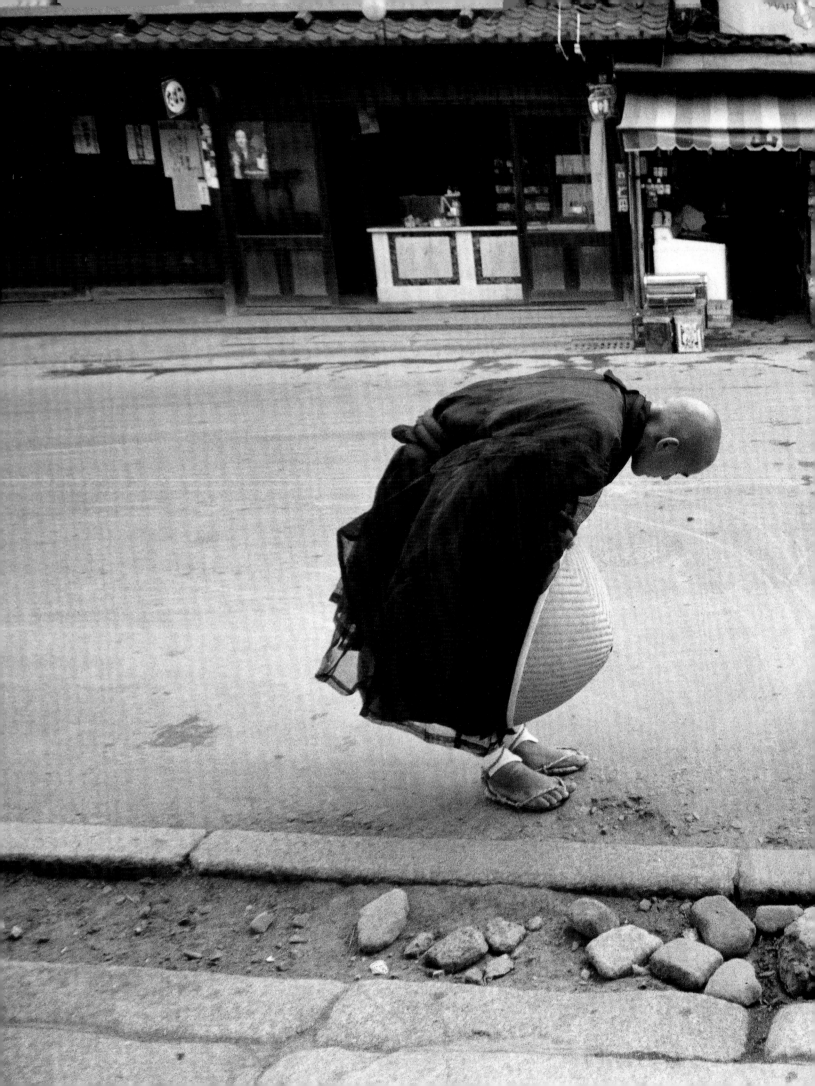

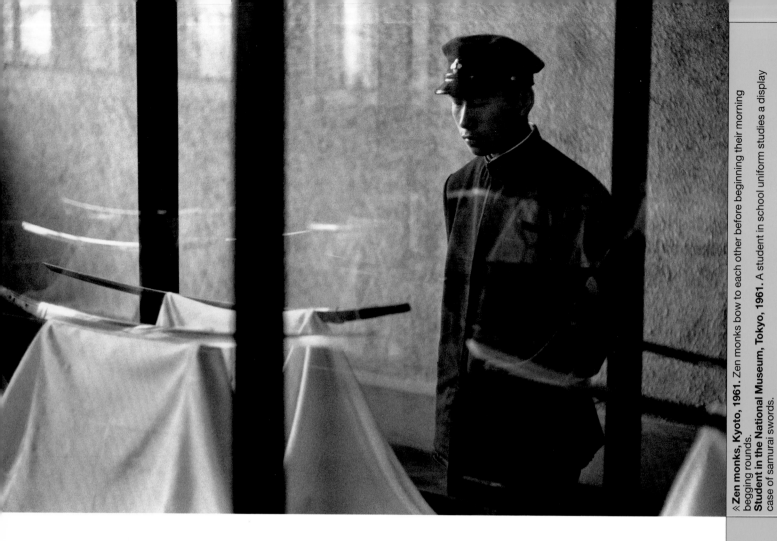

« **Zen monks, Kyoto, 1961.** Zen monks bow to each other before beginning their morning begging rounds.
Student in the National Museum, Tokyo, 1961. A student in school uniform studies a display case of samurai swords.

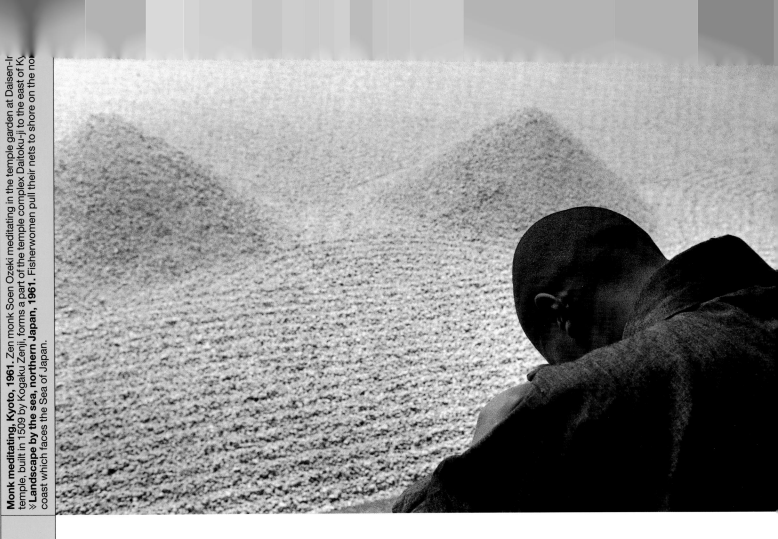

Monk meditating, Kyoto, 1961. Zen monk Soen Ozeki meditating in the temple garden at Daisen-I temple, built in 1509 by Kogaku Zenji, forms a part of the temple complex Daitoku-ji to the east of K ≫ **Landscape by the sea, northern Japan, 1961.** Fisherwomen pull their nets to shore on the no coast which faces the Sea of Japan.

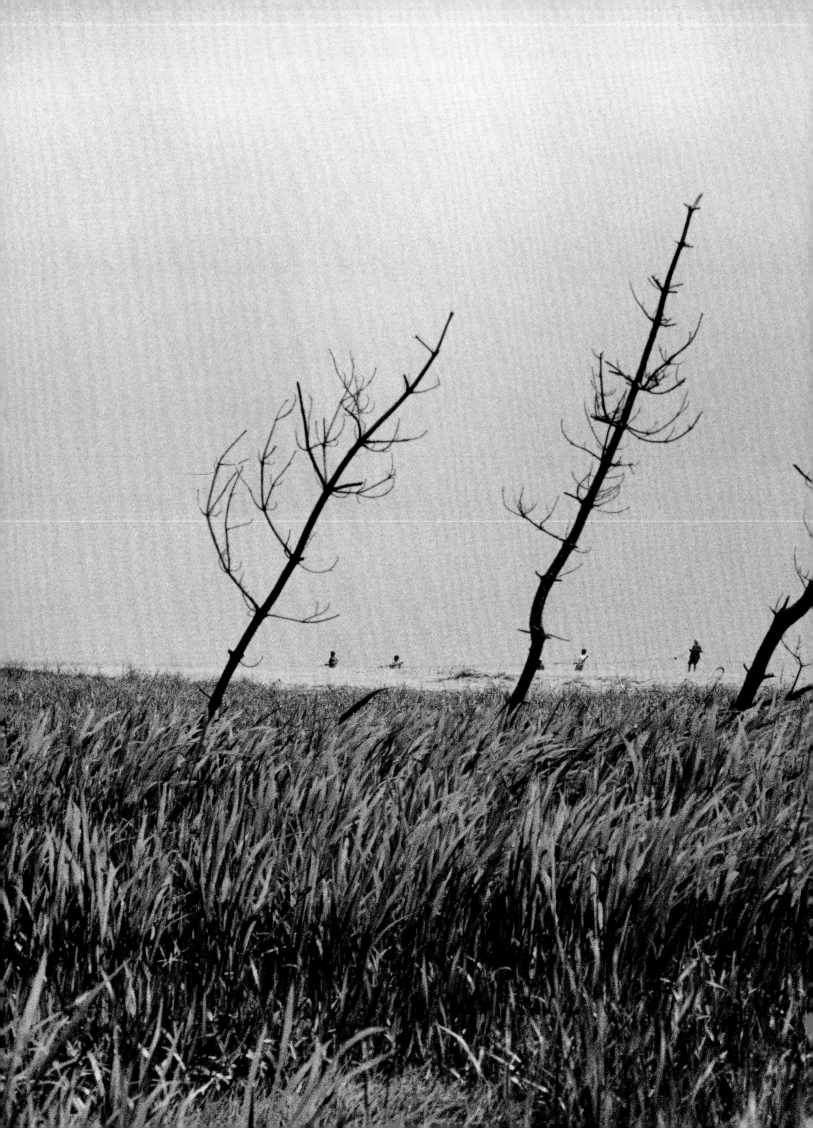

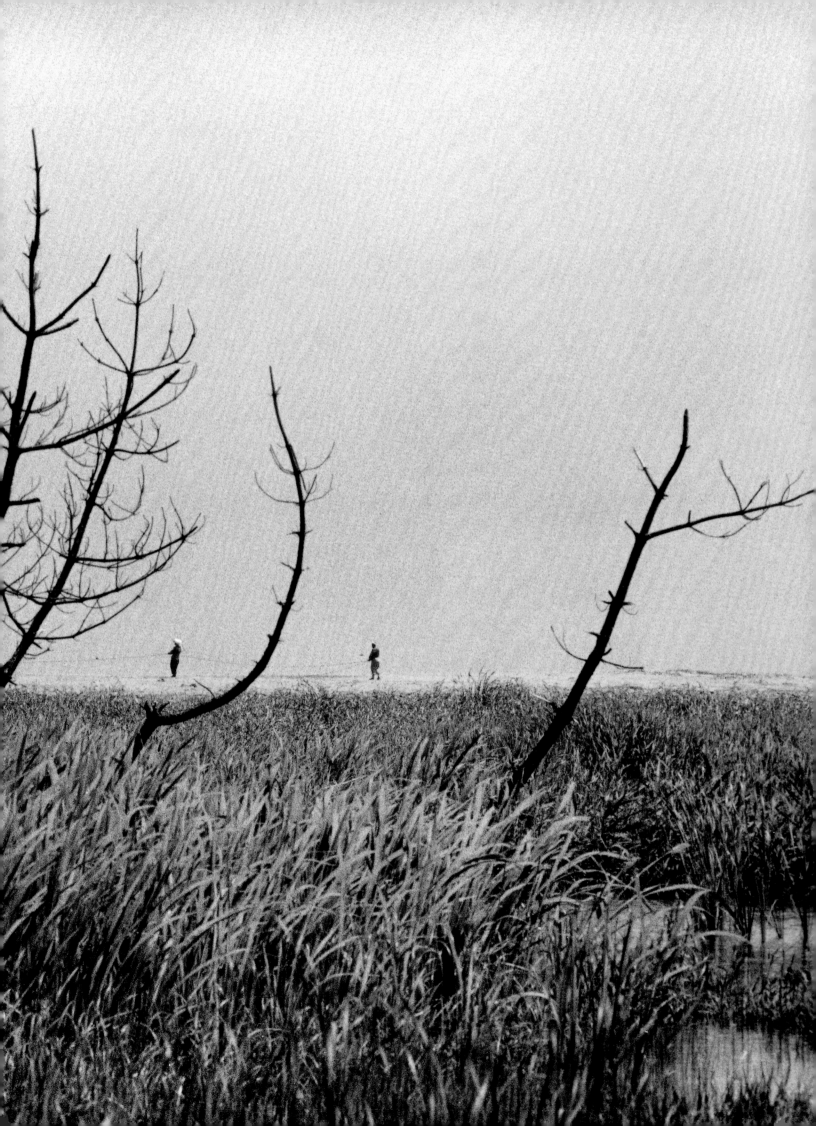

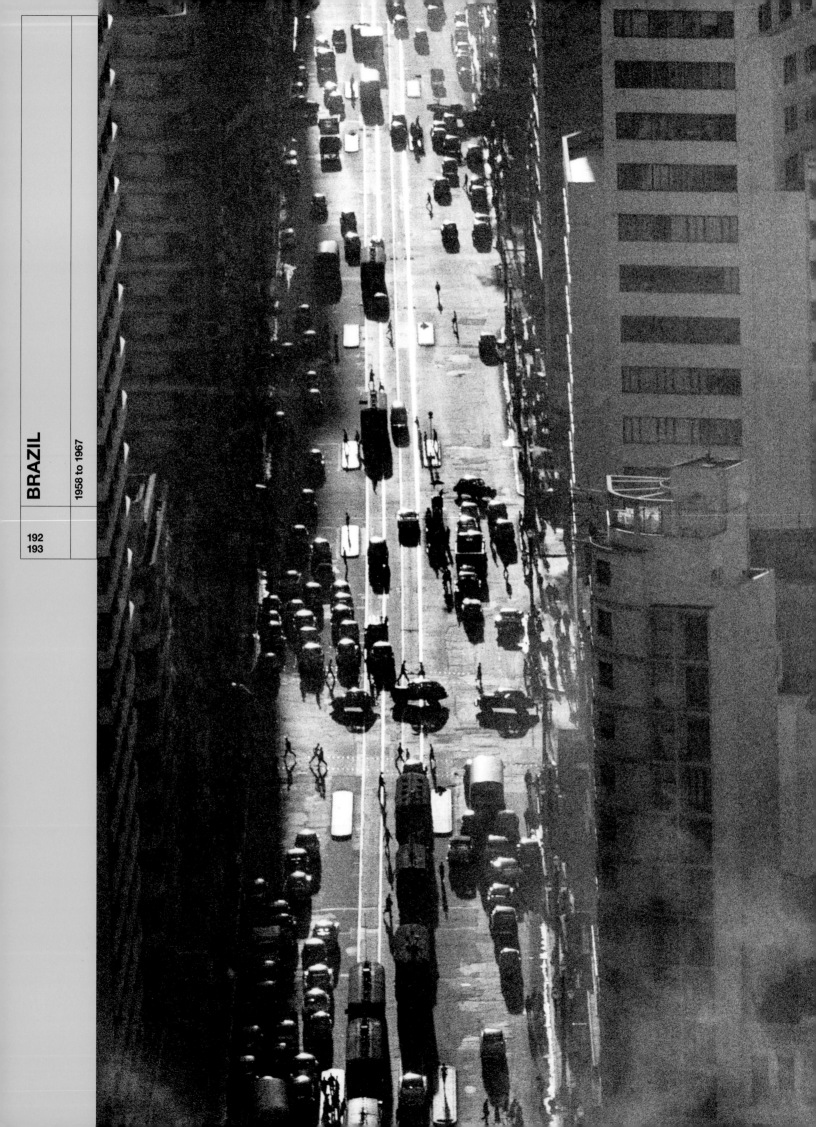

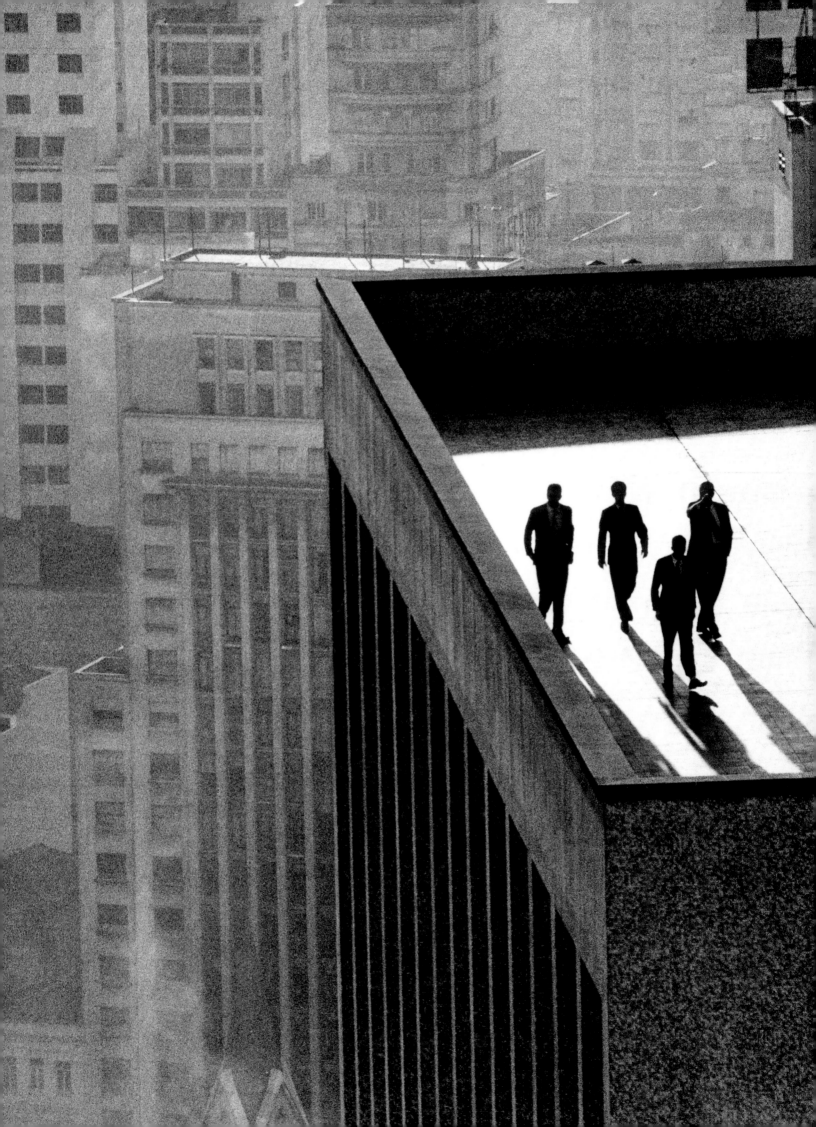

Some of René Burri's most important and best-known photographs were taken in Brazil. The vertical shot *In the Ministry of Health, Rio de Janeiro* from 1960, for example (p. 199). Or *Men on a Rooftop, São Paulo* from the same year (cover, pp. 192–3). Anyone who is even remotely interested in the history and aesthetics of photography knows these images. No published retrospective of Burri's work would be complete without them. We know them from postcards and posters, and they have frequently been used to announce highly regarded individual and group exhibitions. Along with a number of his other images, the Brazil photographs have become part of our collective consciousness.

But why exactly are these images so fascinating? What makes them so distinctive that they have become 'icons' of modernity? Perhaps it is because they convey a message that is universally accessible and, at the same time, very complex. Burri's images are strangely beautiful, shot with amazing artistry. They create a moment of surprise and tell a story, weaving an extraordinary web of contrasts and contradictions. Altogether, these elements create a tension that makes a photograph excellent as opposed to merely good.

'The room, with its criss-crossing shafts of light, becomes a stage,' Arthur Rüegg once said of Burri's *In the Ministry of Health*. 'Two women are walking across it with a clear sense of destination, their path marked by sunlight. Standing together in the shadows, three men have turned around and are gazing after them. It is woven metaphor for the opposite poles of man and woman, light and shadow, soft and hard, horizontal and vertical. It is a specific time and place, a moment injected with urgency and caught with unbelievable precision.' According to Rüegg, Burri is only satisfied 'when he truly succeeds in capturing the pulse of life'. Burri is a critical, political and always obsessive storyteller with a demanding eye.

Burri has very clear ideas about what constitutes a good photograph, but he also needs liberty of

movement, inspiration and a free hand when it comes to choosing his medium and techniques. Typically, Magnum photography is 'concerned photography' which entails being close to the action. It is hardly surprisingly that the wide-angle lens has become a hallmark of this type of photojournalism. Burri, however, has never been dogmatic. He shot his key work *Men on a Rooftop, São Paulo* from the top of an even higher neighbouring building, using a telephoto lens.

Burri has repeatedly received commissions to work in Brazil, a country that must have seemed an ideal place for him to search for the 'pulse of life'. He visited Brazil on his first trip to South America in 1958 and, by 1985, had returned to the country almost a dozen times. He photographed the city of São Paolo as part of a reportage for *Praline*, and in 1960 he reported for *Paris-Match* on the inauguration of Brasília (p. 8; pp. 206–9; p. 439, nos 2–4), a new city built from the ground up. Brasília was the chief vision of the democratically elected president Juscelino Kubitschek and, as *Paris-Match* put it, 'a daring endeavour'. Of course, it was also a utopia turned into reality, something that had always fascinated Burri.

In 1967 Burri returned to Brazil to report on Salvador da Bahia. By then the country had come under military rule. The architect Oscar Niemeyer, communist and creator (along with Lúcio Costa) of Brasília, had left the country to live in exile in France. Once again, Burri shot a large number of 'off-photos', as he called them, none of which was published. Today, almost four decades later, we have the opportunity to take another look at Burri's Brazil and discover it from an exciting new perspective.

» **Omnibus, Salvador da Bahia, 1958.** 'Three continents,' wrote author Hugo Loetscher, 'were necessary to produce the city: Portuguese Europe, black Africa, and the native Indians used South America as their stage.'

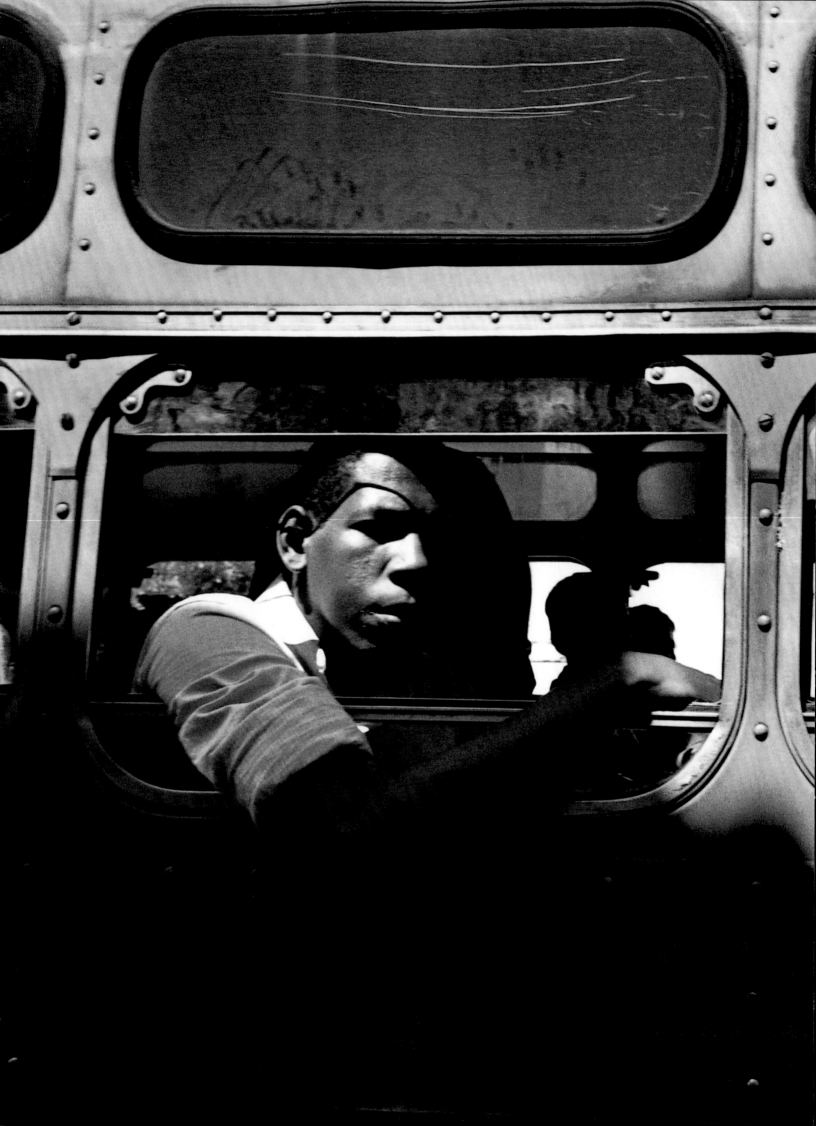

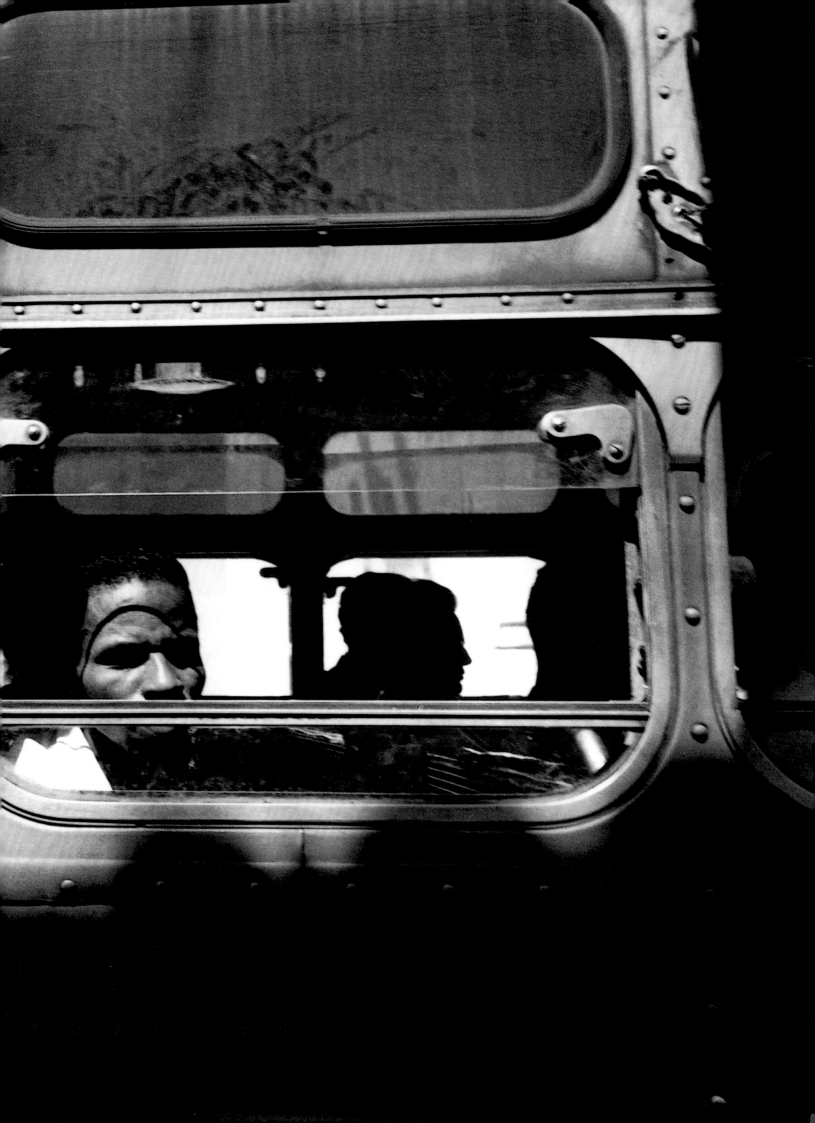

Traffic, São Paulo, 1960. A commission from the magazine *Praline* led Burri to São Paulo. There are several variants of this graphically composed picture.

198

In the Ministry of Health, Rio de Janeiro, 1960. Without question, one of Burri's best-known pictures – taken in the Ministry of Health, built between 1936 and 1945 by Oscar Niemeyer and Lúcio Costa in collaboration with Le Corbusier. It is remarkable not least because of its revolutionary columnar grid. The ribbons of light are caused by reflections from the surrounding buildings.

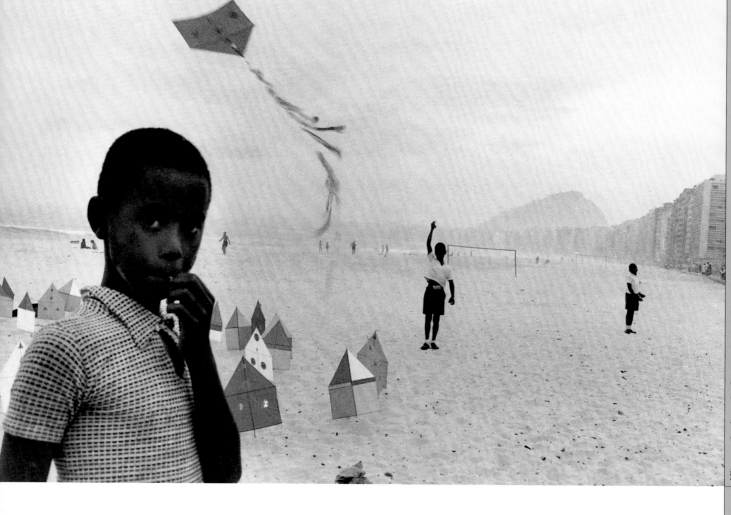

Kite on the beach, Copacabana, Rio de Janeiro, 1958. The beach, which stretches for miles, is the scene of all kinds of sports and leisure activities. Here we see an unusually hazy day, but at least it is still possible to fly a kite.

Working on the beach, Copacabana, Rio de Janeiro, 1958. Portuguese sailors first landed here in 1500. The city of Rio de Janeiro ('January River'), founded on the flat sandy beach by Estácio de Sá in 1565, gets its name from a nearby river and the month it was discovered. ≫ **Danusa Weiner, Copacabana, Rio de Janeiro, 1958.** The Brazilian model and actress on the beach.

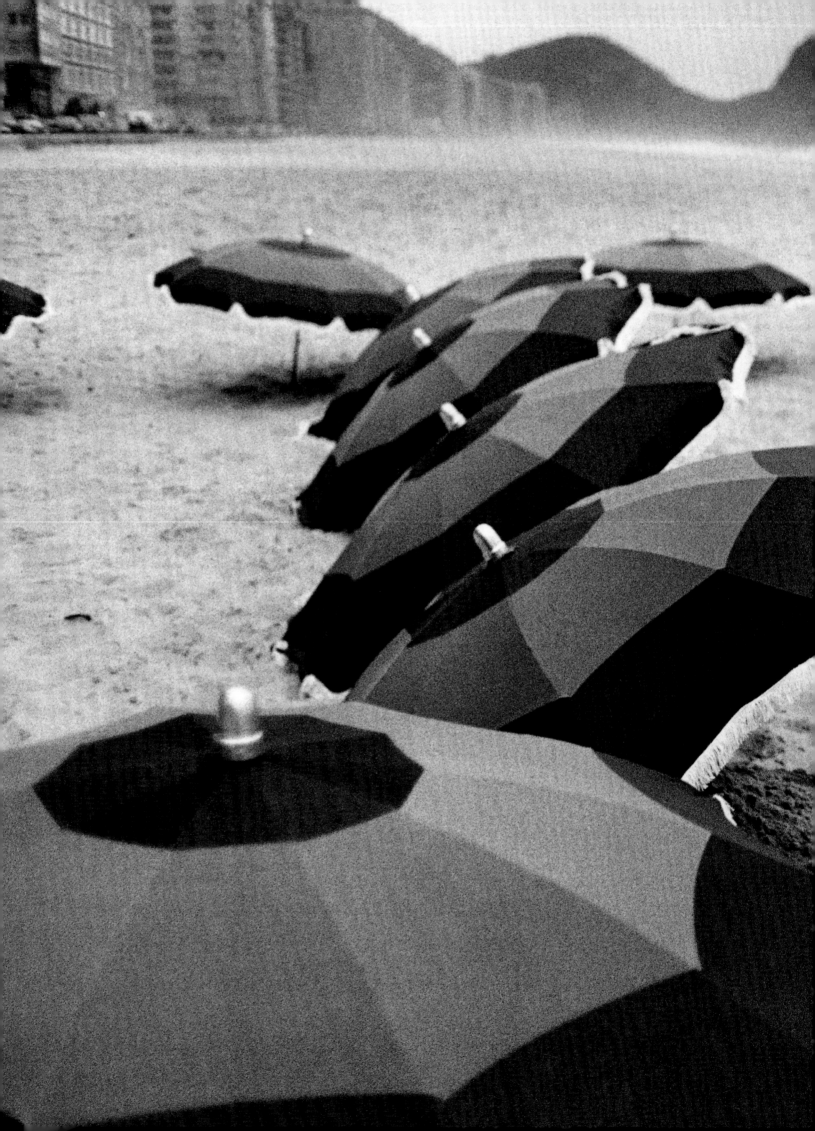

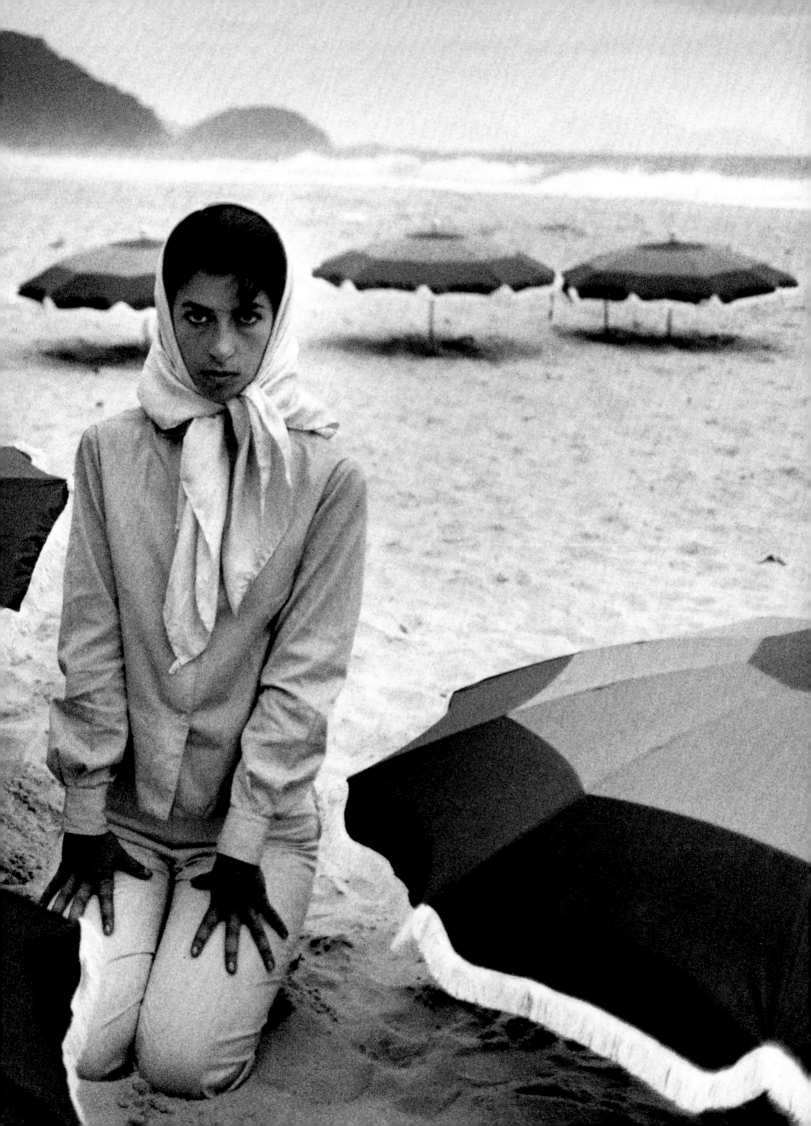

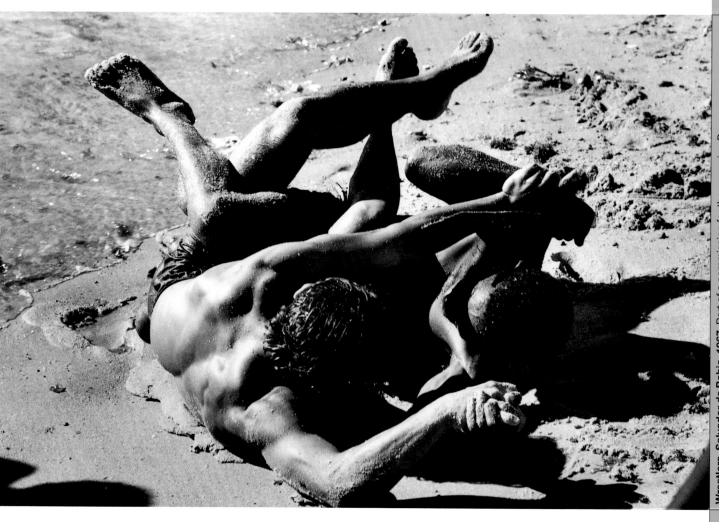

Wrestlers, Salvador da Bahia, 1967. Part of a commission for the magazine *Du*.

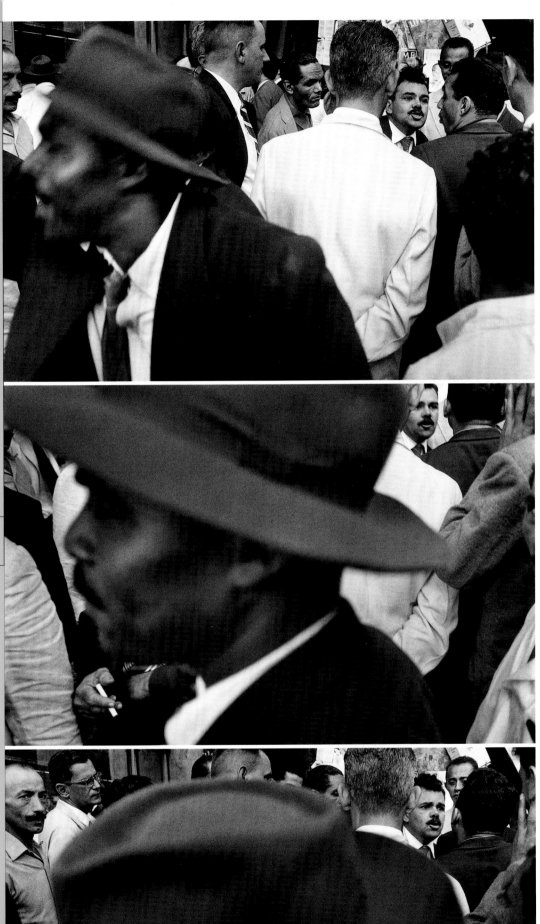

Crowd scene, Avenida Rio Branco, Rio de Janeiro, 1958. Burri sees Brazil as an archetypical society in which classes and ethnic groups mix together. Even clothing no longer functions as a status symbol or sign of belonging to a particular class.

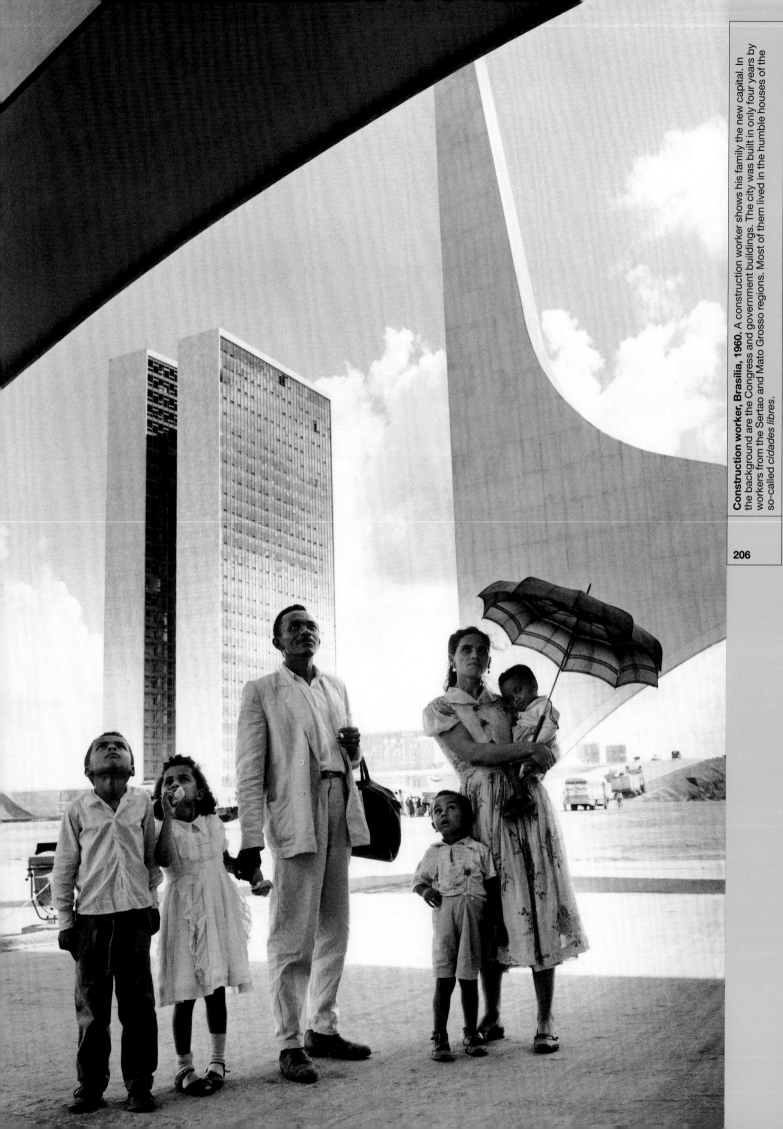

Construction worker, Brasília, 1960. A construction worker shows his family the new capital. In the background are the Congress and government buildings. The city was built in only four years by workers from the Sertao and Mato Grosso regions. Most of them lived in the humble houses of the so-called *cidades libres*.

Building site, Brasília, 1960. Ministries under construction.
≫ **Landscape, Brasília, 1960.** A utopia that became reality in four years on the Planalto, 1,000 km (620 miles) from Rio de Janeiro.

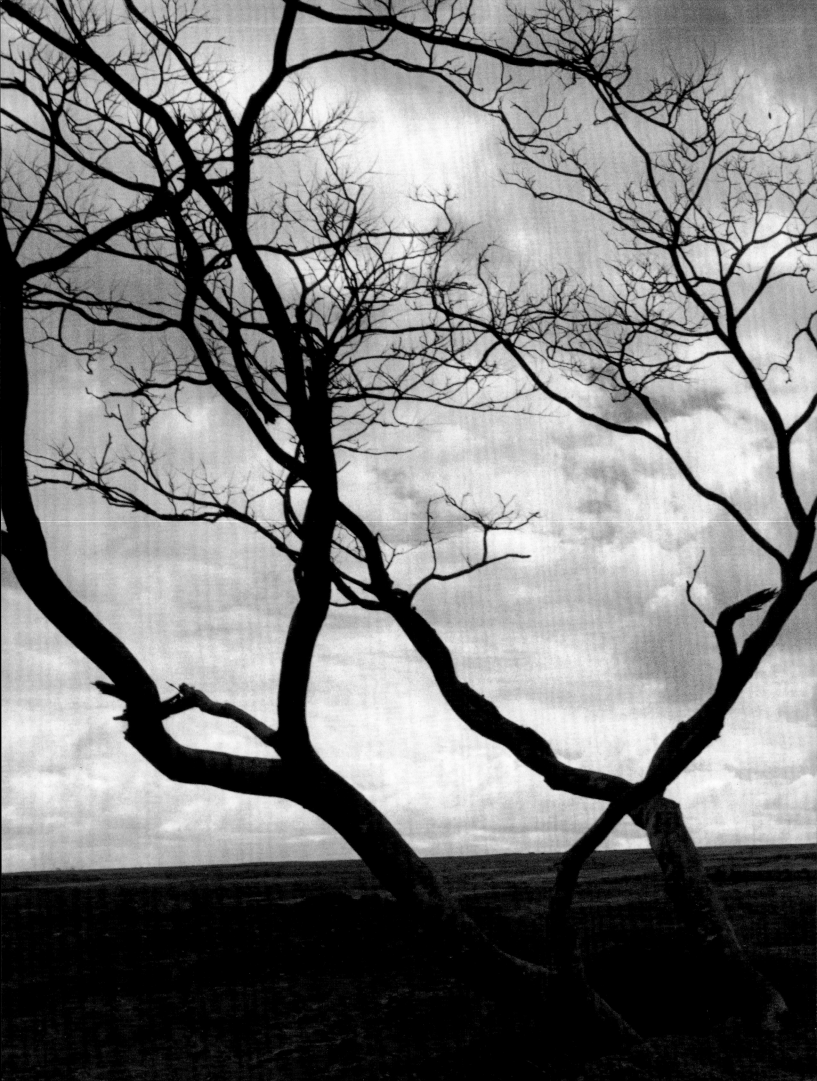

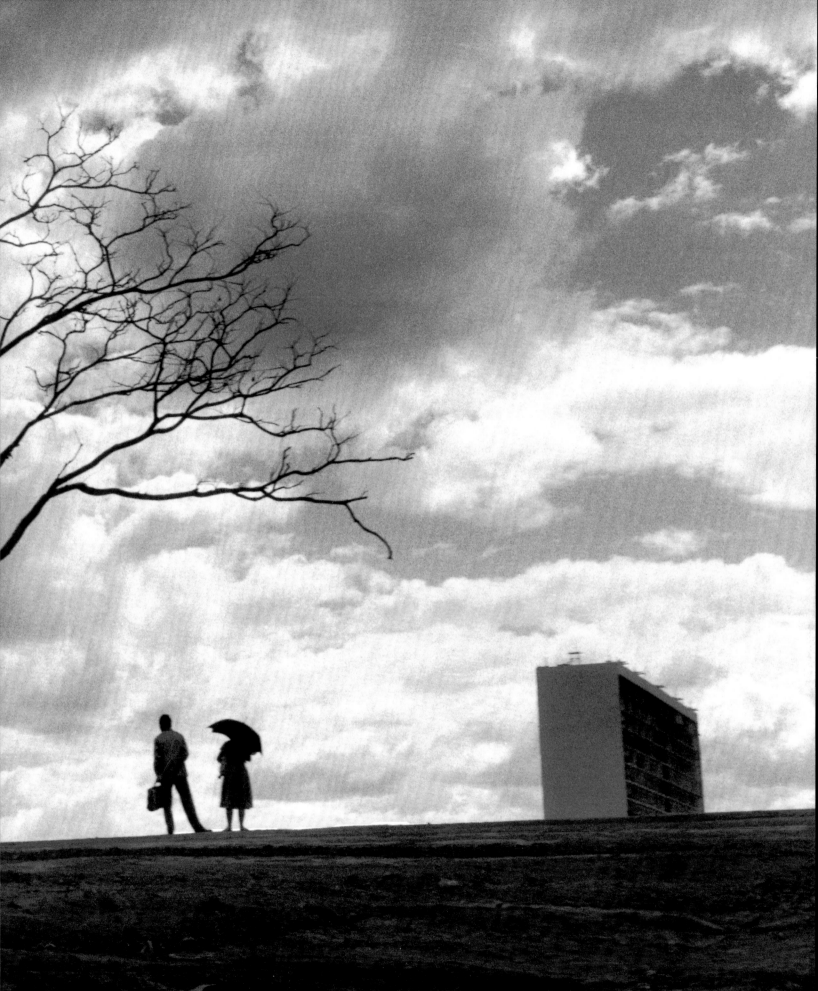

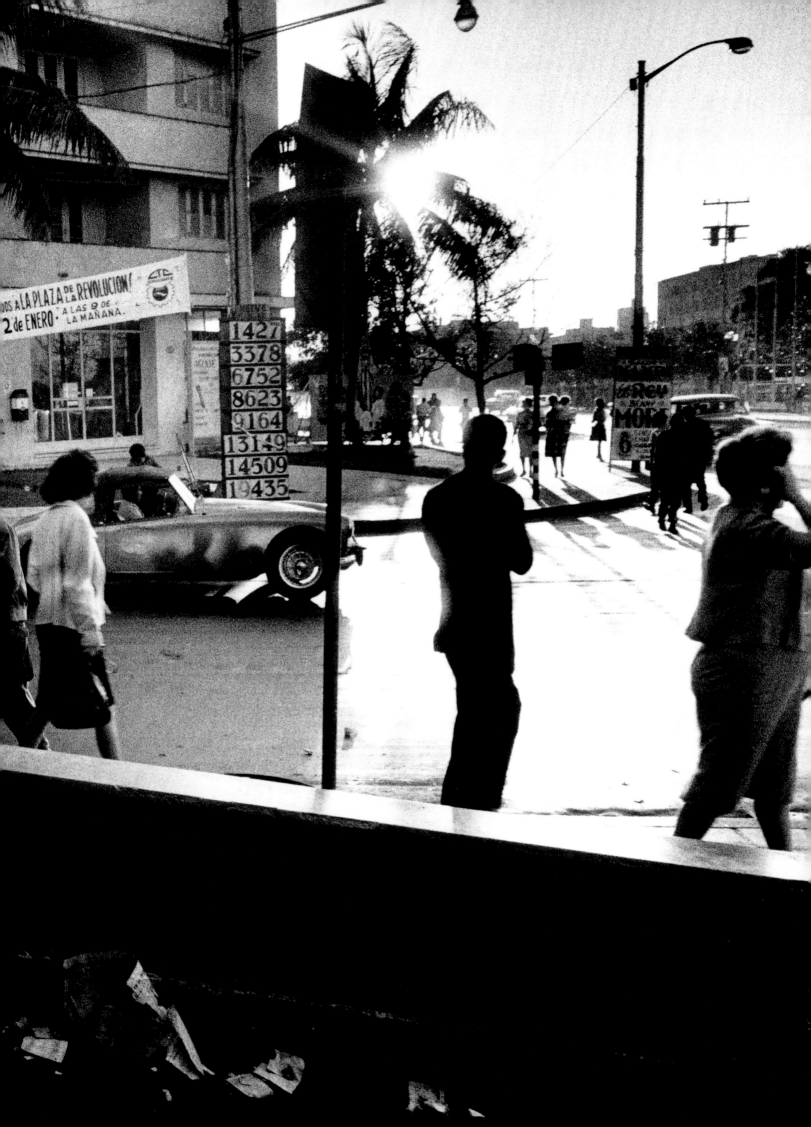

« La Rampa, Havana, 1963. The famous street. On the left, behind the car, is the exit from the former Hilton Hotel – which has been called the Havana Libre since the Revolution.

Cuba is a myth that constantly reinvents itself. The early 1960s were marked by the revolution of 1959, the proclamation of a socialist state in 1961, and the failed attack by exiled Cubans that has gone down in history as the 'Bay of Pigs'. Does anyone remember the domino theory? For the United States, Cuba was no longer a nuisance or provocation but had become a real and visible source of danger.

Not surprisingly, Cuba suddenly became a topic of intense media interest in the US, though the restrictive policies of Cuban officials towards Western journalists made it difficult to get an inside look. Thus it was a veritable coup for the American journalist Laura Berquist when Minister of Industry Che Guevara unexpectedly invited her to an interview. It was less than three months after the Cuban missile crisis. Burri, then thirty years old, was to accompany her.

The American magazine *Look*, the largest competitor to the legendary illustrated weekly *Life*, gave Burri the assignment. As always, Burri's Swiss nationality helped him navigate between the hardened front lines of diplomacy. There were, of course, no direct flights from the United States, so he took a Soviet Iljuschin, from Moscow, stopping in Prague. Burri arrived in Havana on 2 January 1963. In a taxi from the airport, he was already working, taking photographs of tanks returning from a military parade. Later Burri would observe life in the streets, accompany people during their leisure time, photograph a Soviet cosmonaut encircled by Young Pioneers and even see Fidel Castro himself speak.

Berquist's interview took place inside Ernesto 'Che' Guevara's offices. A look through the window would have revealed a peaceful scene of Havana rooftops. Che, however, demanded gruffly that the blinds remain pulled down. He appeared nervous. Burri would later describe him as a 'caged tiger'. With two Leica cameras and a Nikon, and using 35, 50 and 85 mm lenses, he went through eight rolls of film during the three-hour long interview. This would not be his only opportunity to photograph Che, however. A few days

later Burri encountered Che again at a celebration honouring outstanding workers. This time the revolutionary seemed much more cheerful and even winked at Burri. When the story appeared in the magazine the full frame image that has become the icon (pp. 226–7) was reproduced tightly cropped so only Che's head is visible (p. 442). The large, rectangular portrait of the confident Che has become a universal representation of the martyr, appearing on an ever-expanding wave of postcards, posters and book jackets.

Che Guevara made his last public appearance three weeks before Burri's photographs appeared in *Look* on 9 April 1963 (p. 442, nos 1–2). In November 1966 Che went underground and arrived in Bolivia under a false name. Less than a year later, in October 1967, he was taken captive in the jungle by the Bolivian military and executed.

≫ **Street vendor, Havana, 1963.** In the university area a street vendor sells portraits of Lenin and Fidel Castro.

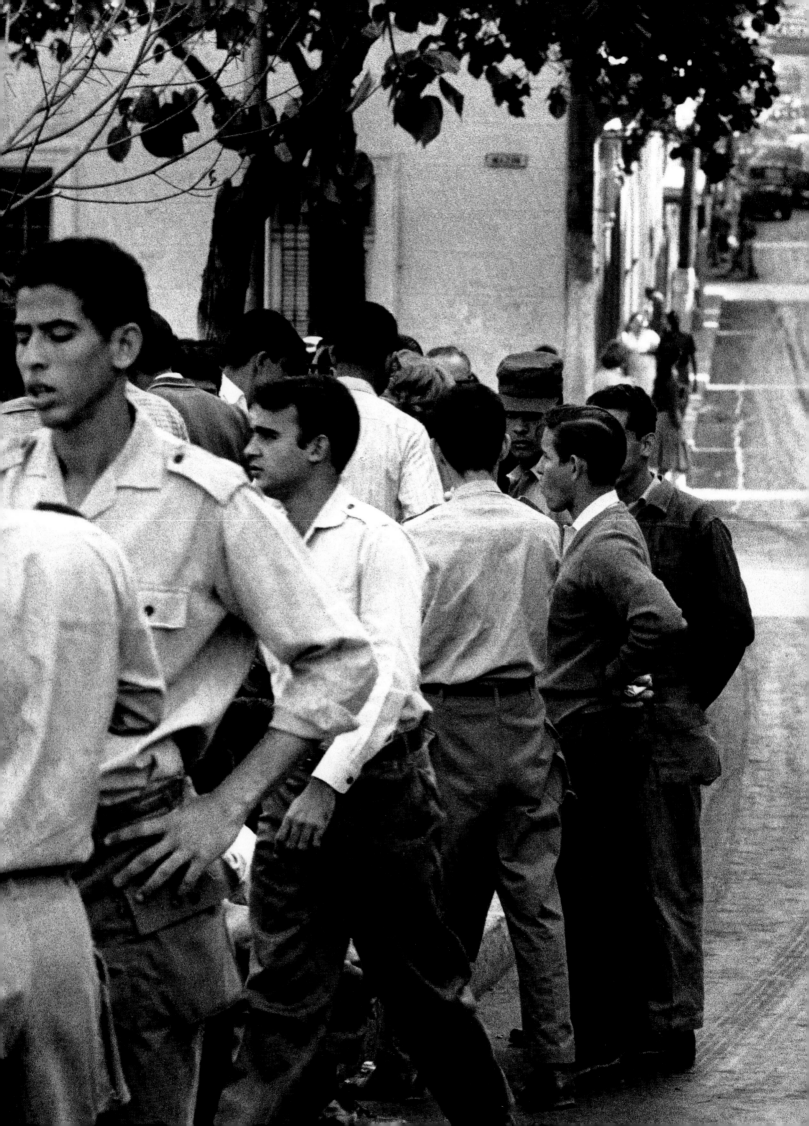

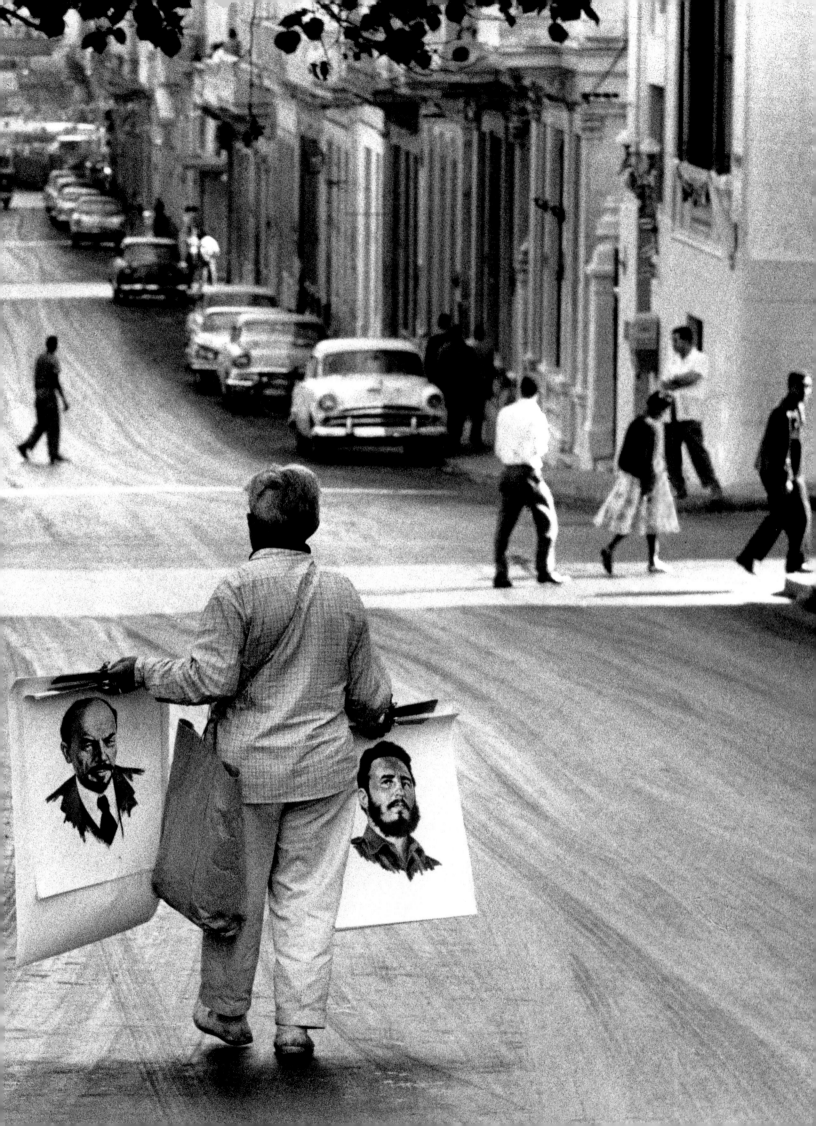

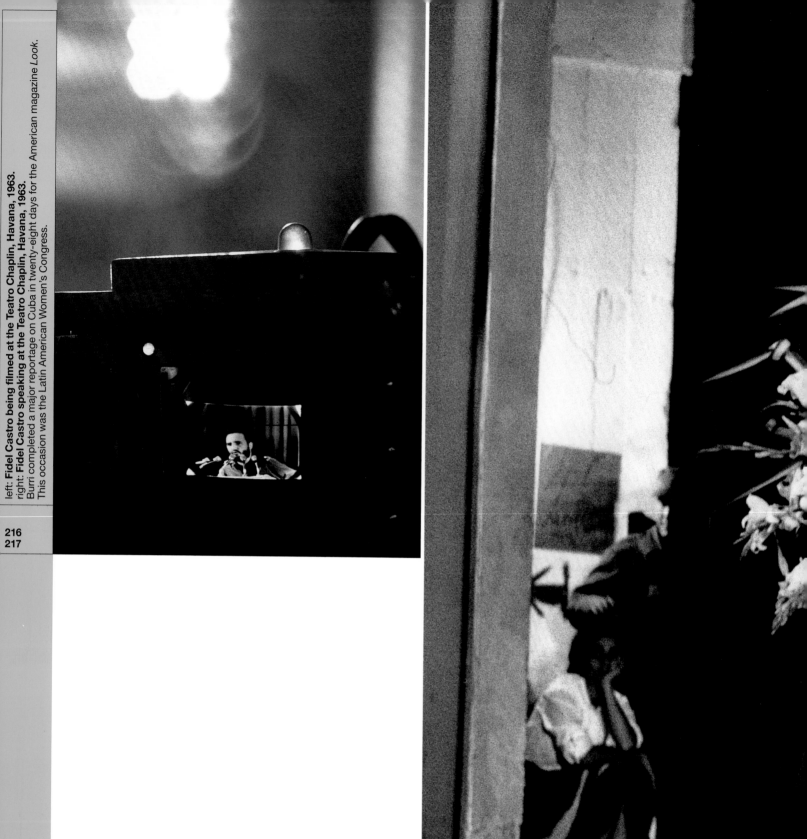

left: **Fidel Castro being filmed at the Teatro Chaplin, Havana, 1963.**
right: **Fidel Castro speaking at the Teatro Chaplin, Havana, 1963.**
Burri completed a major reportage on Cuba in twenty-eight days for the American magazine *Look*.
This occasion was the Latin American Women's Congress.

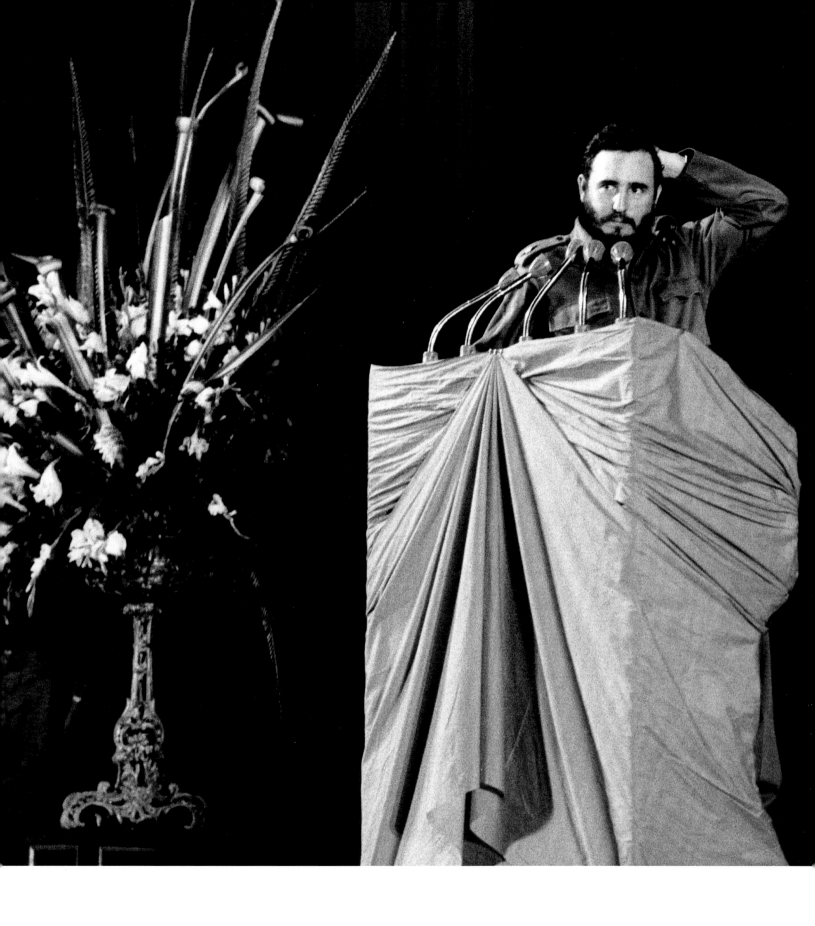

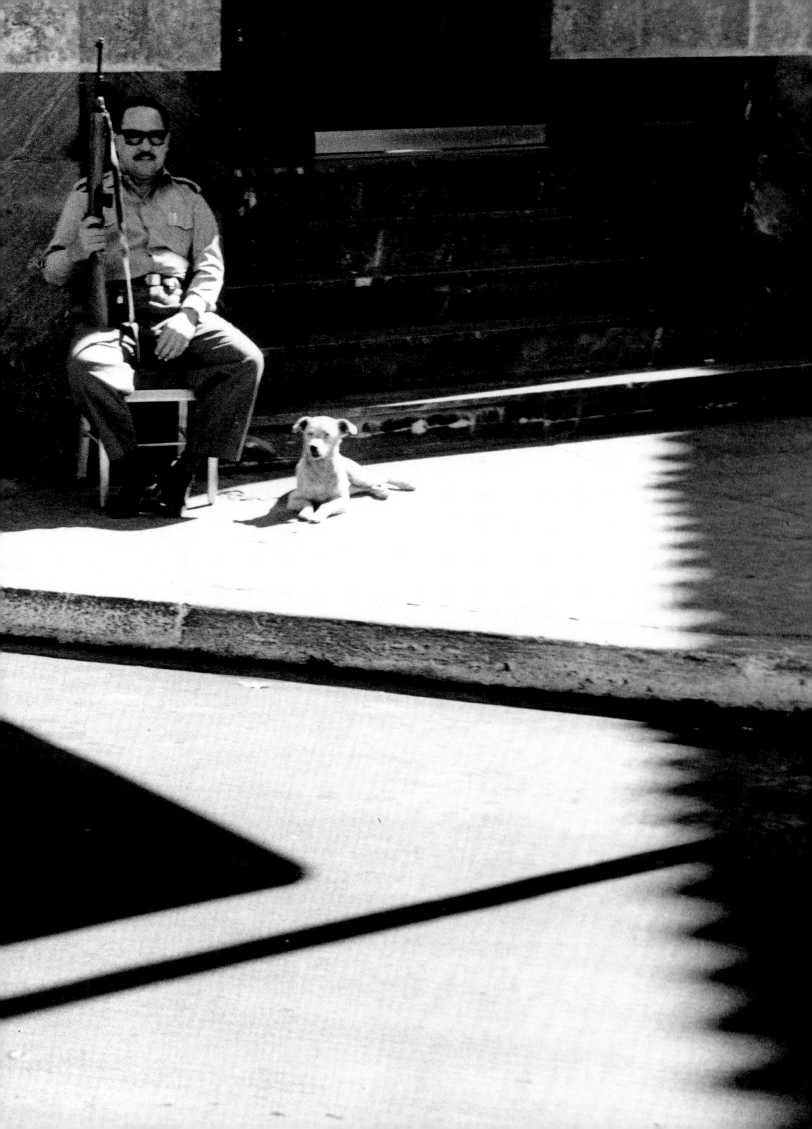

« **Militia guard, Havana, 1963.** The militia guard Cuba's public buildings just as they did before the Revolution.
Employees at the Banco Nacional, Havana, 1963. Employees of the former commercial bank hold a dance every Saturday. The entertainment shows some of the enthusiasm of the successful Revolution.

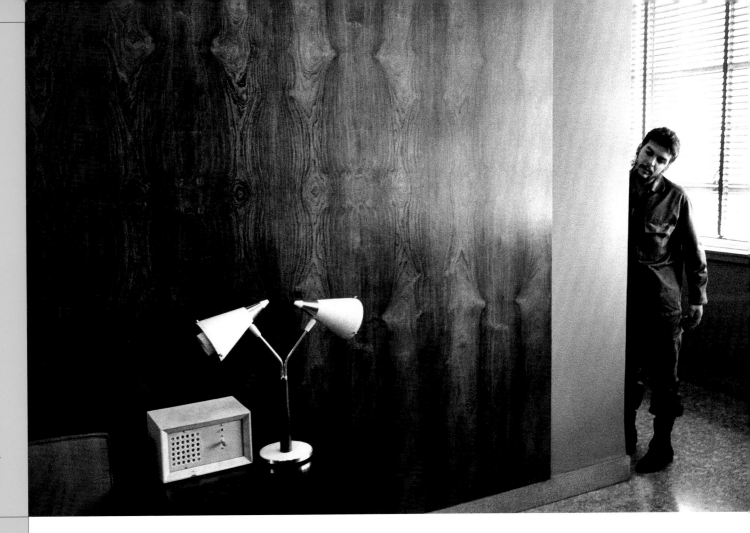

Che Guevara in the Ministry of Industry, Havana, 1963. The well-known journalist Laura Berquist asked the questions.

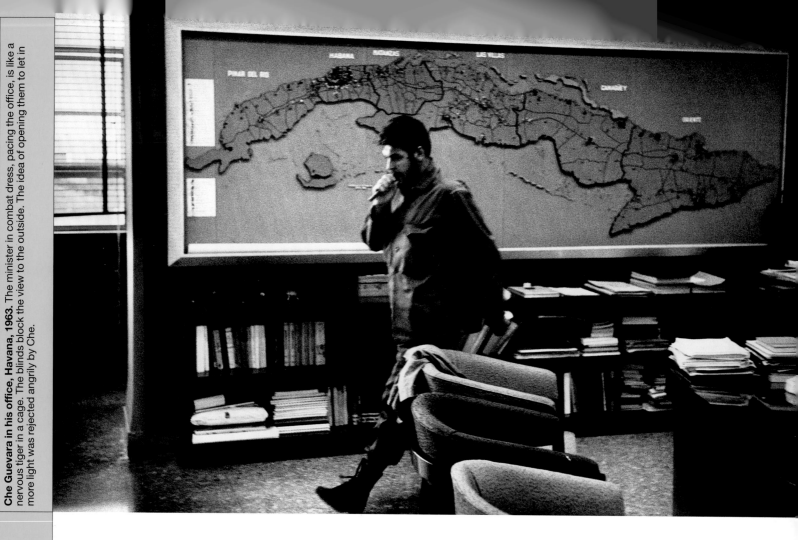

Che Guevara in his office, Havana, 1963. The minister in combat dress, pacing the office, is like a nervous tiger in a cage. The blinds block the view to the outside. The idea of opening them to let in more light was rejected angrily by Che.

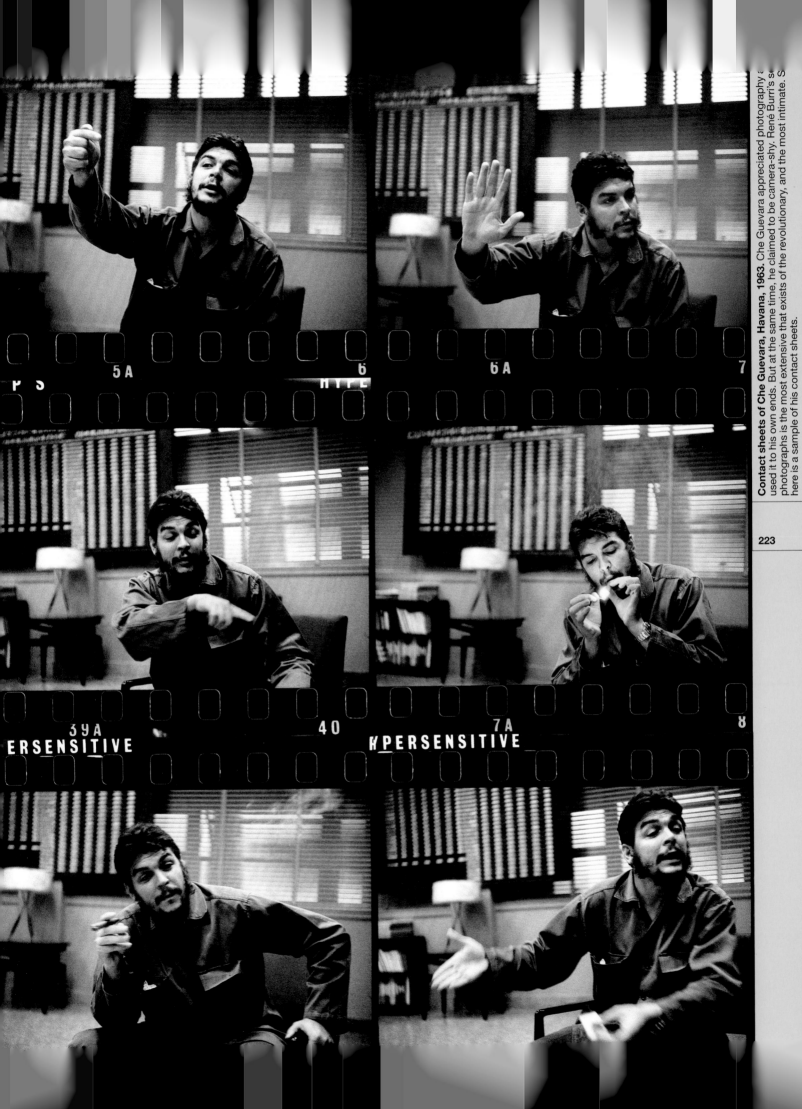

Contact sheets of Che Guevara, Havana, 1963. Che Guevara appreciated photography used it to his own ends. But at the same time, he claimed to be camera-shy. René Burri's photographs is the most extensive that exists of the revolutionary, and the most intimate. S here is a sample of his contact sheets.

223

P 5 5A 6 6A 7

39A 40 7A 8

ERSENSITIVE PERSENSITIVE

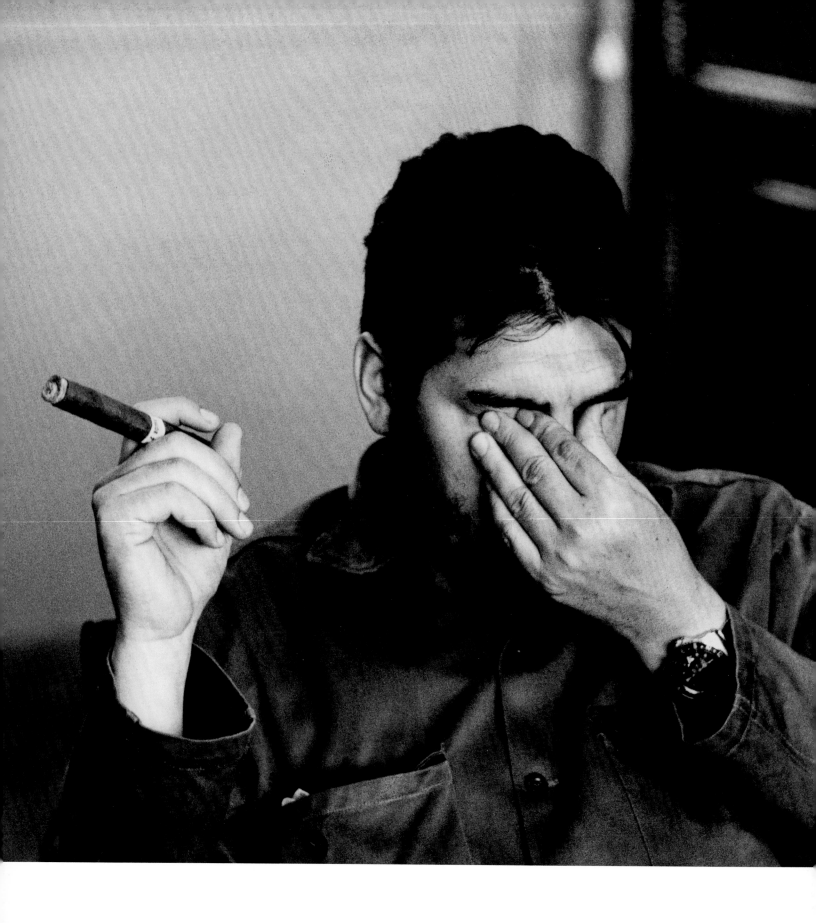

left: **Che Guevara holding cigar, Havana, 1963.**
right: **Che Guevara at work, Havana, 1963.** The interview is not least a battle of ideologies. Che, Minister for Industry, tries to convince his US interviewer of the successes of the Cuban revolution. The conversation is said to have lasted two whole hours.

Che Guevara, Havana, 1963. The icon: this picture appeared on p. 27 of *Look* (published 9 April 1963) in a very small format and severely cropped (p. 442)

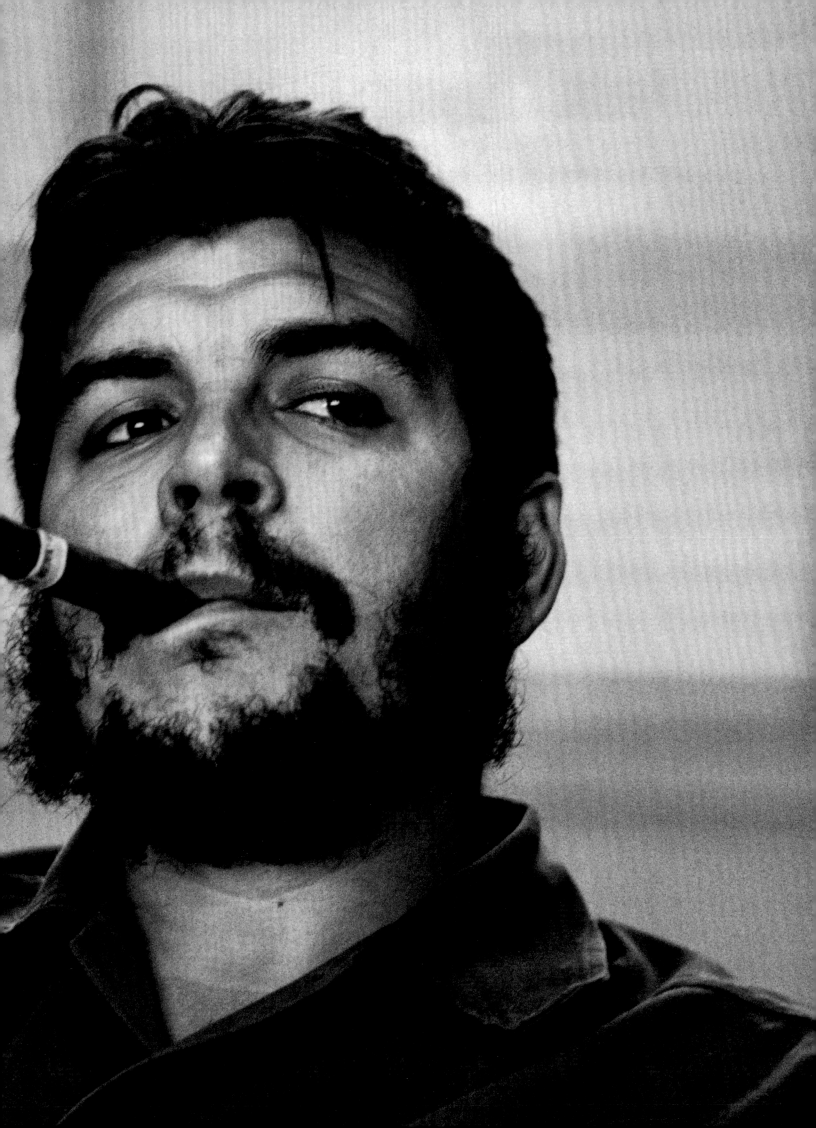

left: **Pavel Popovich with Young Pioneers, Havana, 1963.** Pavel Popovich was a Russian cosmonaut.
right: **Chernobyl victims, Havana, 1963.** Denis Fomin (eight) and Tichuk Slavik (nine), victims of the
Chernobyl accident, spent weeks receiving medical treatment in the Cuban seaside resort of Tarara.
Over 12,500 patients (11,000 children) were treated after the 1986 nuclear disaster at Castro's initiative.

Chess players, Havana, 1963. These men are playing chess in the former Spanish club, now transformed into a cultural centre.

Plaza José Martí, Havana, 1993. View of the plaza that was named after the poet and later national hero José Martí (1853–95).

top left: **Local, Trinidad, 1993.** A colonial atmosphere lingers on. Part of a reportage for *Du* magazine.
bottom left: **People driving, Malecón, Havana, 1993.** Young people enjoying their leisure time.
right: **At the beach, near Havana, 1993.** Sunday by the sea.
Burri took these pictures three decades after his first visit to Cuba.

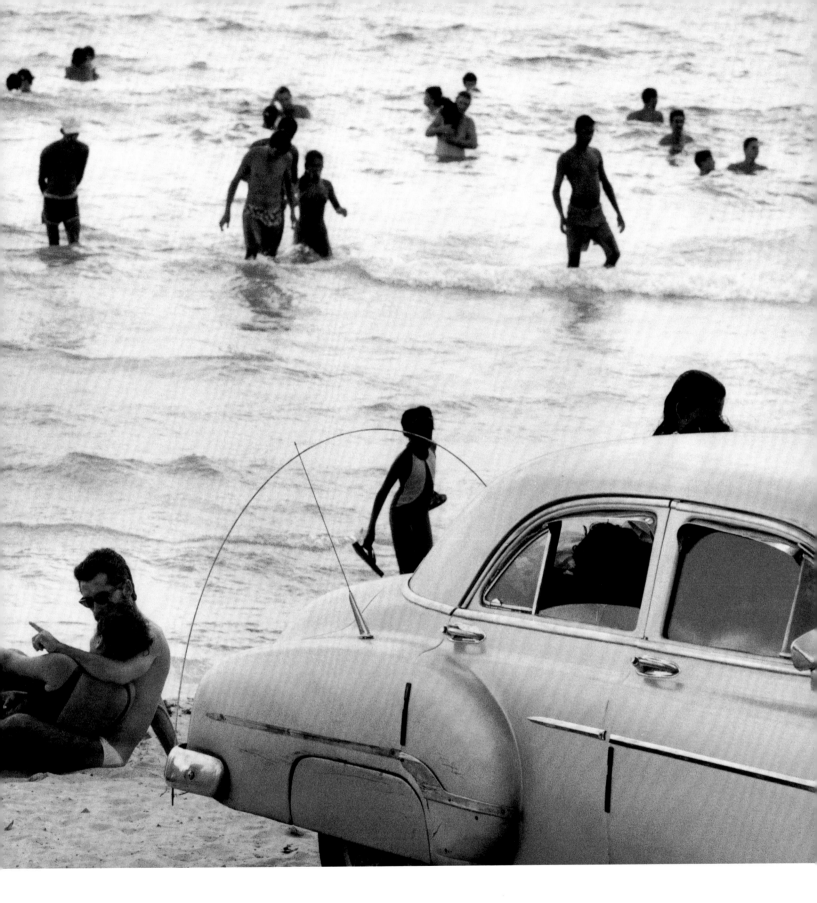

Dancers rehearsing, Havana, 1993. Girls from the nightclub rehearse their dance numbers on the terrace of the Hotel Inglaterra.

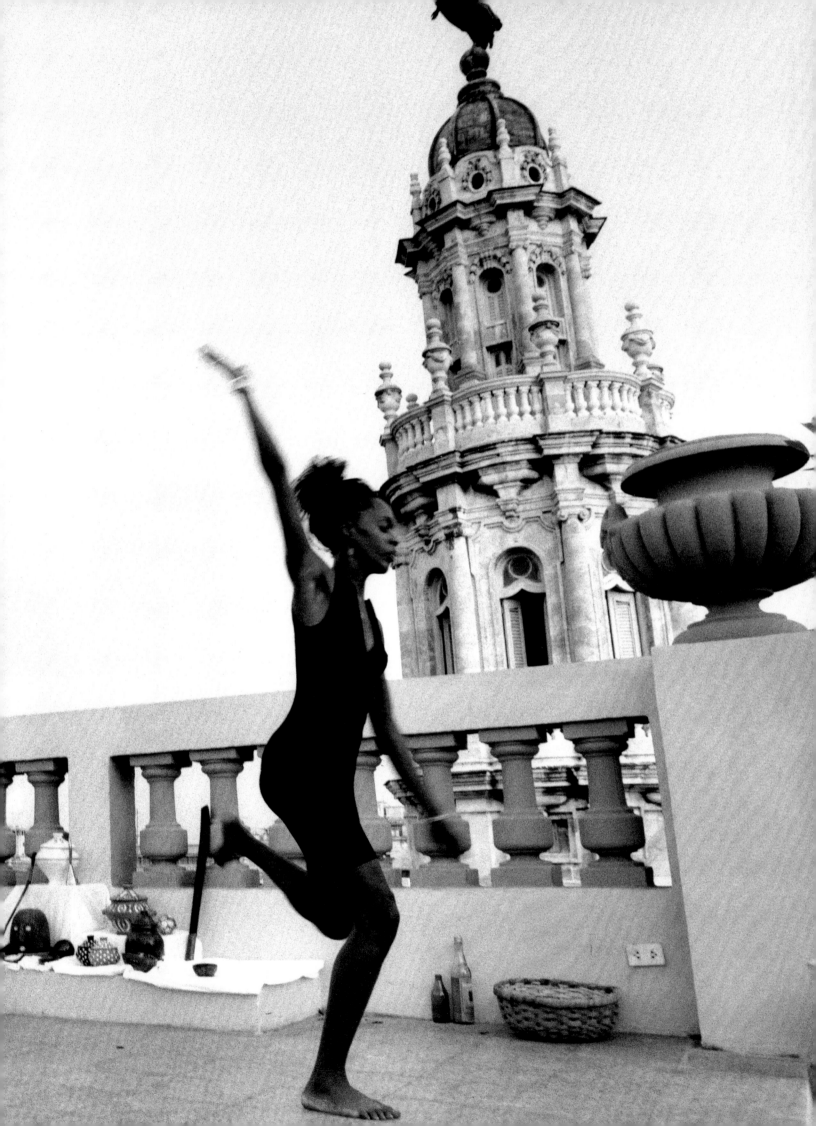

René Burri's examination of the United States spans decades. He took his first photographs of the US in 1959 while attending a meeting of Magnum members in New York. The country has remained a challenge for the photographer ever since. Burri's long and intense preoccupation with the US sets him apart from other photographers, such as Walker Evans (*American Photographs*, 1938) or Robert Frank (*Les Américains* [*The Americans*], 1958). Their works were created during a defined timespan, and were designed as programmatic statements, following the specific and restrictive logic of a precise plan. Burri's view of the US however has remained a work in progress, a large mosaic to which he has continually added new topics and impressions.

Although Burri has visited the US frequently and often stayed for long periods of time, he has never lived there and become a true American like his countryman Robert Frank. When Burri visits the US, he does so as an outsider – both in a geographic and a psychological sense. Burri sees everything with the alert eye of a foreigner. Even though the US space programme was in decline at the time, it is hard to imagine that an American could have looked at it and seen the 'ruins of the future' that Burri saw.

Burri has travelled to the US on countless occasions: sometimes to attend meetings at Magnum's New York office, opened in 1947 and the agency's most important bureau after the Paris headquarters; sometimes on industry commissions, such as his long-term assignment to illustrate the annual reports of Rank Xerox. Burri has also received a number of standard assignments, such as reporting along with other Magnum photographers for the funeral of John F. Kennedy in Washington, DC in 1963 (pp. 244–6).

It is typical of Burri that he always made use of these trips to take his own pictures – he never seems to have simply put away his camera after finishing his commissioned work. His most conducive working conditions were in 1971 when he spent several weeks in the US working on a special Chicago issue

for *Du* magazine, together with the writer Hugo Loetscher. Burri was left relatively free in his choice of topics and the artistic direction of the photographs. In an environment unrestrained by the high-pressure deadlines typical of the daily and weekly press, Burri was able to construct the type of ambitious photographic essay that is rare in today's media landscape.

His images of the US would be incomplete without the colour that imbues everyday American culture. They would also be incomplete without the portraits of American artists, writers and intellectuals, many of which were the product of chance encounters. Chance also led to Burri's photo series *Blackout* from 1965. He was cutting his film on China in Elliott Erwitt's New York studio when the power suddenly went out. Burri instinctively grabbed his camera and went out into the black streets to do the virtually impossible: to photograph a city without light. The metropolis was dark, but by no means chaotic, and the streets remained calm except for the burning newspapers and telephone books that had been turned into makeshift torches. The effect was surreal. This became a remarkable series of photographs, an example of which is published here for the first time (p. 28). It is a photo essay in the tradition of the avant-garde dedicated to expanding our view and extending our limits of perception.

Statue of Liberty, New York, 1959. This photograph was taken from a helicopter over Manhattan. Burri was travelling with Bruce Davidson who was shooting a Smirnoff ad.

Newlyweds, New York, 1959. Driving down Broadway.

left: **Times Square, New York, 1959.**
right: **Tepee, New Mexico, 1967.** A traditional tepee (although this one is made out of concrete) on Route 40 acts as a sign for an Indian supermarket called Outpost.

242
243

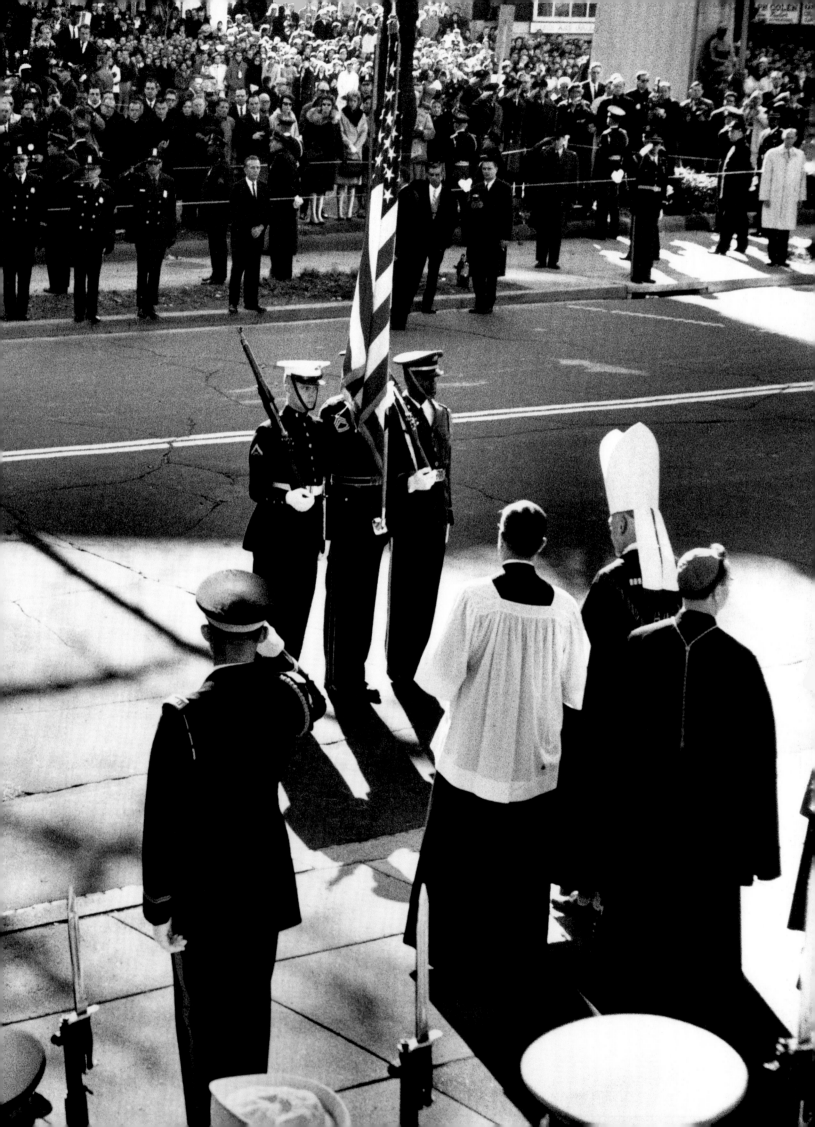

« **John F. Kennedy's funeral, Washington, 1963.** A national day of mourning for the assassinated thirty-fifth president of the United States of America, John Fitzgerald Kennedy. **Mourners, Washington, 1963.** Memorial service for John F. Kennedy.

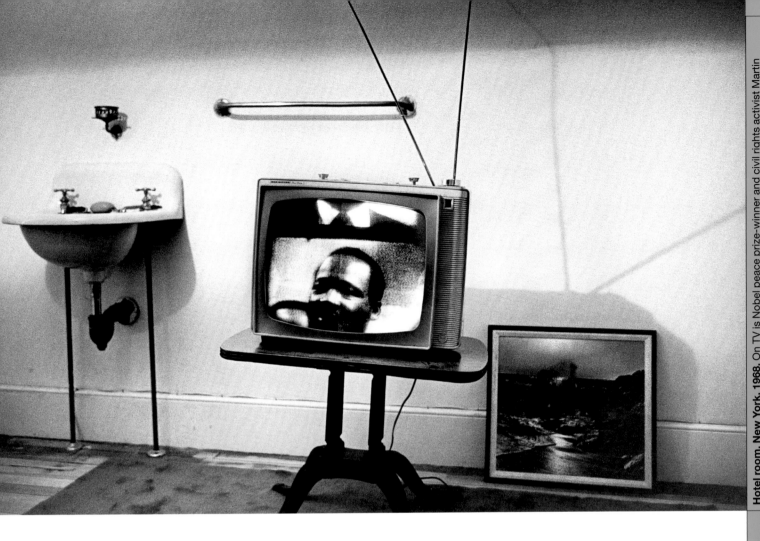

Hotel room, New York, 1968. On TV is Nobel peace prize-winner and civil rights activist Martin Luther King, assassinated in 1968.
≫ **Parade, New York, 1974.** Italians parade on Fifth Avenue.

247

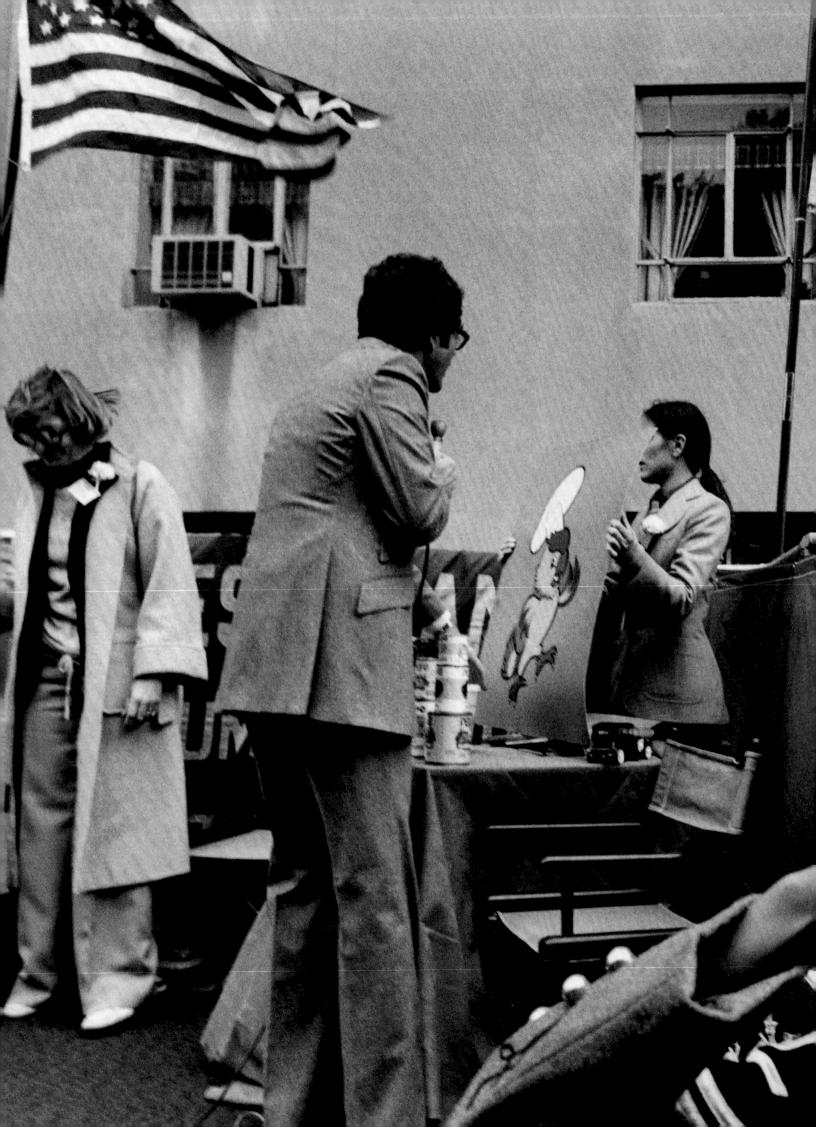

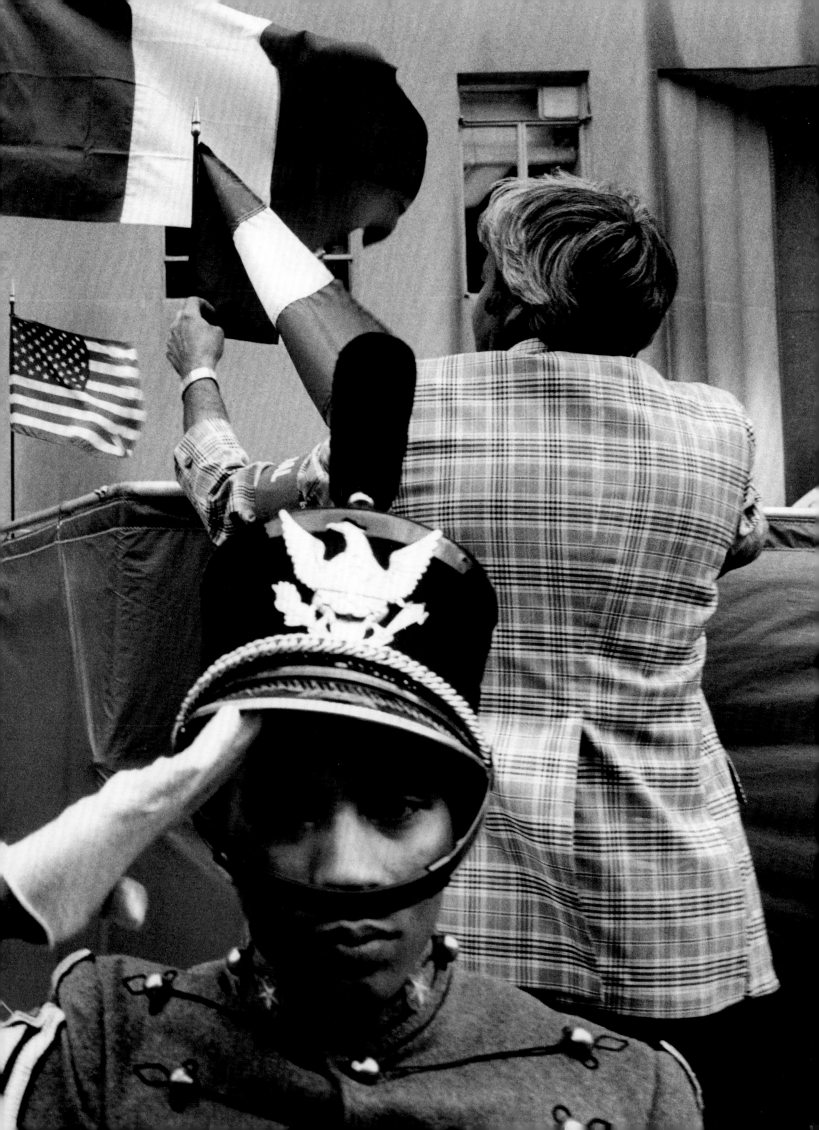

→ 6A

→ 7

→ 7A

→ 8 F

→ 12A

→ 13

→ 13A

→ 14

→ 18A

→ 19

→ 19A

→ 20

With the advent of space travel in the 1960s, one of the great dreams of humankind had become a reality. Or had reality become a dream? Shifting the public's gaze to the night sky was an excellent way of distracting it from the crises and conflicts on the ground. Did anyone think of physicist Max Born's sceptical words when they saw the television images of Neil Armstrong taking his first steps on the moon in 1969? Born had asserted to journalist William Hines that he belonged to a generation that still differentiated between intellect and reason: 'Intellect distinguishes between the possible and the impossible; reason distinguishes between the sensible and the senseless. Space flight is a triumph of intellect and a tragic failure of reason.' He felt that, however interesting it might be to put men on the moon, it was a huge distraction from what needed to be done for people here on earth. Indeed, space travel would become a race for military dominance between the superpowers, with little tangible benefit for the people involved.

In the United States, Dwight D. Eisenhower authorized the 'development of small, unmanned satellites' in 1957 and 1958. This was the beginning of what became known as the 'space race'. In 1961 the Russian astronaut Yuri Gagarin successfully orbited the earth and opened up the era of manned space travel. Shortly thereafter, the US instituted the ambitious Apollo programme and sent a message to the world: US astronauts would set foot on the moon by the end of the decade. The US president John F. Kennedy said that the time had come for the American people to climb to the top of the mountain, to regain strength, to become enthusiastic about those distant summits that make up the nation's destiny and feed the American dream.

Burri's own trip into space was less melodramatic. It began on the film screen. In the early 1940s he became enchanted with George Méliès's film classic *A Trip to the Moon* shown at the Zurich Fip-Fop Club. He was an avid reader of Jules Verne. And, though he should have stayed in the air-raid shelter with his parents, he would

often go to the rooftop of their home in Zurich to watch Swiss fighter planes force Allied bombers to land when they strayed into Swiss airspace. Thus Burri was introduced to aviation and space travel by the war and the cinema. An introduction not all that different from what the US space missions really were: prestige projects backed by military interests and, in an era of television, public entertainment.

In 1969 he saw the moon landing on television. Later an industry assignment brought the photographer to Cape Canaveral in Florida where he was allowed to photograph the rusting relics of the Apollo programme. Rolf Gillhausen published the story in *Stern*. The magazine presented a portfolio with the title 'Frittered Away', asking the legitimate question, 'What conclusion will future archaeologists draw from the billions of dollars worth of rocket debris that litters our earth?' Ten years later in 1979, Burri created a reportage on the twelve Apollo astronauts for *Life*. A few years later, he would track the early days of the space shuttle Columbia (p. 447, nos 1–2).

Burri's photo essays were published in *Life*, *Stern* and *Transatlantik* as documents of an absurd faith in progress. On 10 February 2003 after the tragic loss of a second space shuttle, *Time* magazine printed a picture of the Columbia taken by Burri in 1981. In the commentary, Gregg Easterbrook wrote that 'the Space Shuttle must be stopped,' rearticulating what William Hines had stated earlier: the Columbia 'was a failure before it even took off in April 1981'. Burri's colour photograph of the Columbia prior to its launch accompanies these words, only this time, the image is no larger than a matchbox. What could have better illustrated the parallel decline of space travel and the great magazines?

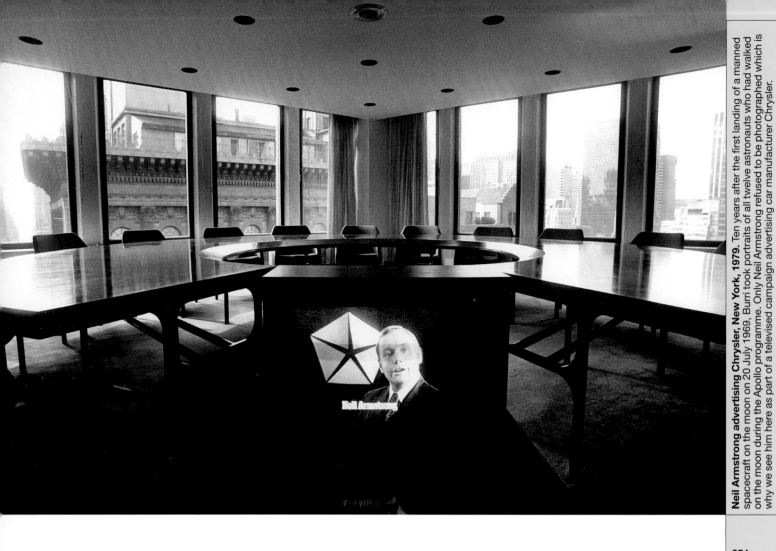

Neil Armstrong advertising Chrysler, New York, 1979. Ten years after the first landing of a manned spacecraft on the moon on 20 July 1969, Burri took portraits of all twelve astronauts who had walked on the moon during the Apollo programme. Only Neil Armstrong refused to be photographed which is why we see him here as part of a televised campaign advertising car manufacturer Chrysler.

Space Shuttle Columbia, Cape Canaveral, 1979. Columbia is brought from the Vehicle Assembly Building (VAB) to the launch pad on a 'Crawler'. This 5.5 kilometre (3 $\frac{1}{2}$ mile) journey takes seven hours. » **Birds in flight, Cape Canaveral, 1978.** After the lift-off of Space Shuttle Columbia. The Cape Canaveral space centre is located in the middle of a wildlife reserve and air force base.

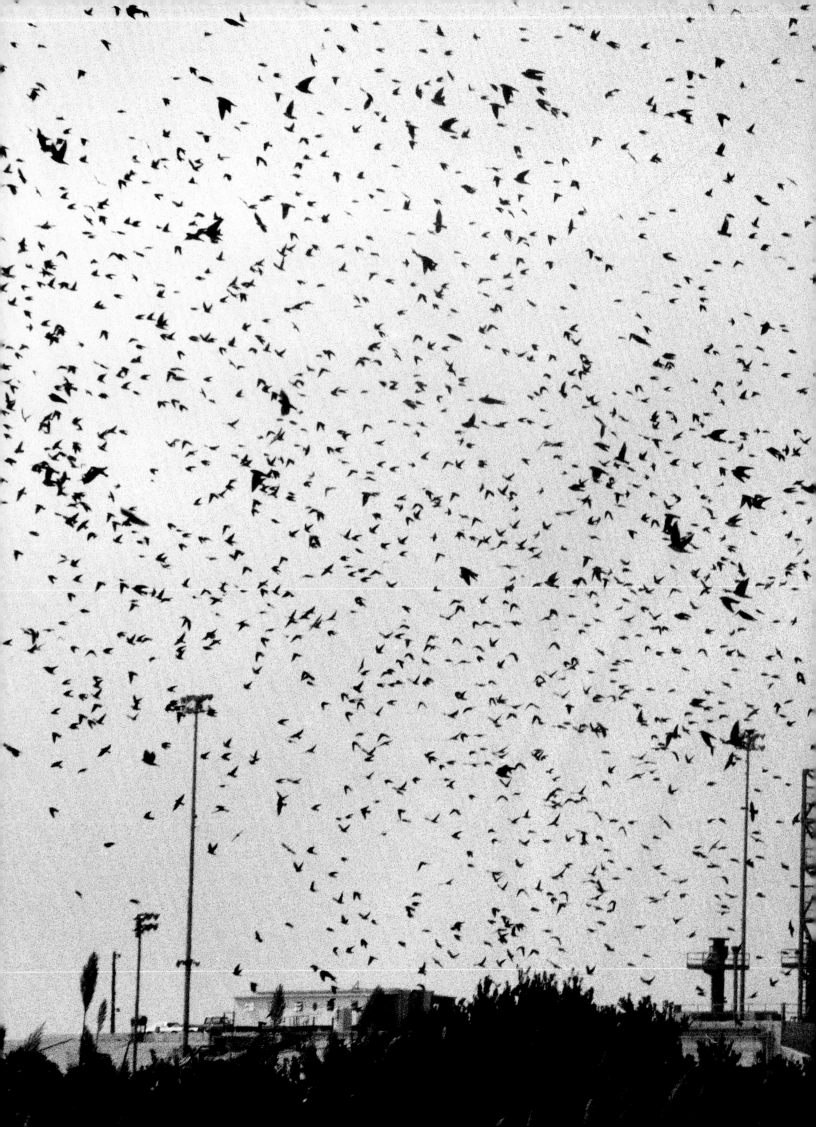

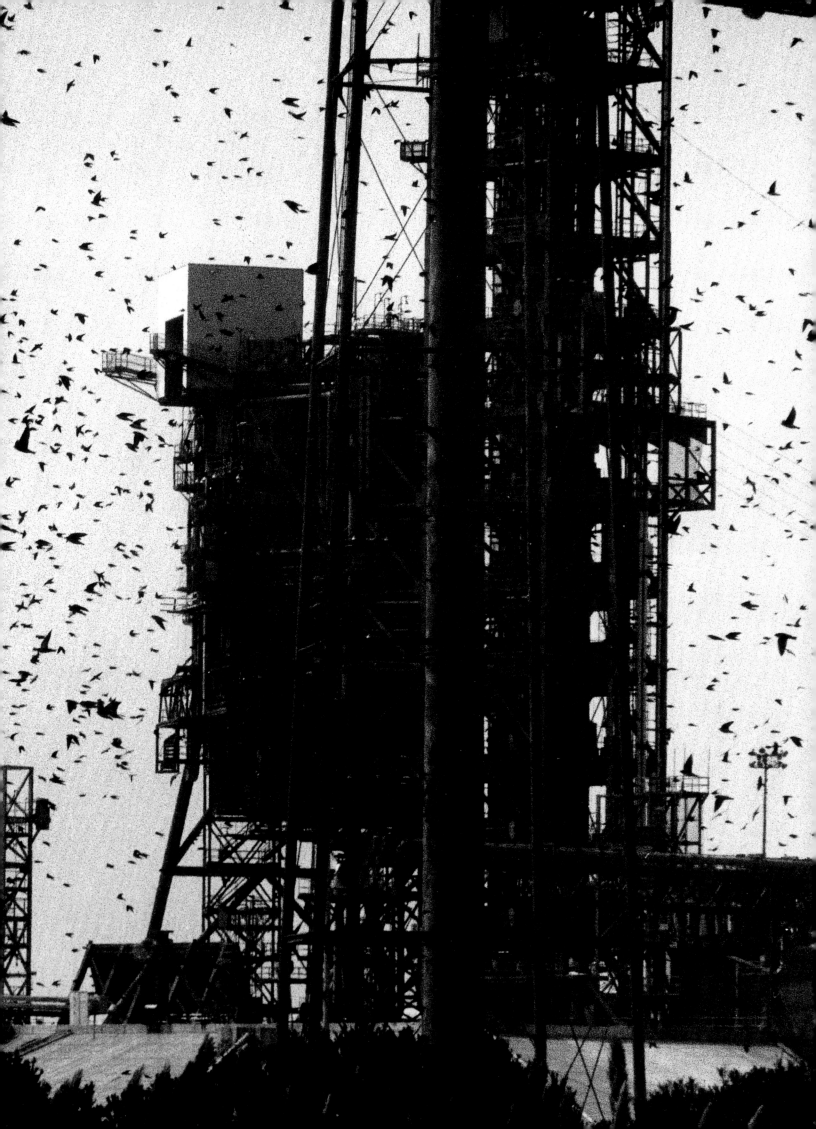

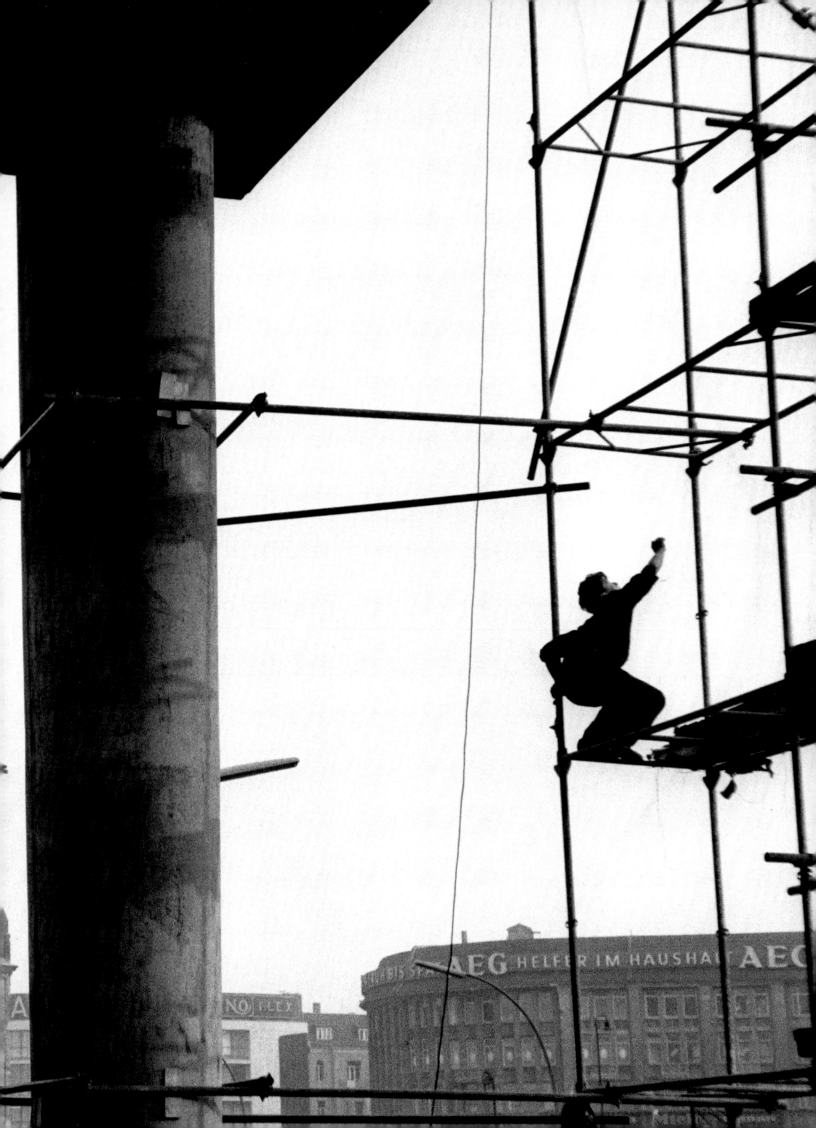

« **Kaiser Wilhelm Memorial Church, Berlin, 1959.** It was not until the early 1960s that the war-damaged ruins of this nineteenth-century church in the middle of Berlin were complemented by architect Egon Eiermann's modern addition. Located near the Zoologischer Garten station, the architectural ensemble is viewed today as a warning against war and violence.

René Burri's attitude towards Germany and its people is ambivalent. German is his native language. His mother was from Freiburg, although after moving to Switzerland as a young woman she learned Swiss German very quickly to avoid standing out. In the Zurich of the late 1940s and early 1950s, German was the language of the stage, and Burri was an enthusiastic theatre-goer. German was also the language of the young generation of poets and writers who formed the legendary Group 47. The teenage Burri quickly recognized their works for what they were: the first modern, relevant writing in an idiom that could be understood without having to refer to a dictionary.

But German had a darker reputation as the language of the soldiers, murderers and criminals who lived just beyond the border – a border that was threateningly close during the war years. Burri loved the Italians and their easy way of living; he held in high regard the French and their self-assured nonchalance. However, the Germans possessed an absolute fascination for him. They were a people that had not become a nation until the latter part of the nineteenth century – and had done so through war. Now, in the years following World War II, they were confronted with the ruins of their country. René Burri began to take photographs.

Burri took his first pictures in war-torn Munich and the ruins of Ulm while on a cycling tour of southern Germany in the early 1950s. Later, while on commission for *Bunte Illustrierte*, he would find opportunities to work on his very personal and ambitious photo essay. He was drawn to the contrasting elements of Germany and the way the war had thrown into relief pre-existing divisions and boundaries.

It was with this in mind that he began to photograph both West and East Germany in the mid-1950s. He captured city and countryside. He photographed young and old, the past and present, work and play, the privileged and impoverished, love and death, memories of the past and hope for the future. He photographed the old and the new Germany. Burri

looked around him and documented what he saw, bequeathing the complex results to future generations. But the content presents only one side of the story. The formal qualities of his work should not be ignored. His compositions are less radical than those of Robert Frank, who sometimes conveys the impression that the US was simply a vehicle in his search for a new and revolutionary visual language. Burri remains, for the most part, a journalist and follower of his teacher Hans Finsler, who taught Burri a deliberateness and mastery of composition that was more indebted to reason than emotions. When the first edition of Burri's book *Die Deutschen* was published in 1962, it was met with lukewarm reviews – although one French critic did herald the book as 'a remarkably illuminating description of Germany today'. Most critics, however, failed to look beyond their first impressions of René Burri's grey photographs, dismissing them as unnecessarily ugly.

Since then the book has evolved through revised and expanded editions published in 1986, 1989 and 1999. It is, without question, the most important and cohesive work of Burri's distinguished career, and Germany remains a subject of great interest to the photographer.

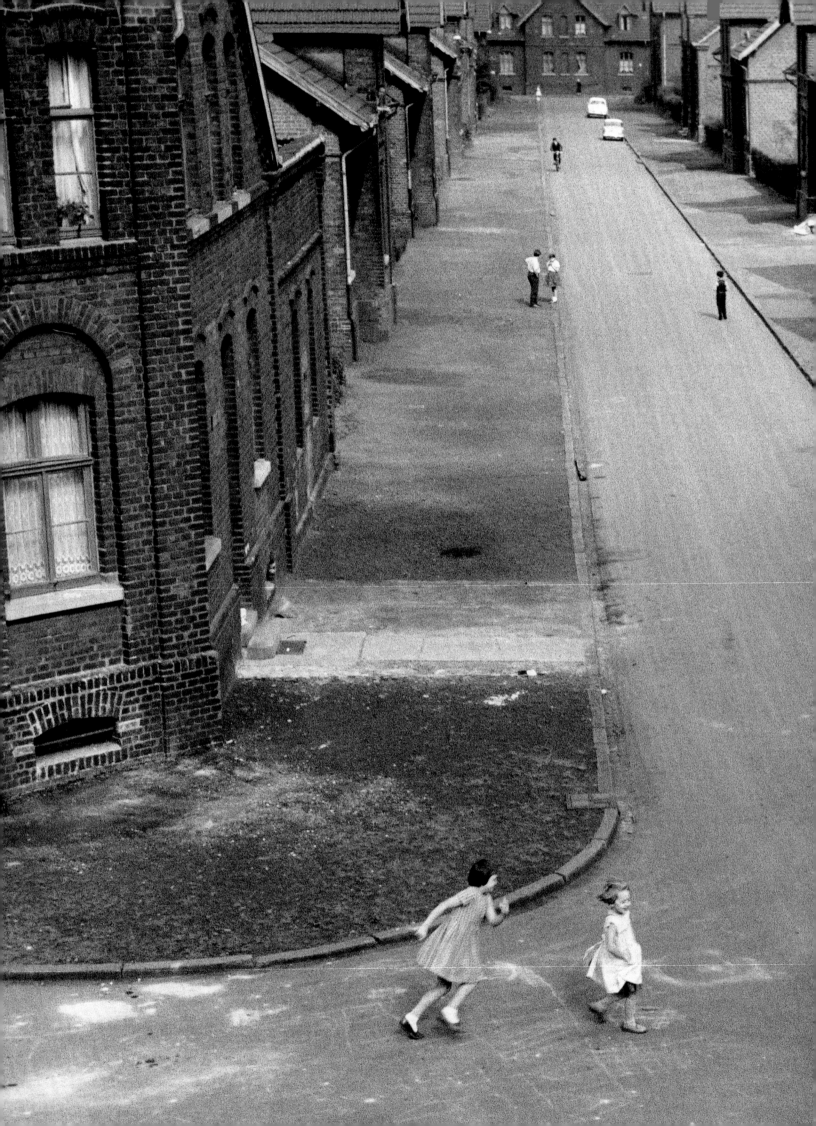

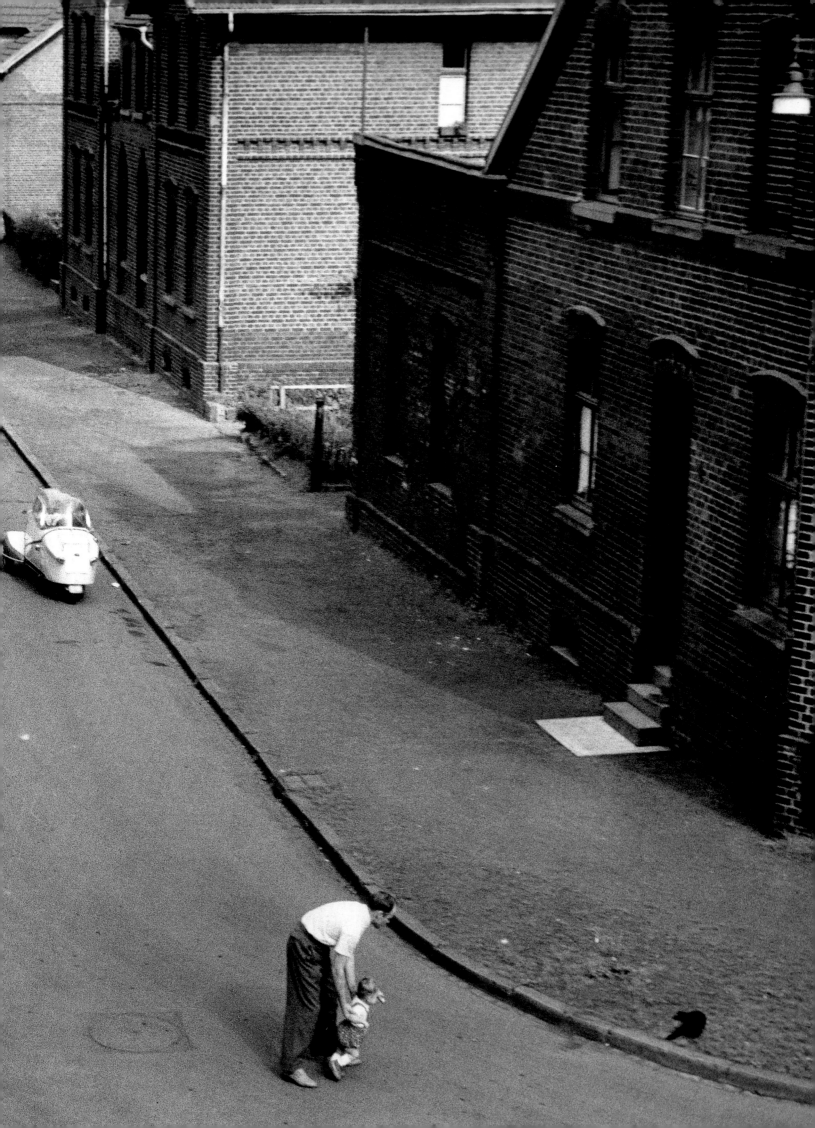

Interbau, Berlin, 1957. *Interbau* was an international building exhibition that took place in Berlin in 1957. Leading international architects worked on the Hansaviertel district at the invitation of the Berlin senate. Oscar Niemeyer and Le Corbusier were among those who were involved, although their plans were only built in a modified form.

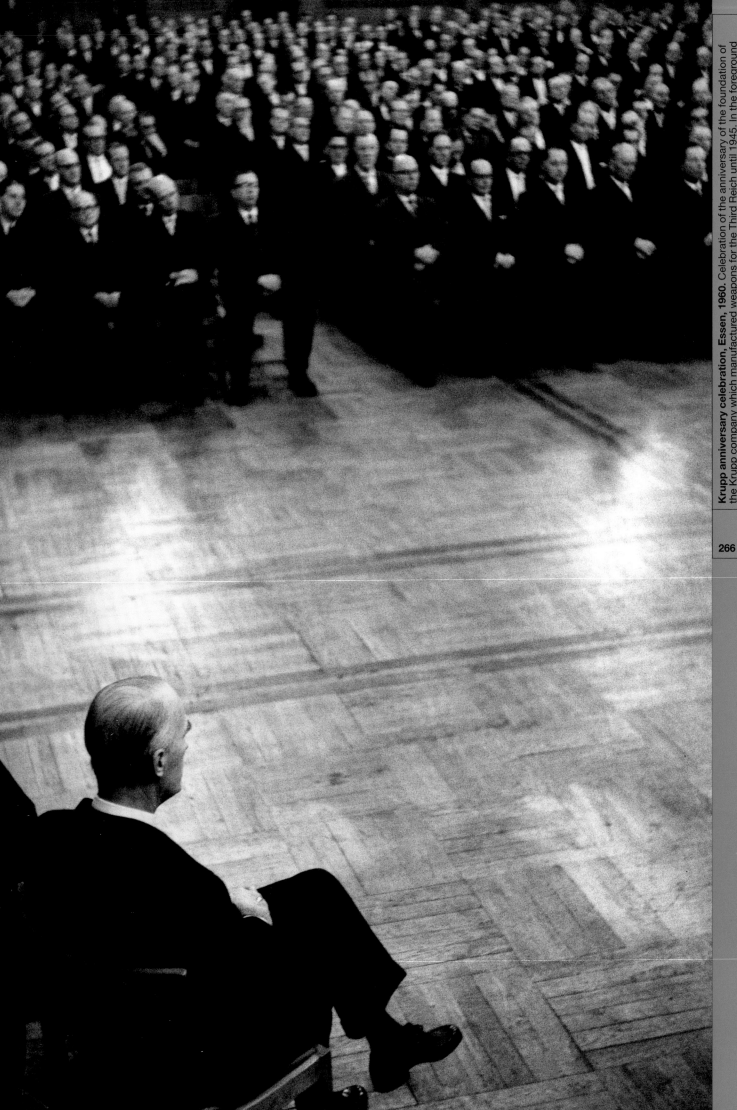

Krupp anniversary celebration, Essen, 1960. Celebration of the anniversary of the foundation of the Krupp company which manufactured weapons for the Third Reich until 1945. In the foreground is Alfred Krupp von Bohlen und Halbach, whose father was prosecuted and sentenced to many years in jail at the Nuremberg trials (1945–6) for his ties to the Nazi party.

Tenth anniversary of the German Democratic Republic, East Berlin, 1959. On the platform are the politburo, party officials and military officers.

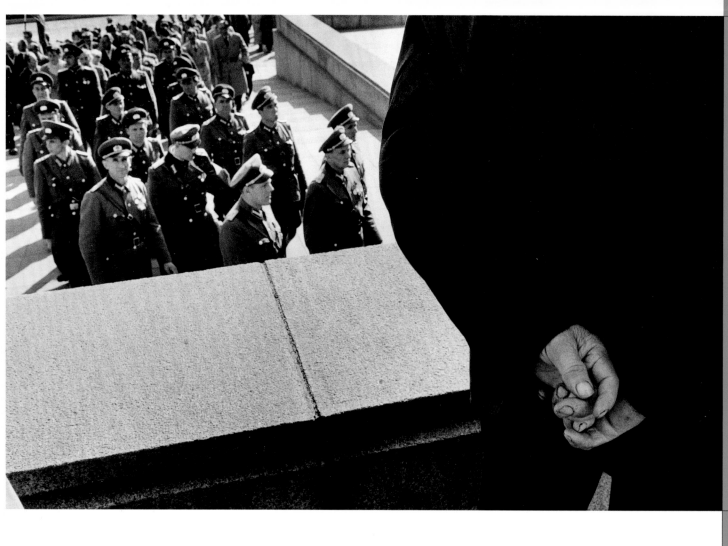

≪ **Rehearsal, East Berlin, 1959.** A rehearsal for *Winterschlacht* (Winter Battle) by Johannes R. Becher at the Berliner Ensemble, which was founded by Bertolt Brecht.
Soviet war memorial, Treptow, East Berlin, 1959. With twenty million dead, the USSR experienced a greater loss of life in World War II than any other nation.

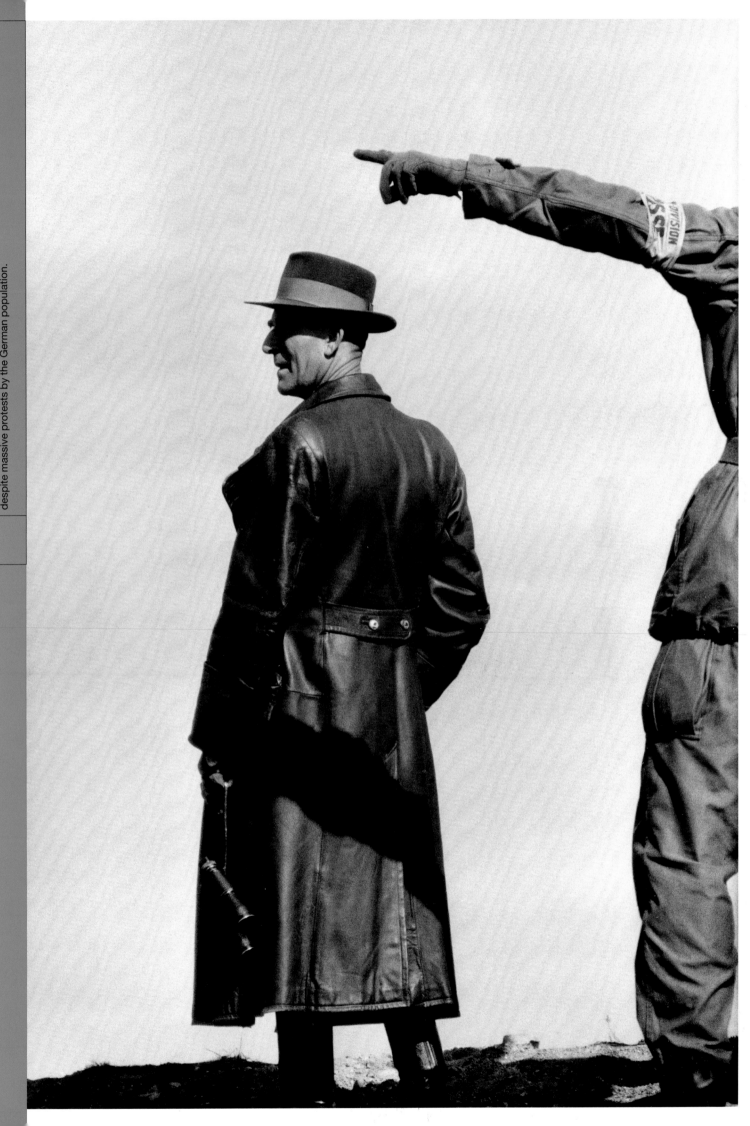

West German officers, Lüneburger Heath, 1959. Officers of the West German army observe tank manoeuvres. After 1955–6, West Germany built up its own army under the supreme command of NATO, despite massive protests by the German population.

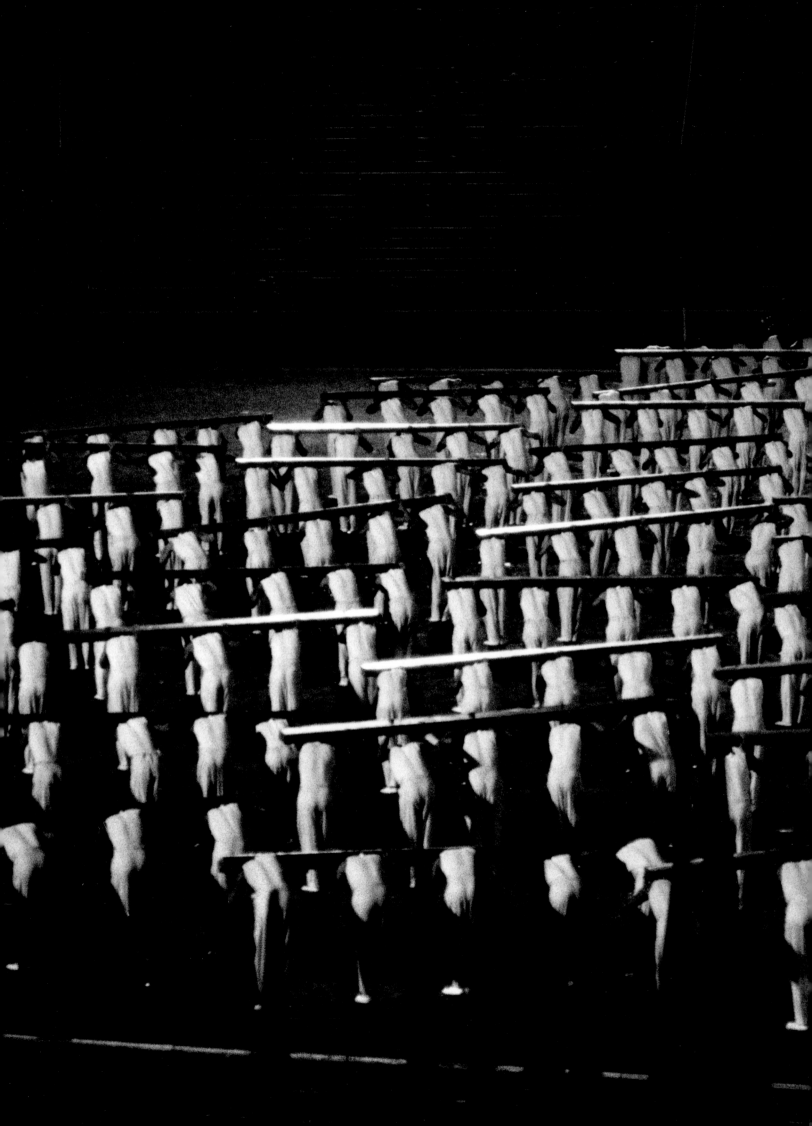

≪Gymnasts, Leipzig, 1957. Gymnastics at Spartakiade, the international games of the socialist countries.
The Berlin Wall, Berlin, 1961. The Berlin Wall, built in August 1961, is still new in this photograph.
Over the years, this simple wall would gradually be replaced by a sophisticated and more permanent
border security system.

In the street, Frankfurt am Main, 1959. The metropolis and later financial centre on the Main River had been discussed for a time as a possible capital for the Federal Republic of Germany. In the end, Bonn was selected, a decision for which Konrad Adenauer, the Chancellor, had lobbied intensely.

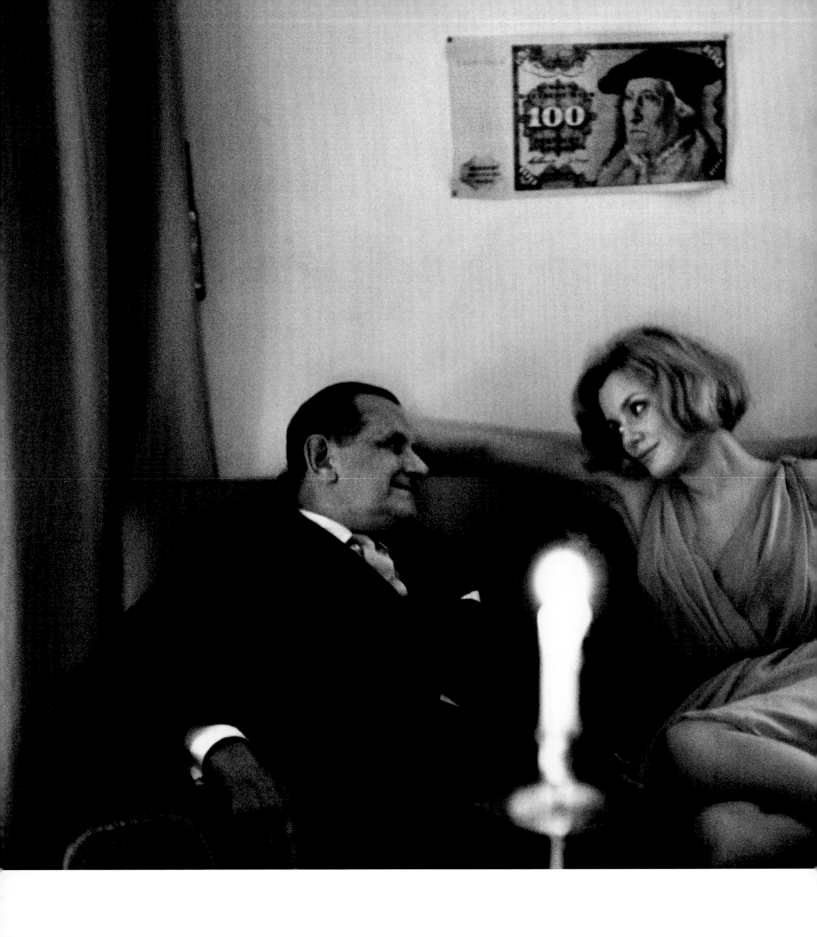

left: **Party, West Berlin, 1964.** The German mark, introduced in June 1948 and seen here on the wall in oversize, quickly became a symbol of the West German economic miracle.
right: **Official at the Sportpalast, West Berlin, 1959.** This photograph was taken on the evening of a jazz concert at the Sportpalast.

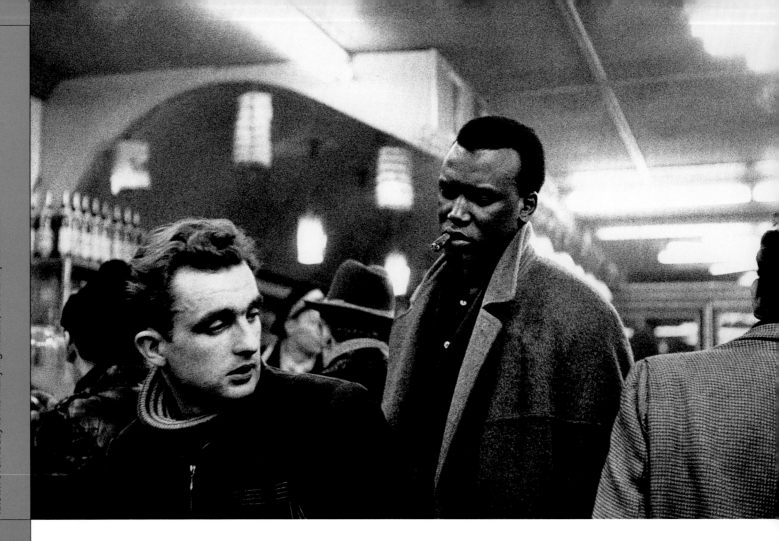

GI on leave, Hamburg, 1960. A GI on leave visits the Reeperbahn district of Hamburg, which is well-known even today for its many nightclubs, bars and prostitutes.

Couple kissing, Hamburg, 1960. This couple are in Hamburg's famous red light district, the Reeperbahn, near the harbour.

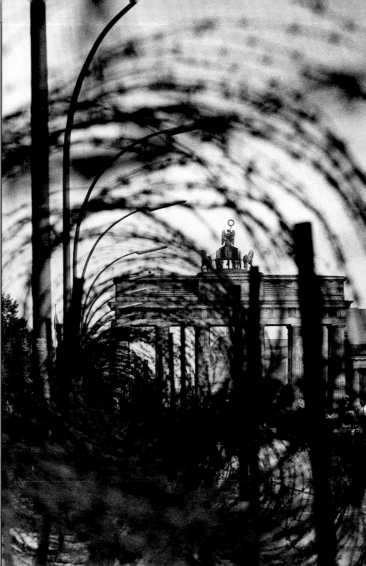

left: **Brandenburg Gate, West Berlin, 1961.** The famous Berlin landmark seen from the Russian soldiers' memorial.
right: **Courtyard, Aachen, 1962.**
▷ **The Goldener Engel, Baumholder, 1959.** 'The Golden Angel' inn.

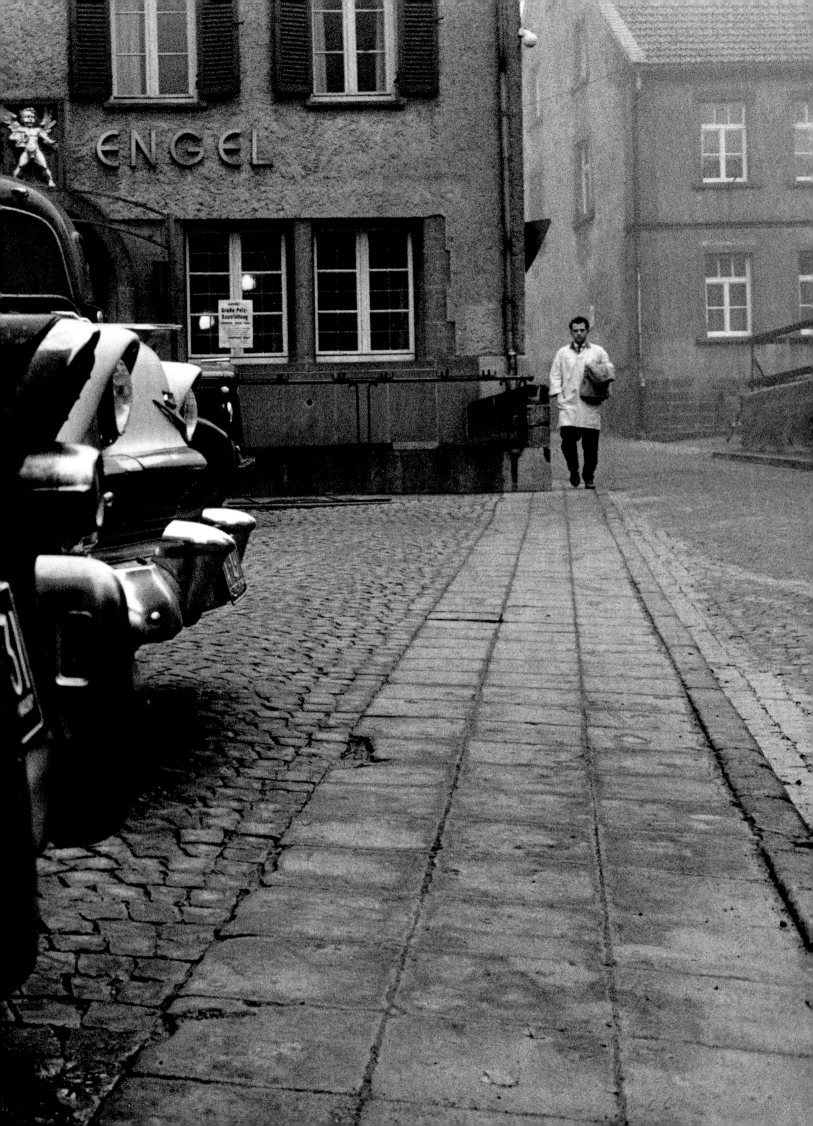

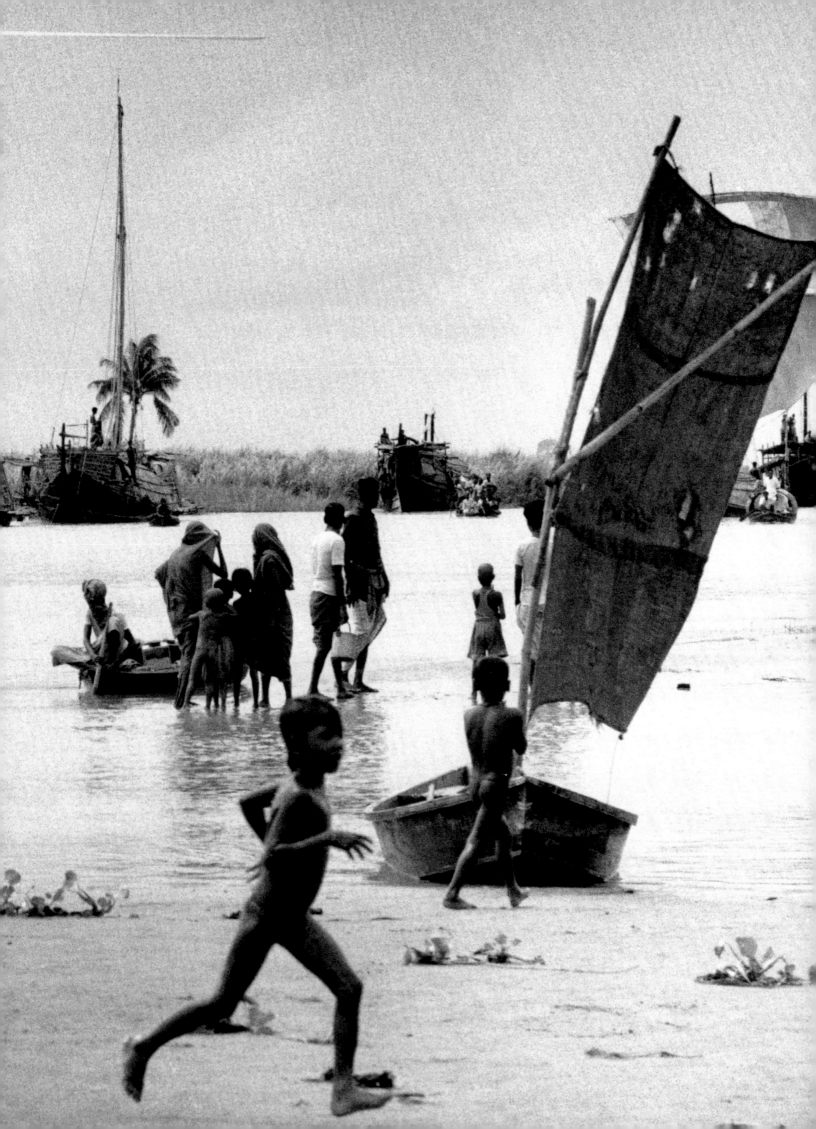

Pakistan did not receive very much media attention in the early 1960s. True, hardly a day went by without violence erupting between the Muslims in West Pakistan and the Hindus in East Bengal. For most people in the Western world, however, this seemed insignificant in light of the greater East–West conflict playing out in Cuba, Korea, Vietnam and East and West Germany. Talk of 'indirect warfare' between the superpowers became common. The only question was when they would strike out directly at one another instead of using other countries as their stage.

It was not until 1971 that Pakistan became the centre of global media attention. That year marked the beginning of a bloody civil war and a short but devastating military conflict with India. Pakistan was defeated and lost its smaller but more densely populated eastern half which declared its independence as the People's Republic of Bangladesh on 6 December 1971. Millions on both sides lost their lives and Pakistan itself was thrown into political turmoil.

When Burri travelled to Pakistan in 1963, the country was still comparatively calm, an unlikely destination for international journalists or photographers. It all began with a phone call from New York. Inge Bondi, then editorial manager of Magnum's New York bureau, had secured another 'commercial assignment'. With the magazine industry already in decline, these sorts of jobs were no longer just everyday business but had become a matter of survival. This time, it was Pakistan International Airways (PIA) that had made enquiries. Though comparatively small, the airline had begun to expand under the leadership of Nur Khan. Nur Khan was seeking a photographer to provide pictures for the airline's calendars, brochures and other public relations material. As Burri recalls, the budget was so small that other photographers had turned down the job. Burri, however, saw his chance to discover a little-known corner of the world, all expenses paid. He was only twenty-eight years old. He had already travelled extensively in Europe and been to the United States. He had lived and worked in South America and

reported from Cyprus and the Middle East. He knew, however, that Pakistan would allow him to extend his travels even further east – and come closer to his secret goal: China.

A preliminary briefing was arranged in New York. What should he photograph? Why, London, Rome, Paris, of course – the European destinations of PIA. It goes without saying that this was not exactly what the Magnum photographer had in mind. So he thought quickly and surprised Nur Khan and his public relations manager Omar Kureishi with a suggestion: why not place their own country in the spotlight? They were immediately taken with the idea. For the next two years, Burri travelled through Pakistan and East Bengal, sounding out the country in cars, helicopters and small planes. The photographs he took would, in their fresh beauty, determine the popular image of Pakistan for years to come.

For the PIA calendars, advertisements and brochures he took colour photographs. But he always had a black-and-white camera with him as well. The result was a parallel and very unofficial view of the poverty, backwardness and growing unrest in the multi-ethnic nation. These images are a profoundly personal reflection of Burri's political and aesthetic values. According to Burri in an interview for this book, he simply started to take photographs, 'My escorts never knew what I was doing exactly.'

Another phone call came at the beginning of 1964. PIA had reached an agreement with the Chinese government and would soon be starting flights to Beijing and Shanghai. 'I got a message and packed my bags,' remembers Burri. He was on the maiden flight in the capacity of official photographer and arrived in Beijing at the end of April. He was received, along with airline representatives, in the Great Hall of the People by Zhou Enlai. The ensuing photographs, which appeared exclusively in *Life* magazine, made up his first major reportage on China (see chapter on China; p. 440, nos 1–2, 4). Burri had found a new and important topic – indirectly through Pakistan.

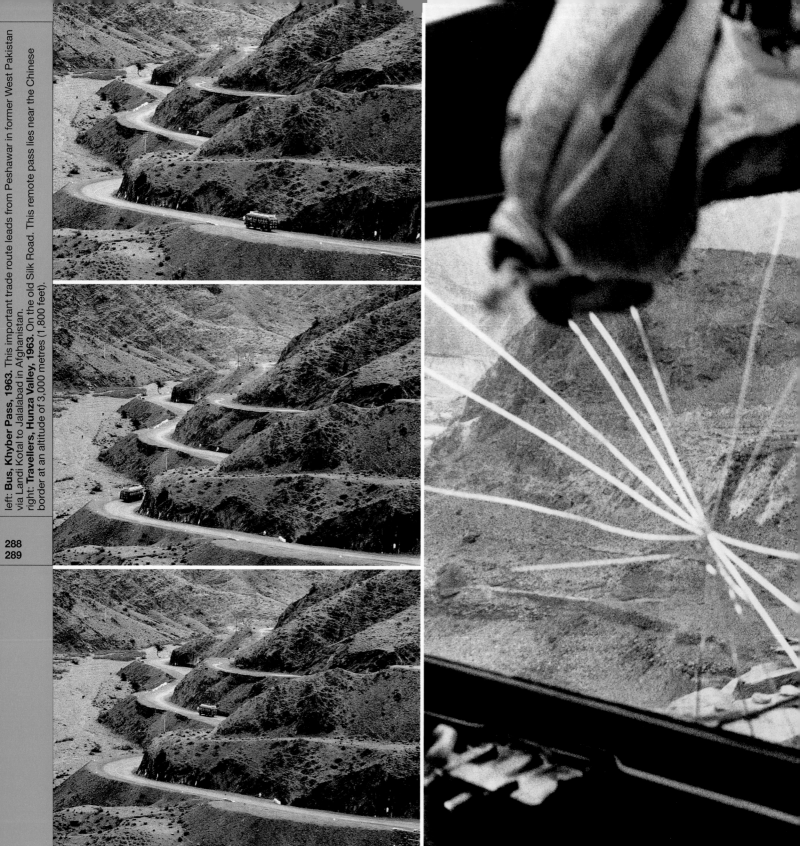

left: **Bus, Khyber Pass, 1963.** This important trade route leads from Peshawar in former West Pakistan via Landi Kotal to Jalalabad in Afghanistan.
right: **Travellers, Hunza Valley, 1963.** On the old Silk Road. This remote pass lies near the Chinese border at an altitude of 3,000 metres (1,800 feet).

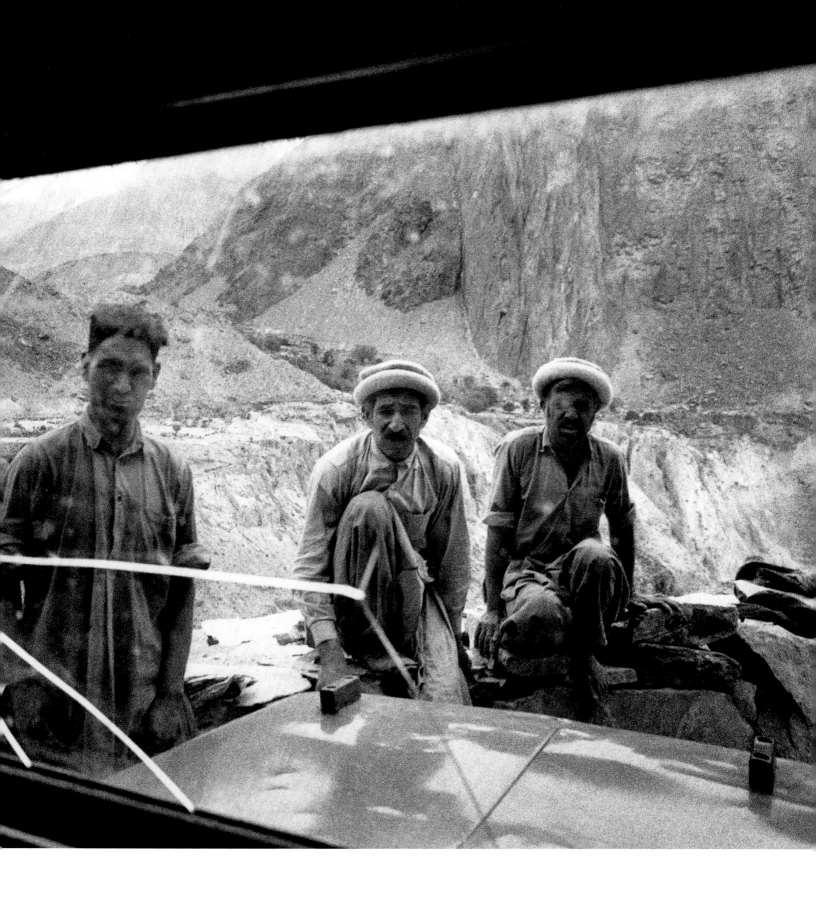

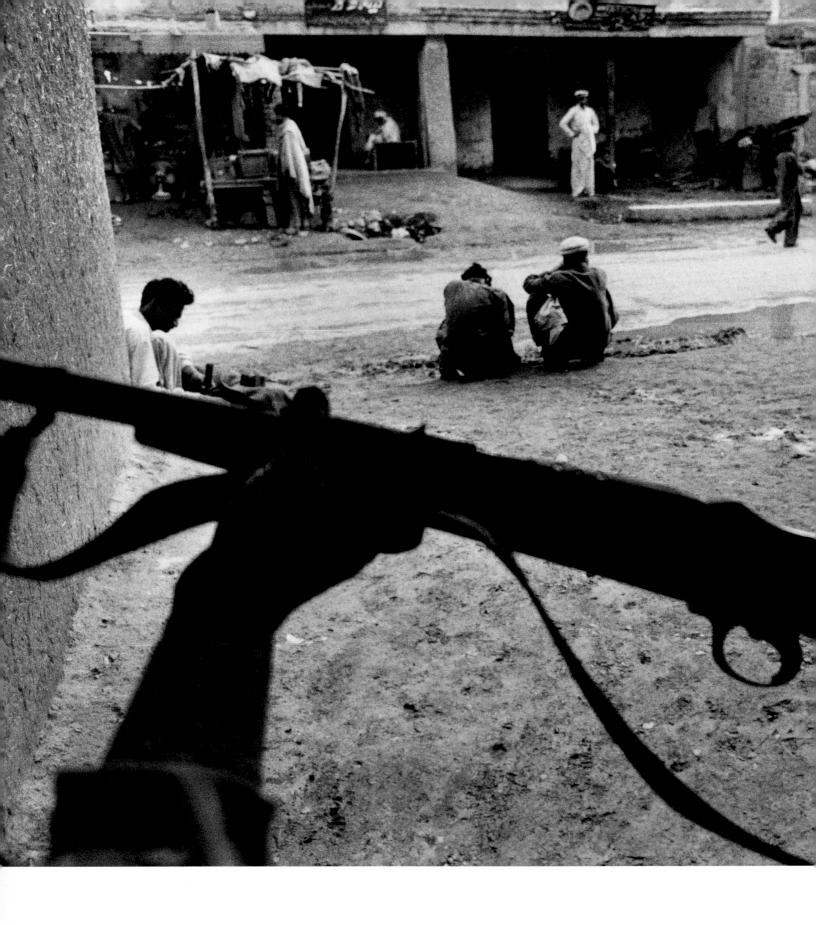

left: **Gun workshop, Landi Kotal, 1963.**
right: **Gun-maker, Landi Kotal, 1963.**
The gun-making workshops are the main feature of the village. Although old fashioned, they are actually fairly efficient, and weaponry has been produced and copied here for centuries.

290
291

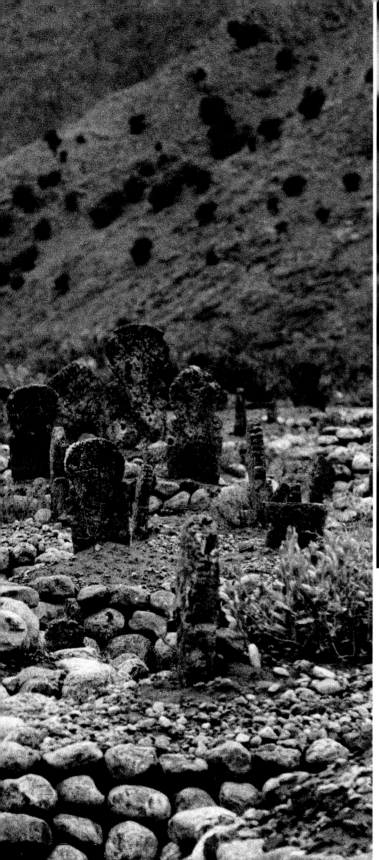

left: Cemetery, near Landi Kotal, 1963.
right: Pakistani woman in traditional burka, East Pakistan, 1963.
≫Shadow of a tree, Rohtas, West Pakistan, 1963. The fort at Rohtas is from the old Mogul Empire.

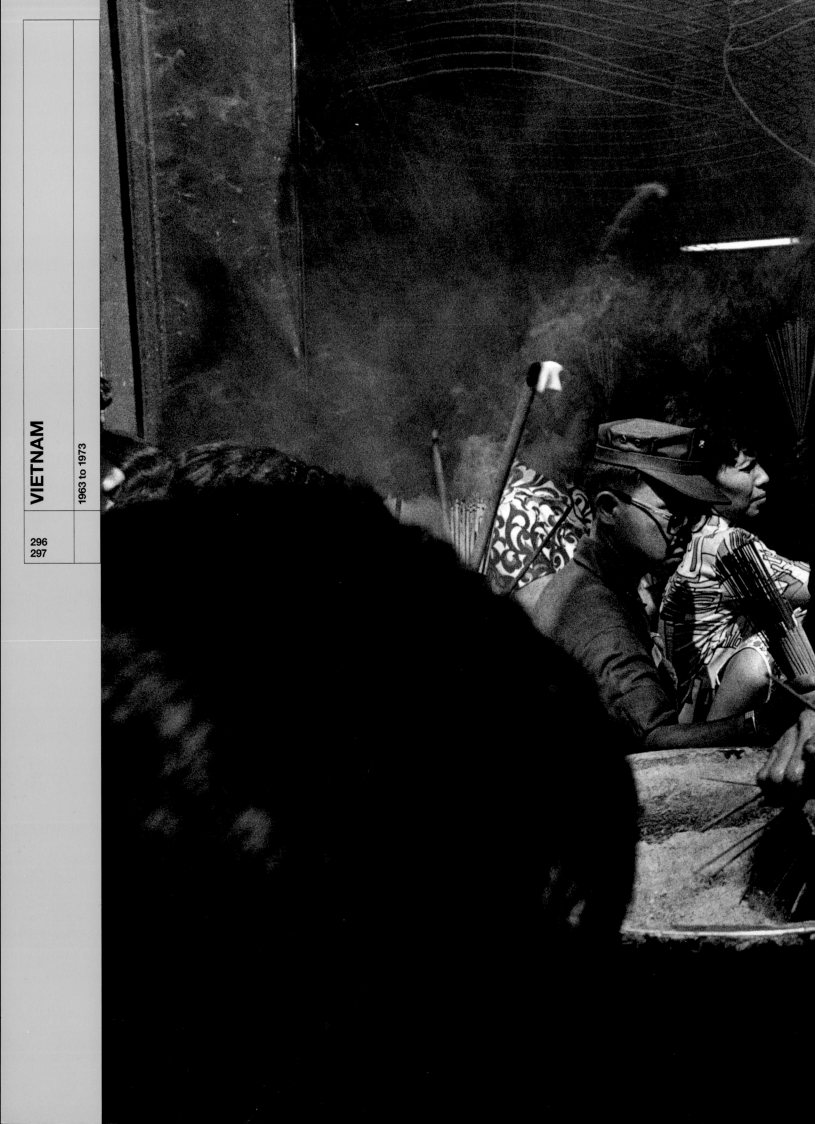

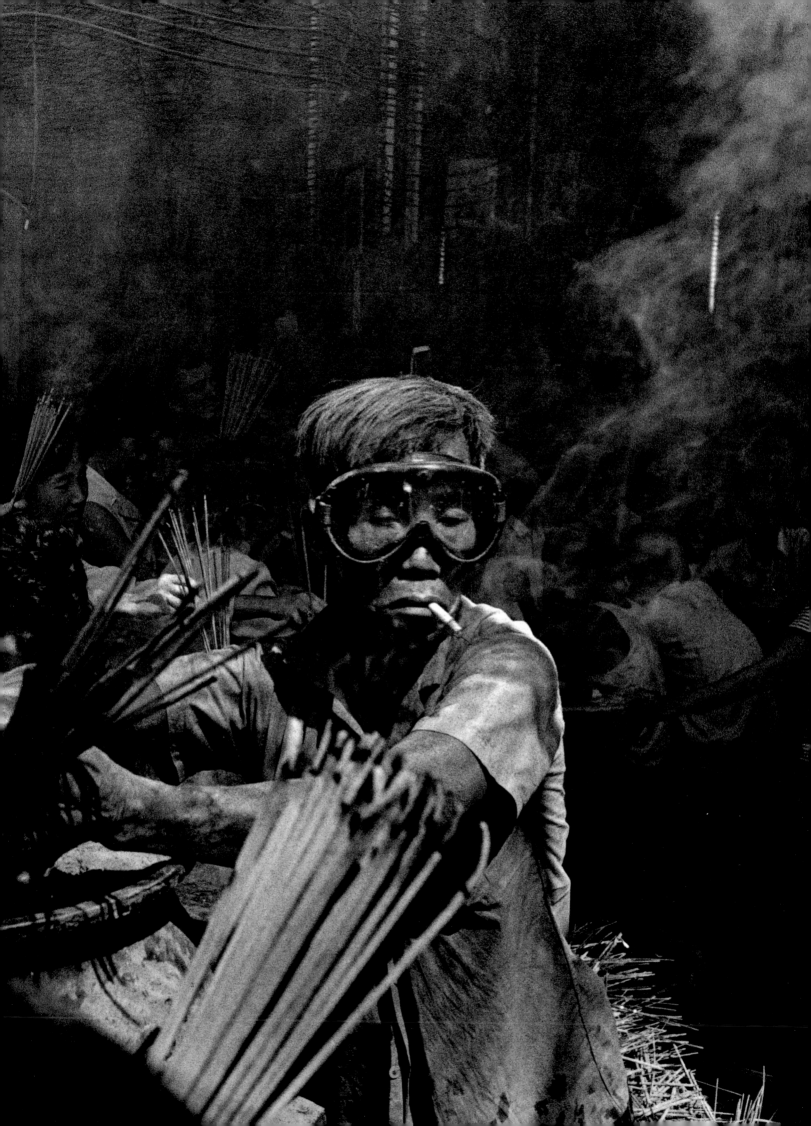

René Burri arrived in Vietnam at roughly the half-way point between the French withdrawal in 1954 and the Paris ceasefire agreement of 1973. The US Air Force had not yet started its large-scale bombing of the country. However, as Burri's images clearly show, the Americans were already intensely involved in the war by 1963. This was a conflict that, like no other, would cast its shadow over the entire decade – and beyond.

Vietnam was the focus of intense journalistic interest. So why did René Burri not play a larger role as a war correspondent? For many of his colleagues, covering the war became a life's work. Philip Jones Griffiths or Larry Burrows spring to mind. Like them, Burri was always on the lookout for important new stories, and he would most certainly have found enough material in Vietnam for reportages and photo essays. Perhaps the answer lies in Burri's natural instinct for survival. Robert Capa, whom Burri would no longer have the chance to meet, had trodden on a mine in North Vietnam in 1954. David Seymour, something of a father figure for Burri at Magnum, had lost his life in 1956 on the Suez Front. If Burri had not noticed it before, he certainly became aware of the mortal danger involved in war reporting in the unprotected hold of a US helicopter. Unlike journalists and photographers, military personnel on board were protected from enemy gunfire by pre-installed armour plating in the flooring.

There is, however, something we need to add to this. Something that intersects with Burri's attitude towards the genre we normally call 'war photography'. Bertolt Brecht once said that an exterior shot of the Krupp steelworks would say little or nothing about what was actually inside. In exactly the same way, modern wars are the result of complex global interests, the often hidden structures of which are impossible to uncover with 'simple' war photographs. Instead, the public is fed with action shots and scenes of terror which, if they have not already been used as propaganda, serve as the requisite 'shock photos' for the morning papers. Benjamin Henrichs, a former

editor of *Die Zeit*, once said that 'our society is riddled with an illicit, war-hungry desire – a society that has provided its citizens with everything, sentencing them to a life of boredom.' He described how a society addicted to pictures was disappointed by the imageless Falklands War. The war reporter has become more than ever an indispensable cog in a system that is, in reality, more about entertainment than information.

One would be hard pressed to find a picture of a corpse in René Burri's photo archive. It is not that the horrors of war have passed him by. Rather, Burri does not trust the spirit or purpose of such images, in the same way that he mistrusts a line of business that has always been 'embedded' with the troops in some way or another, corrupted by the interests of those who allow photography at the front line. Burri also knew that the war photographer has little room for manoeuvre. One step too far can literally mean death – which Robert Capa's demise shows if nothing else. Is it possible to take meaningful pictures under conditions like these?

Capa was addicted to war. Others were too, and are still. Burri was able to avoid being sucked into this obsession early on. He did so not by sanitizing his pictures of the world. René Burri pursued a different type of war photography. In Saigon 1973, a group of Vietcong prisoners of war are marching across the runway of Than Son Nut airport (p. 312–13). Nearly every member of the group is missing a leg. A bizarre choreography. And just one example of Burri's response to the popular iconography of war.

≪ Couple at brothel, near Saigon, 1973.
Burning joss sticks, Cholon, Saigon, 1973. Joss sticks are lit to celebrate the Chinese New Year.

Refugees, near the Cambodian border, 1973.

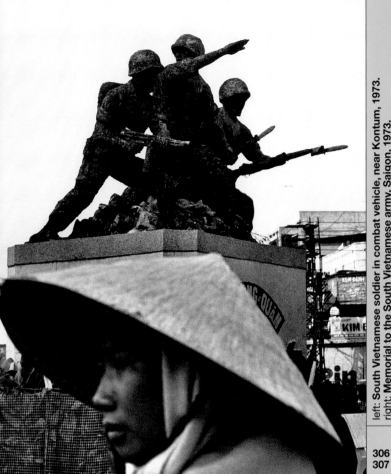

left: **South Vietnamese soldier in combat vehicle, near Kontum, 1973.**
right: **Memorial to the South Vietnamese army, Saigon, 1973.**
≫**Troops landing, Mekong Delta, 1963.** South Vietnamese troops are flown to the Mekong Delta by US pilots.

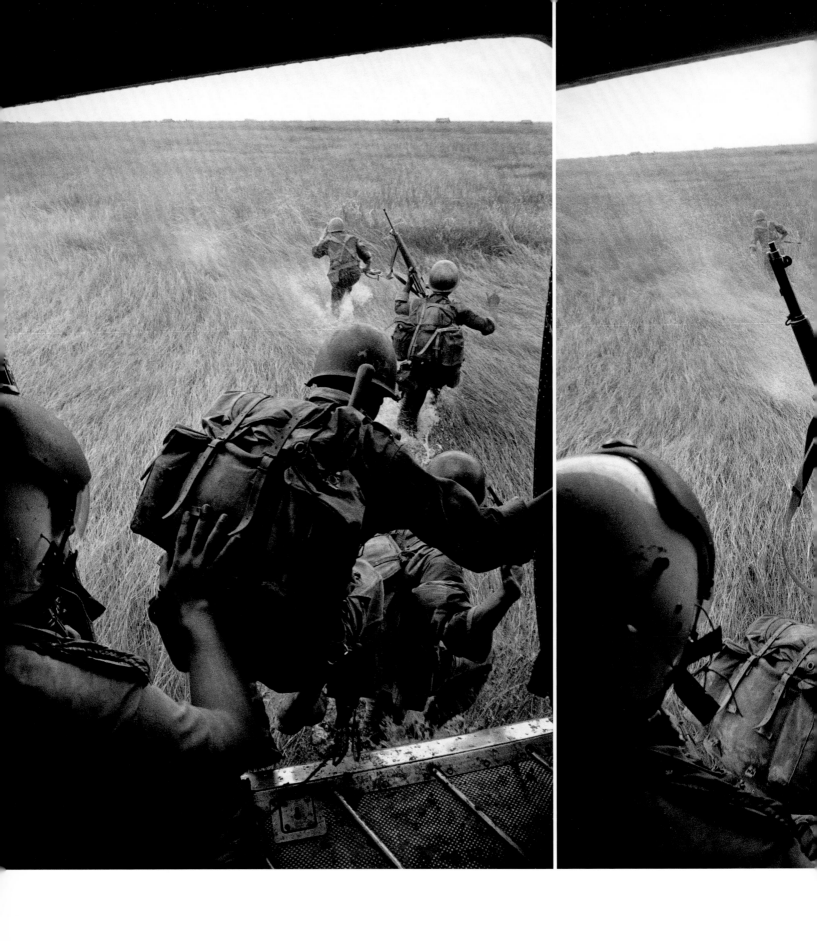

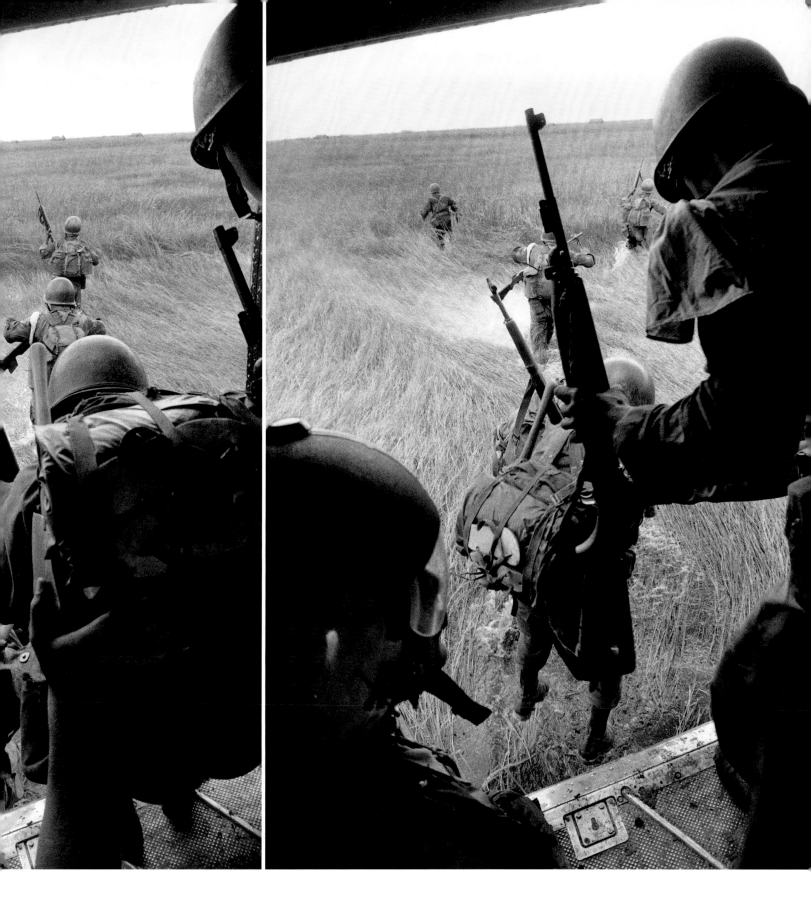

Bomb craters, near the Cambodian border, 1973.

≫ **Prisoners, Saigon, 1973.** Following negotiations between the US and North Vietnam a group of Vietcong are about to be flown from Than Son Nut airport to Hanoi for a prisoner exchange.

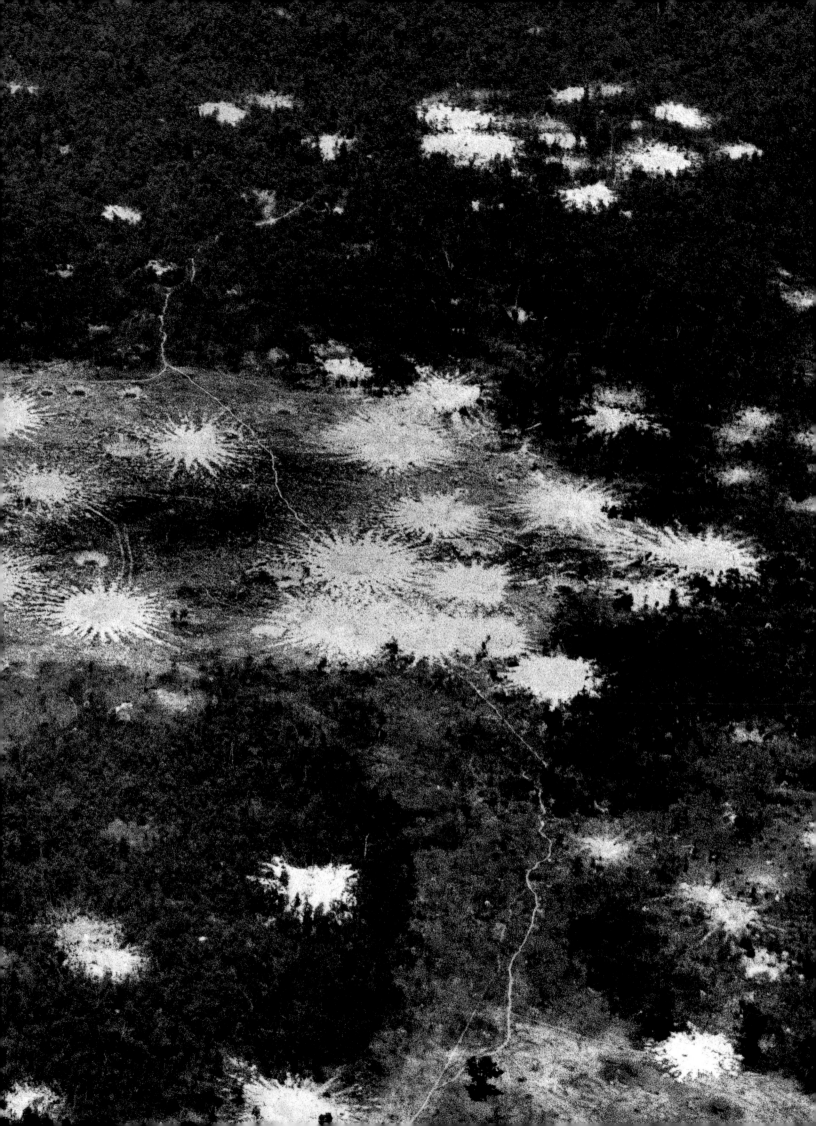

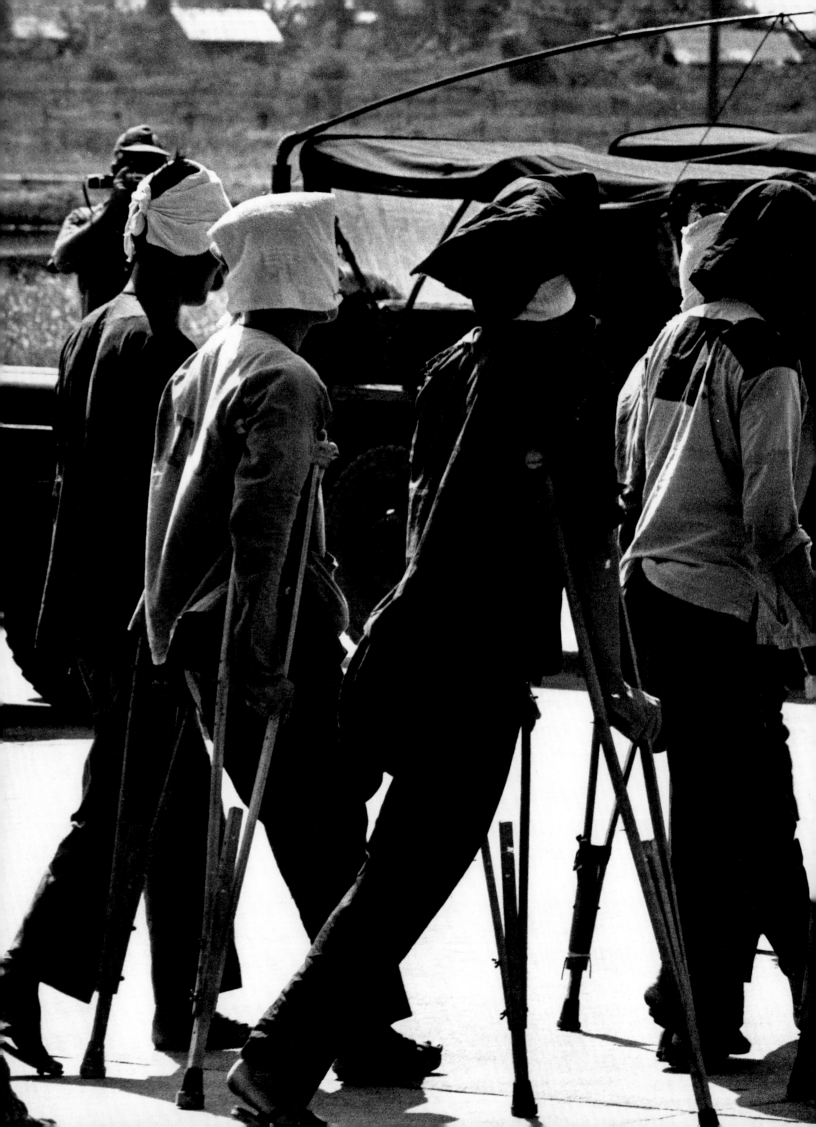

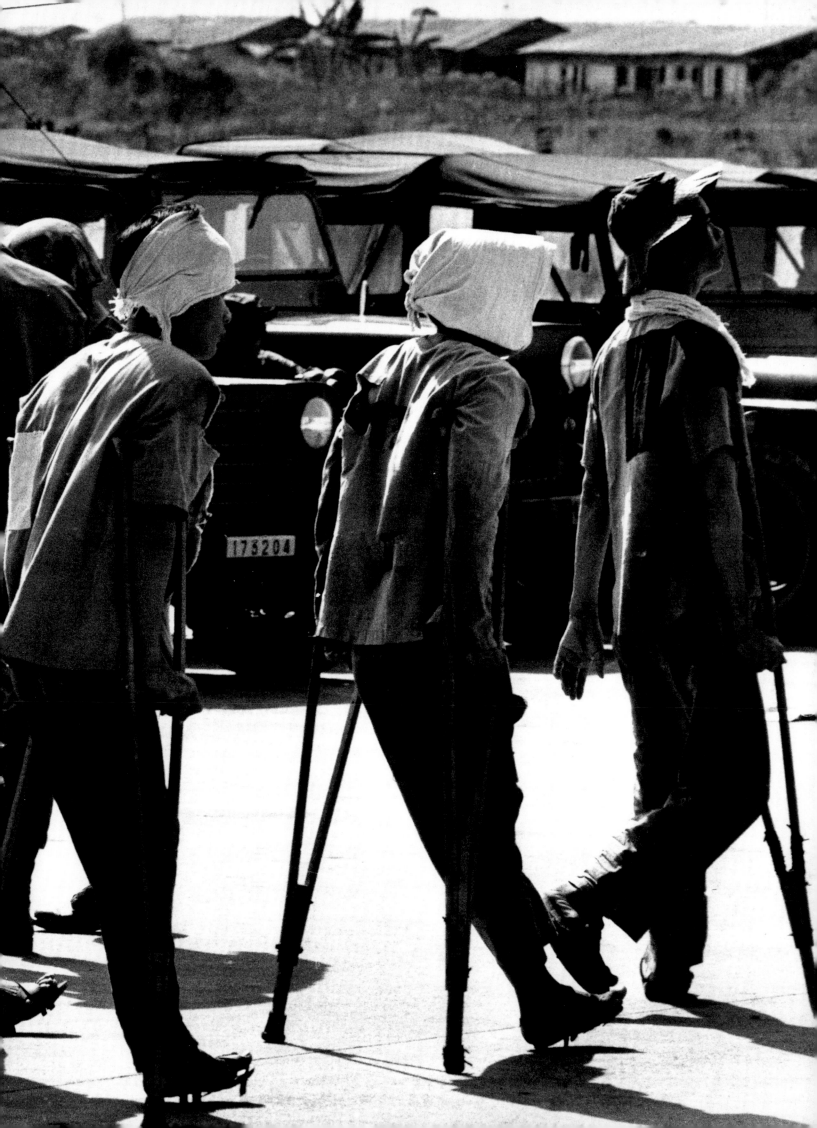

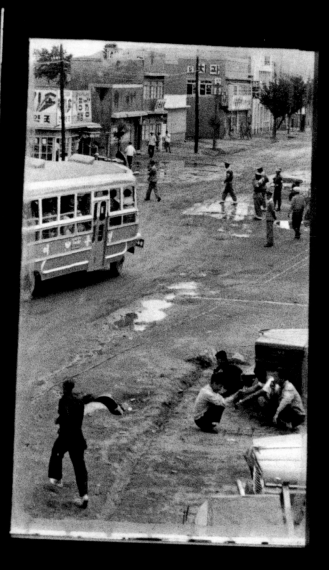

When the Korean war came to an end in 1953, René Burri was only twenty years old. That same year he completed his studies at the School of Arts and Crafts in Zurich. After his military service, he immediately set out on assignments for French, Swiss and, in particular, German magazines. In the late 1950s West Germany became the main focus of his work. People have often asked him what he found so fascinating about the country. 'The ruptures, the contradictions,' answers Burri, 'and the fact that the fault-lines of history intersect in Germany in a very visible way.'

The same can be said of Korea, also a country scarred and divided by war. Like Germany, it had become a country of two opposing systems, two hostile ideologies separated by a high-security border. When Werner Bischof visited Seoul in 1952, he described the sight of the city as 'horrible, like Germany after the war, no house spared. The only illuminated block in these ruins was the press centre, hundreds of journalists. They looked to me like "vultures of the battlefield."'

Burri arrived in South Korea in 1961 on his way back from Japan. It was eight years after the armistice agreement in Panmunjom which fixed the border between the two Koreas at the 38th parallel – almost exactly where it had been before the war. This was anything but a peace treaty. North and South Korea would remain fraternal enemies for decades. Indeed, the region has remained a political and military powder keg to this very day. Even the smallest of skirmishes has the potential to escalate into all-out conflict and is the cause of international concern.

This was already the case before North Korea, one of the last communist countries, was suspected of possessing a nuclear bomb. In 1961 a military coup in South Korea made the world sit up and take notice. A small group of officers acting under General Park Chung Hee deposed the elected government led by Chang Myon and abolished the new parliamentary constitution. Years of military dictatorship marked

by the suppression of civil rights and forceful anti-communist rhetoric followed. Martial law was repeatedly invoked.

Reporting together with Bernie Kalb for *The New York Times Magazine*, René Burri arrived in South Korea only two weeks after the coup. The country greeted them, as Burri recalls, with a deathly silence. The only visible sign of the heavy-handed new regime was a sole cigarette smuggler being dragged away quickly by the police. Burri captured the image (p. 321). On Memorial Day (6 June), Burri observed relatives visiting the largest military cemetery outside the capital, an endless sea of 140,000 graves. In South Korea alone more than a million people lost their lives during the war. South Korea, wrote Kalb, was a country 'where men cannot remember when the fortune of the nation has been anything but ill and its life anything but unhappy'.

In the evening, Burri followed American GIs into a nightclub where he took what proved to be one of his most powerful and best-known photographs of the country (pp. 324–5). He also took pictures of students on their way to university. Only later would the real significance of these images become clear. Burri returned to Seoul twenty-six years later in 1987. It had become 'a completely different city', as the photographer recalls. He was supposed to be reporting on the state of South Korea on the eve of the Olympic Games. Instead, he found himself caught up in the violent student protests that eventually led to a liberalization of South Korean society. South Korea had once again become the subject of world attention. Armed with camera and gas mask, Burri completed a reportage entitled 'The Quirks of Korea', which appeared in the September 1987 issue of *Life*. René Burri was standing near – very near – the fault-lines of history once again.

≫ **In the street, Seoul, 1961.** It is the era following the military coup staged by General Park Chung Hee and four thousand paratroopers. The 'rule of generals' in South Korea had begun.

317

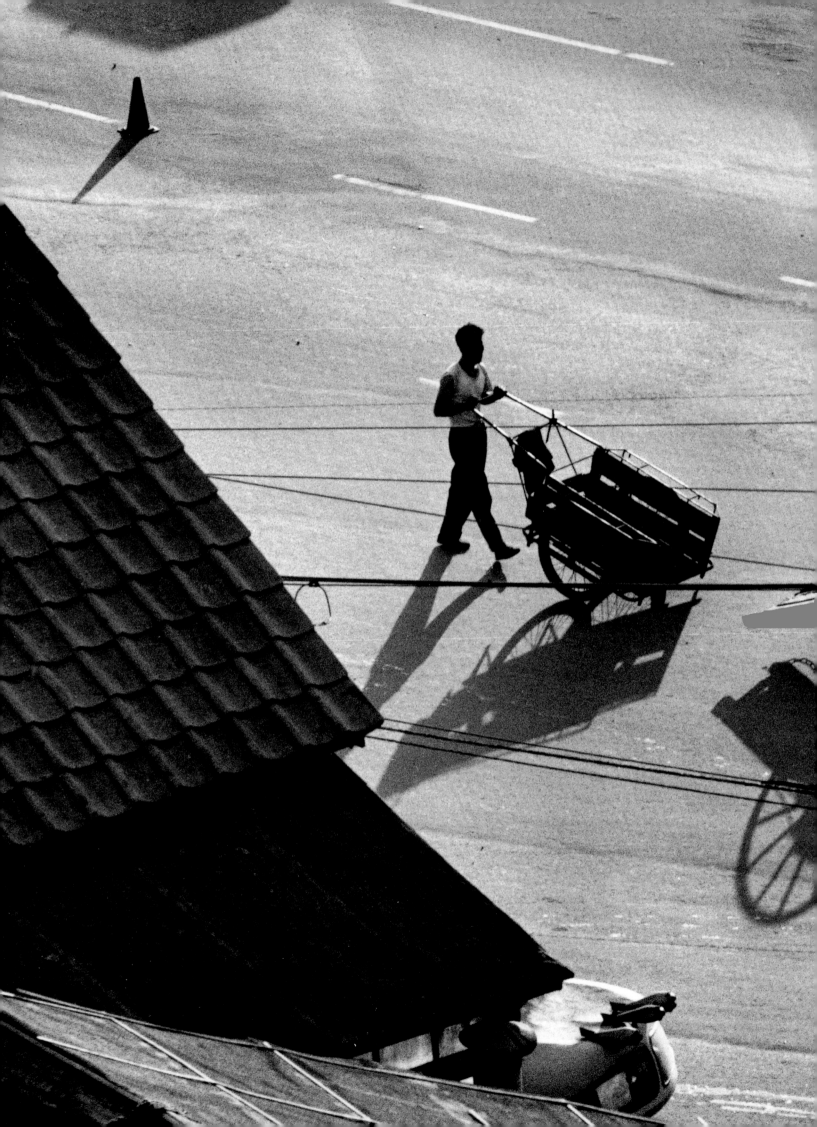

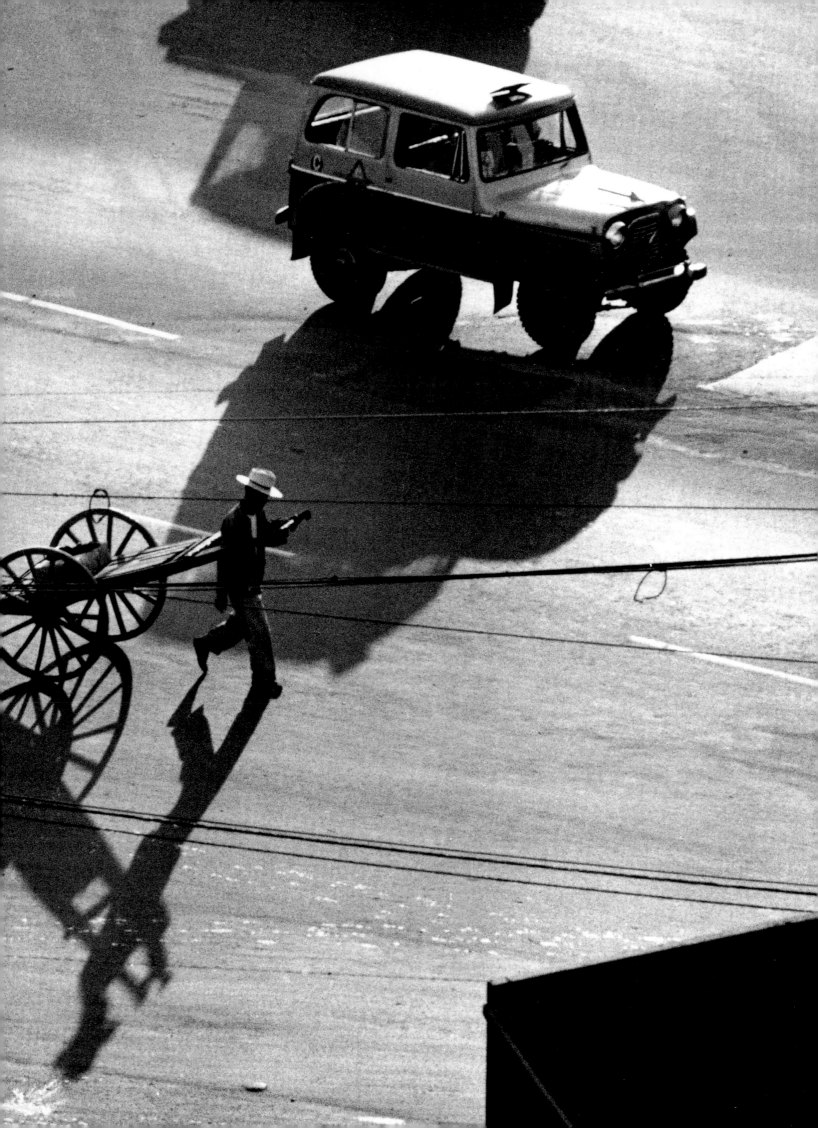

Refugee camp, Seoul, 1961. The camp is in the hills around the capital.

Smuggler being arrested, Seoul, 1961. Military police arrest a young man caught smuggling American cigarettes. He will go to prison for this.

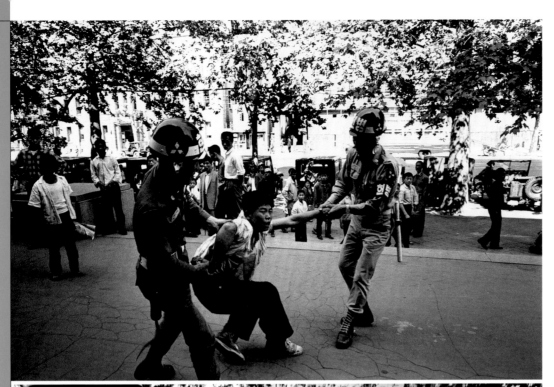

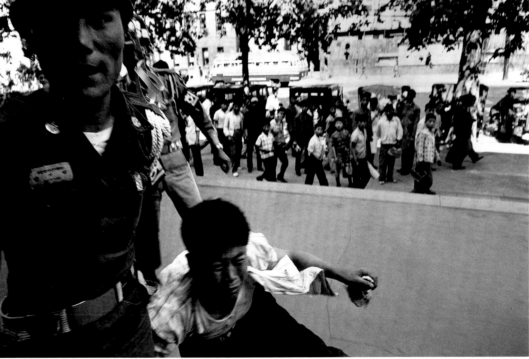

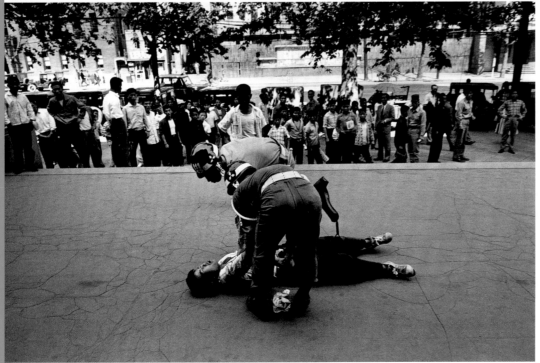

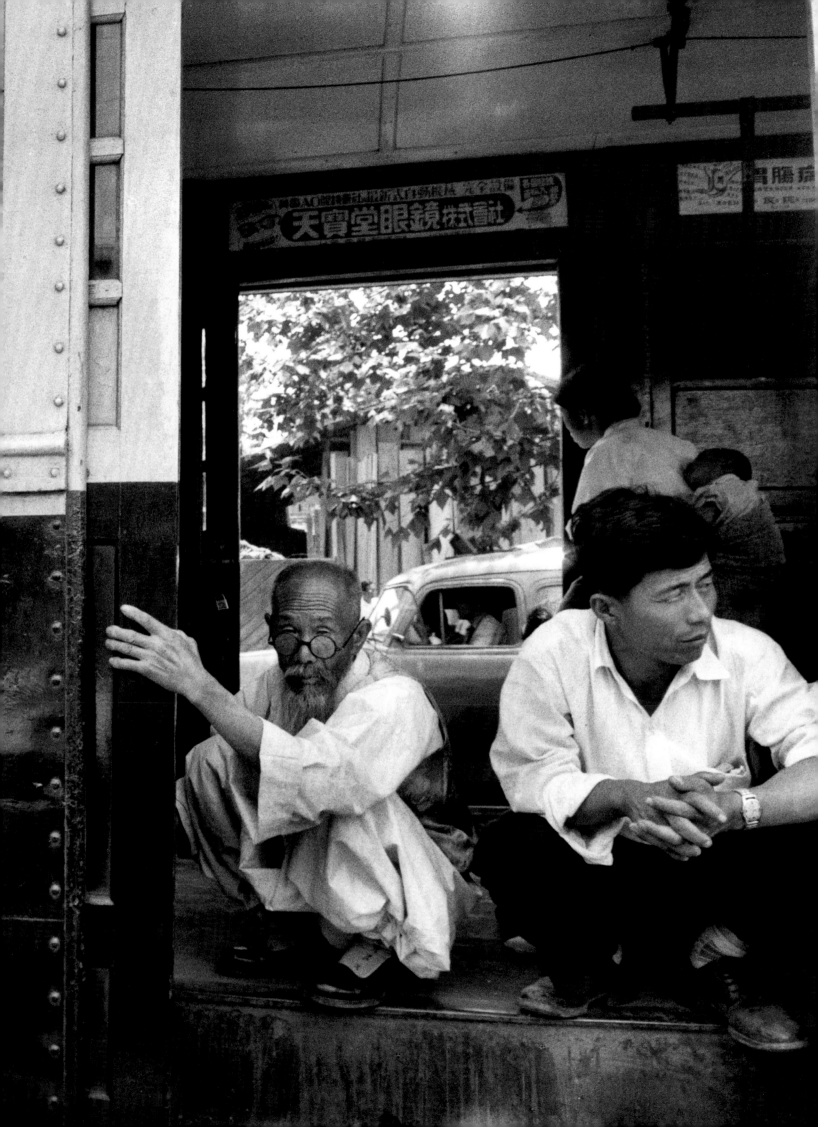

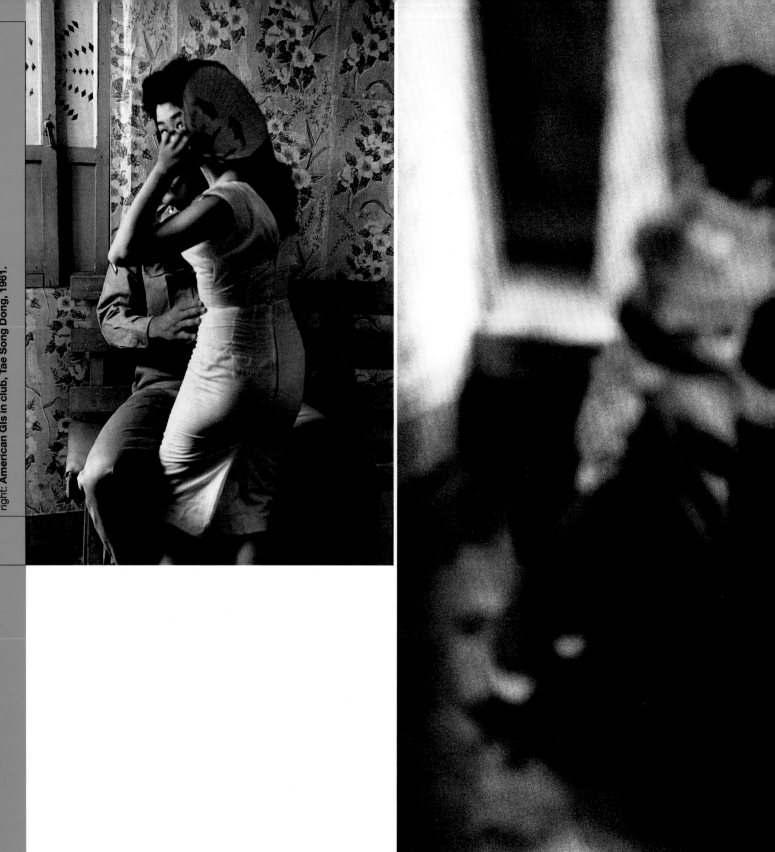

« On the tram, Seoul, 1961.
left: American GI and prostitute, Tae Song Dong, 1961.
right: American GIs in club, Tae Song Dong, 1961.

324
325

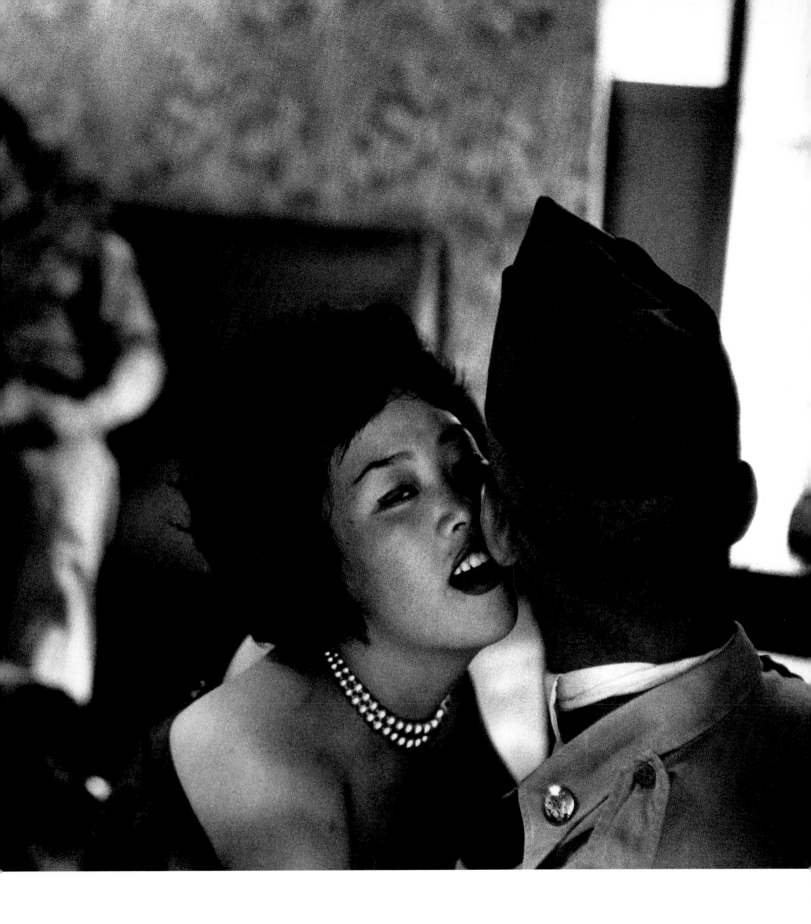

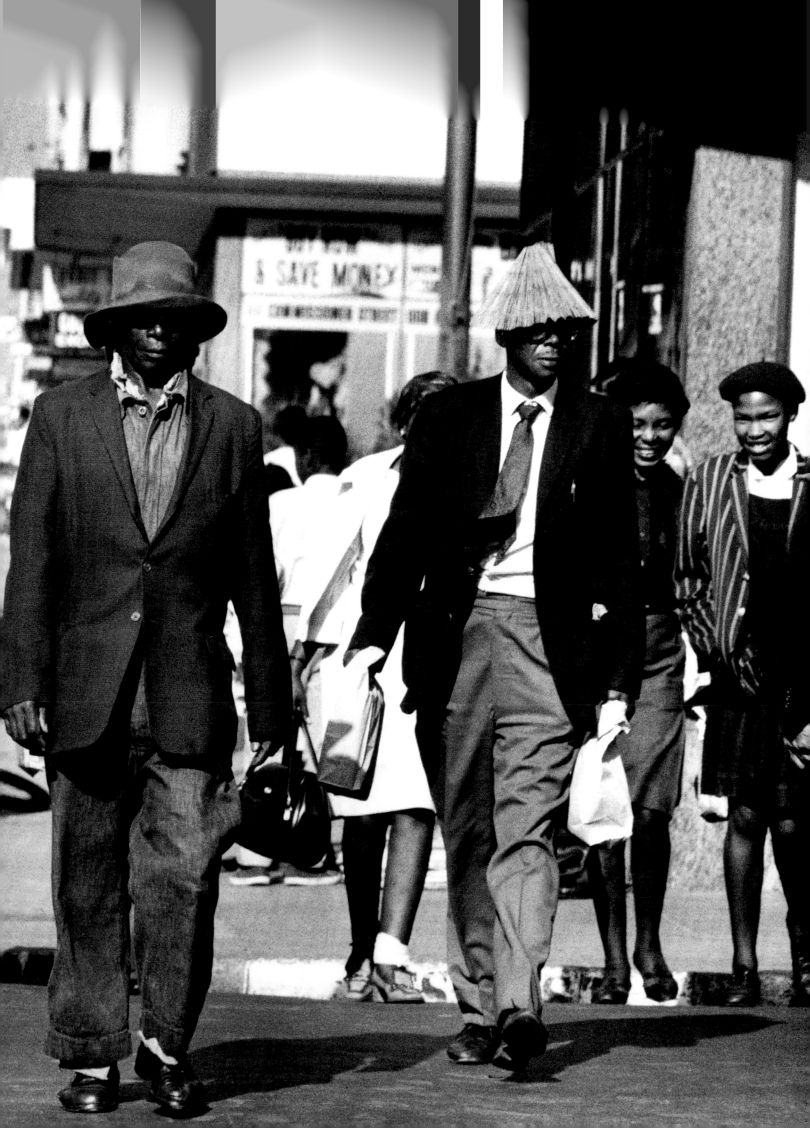

South Africa is a beautiful country blessed with unique flora and fauna, a lush coastline and a climate ideally suited to Europeans – the requisite opening line of any reportage on South Africa in the 1960s. Take, for example, the French magazine *Réalités*, which in the late 1960s asserted that 'South Africa is Europe and Africa closely bound up in one: inland deserts, untouched Savannahs, rich and wild tropical forests as well as mining towns, landscapes dotted with white farmhouses and a whole population originating from northern Europe, established with the necessary finances into the reality of Africa.'

South Africa is indeed an oasis of sorts. But part of its uniqueness also made it the subject of international scorn well into the 1990s: the system of apartheid. Of course, racism – the overt and hierarchical treatment of specific ethnic groups – is not unique to South Africa. In fact, the twentieth century could possibly be described as the century of racism. The genocide in Armenia, the Holocaust and the massacres in the Balkans are only three of the most heinous racist crimes. Even in the US in the 1960s it took the civil rights movement to achieve anything remotely akin to equality. However, no country after World War II legalized, even institutionlized, racism in the same way as South Africa.

Overt racial discrimination in South Africa actually dates back to 1911 when European settlers and their descendants passed laws designed to bring the political and economic activities of the black majority to a standstill. Almost 68 per cent of the population was black at the time. However, it was not until after the electoral victory of the National Party in 1948 that the institutionalized large-scale system of racial discrimination known as apartheid was established. The 'Group Areas Act' passed in 1950 made the territorial separation of 'whites', 'blacks', 'coloureds' and 'Asians' permanent, and led to the forced resettlement of millions of black Africans.

When Burri visited South Africa in 1968, the inhuman policies of apartheid were at their peak. The police had

no qualms about brutally suppressing peaceful protests, as seen in the Sharpeville massacre of 1960. The African Nation Congress and Pan-African National Congress were banned. Nelson Mandela, later winner of the Nobel Peace Prize, was sentenced to life imprisonment. On the world stage, South Africa was shunned by most other nations and barred from the Commonwealth. It also became the object of wide-ranging embargoes and sanctions.

But Burri had not come to report on this when he travelled there on assignment for *Réalités*, a magazine more akin to *National Geographic* than *Paris-Match*. He was travelling together with a journalist, who, as Burri recalls, suffered a breakdown due to the pressure of the circumstances. According to Burri, the people who accompanied them 'were always careful to portray things from their own point of view'. Freedom of the press was nowhere in sight. As Burri remembers, 'They always flew into a rage if I tried to include blacks in my photos. But naturally I reacted a bit differently.' Burri's photographs appeared in *Réalités* as a ten-page colour photo essay with a moderately critical undertone. *A Life Like That in Ancient Africa* was the title of a photograph he took of a young Zulu woman, proudly displaying her nudity in a way inimical to the 'rigorous mores of the protestant Afrikaners' (A black-and-white version of the picture appears on p. 332.). A more clearly political story illustrated by Burri was published later in the Brazilian magazine *Manchete*. The black-and-white photographs Burri took with his Leica, however, have remained largely unpublished.

Burri's colleague Raymond Depardon, also a Magnum photographer, was an enthusiastic observer of North Africa. Bruno Barbey and Harry Gruyaert visited Morocco many times over the years. Marc Riboud was a frequent visitor to sub-Saharan Africa. And Ian Berry is well-known for his numerous reports on South Africa and apartheid. But for Burri, Africa never became the chief focus of his interest, and his first journey through the southern tip of the continent was also his last.

≫ **Bantu dancers, Kenya, 1984.** Commissioned to do a piece for *Libération* on the 'cradle of humanity', Burri also took pictures of contemporary Kenya. Here we see Bantu dancers in a tourist camp. Nearby was the house of the founder of the Boy Scouts, Sir Robert Stephenson Smyth Baden-Powell.

329

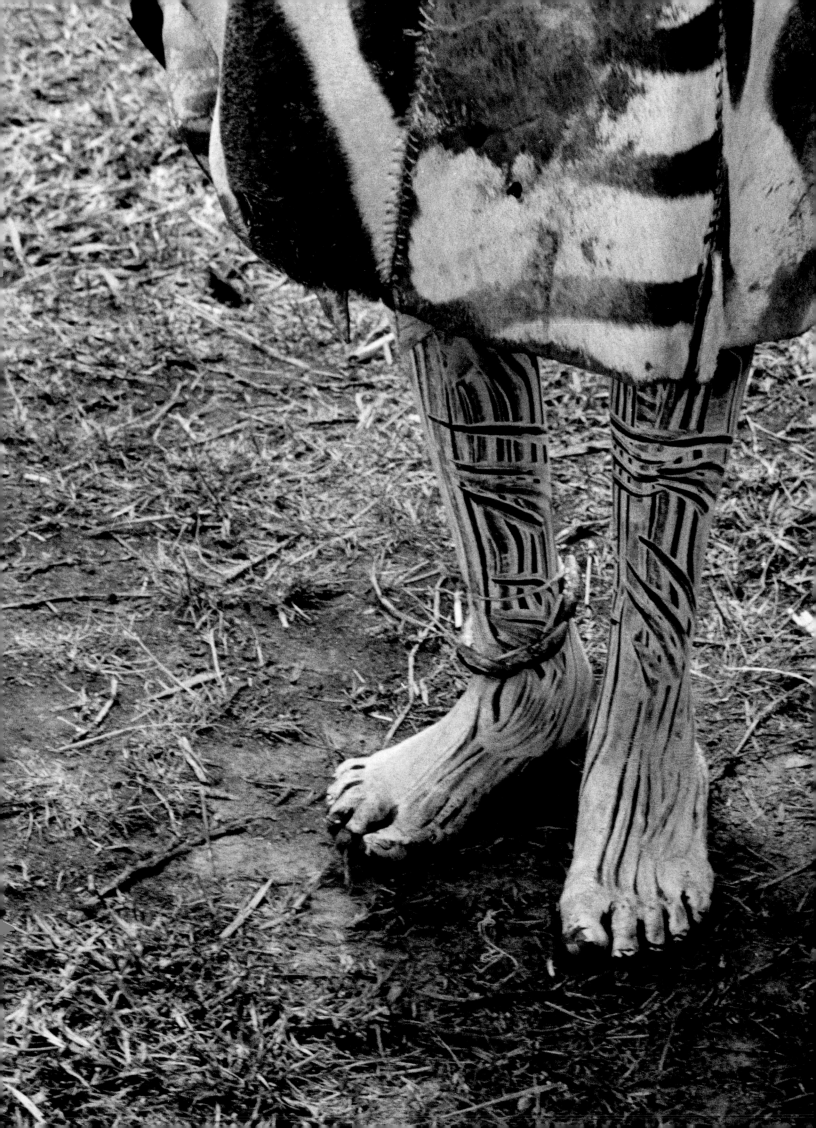

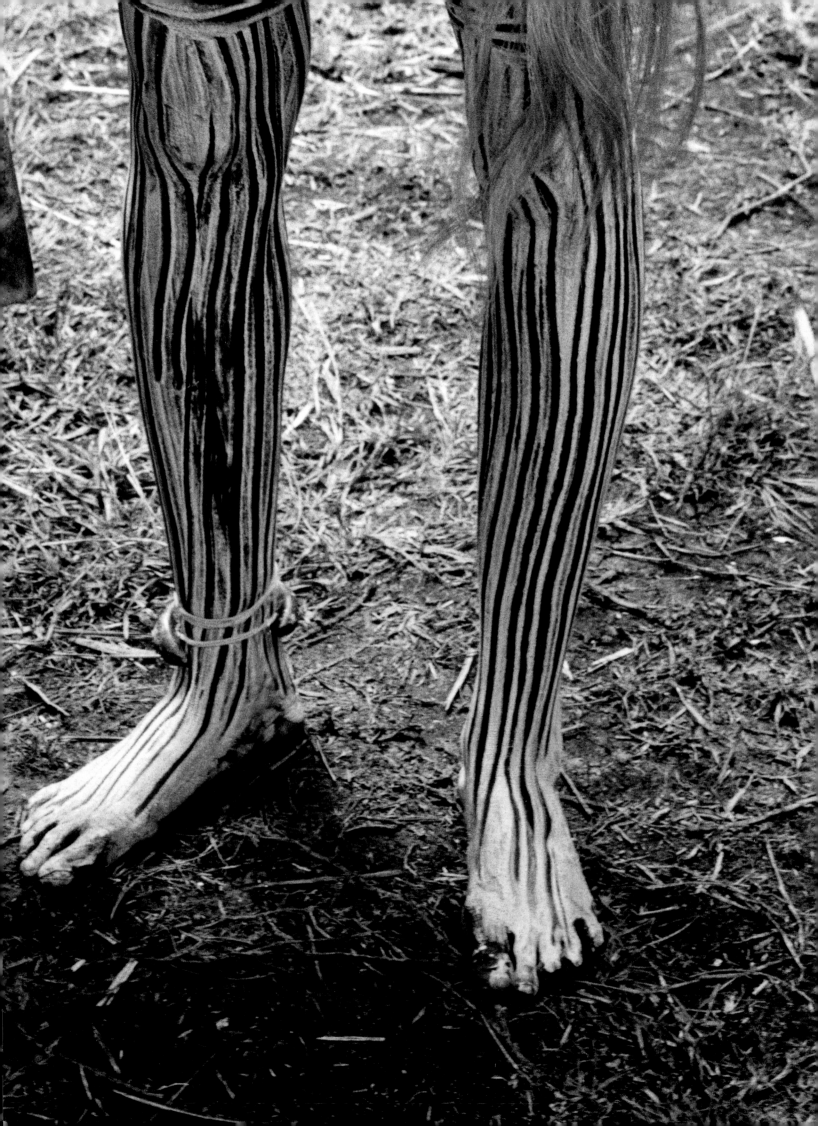

Zulu woman, South Africa, 1968. After the Group Areas Act was passed on 13 June 1950, most black South Africans were forced to move to the so-called Bantu homelands.

Woman in 'white district', Cape Town, South Africa, 1968. Black people who worked in the 'white districts' could not live there, but had to live in townships. Starting in the 1960s, these became centres of protests against apartheid.

left: **Mining slag, Johannesburg, South Africa, 1968.** In the background is the skyline of Johannesburg.
top right: **Landscape study of lake, South Africa, 1968.**
bottom right: **Landscape study of wasteland, South Africa, 1968.**

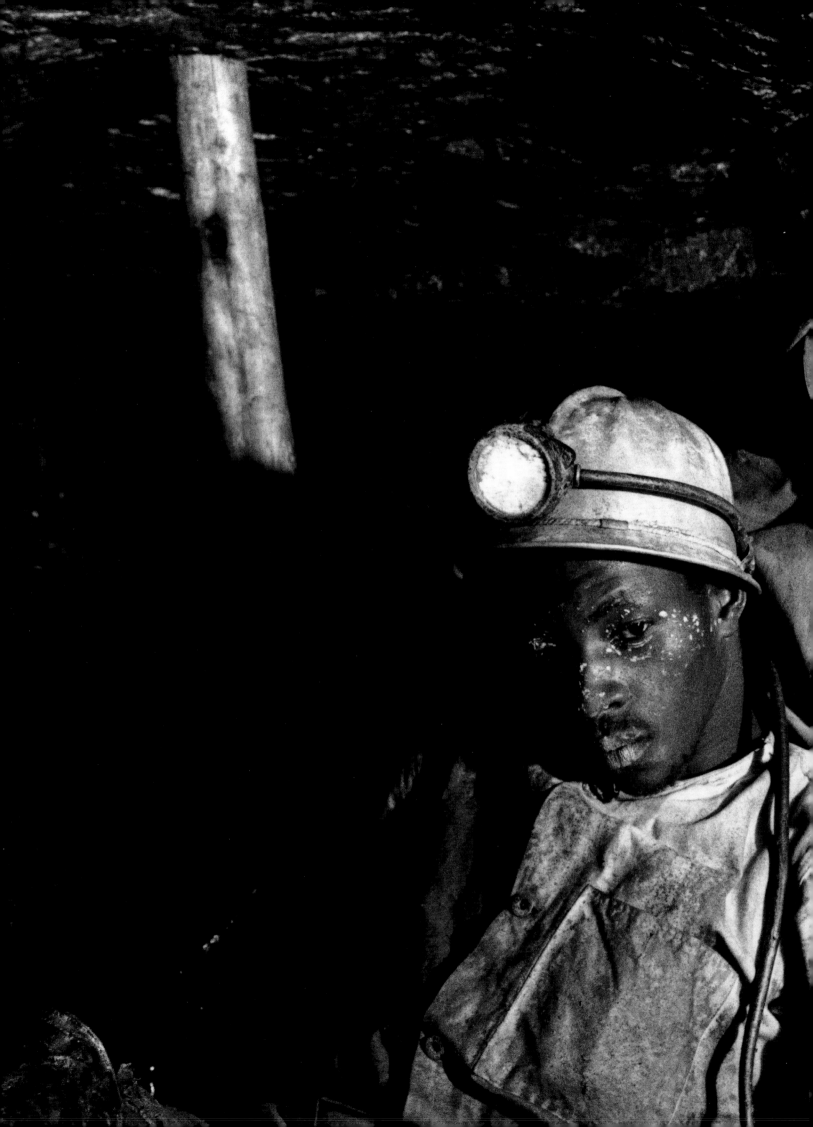

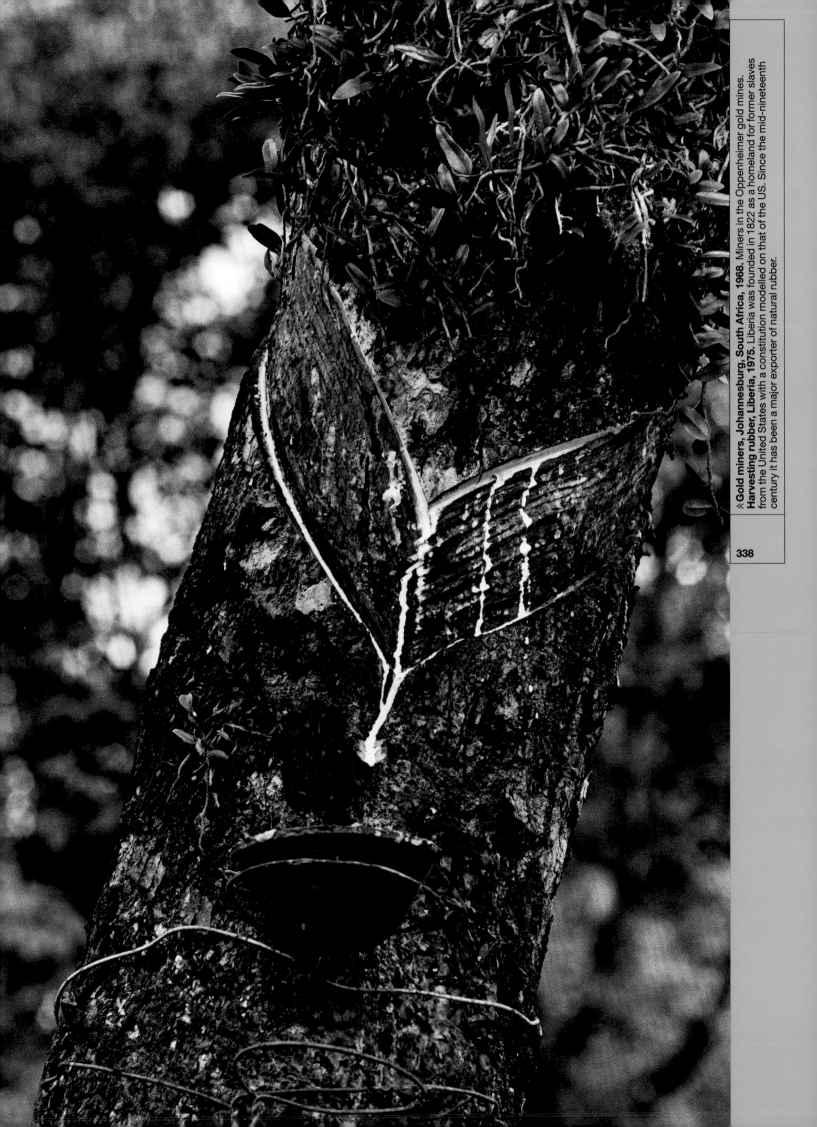

《 **Gold miners, Johannesburg, South Africa, 1968.** Miners in the Oppenheimer gold mines. **Harvesting rubber, Liberia, 1975.** Liberia was founded in 1822 as a homeland for former slaves from the United States with a constitution modelled on that of the US. Since the mid-nineteenth century it has been a major exporter of natural rubber.

Child, Liberia, 1975. The country has been recognized as an independent republic since 1847.

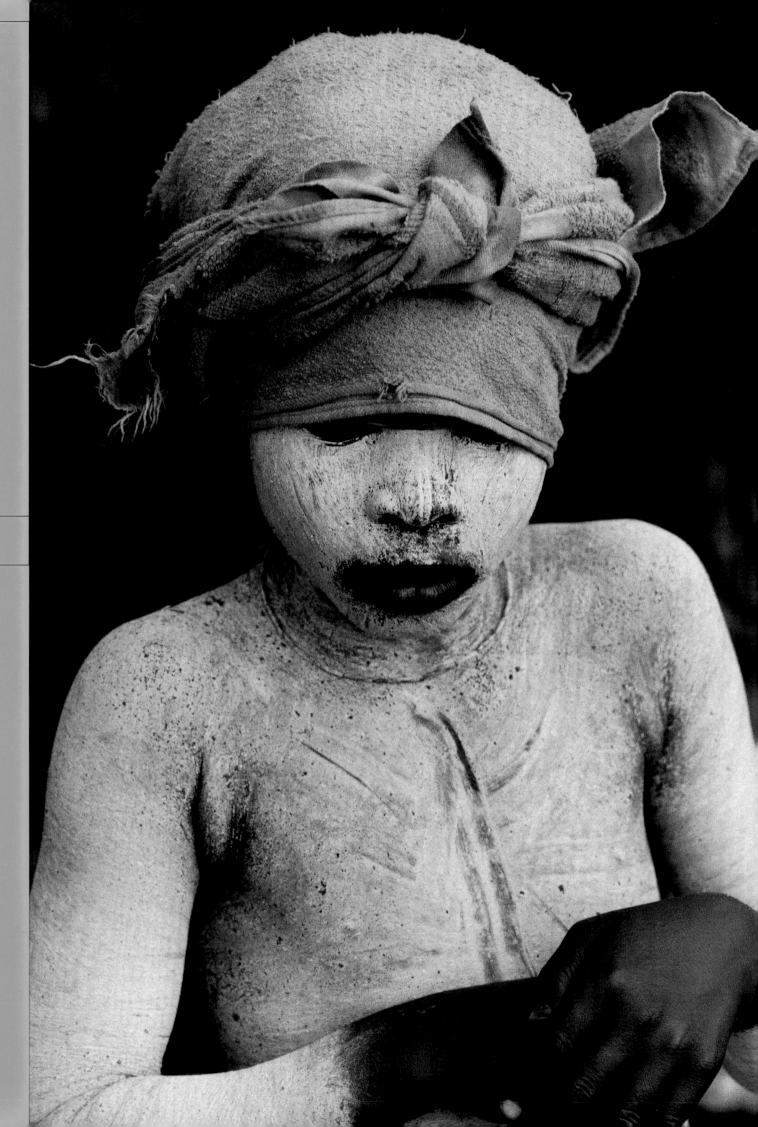

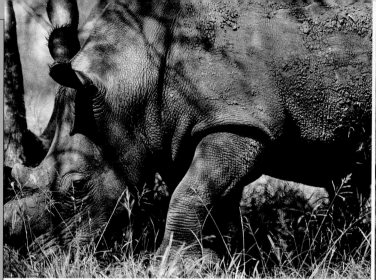

left: **Rhinoceros, Mala Mala Game Reserve, South Africa, 1968.**
right: **Animal traps, Mala Mala Game Reserve, South Africa, 1968.**
≫**Ranger, Mala Mala Game Reserve, South Africa, 1968.**
Smaller than the better-known Kruger National Park, Mala Mala was a favourite with rich whites.

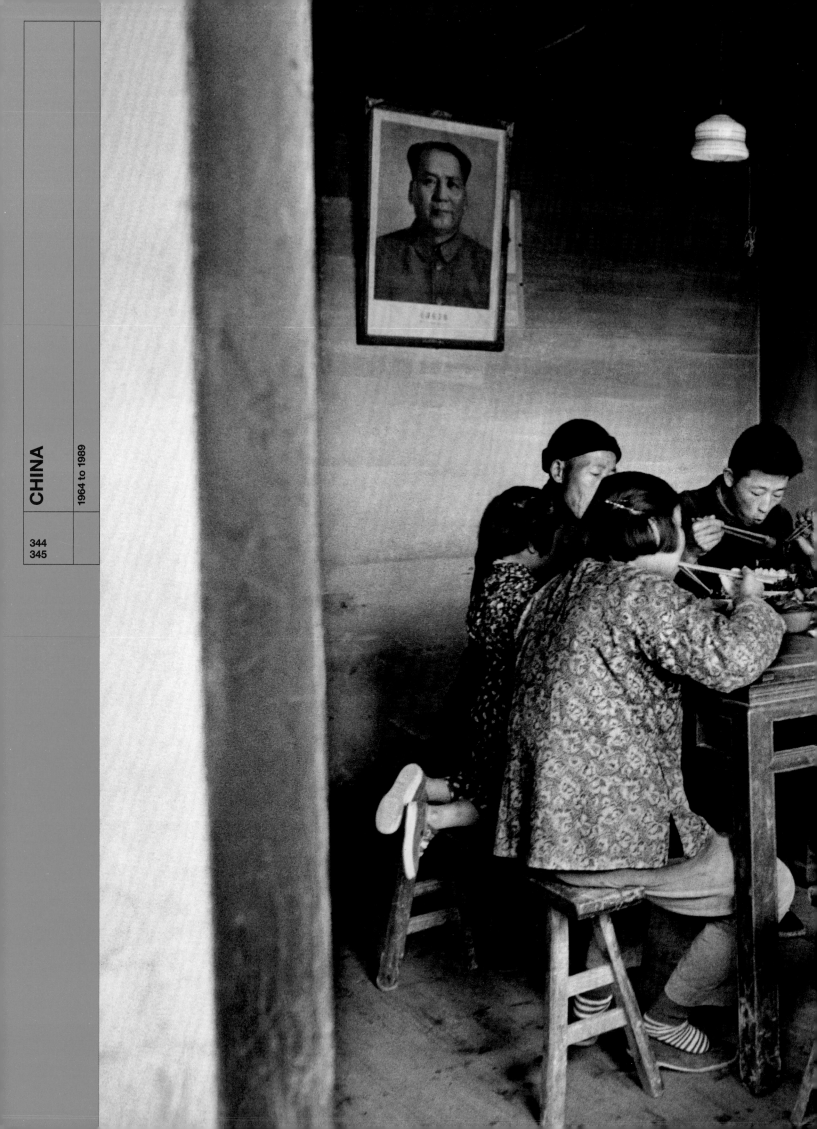

René Burri first visited China in 1964, fifteen years after the Communist victory over the Nationalist government and the founding of the People's Republic. China was still isolated from the rest of the world in those days, a *terra incognita* that was almost inaccessible to Western photographers and journalists. Obtaining a visa was something of an adventure, but the advantages were considerable. Photographs from within China were guaranteed to attract attention in a curious West.

In 1972 the Metropolitan Museum of Art in New York ran an exhibition entitled 'Behind the Great Wall of China'. It examined the work of photographers ranging from the nineteenth century to the present day. The collection offered a tantalising glimpse of a distant, alien and politically isolated culture that had expressed no interest in engaging in a dialogue with the Western world. At the heart of the exhibition were works by Henri Cartier-Bresson who had spent a number of months in China in 1949 and several more weeks in 1958. Next to these were photographs by Marc Riboud and Burri, two of the few Westerners who had been allowed to photograph China in the 1960s. The exhibition at the Metropolitan was actually Burri's second opportunity to present his impressions of China in a prominent forum. In 1966 the Zurich gallery Form had run an individual exhibition on the subject entitled 'China', Burri's first one-man show.

The first of his many futile attempts to obtain a visa for China was in the late 1950s. And when his dream of visiting the country finally became a reality, it was in an entirely unexpected fashion. As the unofficial in-house photographer for Pakistan International Airlines (PIA), he was present at the opening ceremonies for the first international air connection from Karachi to Shanghai and Beijing. This was an important political development that was as much a surprise for the Russians as it was for the Americans. On a smaller scale, however, it was an opportunity for the young photographer to add a topic of international importance to his already widely admired collection of reportages from Europe, Latin America and the Middle East.

The China that Burri entered in April and May of 1964 was a lonely giant within the international community. Its ties to Russia had been definitively severed, the Russian advisors having left the country four years earlier. 'But for how long?' asked Robert Guillain in his ten-part series for *The Washington Post* in 1964, illustrated by Burri.

In addition to the series in *The Washington Post*, Burri's photographs of China were also published in *Life* in November 1964 (p. 440, nos 1–2, 4). Although cut down to six pages due to the sudden death of Indian prime minister Jawaharlal Nehru, the photo essay entitled 'Red China – Spruced up for Show' was an important landmark in Burri's career. Burri returned to China at the end of that same year aided by the Swiss ambassador Walter Keller. Between May and September of 1965 Burri and his wife Rosellina prepared a three-part film for *Encyclopedia Britannica*. In 1968, the fifty-minute BBC documentary *The Two Faces of China* was created using this same material. Burri justifies his change from photography to film by citing the editorial policies of the big illustrated magazines and journals. He felt that they were becoming too restrictive. Of course, this did not keep Burri from pursuing his own personal assignments in black-and-white.

In 1985 Burri returned to China once more. The result was an article for *Stern*, and other magazines, about the fiftieth anniversary of Mao Tse-tung's Long March. His most recent trip was in 1989 when he was witness to the peaceful student protests in Tiananmen Square. When the protests were eventually put down in a bloody massacre, Burri did not let his horror at the event affect his fundamental sympathy and affinity for China. For all its problems, China is for Burri a place of immense spirit and energy, and he has sought to engage with Chinese culture time and time again.

» **Propaganda poster, Shanghai, 1964.** Near the Nanking Road: a propaganda poster against US imperialism.

347

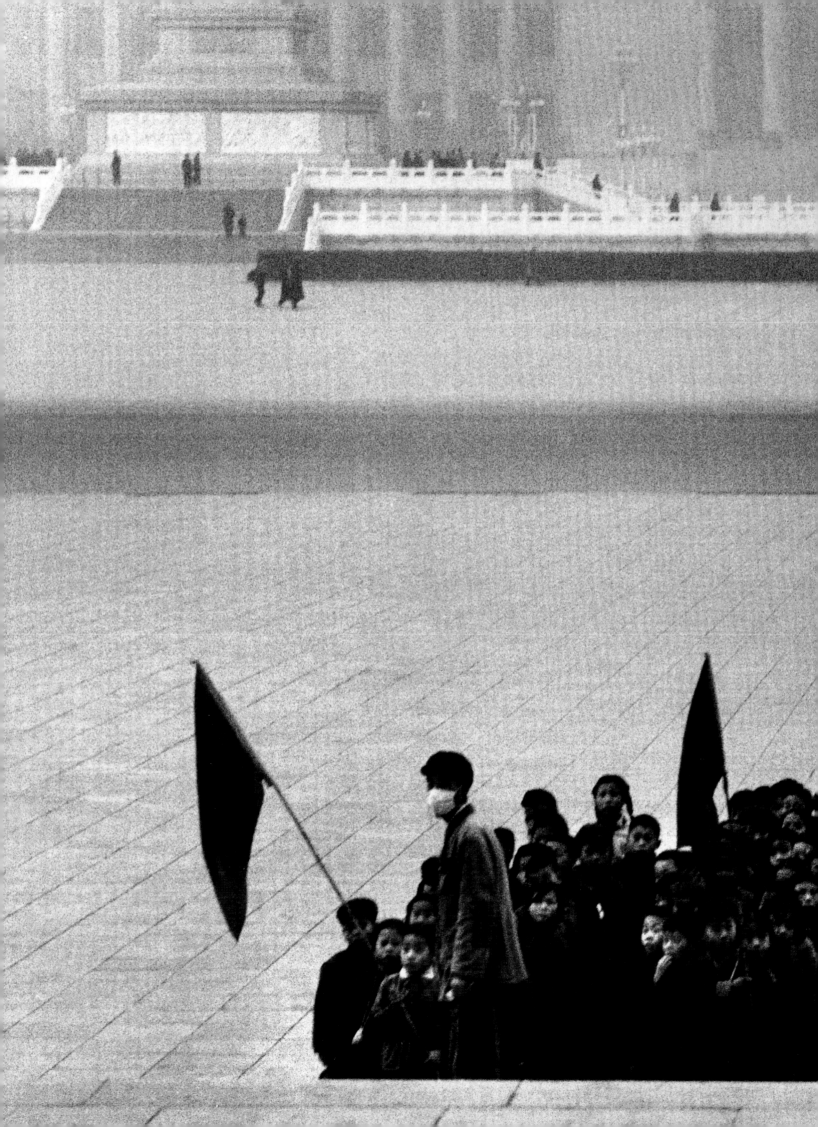

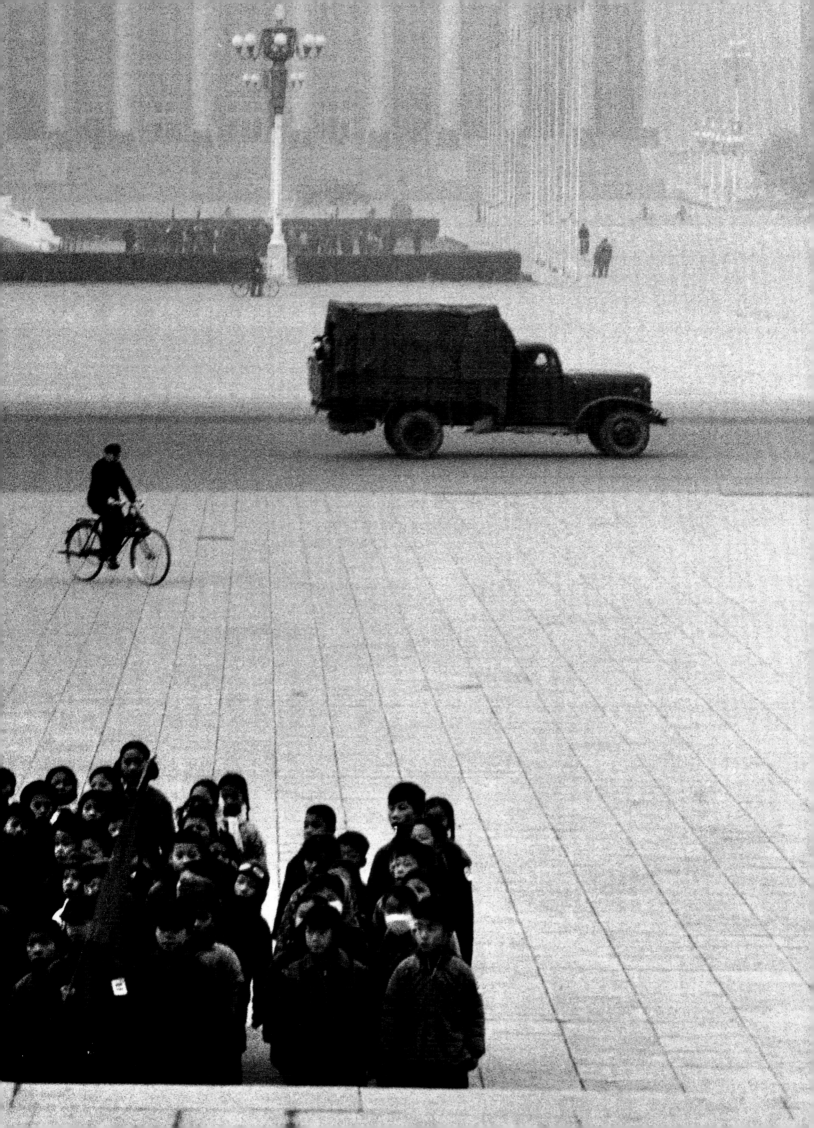

≪ **Young Pioneers, Tiananmen Square, Beijing, 1964.** In front of the Museum of the Revolution.
left: **Local men, Guangdong, 1964.**
right: **Portrait of Sun Yat-sen, Tiananmen Square, Beijing, 1989.** Sun Yat-sen was the founder of the revolutionary party the Kuomintang.

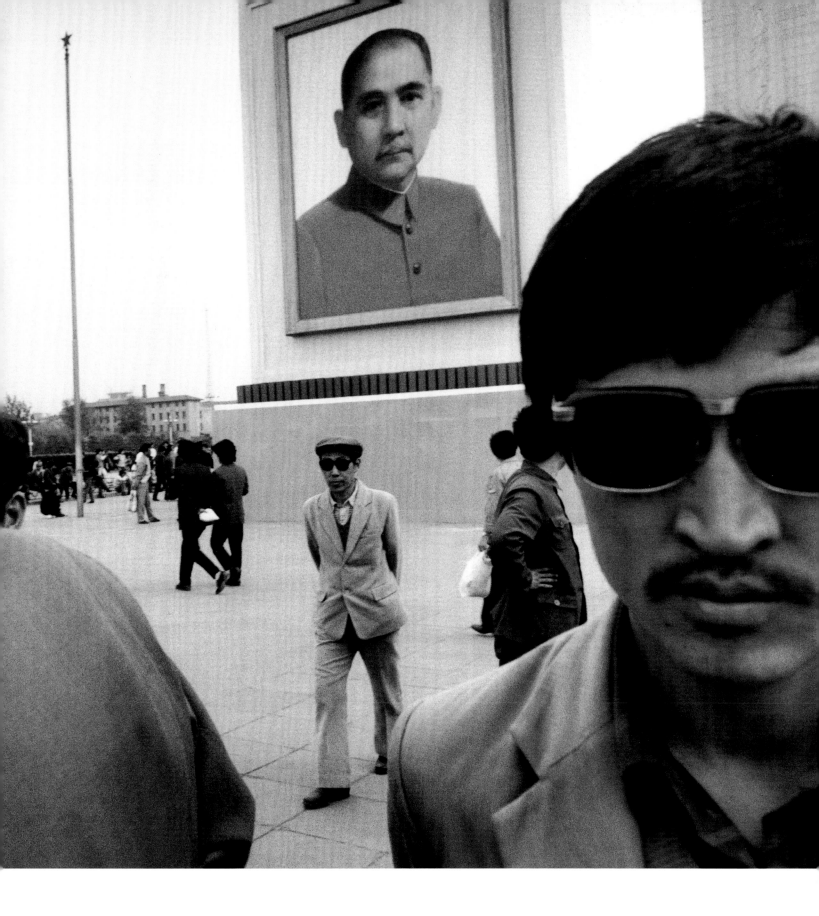

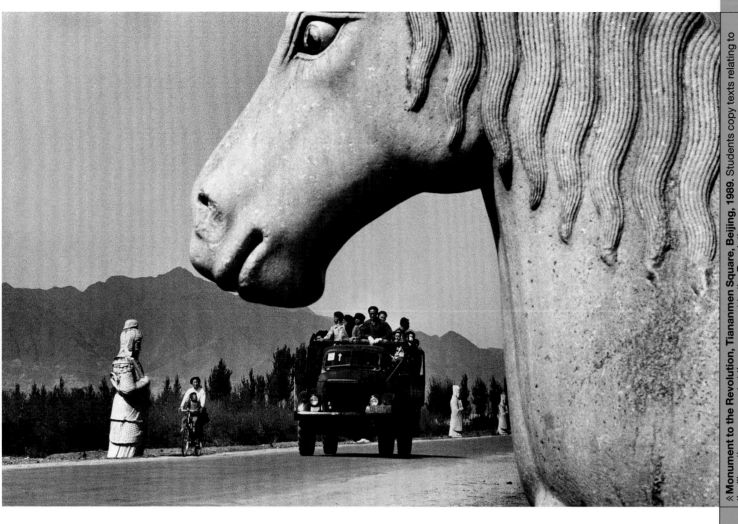

≪ **Monument to the Revolution, Tiananmen Square, Beijing, 1989.** Students copy texts relating to the liberation movement at the monument to the Revolution.

Ming statues, on the road to Badaling, 1964.

Soldiers in Tiananmen Square, Beijing, 1989. Soldiers try to stop a group of students; they have not yet resorted to force.

Old man praying in pagoda, Wu Shi, 1964. Wu Shi is often called the Venice of China.

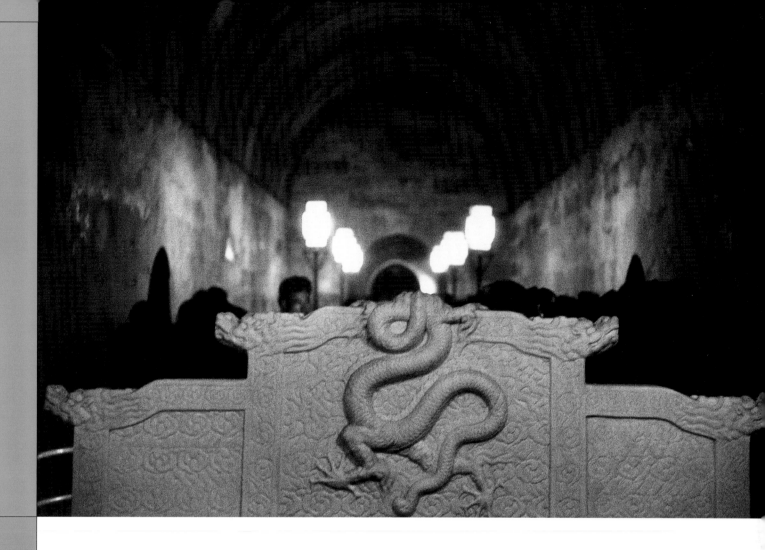

Ming dynasty tombs, near Badaling, 1964.

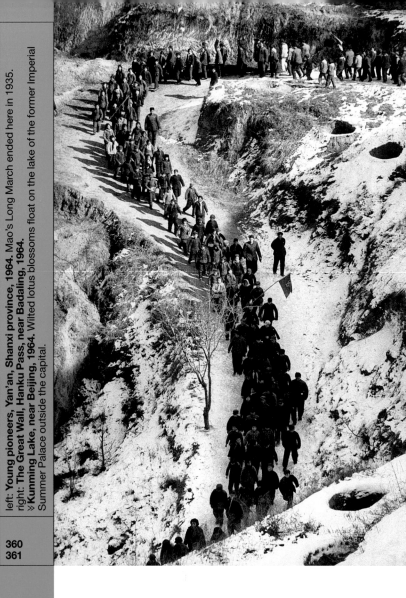

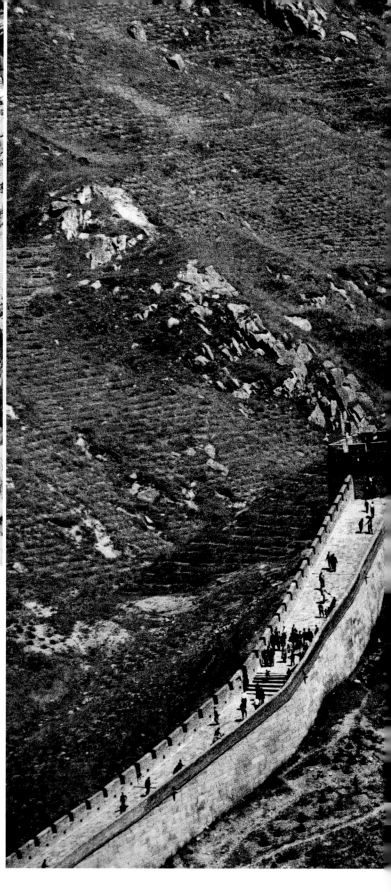

left: **Young pioneers, Yan'an, Shanxi province, 1964.** Mao's Long March ended here in 1935.
right: **The Great Wall, Hanku Pass, near Badaling, 1964.**
≫ **Kunming Lake, near Beijing, 1964.** Wilted lotus blossoms float on the lake of the former Imperial Summer Palace outside the capital.

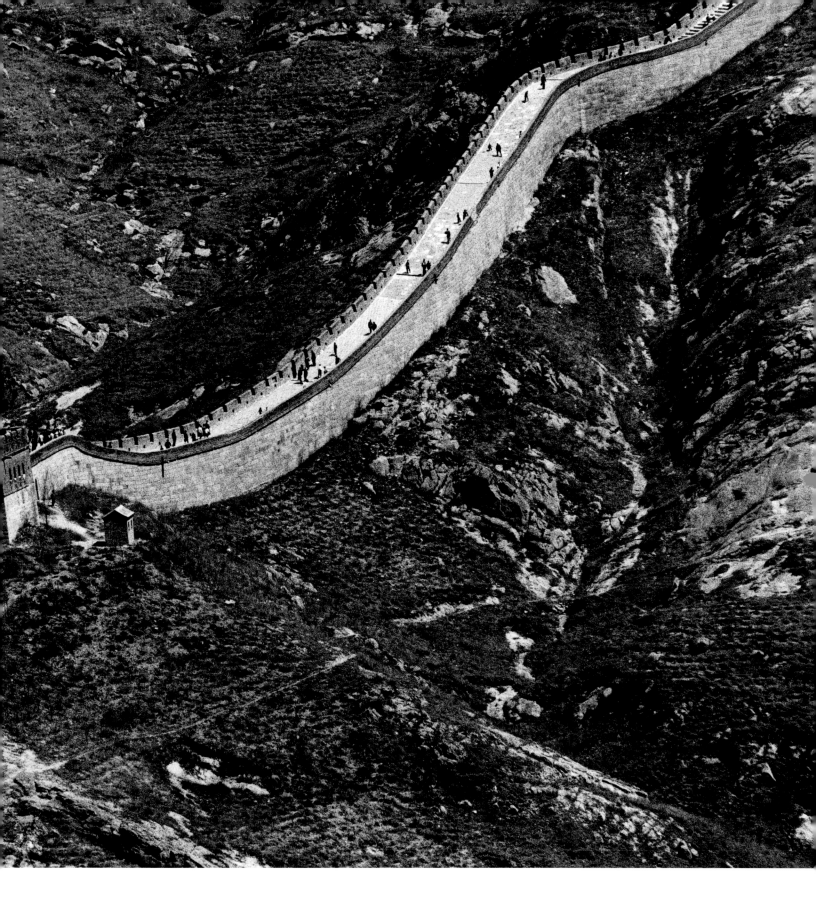

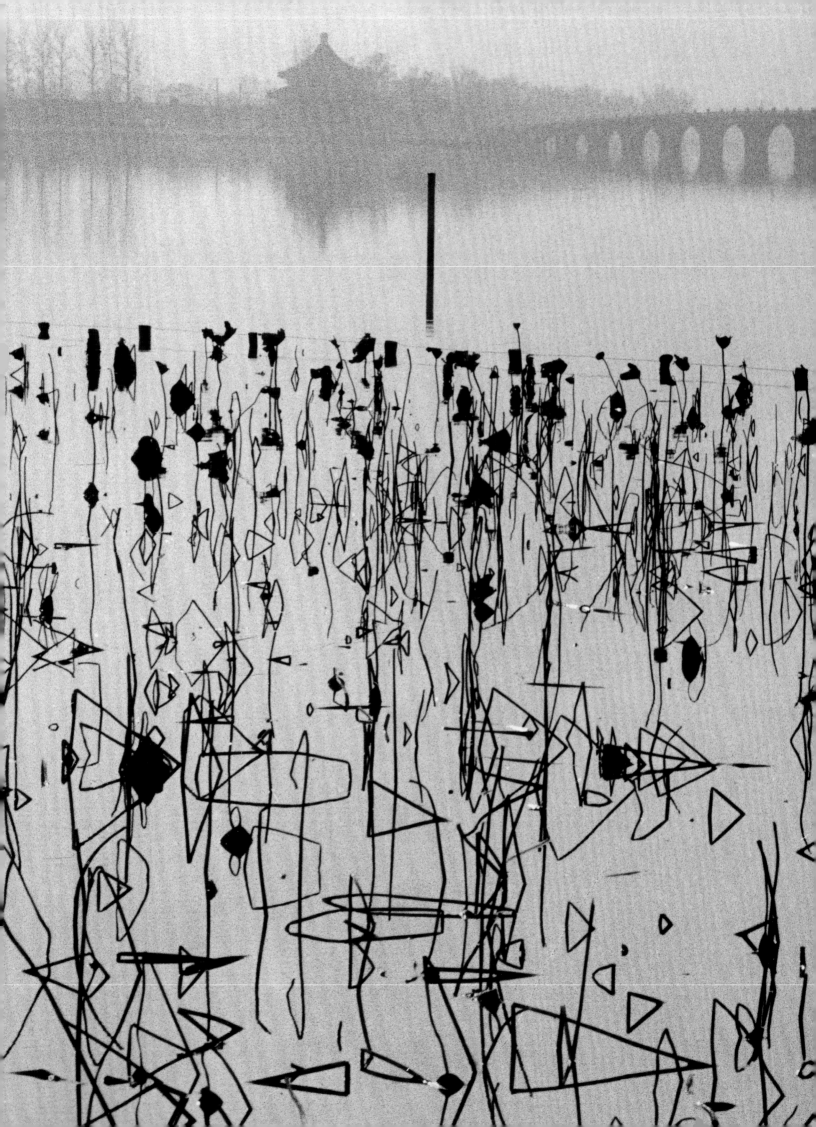

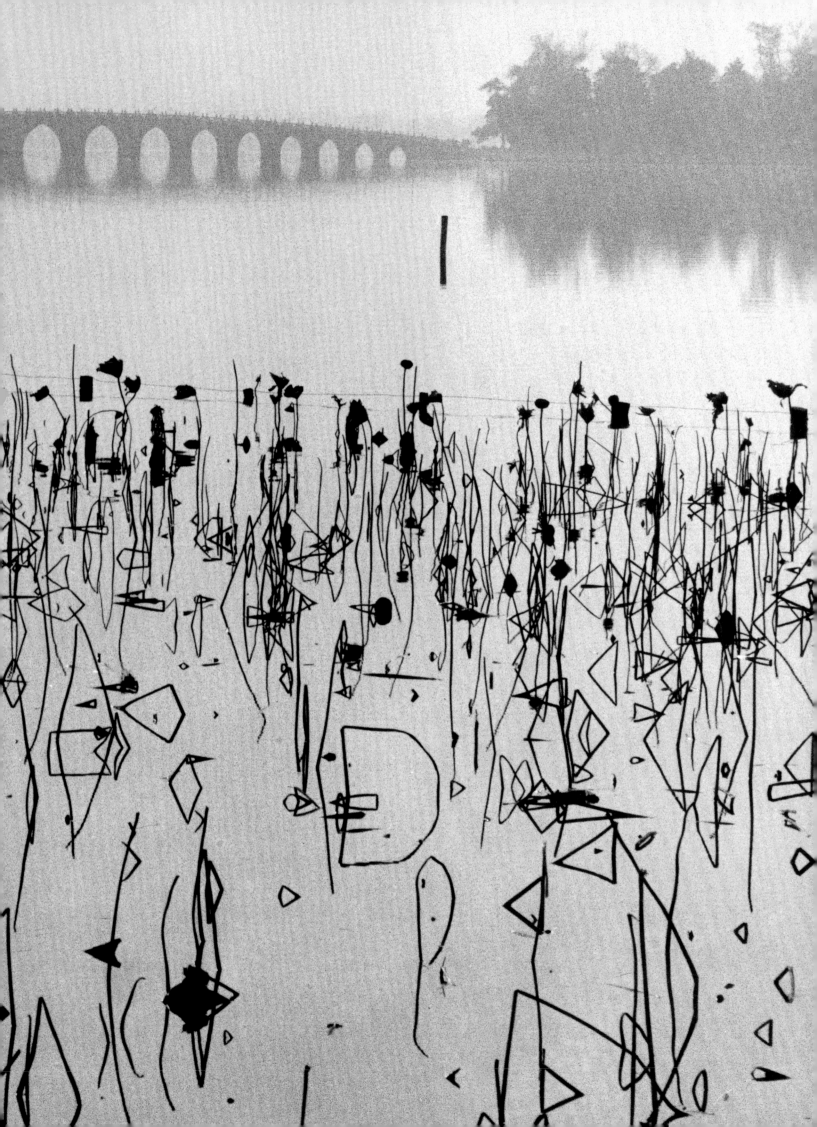

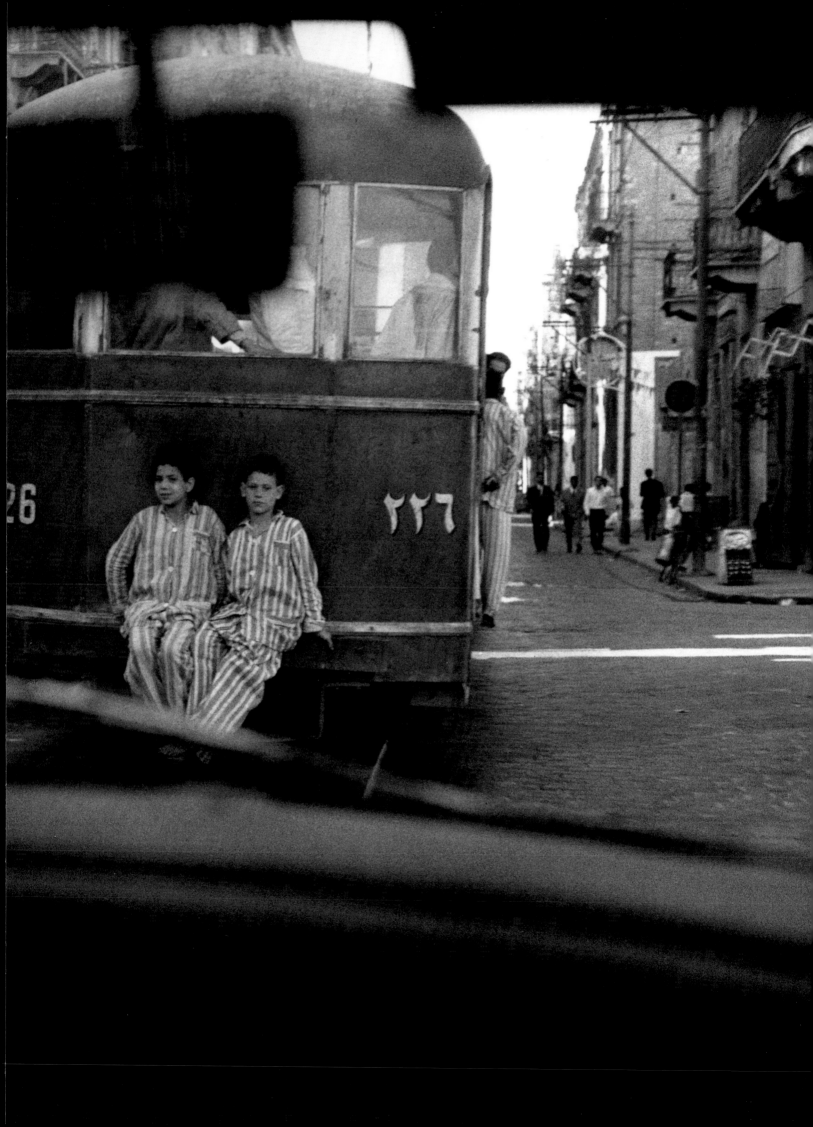

If René Burri ever fit the definition of a photojournalist, it was during the late 1950s when he was working in the Middle East. Of course, Burri also reported on numerous important events in the 1970s and 1980s. But the years between 1956 and 1960 were exceptionally turbulent for Burri, and his hectic travel schedule matched precisely the popular image of the photojournalist at the time. Press photography was just coming of age, and its promise of travel and adventure had begun to lure professionals from other photography fields, including Walter Bosshard, Gotthard Schuh and Paul Senn, to name only a few Swiss converts. Though he had never planned on entering the world of photojournalism, Burri's success was particularly spectacular and rapid. This was due to three fortuitous elements. First, his youth made the considerable physical demands of the profession easier. Second, the 1950s were the heyday of the illustrated weeklies such as *Life*, *Look*, *Paris-Match* and *Jours de France*, and good reporters and photographers were desperately needed. Third, the increasingly alarming events in the Middle East necessitated coverage in the media. The historian Eric Hobsbawm was hardly the first person to refer to the Middle East as a 'powder keg'.

As a metaphor, this epithet is not entirely correct. The Middle East of the late 1950s was not on the verge of a single all-encompassing explosion, but was wracked by a continuous and escalating series of coups, revolutions and regional wars. Burri followed these developments from the 1950s to the mid-1980s. His involvement began in Prague in the summer of 1956 when he received a telephone call from the Magnum bureau in Paris. Egypt's president, Gamal Abdel Nasser, had nationalized the Suez Canal. This was tantamount to a declaration of war on England and France and also served as the spark that eventually ignited the second Arab–Israeli war on the Sinai Peninsula which lasted from October to November 1956. The situation in the region was exceedingly tense. Georg Gerster, who accompanied

Burri on the last tanker through the Suez Canal, recalls that they felt as if they were at the 'centre of the hurricane'. He was even mistaken for a British spy because of his camera and was almost lynched by a mob of angry civilians. Only through the intervention of the director of Port Said was he spared.

Burri's breathtaking reportages were published in quick succession by *Bunte Illustrierte*, *Sie und Er*, *Jours de France* (p. 436, nos 1–2), *Paris-Match* (p. 436, nos 3–4; p. 437, nos 1–2, 4), and Zurich's *Weltwoche*. Next, Burri covered the short-lived union of Syria and Egypt as the United Arab Republic, and he travelled to Baghdad after General Kassem seized power, putting a bloody end to the Iraqi monarchy. He reported on the construction of the Aswan Dam, where he discovered that Algerian National Liberation Front (FLN) fighters were trained at the military training camp in Cairo (pp. 386–7).

In 1960, against cut-throat competition, Burri had successfully captured the most spectacular picture of the long-awaited successor to the Iranian throne. He would report from Iran time and again. Through the 1970s and 1980s he travelled extensively in the region, visiting Israel and Lebanon alongside Syria and Egypt; in 1974, he reported on the planned re-opening of the Suez Canal for *The Sunday Times Magazine* (p. 444) and *Stern*. And in 1989 he delivered a portrait of the Nobel prize winner for literature, the Egyptian novelist Naguib Mahfouz, to *Schweizer Illustrierte* (p. 420).

His photographs for the magazines were in colour, but he almost always used black-and-white in his personal work. By turning his official assignments into opportunities to pursue his own creative photography, Burri was able to supplement restrictive magazine aesthetics with his own interpretations of events and places. His independent style betrays his awareness that television would soon transcend printed journalism. His prognosis on the subject in 1959 after his story on the return of Archbishop Makarios to Cyprus had become a global reality by 1989.

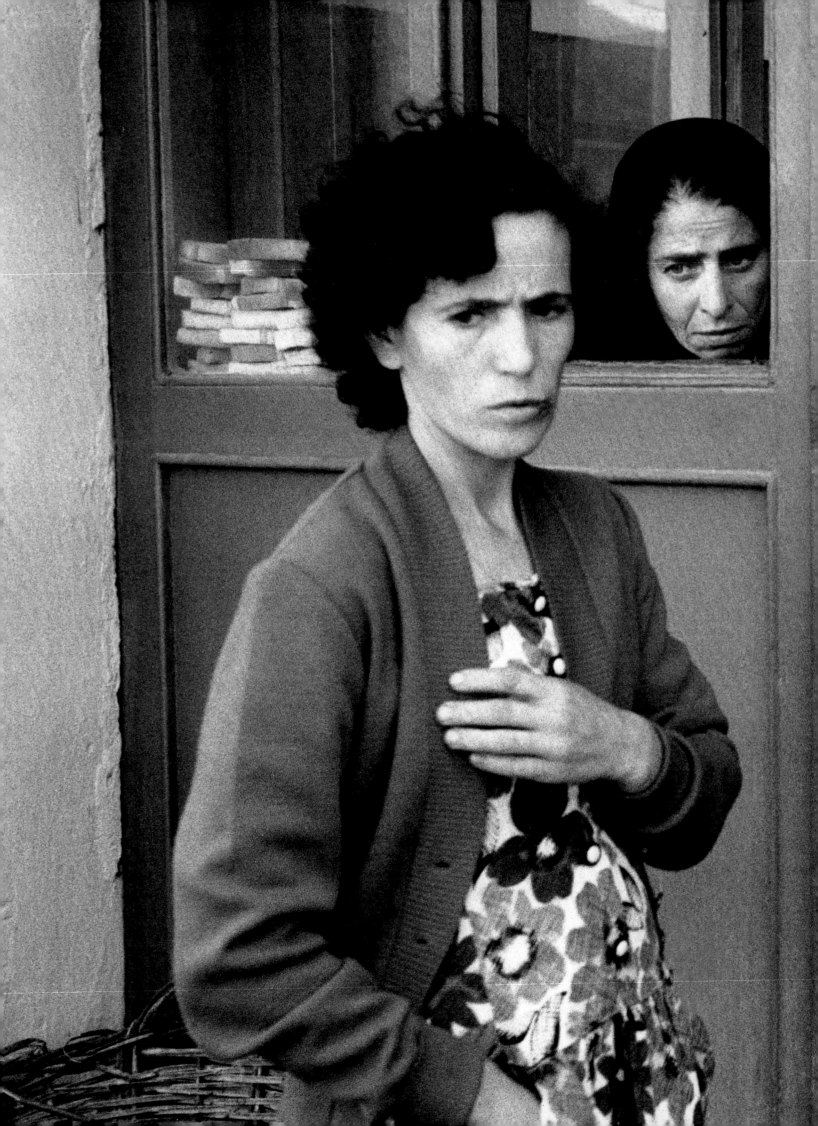

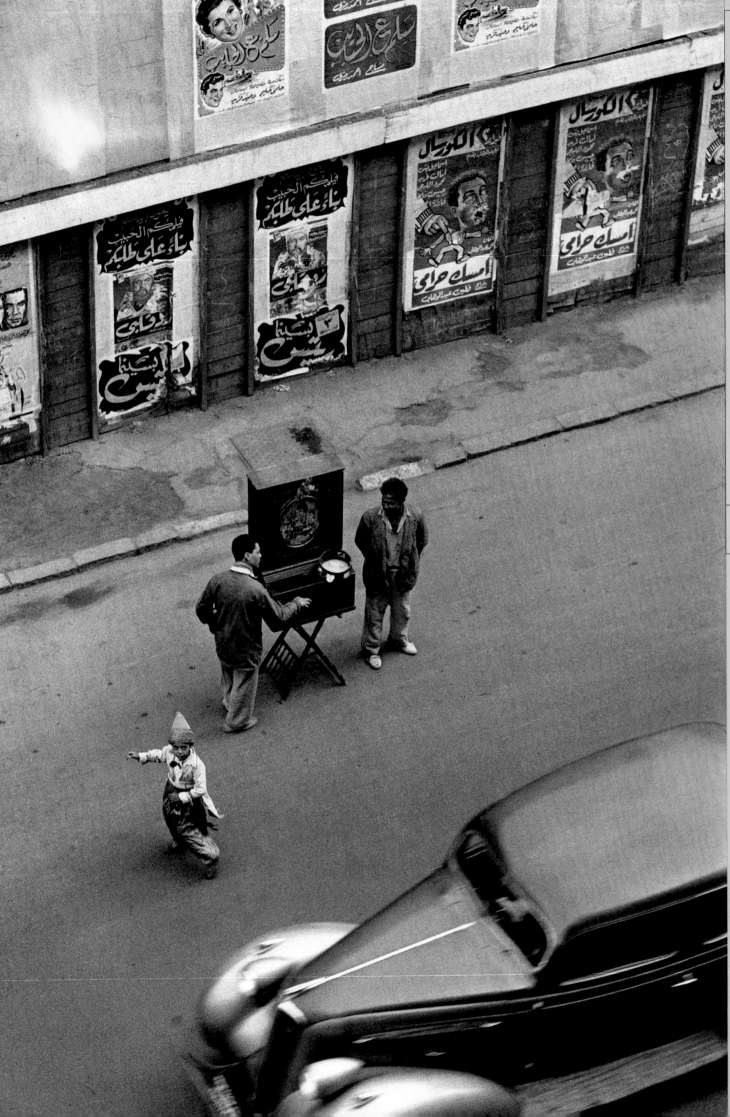

Street entertainer, Cairo, Egypt, 1958. View from the Hotel Windsor onto Cairo's inner city.

Garden restaurant, near Tehran, Iran, 1960.

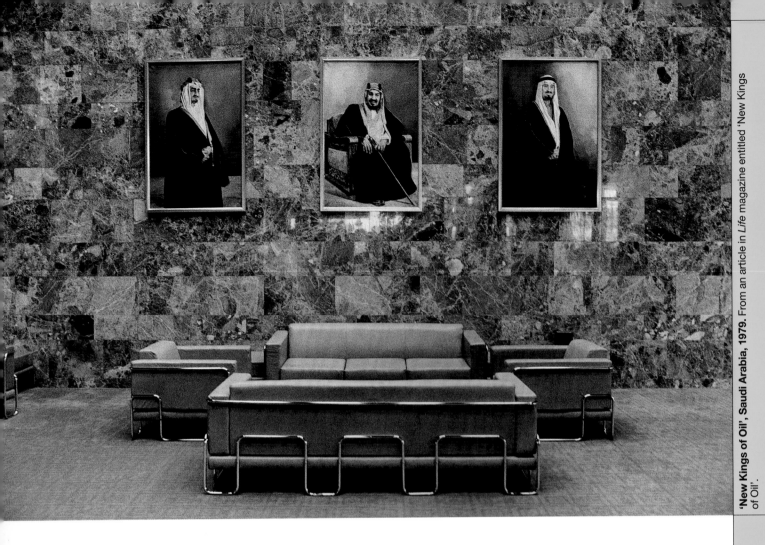

'New Kings of Oil', Saudi Arabia, 1979. From an article in *Life* magazine entitled 'New Kings of Oil'.

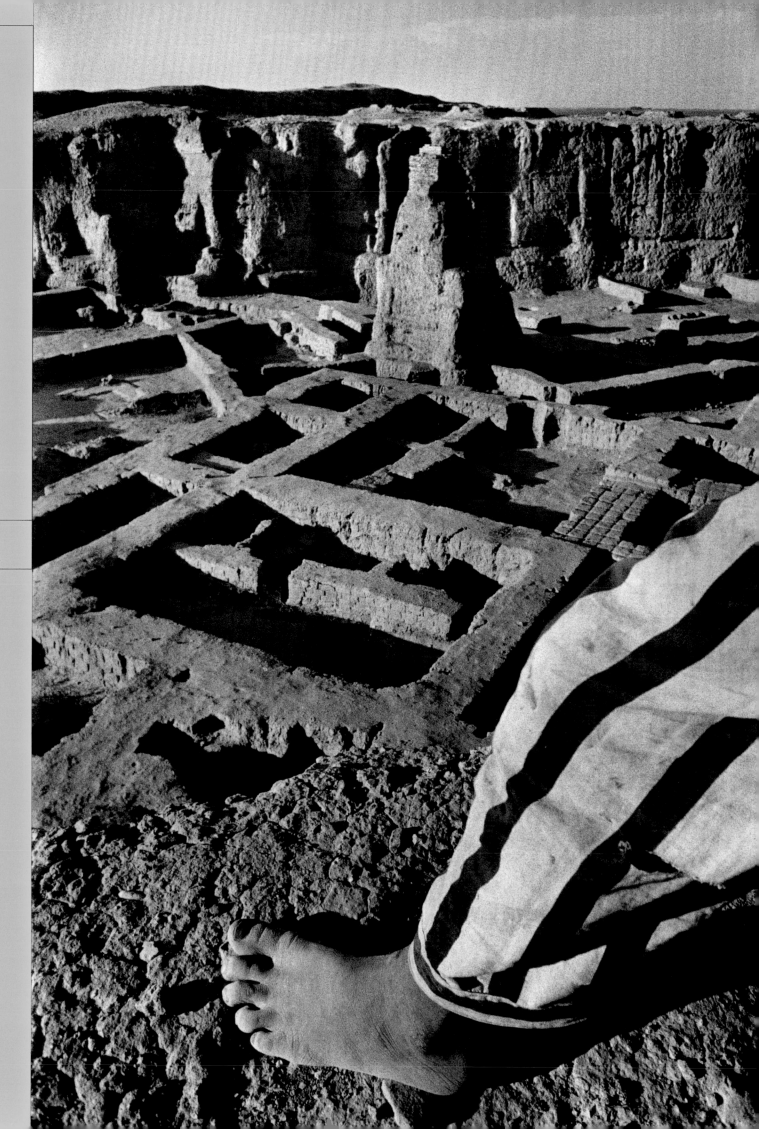

Archaeological site, Shoosh, Khuzestan, Iran, 1960.

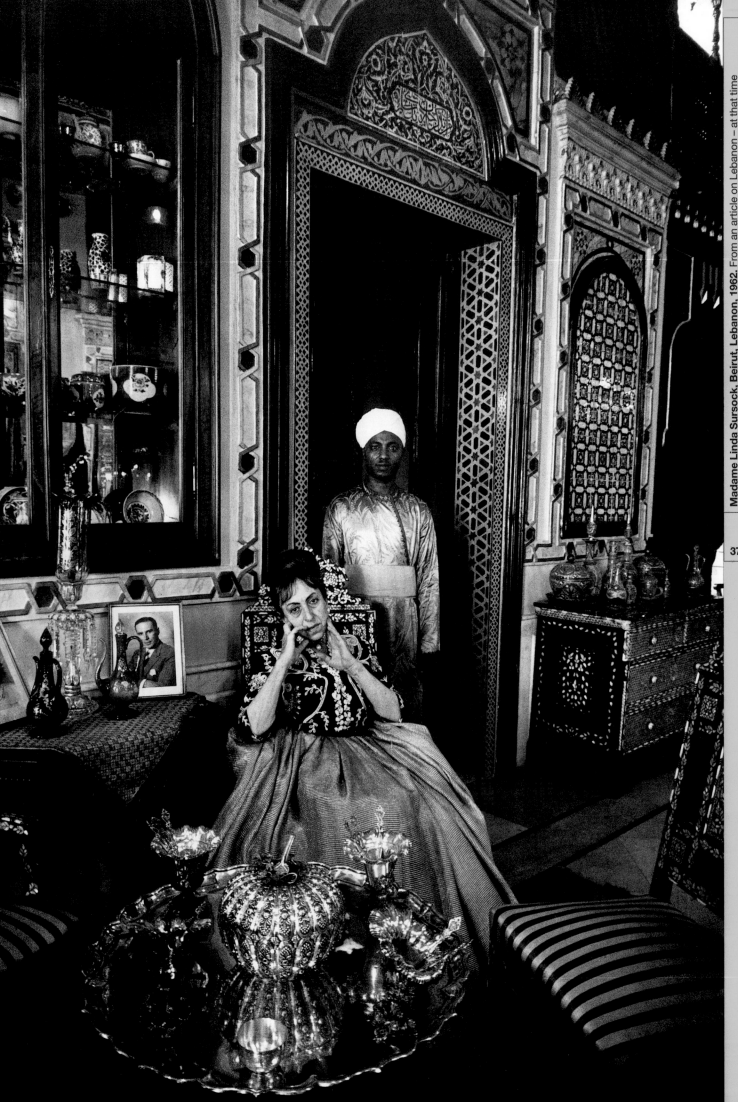

Madame Linda Sursock, Beirut, Lebanon, 1962. From an article on Lebanon – at that time considered the 'Switzerland of the Middle East' – for *Vogue*. Madame Linda Sursock was described by *Vogue* as 'an extraordinary woman … [who] lives surrounded by multiple riches, marble pools and a changing mosaic of celebrities – a Sursock invitation is the symbol, the cachet of a VIP life.'

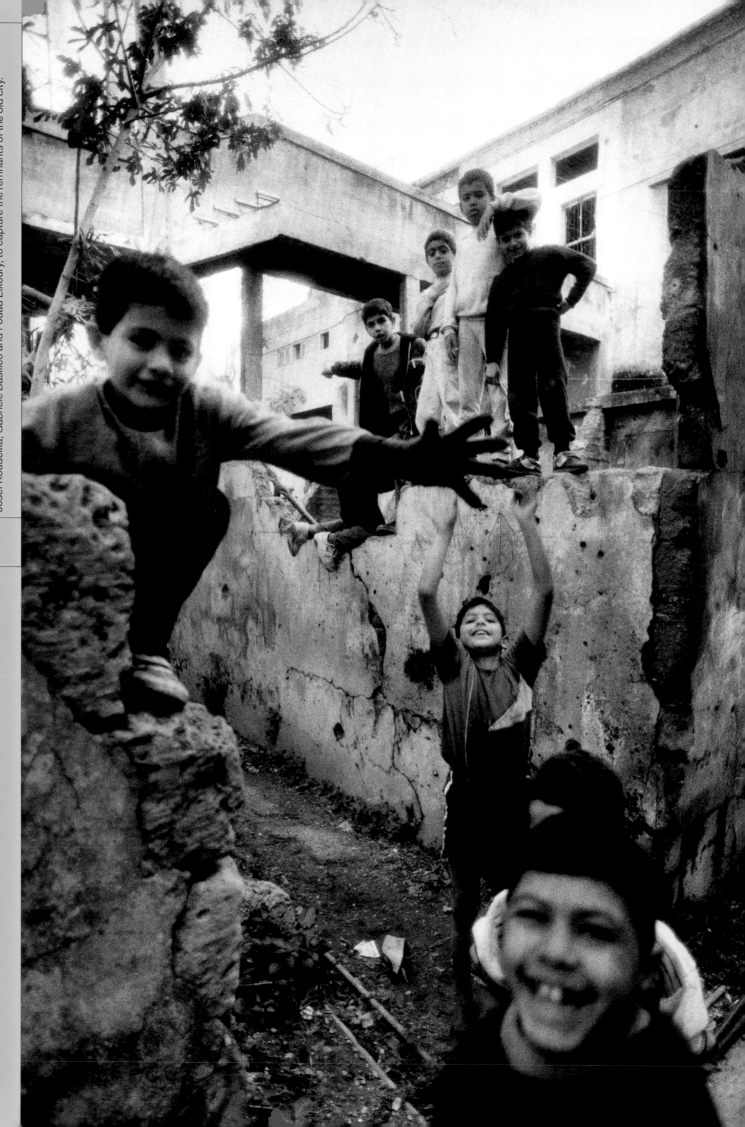

Children playing in ruins, Beirut, Lebanon, 1991. The old city reduced to rubble by successive conflicts. A wealthy Lebanese client commissioned Burri, alongside Robert Frank, Raymond Depardon, Josef Koudelka, Gabriele Basilico and Fouad Elkoury, to capture the remnants of the old city.

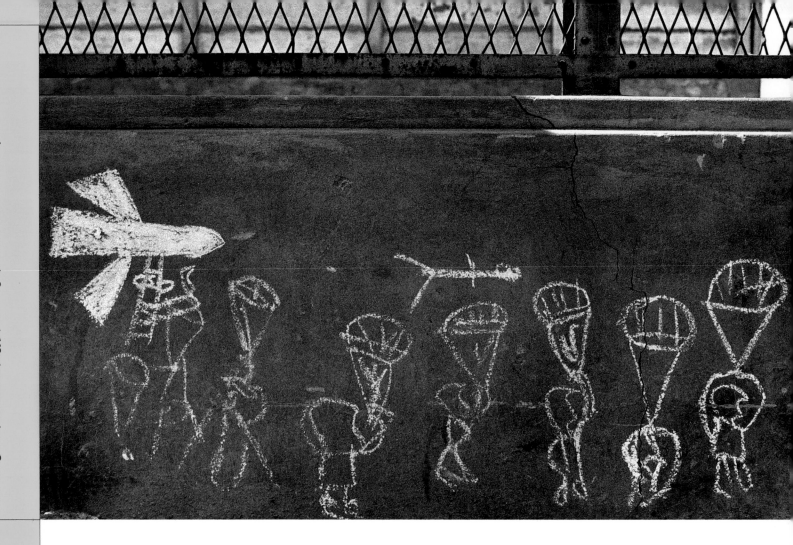

Children's graffiti, Suez Canal, Egypt, 1967. A graphic reminder of the Six Day War.

Hieroglyphics, Luxor, Upper Egypt, 1970.

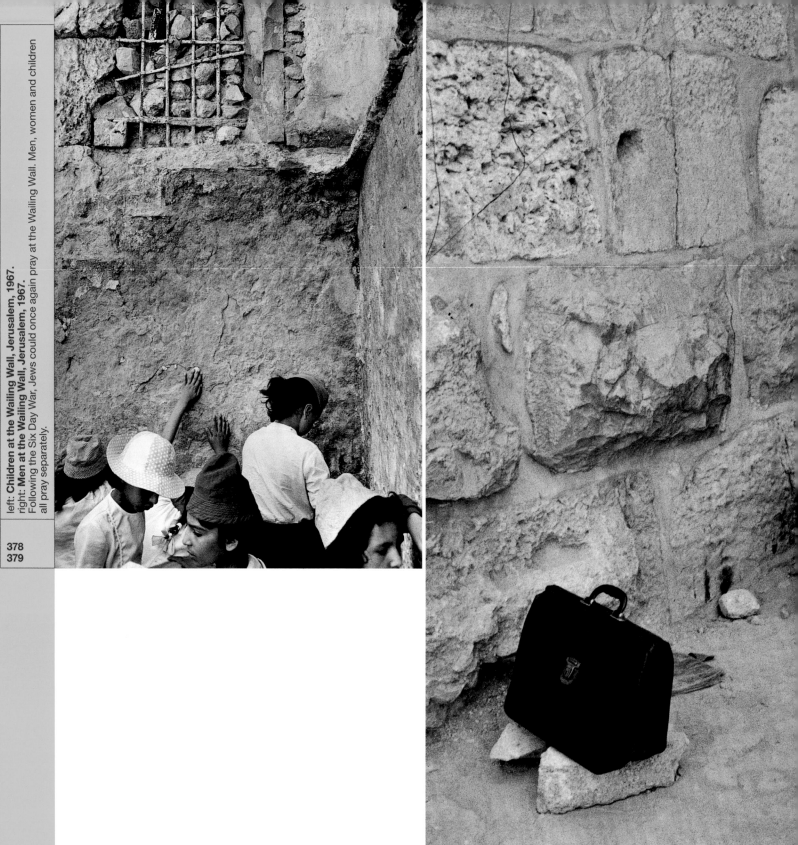

left: **Children at the Wailing Wall, Jerusalem, 1967.**
right: **Men at the Wailing Wall, Jerusalem, 1967.**
Following the Six Day War, Jews could once again pray at the Wailing Wall. Men, women and children all pray separately.

378
379

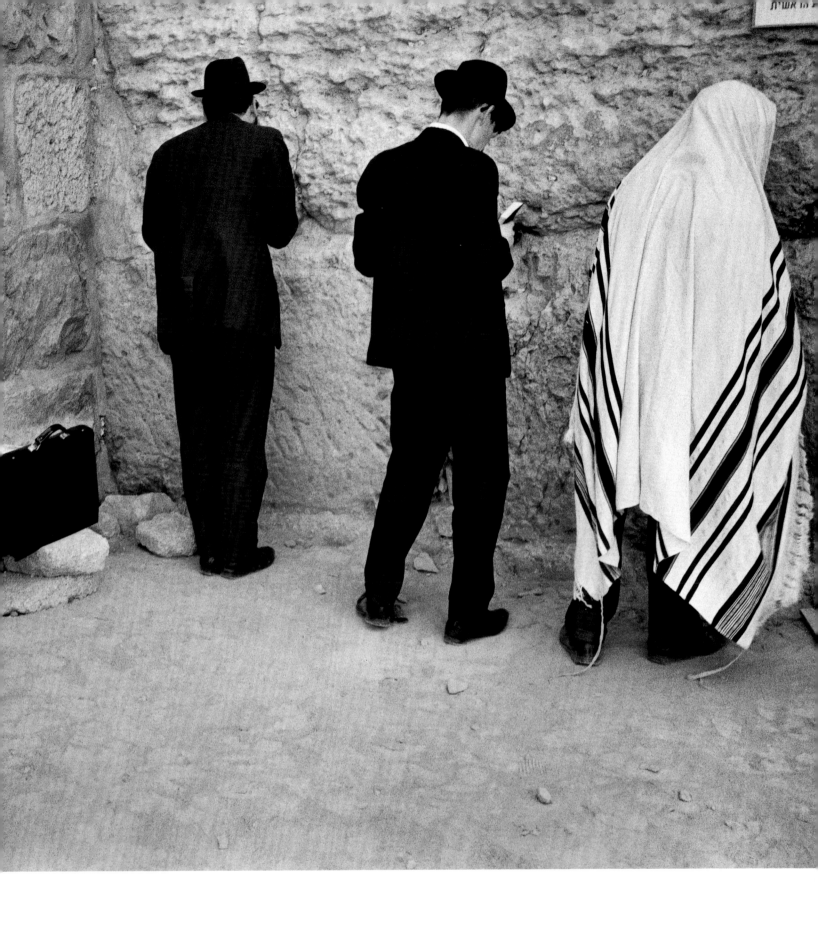

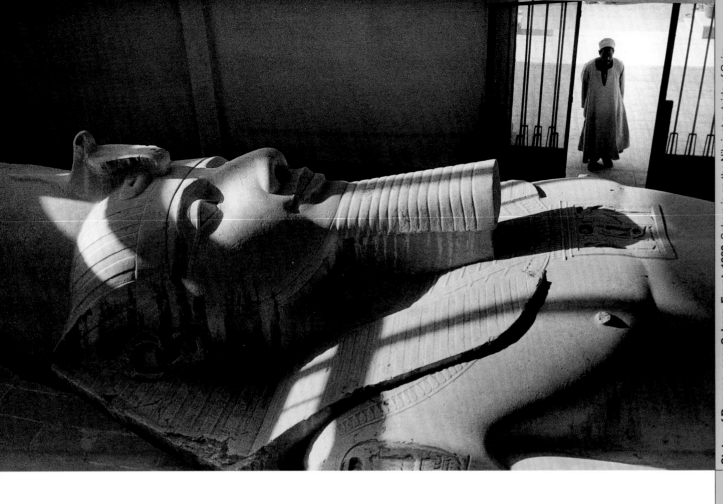

Statue of Ramses, near Sakara, Egypt, 1962. Sakara is on the Nile just outside of Cairo.

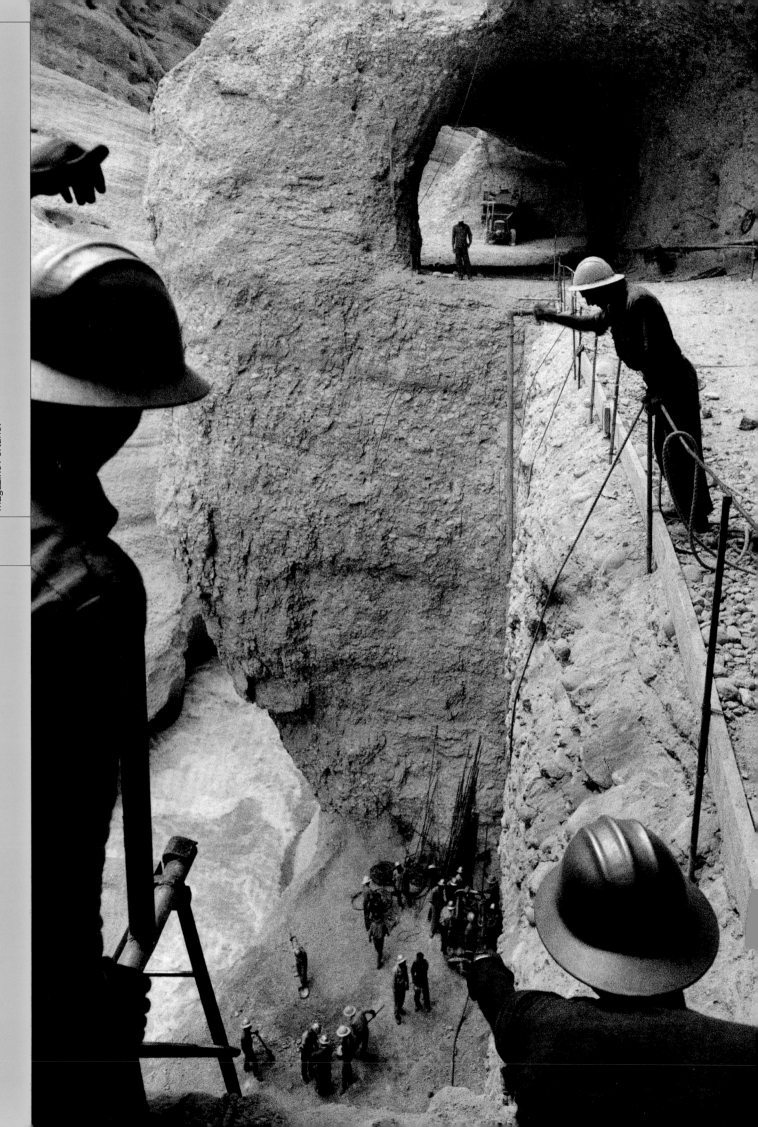

Construction of the Dez Dam, Iran, 1959. Burri took this photograph for an article in the US financial magazine *Fortune*.

left: **Springtime equestrian games, Luxor, Egypt, 1959.**
right: **Russian film festival, Cairo, Egypt, 1958.**
≫ **Military display, near Tehran, Iran, 1960.** A military display in the desert by the Iranian army in front of an invited audience of politicians and diplomats.

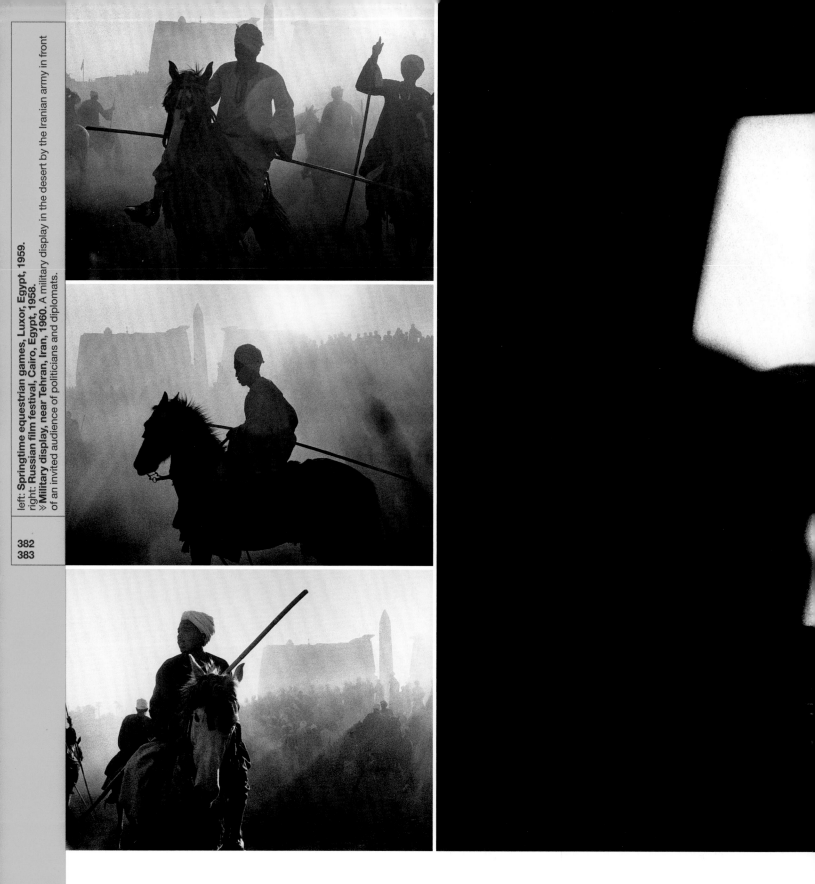

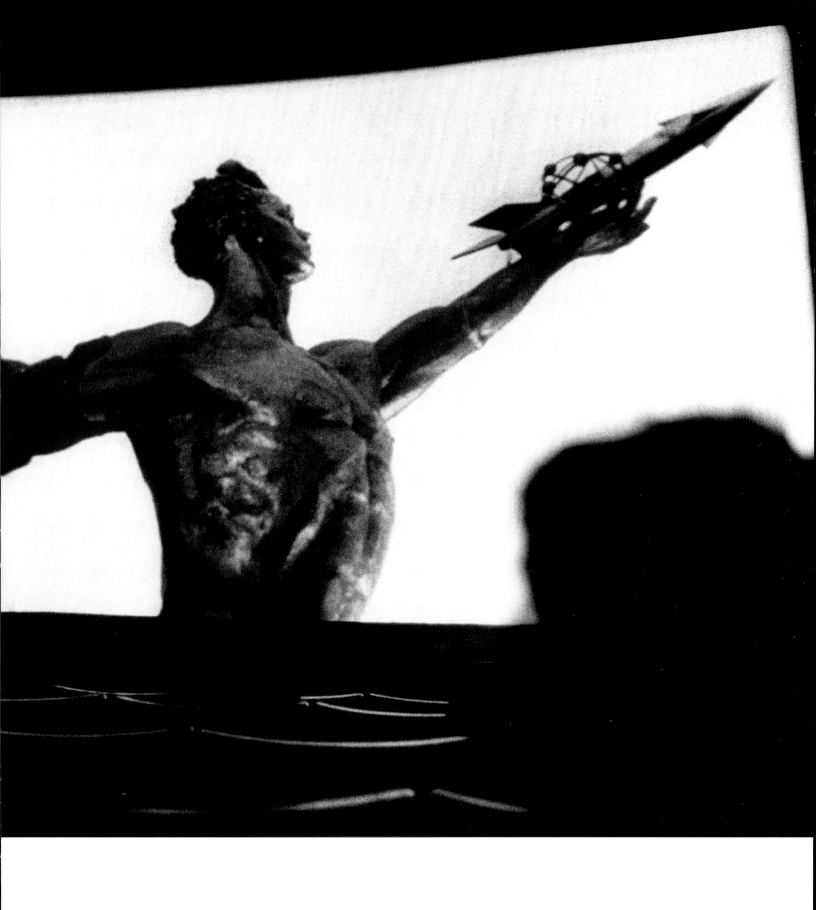

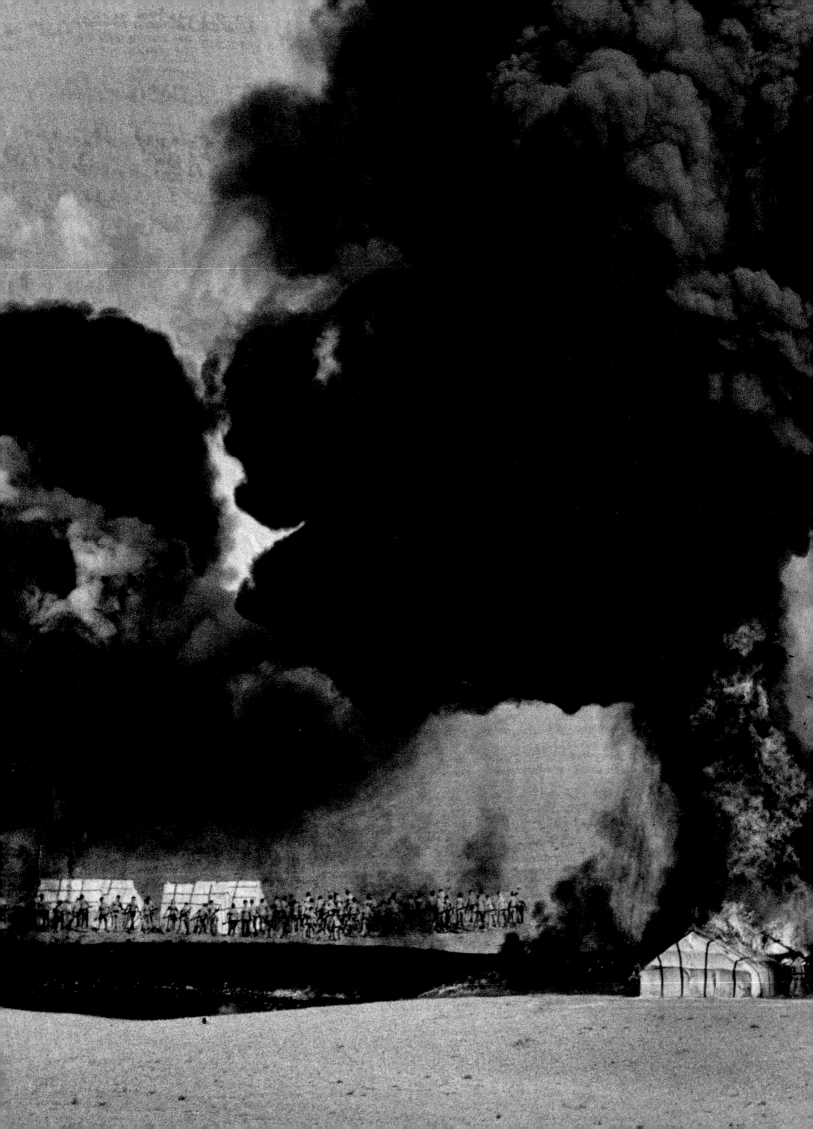

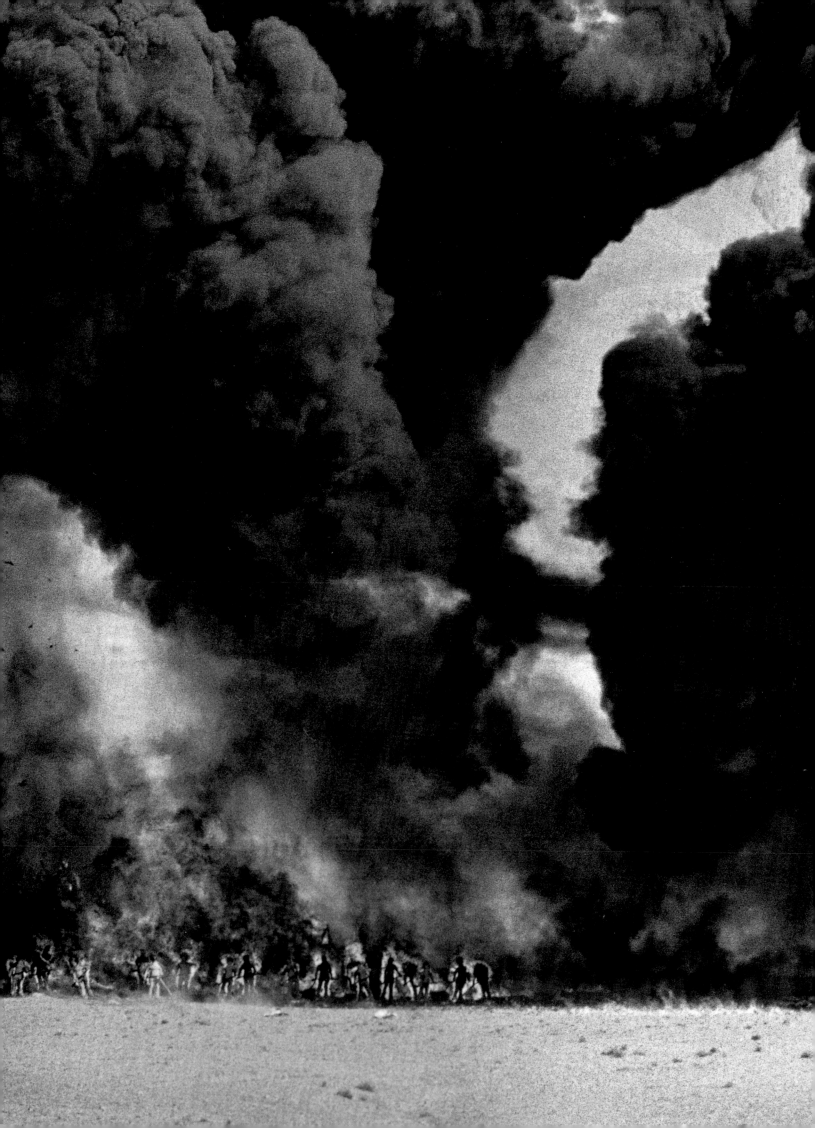

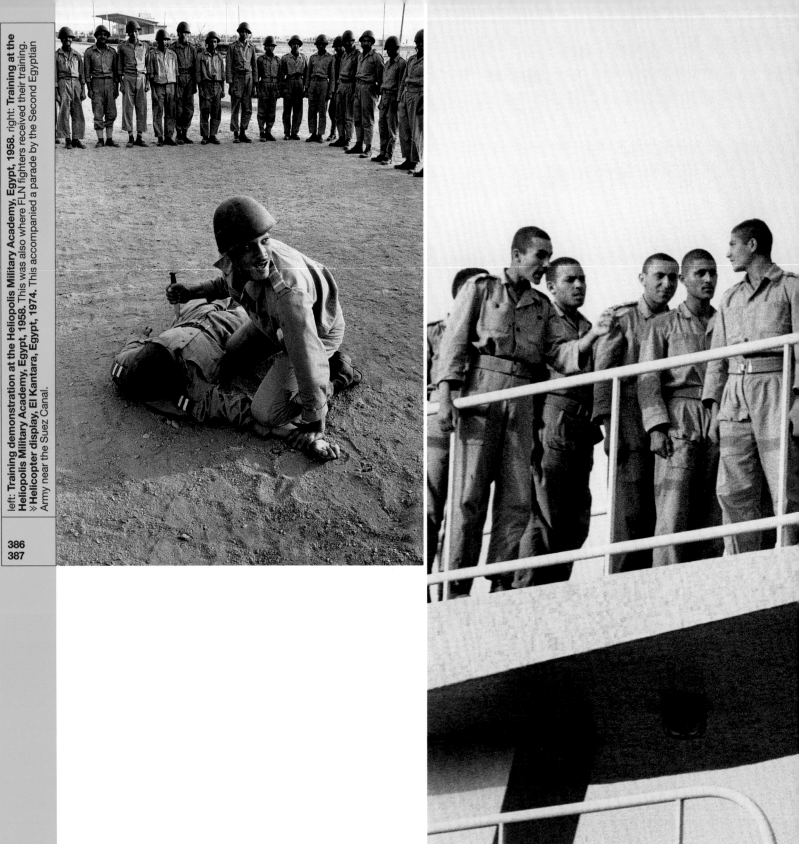

left: **Training demonstration at the Heliopolis Military Academy, Egypt, 1958.** right: **Training at the Heliopolis Military Academy, Egypt, 1958.** This was also where FLN fighters received their training. ≫ **Helicopter display, El Kantara, Egypt, 1974.** This accompanied a parade by the Second Egyptian Army near the Suez Canal.

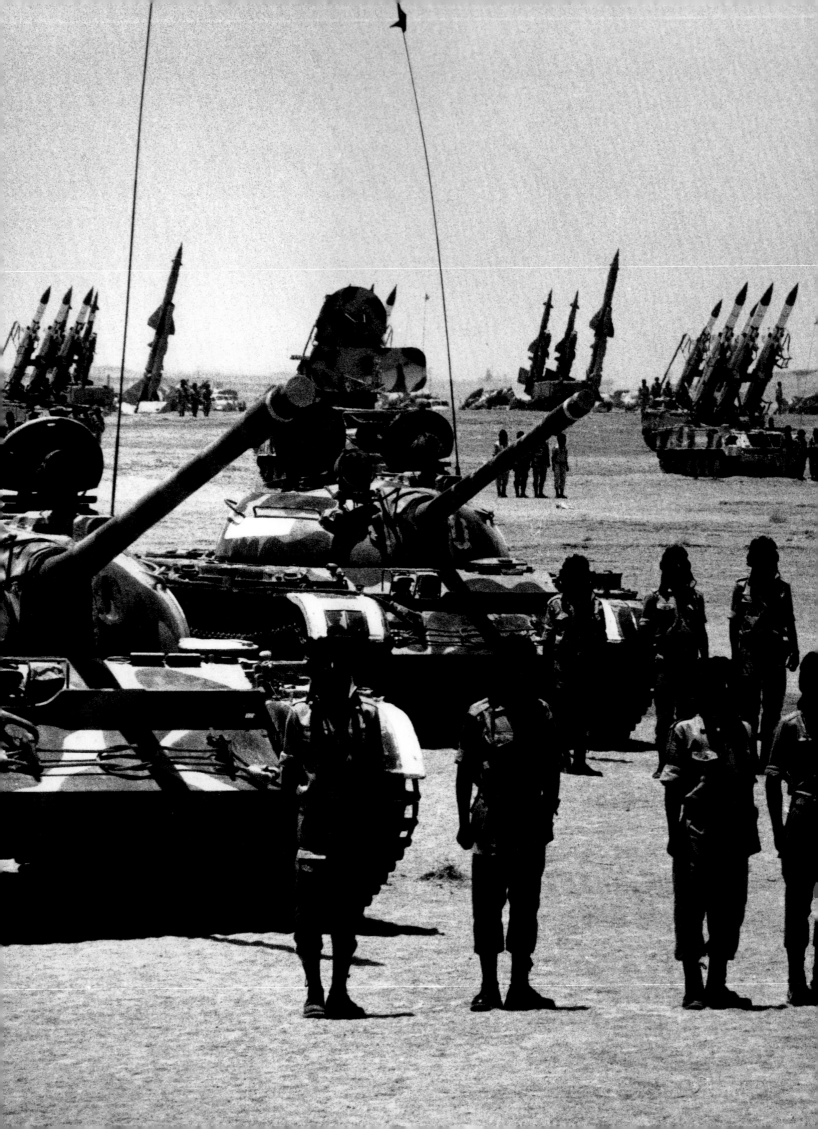

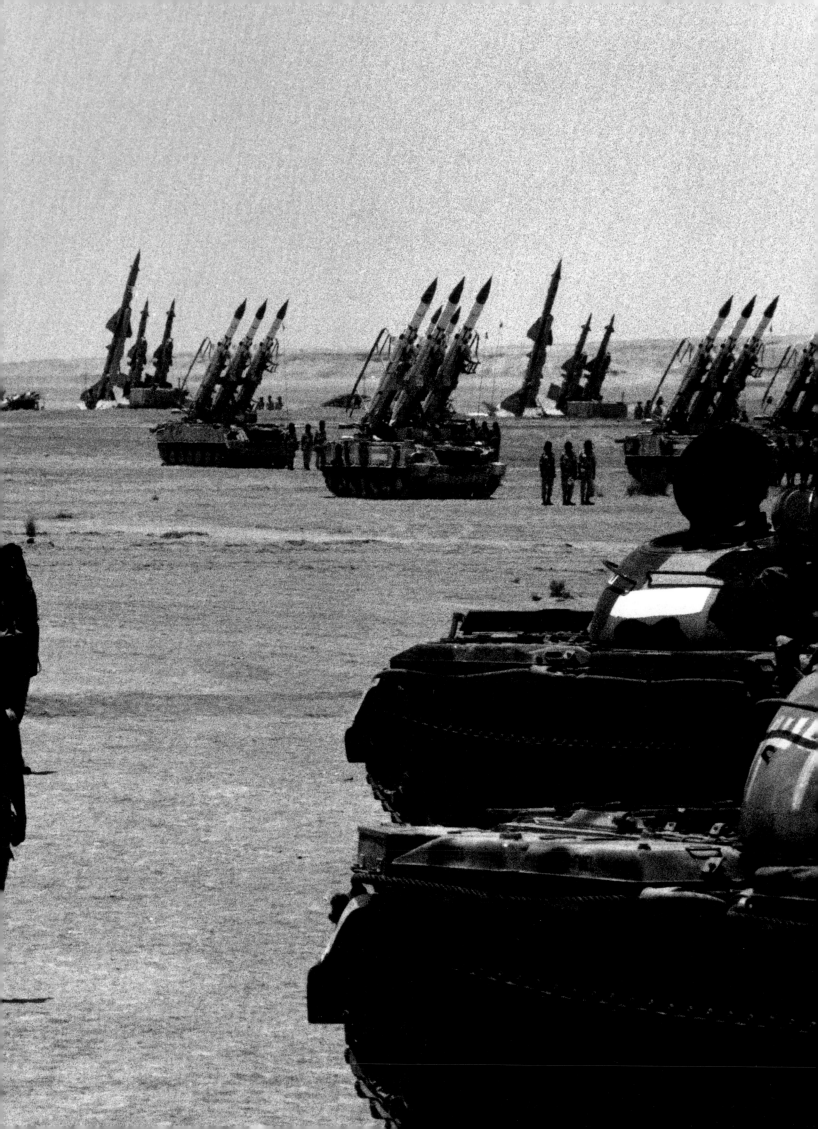

△ **Military inspection, Suez Canal, Egypt, 1974.** President Sadat inspects the Second Egyptian Army after the Yom Kippur War.

Remains of Russian-made helicopter, Bir Gifgafa, Egypt, 1967. At the beginning of the Six Day War, Israeli fighter planes destroyed the Egyptian air force on the ground.

Egyptian army convoy, Mitla Pass, Egypt, 1967. This convoy was destroyed by the Israeli's in the Six Day War.

≫ **Caravan, United Arab Emirates, 1975.**

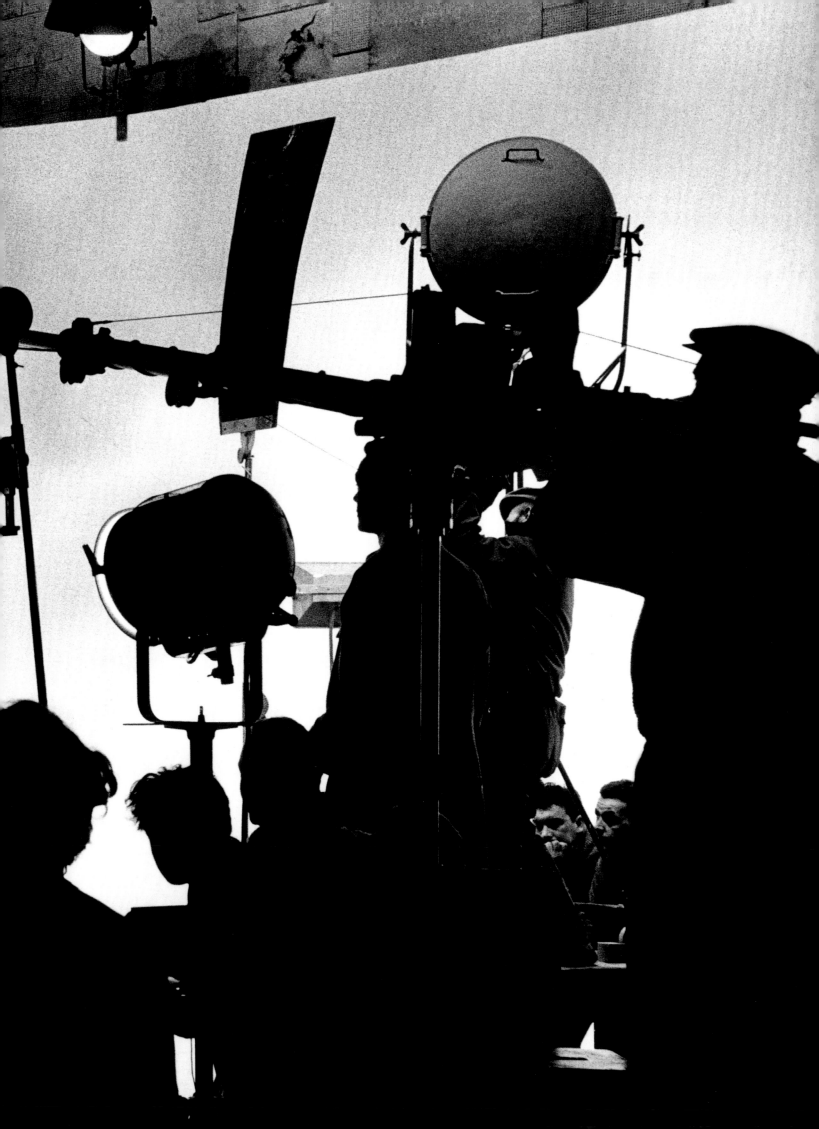

Rosellina Burri, René Burri's first wife, died tragically young. But in Burri's portrait of her, we see her laughing (p. 401). It is a warm laugh – full of life, infectious, hard to contain. The photograph conveys a delightful *joie de vivre* and is also a declaration of love. In the background, slightly out of focus but still recognizable, is Werner Bischof's famous *Flute Player, On the Road to Cuzco* from 1954. Bischof, Rosellina's first husband, died in a car accident in the Peruvian Andes. The portrait shows that death is part of life, even when life seems to be at its happiest.

The photograph was taken in a moment of playfulness between Burri and his wife in 1956. The image did not require elaborate preparation, but was a work of spontaneity, indebted to the deep spiritual connection between the photographer and his 'model'. Indeed, portraits are always interactive; the subject is constantly aware of the camera's presence. The portraitist tells us a great deal about his own personality in his photographs, restraining or extending himself depending on how he directs the scene. He determines the background, the lighting, the ambience. He chooses the camera and the lens. In other words, the portrait reflects the character of the artist who conceives, stages and produces the image as much as it records the subject. At the release of Burri's second portfolio in November 1959, *Modern Photography* wrote that 'you can tell a great deal about a photographer just by looking at his pictures, regardless of having ever met him. Things that were obvious when we talked with René Burri were equally obvious to us when we first saw and published some of his photographs in *Discovery* in November 1956. He is a gentle, thoughtful man; he is sensitive, yet disciplined, sympathetic to people and their emotions, yet artistic and conscious of design.'

Burri did not teach himself photography, but belongs to the group of twentieth-century masters who actually studied their profession. Nevertheless, no amount of studying will teach a photographer how to win over the hearts and minds of his subjects. Burri has always

understood how to do this. His professional seriousness is matched by his easygoing manner – a certain nonchalance. How else can one explain the tolerance and amiability of other twentieth-century artists toward Burri? He was allowed to accompany Picasso, Le Corbusier and Jean Tinguely for days, weeks and sometimes even months with his camera. Burri also photographed others – writers, scientists and film-makers – out of spontaneous interest whenever the chance presented itself. Importantly, he always includes the surrounding milieu in his portraits. This might be a studio or the artist's workshop, a private home or a stretch of coast during a stroll. Context is part of how Burri defines a portrait, and he has always presented his subjects within a historical framework.

René Burri's portraits have often arisen out of larger assignments. For example, Burri photographed the sculptor Alberto Giacometti in 1960 as part of a series on Swiss artists living in Paris for *Schweizer Illustrierte* (pp. 404–5). The photographer observed Giacometti at work for an entire day. From time to time, the two would take a break, also part of the creative process, and go to the café opposite Giacometti's studio. During one of these pauses, the artist took a matchbox out of his pocket. He opened it slowly and presented to Burri a tiny sculpture the size of a match. Then he told the photographer that 'you can work for days, for weeks on a large project, and this is the result.' Would the artist have granted any other visitor such an insight into his soul?

Ingrid Bergman, Boulogne-Billancourt, 1956. Magnum photographer Chim had contacted Ingrid Bergman and sent Burri to the film studios.

Rosellina Burri, Zurich-Leimbach, 1956. Burri's first wife, who died in 1986.

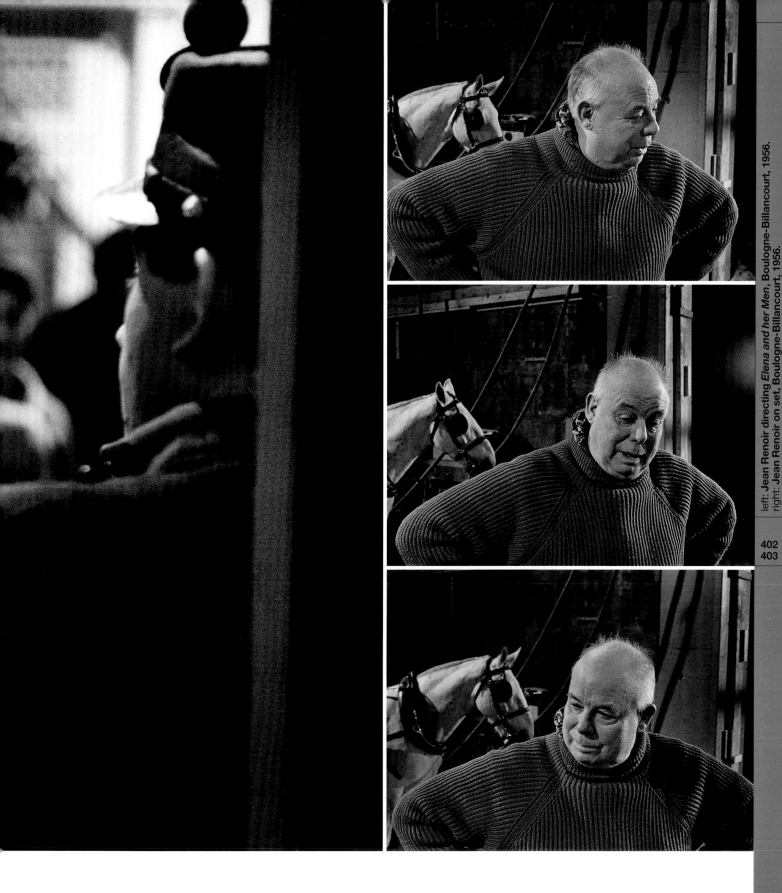

left: Jean Renoir directing *Elena and her Men*, Boulogne–Billancourt, 1956.
right: Jean Renoir on set, Boulogne–Billancourt, 1956.

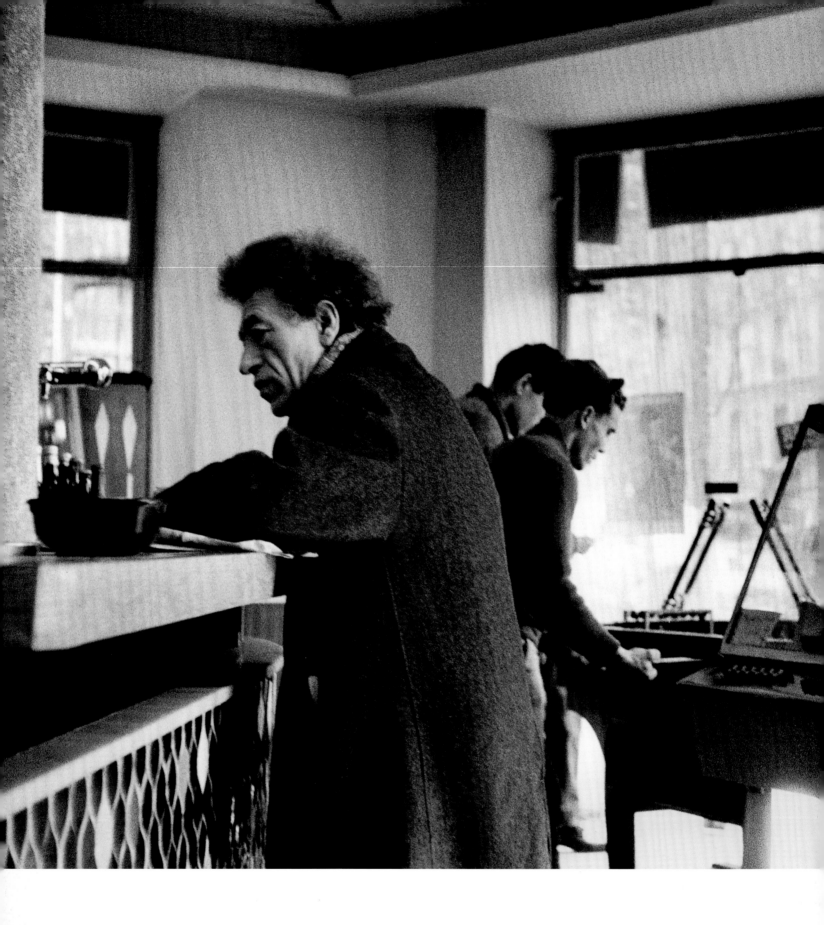

left: **Alberto Giacometti in café, Paris, 1960.** The café was located across the street from his studio in the rue Hippolyte Maindron. right: **Alberto Giacometti in his studio, Paris, 1960.** From an article for the *Schweizer Illustrierte* entitled 'Swiss Artists Find Their Way in Paris'. ≫ **Jean Tinguely, Fontainebleau, 1972.** Tinguely with his sculpture *The Cyclops* in the forest of Fontainebleau near Paris.

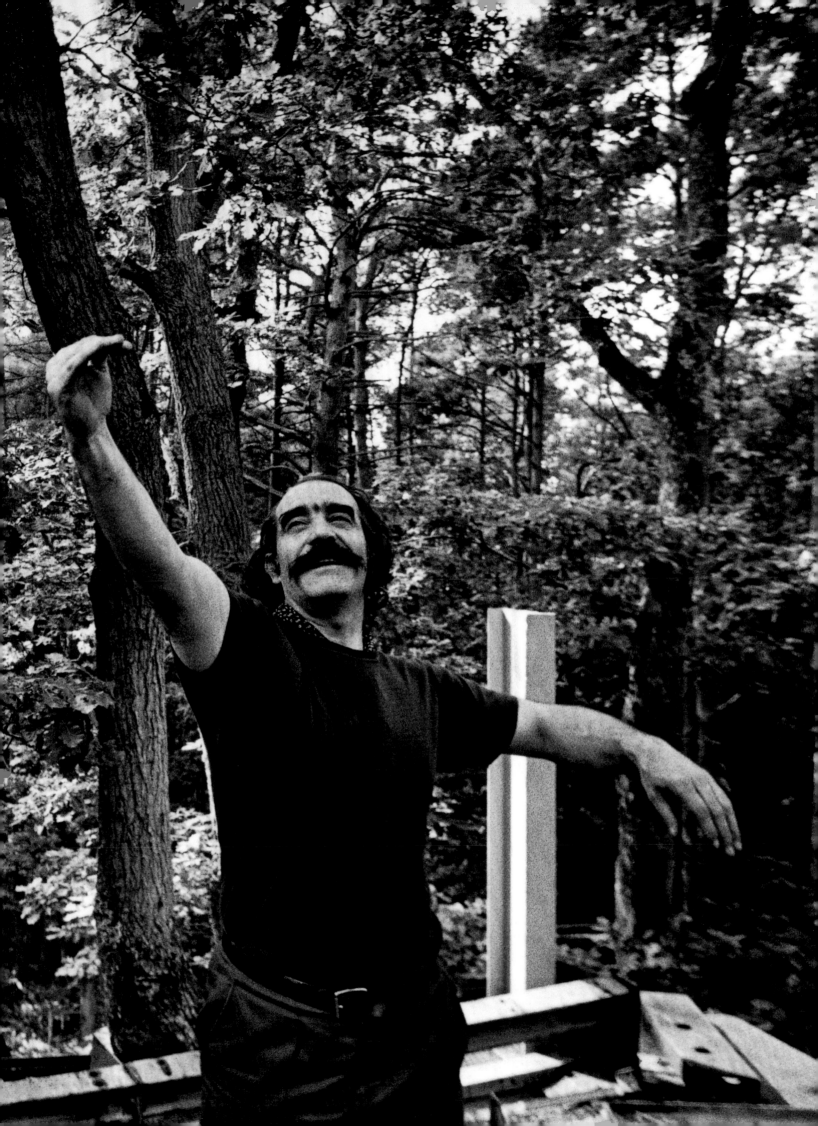

Yves Klein in his studio, Paris, 1961. Klein became particularly well known for his *Anthropométries* – pictures made with the imprint of the human body usually using blue paint – which he began in the late 1950s. ≫ **Oskar Kokoschka in his studio, Villeneuve, Lake Geneva, 1957.** left: **Kokoschka at work.** centre: **Working sketch.** right: **Kokoschka painting.**

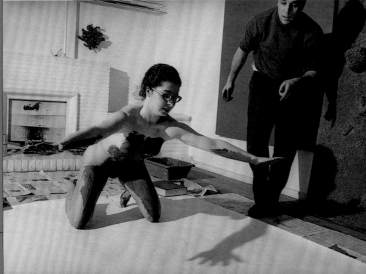

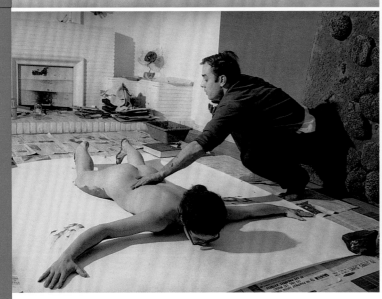

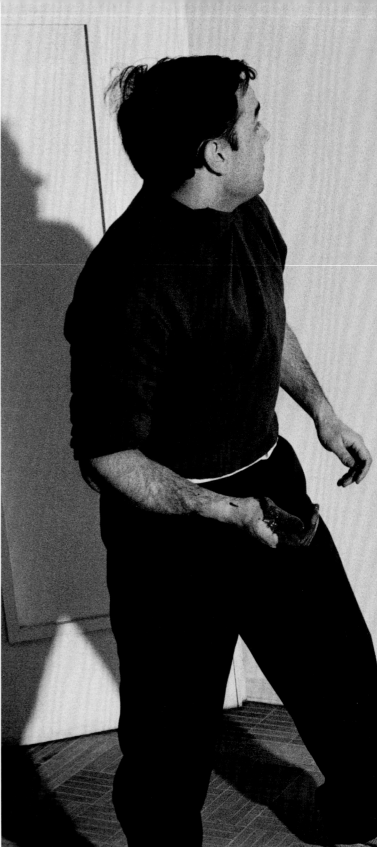

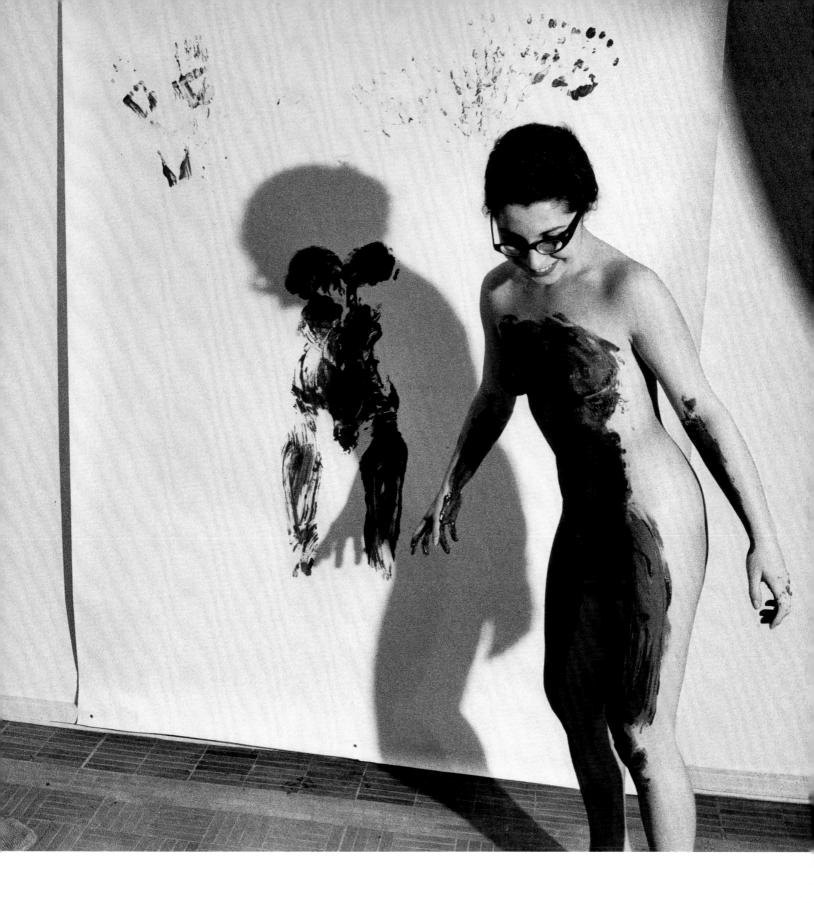

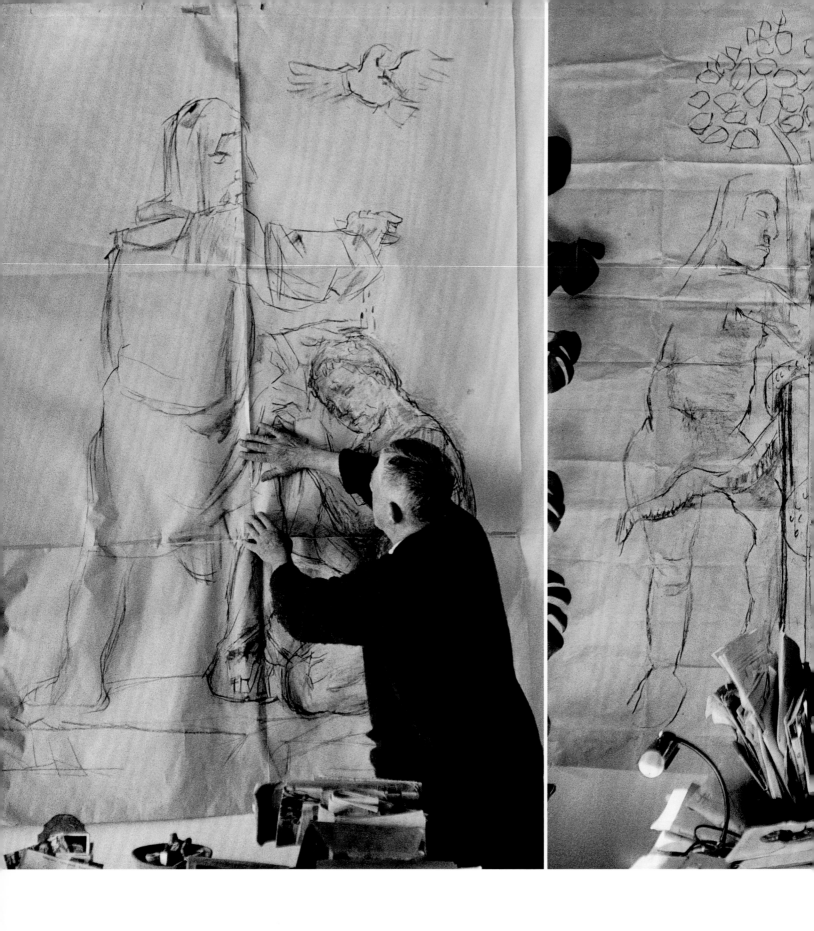

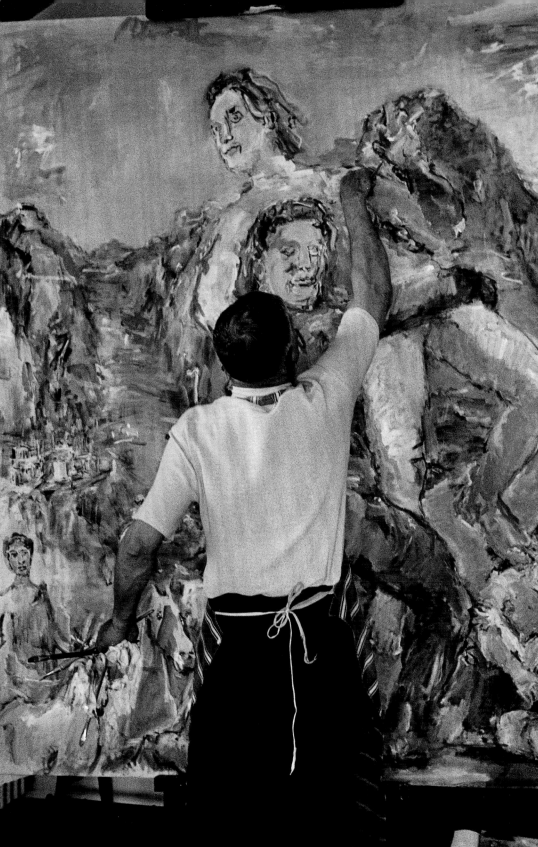

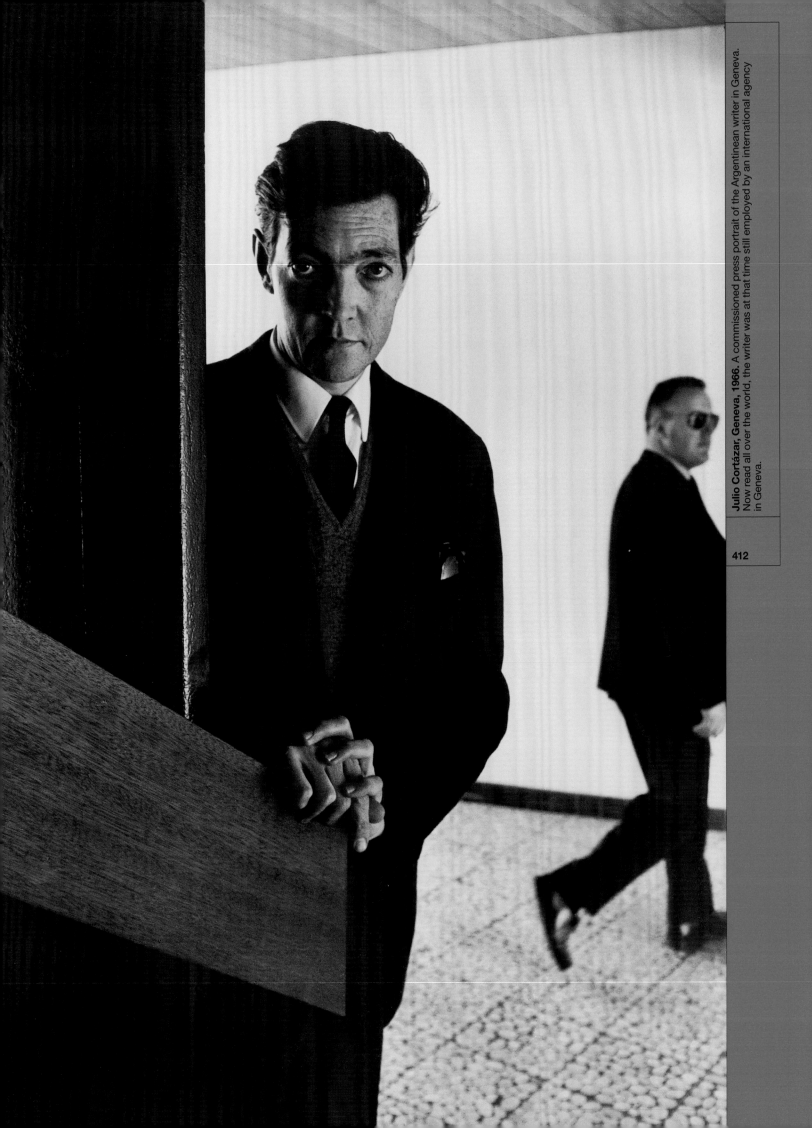

Julio Cortázar, Geneva, 1966. A commissioned press portrait of the Argentinean writer in Geneva. Now read all over the world, the writer was at that time still employed by an international agency in Geneva.

Edward Finnegan, New York, 1998. A portrait of the painter and sculptor Rolando Pelais, alias Edward Finnegan, who lives and works in New York's West Village.

Hiroshi Hamaya, near Oiso, Japan, 1961. On the beach near Oiso at the foot of Mount Fuji. Hamaya has been a member of Magnum since 1960.

414

Adrian Wettach, Imperia Oneglia, Italy, 1955. In old age, Adrian Wettach, alias Grock the famous clown and star of many variety shows, retired to Imperia Oneglia.

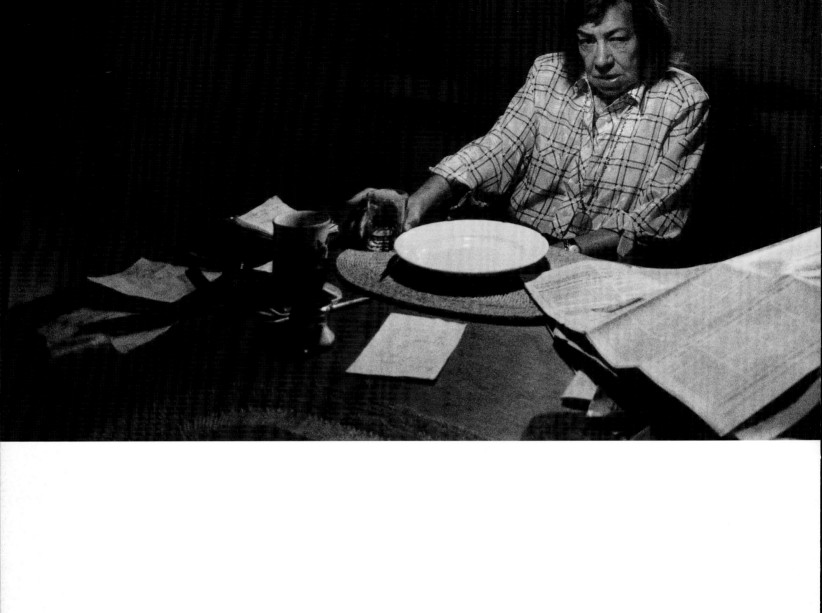

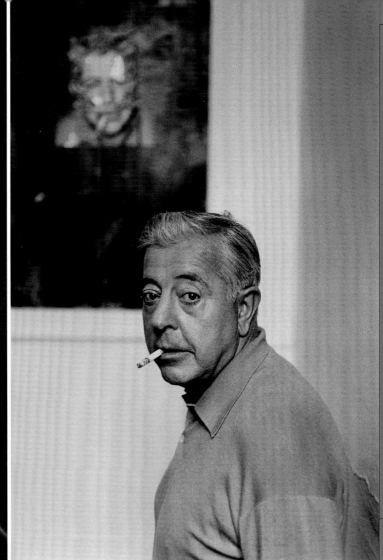

left: **Patricia Highsmith, Maggia valley, Tessin, Switzerland, 1988.** This photograph of the author was part of an article for *The New York Times Magazine*. It was reprinted in the magazine *Manchete*.
right: **Jacques Prévert, Paris, 1956.** This photograph was taken in the poet's apartment above the Moulin Rouge.

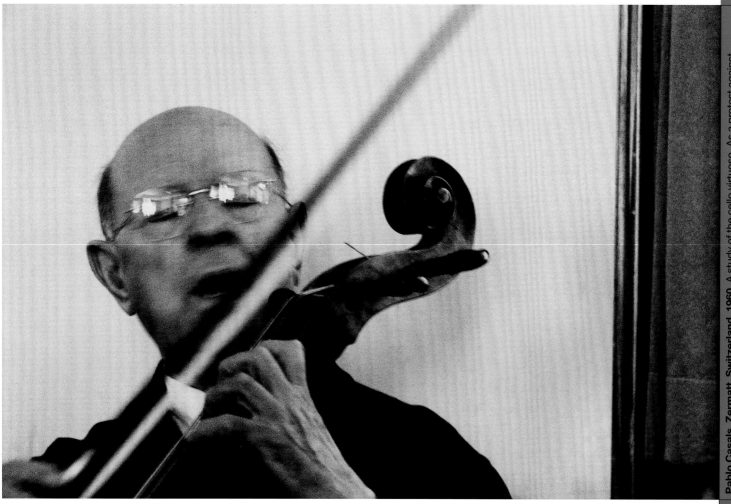

Pablo Casals, Zermatt, Switzerland, 1960. A study of the cello virtuoso. As a protest against Franco's dictatorship, the Spanish-born Casals lived in southern France and eventually moved to San Juan, Puerto Rico, where he lived until his death in 1973.

Pablo Casals playing, Zermatt, Switzerland, 1960. The photo was taken during the master class which took place every year in Zermatt under the patronage of Pablo Casals.

Naguib Mahfouz, Cairo, 1988. A portrait of the novelist and Nobel laureate, commissioned by the *Schweizer Illustrierte*. The series of colour photos appeared in January 1989 under the title 'The Heretic of Cairo'.

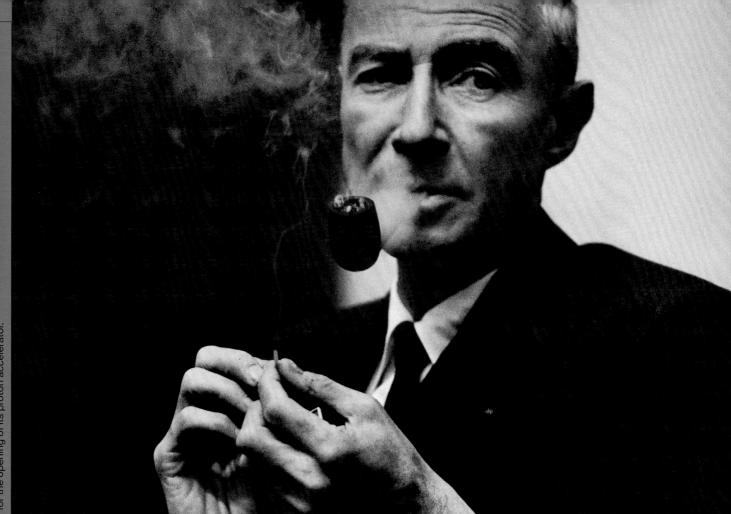

421

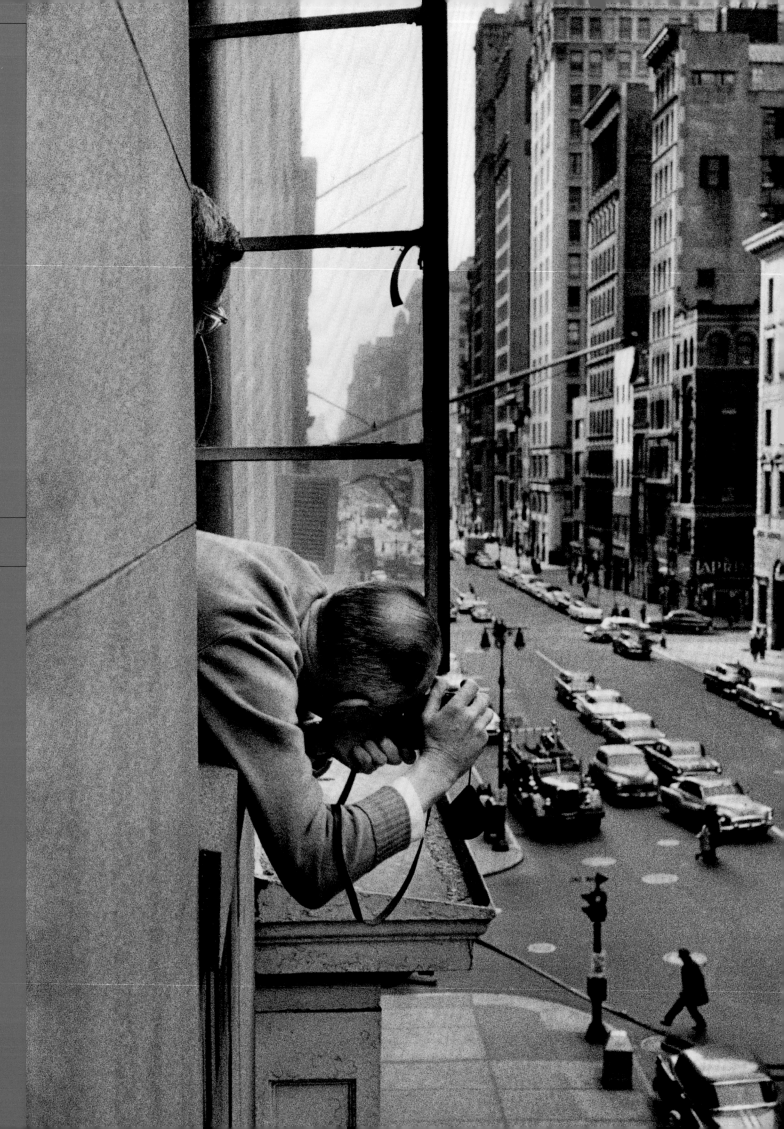

Henri Cartier-Bresson at work, New York, 1959. View from Cornell Capa's apartment on Fifth Avenue. Shortly before, a meeting of Magnum had ratified René Burri's membership.

Henri Cartier-Bresson, New York, 1959. Cartier-Bresson is known for being camera-shy. He describes his photographic work as 'stalking', and thus finds celebrity a hindrance. Burri was allowed to take his picture on many occasions, however – a sign of trust and sympathy on the part of an older colleague.

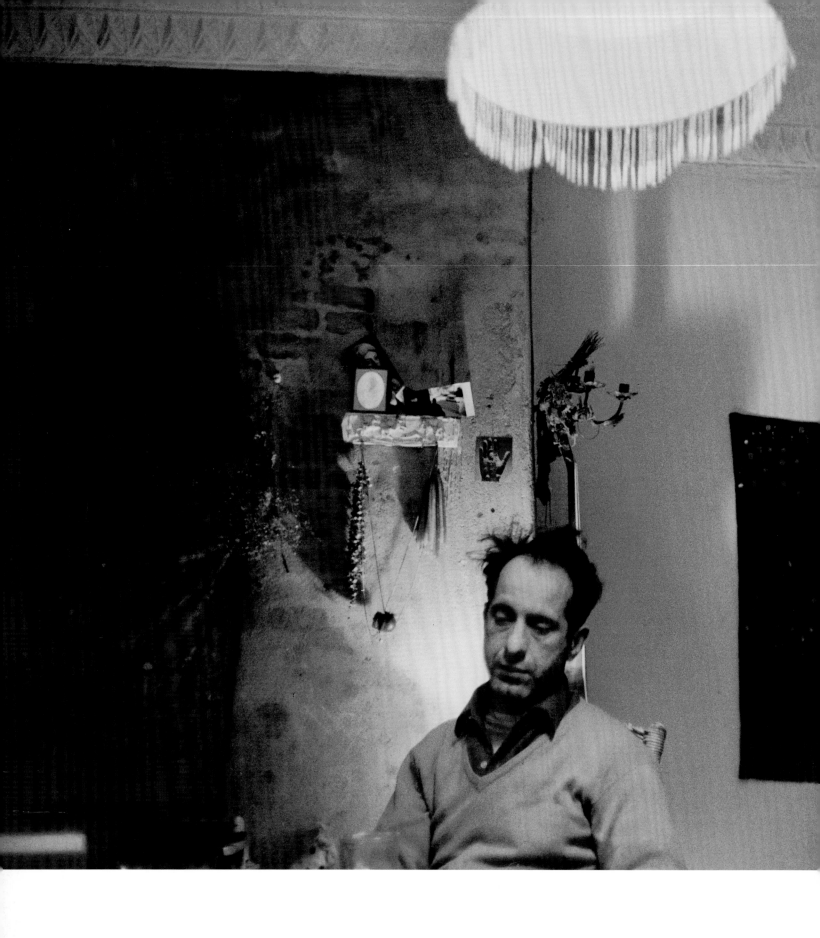

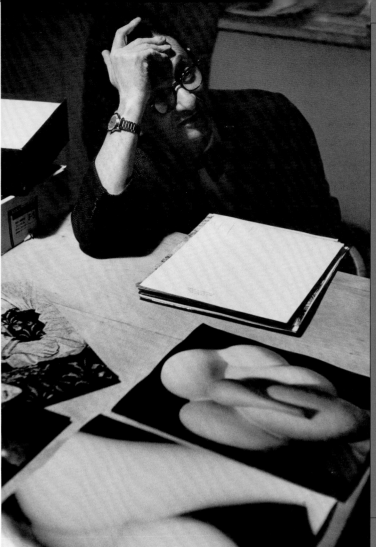

left: **Robert Frank, New York, 1959.** The photographer in his apartment on 203 West 86th Street.
right: **Erwin Blumenfeld, Paris, 1956.** The great Dadaist and fashion photographer, and author of a brilliant autobiography *Einbildungsroman* (published later in English as *Eye to I*), here in the Paris office of the publisher Robert Delpire at 273 boulevard Raspail.

424
425

Man Ray, Basel, 1955. Man Ray came to Basel for a retrospective of his films and Burri was able to take his portrait.

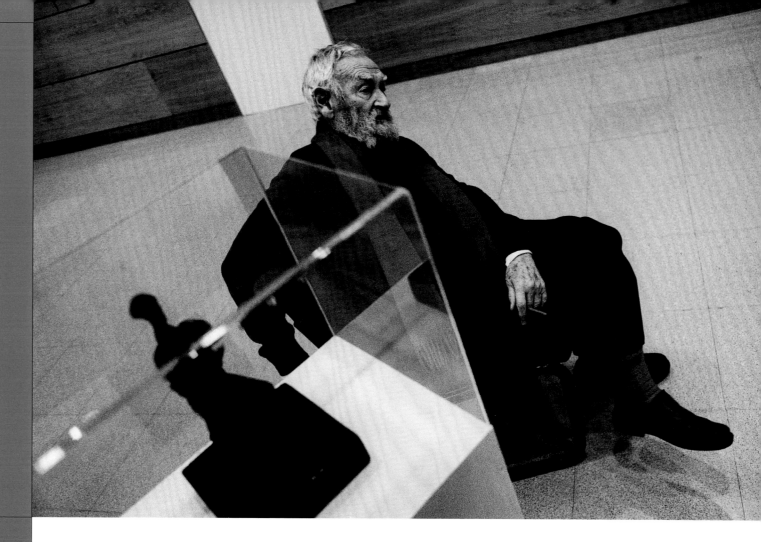

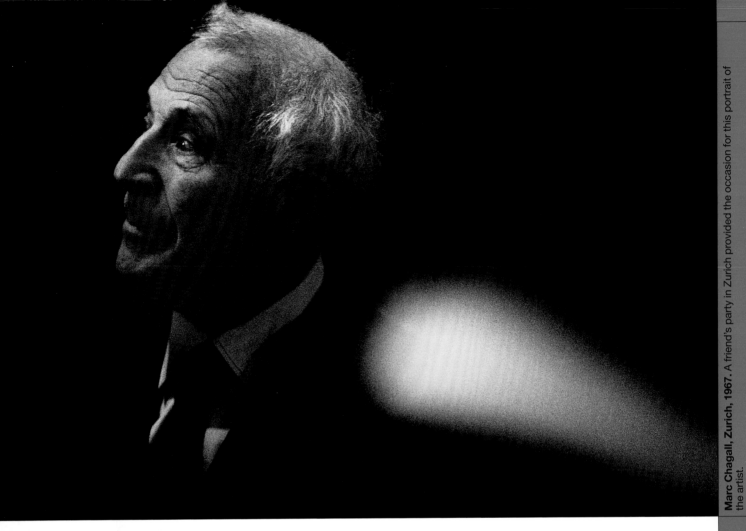

Marc Chagall, Zurich, 1967. A friend's party in Zurich provided the occasion for this portrait of the artist.

Renzo Piano, Paris, 2000. The architect at the Centre Pompidou for an exhibition of his own work. With this building in the heart of Paris, Renzo Piano and Richard Rogers created what is probably the most spectacular museum building of the 1970s and 1980s.

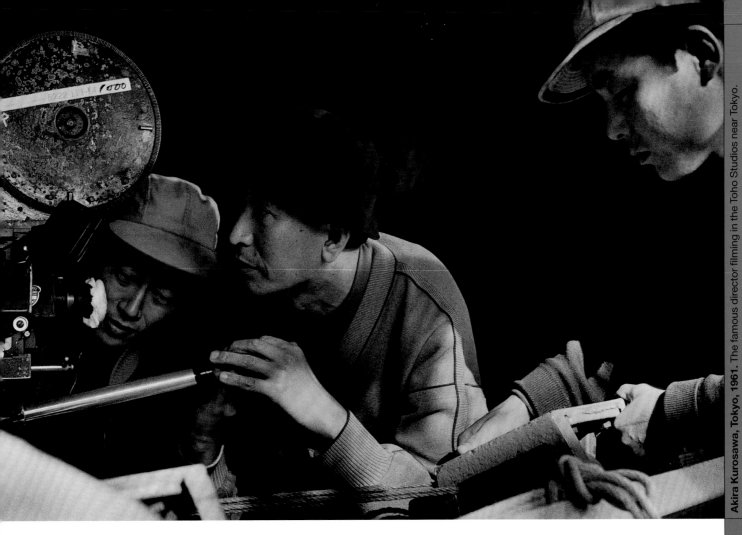

Akira Kurosawa, Tokyo, 1961. The famous director filming in the Toho Studios near Tokyo.

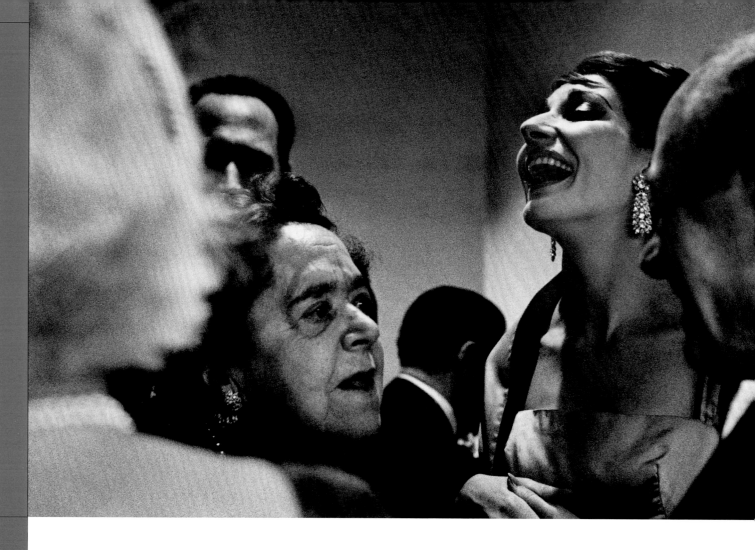

431

Oscar Niemeyer, Brasília, 1960. A great visionary and, as of 1956, creator of Brazil's new capital Brasília, together with President Juscelino Kubitschek and Lúcio Costa. Here we see the architect, a dedicated communist, in a temporary office on the site of construction.

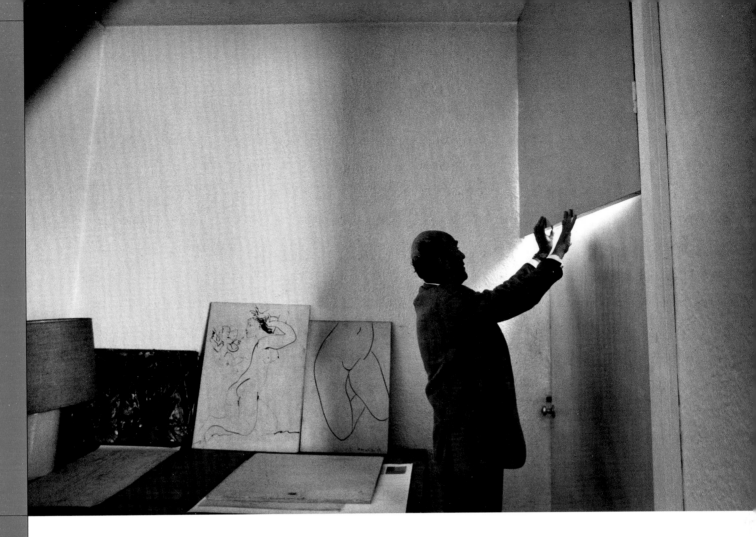

Luis Barragán, Mexico City, 1969. The portrait was part of a series of photo essays entitled '20th Century Houses Around the World' for the weekend edition of the *Daily Telegraph*.

433

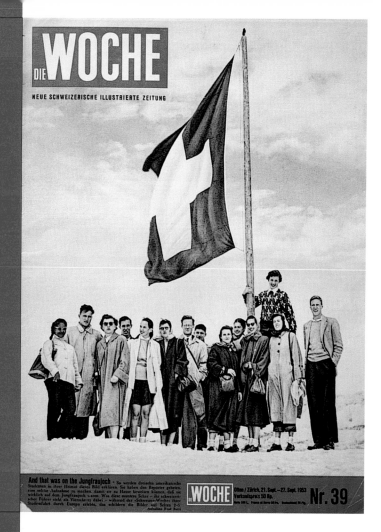

'Pictures are like taxis during rush hour – if you're not fast enough, someone else will get them first.'

René Burri

Everyone knows René Burri's photographs: his portrait of a self-assured Che Guevara, his series on Pablo Picasso and Le Corbusier, or his bold view of São Paulo. All of these images have become icons of modern photography. Burri's impressive oeuvre is one of the most important in recent memory and Burri is without doubt one of the greatest photographers of the twentieth century.

In collaboration with myself as editor, René Burri started re-examining his black-and-white photographs in 1999. We looked through thousands of working prints, contact sheets and vintage prints from all phases of his career and selected the images that eventually came to adorn the pages of the present volume. This was a long and careful process, with an overall plan gradually taking shape as our work progressed. In particular, we asked ourselves two questions while looking through Burri's remarkable archive. First, to what extent could a picture or series of pictures represent Burri's lifelong endeavour to make a personal statement? And second, how much could a given picture tell us about the historical conflicts, ruptures and contradictions that have determined how people worked with or against each other in the period after World War II? Burri, it should be emphasized, is a very political person, an observant and critical chronicler of our time. He found in the camera the ideal medium for expressing his scepticism, his curiosity and his search for the underlying cause of things. In this sense, our book is not least a journey through time and space. A journey that has hardly missed a single conflict, whether social, political or ethnic. A journey from the Suez crisis in the mid-1950s to the fall of the Berlin Wall, the collapse of Communism and beyond.

This book is also, however, a testimony to a kind of photojournalism that does not simply copy the fast-paced, transient pictures on television but tries to plumb the depths of the medium of photography through a new and innovative visual language. Burri is a genuine artist who has always known how to use his bread-and-butter commissioned work to produce a separate body of personal photographs – images that belong to the genre of 'auteur photography'. Of course, our book would not be complete without Burri's iconic images, from the series on the Germans to his widely-known portrait of Che Guevara. But alongside these there is a wealth of material in this volume that has never previously been published. These masterfully crafted images will demonstrate once and for all that it is possible to think like a journalist and, at the same time, to compose pictures that outlive the evening news due to their visual power and inherent truth.

Above all, I wish to thank the photographer, René Burri. Not only did he allow access to his almost inexhaustible archive but he also answered many questions, provided invaluable information, made helpful suggestions and put up with the ideas and criticism of an editor almost a generation younger than himself. These have been years of intense and fruitful conversation with Burri. Certainly, getting to know Burri, the humanist and humanitarian, helped me immeasurably in writing the introductory essay. But in the end, our meetings in Paris were much, much more: they were a gift in themselves. This book is the fruit of our labours. It examines Burri's work in the context of a theoretical debate about the artistic value of photojournalism and in it we see that René Burri's photography from the past five decades holds its own easily and impressively.

CHRONOLOGY

(1–2) 'La Syrie sous les armes', *Jours de France*, no. 155, 2 November 1957
(3–4) 'Monsieur 99%. A Damas, mariage Egypte–Syrie', *Paris-Match*, no. 465, 8 March 1958

436

1933 Born on 9 April in Zurich, Switzerland. His father, Rudolf Otto, worked first as a cook in Geneva, then in Zurich. His mother, Bertha Burri (née Bertha Haas), was born in a village near Freiburg in Breisgau, Germany. She emigrated to Switzerland in the early 1920s.
1940–9 Attends primary school in Zurich.
1949 Begins studies at the School of Arts and Crafts in Zurich. Completes introductory courses under Johannes Itten.
1950 Progresses to the master class in photography under Hans Finsler and the graphics and typography course under Alfred Willimann.
1953 Earns his photography degree *summa cum laude* and receives a school scholarship to shoot a film, now lost, about the Zurich School of Arts and Crafts, which he completes in 1955. Runs a joint studio with Walter Binder. Works as a cameraman for the Walt Disney film production *Switzerland*, directed by Ernst A. Heiniger. Shoots a reportage on young Americans in Switzerland for the magazine *Die Woche* entitled '13 sehen unser Land in 7 Tagen' ('13 See Our Country in 7 Days', no. 39, 21–7 November 1953). It is his first big publication. Visits the first large post-war Picasso retrospective in the Palazzo Reale in Milan. Takes photographs of the exhibition and the painting *Guernica* and is overwhelmed by Picasso's masterpiece.
1954–5 Does his obligatory military service between January and March. Visually documents his time with the military. Changes from a medium-format camera (Rolleiflex) to a 35 mm camera (Leica). After completing military service, shoots film about the Zurich School of Arts and Crafts. Becomes photography assistant in the studio of the renowned graphic artist Josef Müller-Brockmann in Zurich. Collaborates on a work celebrating the anniversary of the Migros company in Zurich. Reports on the Zurich music teacher Mimi Scheiblauer and her work with deaf-mute children for the French magazine *Science & Vie*.
1955 Publishes six pages with seven photographs of Scheiblauer's school for deaf-mute children in the January issue of the magazine *Science & Vie*. The title is 'Les enfants sourds-muets peuvent apprendre la musique' ('Deaf-mute Children Can Learn Music'). Hitchhikes to Paris. Attempts to meet Pablo Picasso, but is unsuccessful. Introduces himself at the Magnum agency, then located on 125 rue Faubourg Saint-Honoré, where his reportage on Scheiblauer's school is received with great interest. Thanks to Magnum's involvement, his reportage is subsequently published in *Münchner Illustrierte* (no. 19, 7 May 1955) and then in *Life* magazine ('Touch of Music for the Deaf', June 1955). On another trip to Paris, Burri visits the chapel of Notre-Dame du Haut in Ronchamp, built by Le Corbusier. Back in Zurich he convinces Manuel Gasser, editor-in-chief of *Weltwoche*, of the value of a photo reportage on the chapel. Through Magnum publishes his reportage on Le Corbusier's spectacular religious building in *Paris-Match* (no. 328, 9–16 July 1955). Travels to

Libya on assignment for *Bunte Illustrierte* to record the dedication of the monument commemorating the fallen soldiers of Erwin Rommel's Africa Corps. Explores Prague, including what today is the Czech Republic and southern Slovakia.
1956 Becomes associate member of Magnum in Paris and New York. Prepares a reportage for *Bunte Illustrierte* on the rearmament of West Germany. Travels through southern Italy and Sicily. Carries out his own reportage on tuna fishing and sea-salt production. Is sent by David Seymour on commission from *The New York Times* to travel to Plzeň, where he is to report on Czechoslovakia, known then as the 'armoury of the East'. Flies to Cairo following outbreak of the Suez crisis and, accompanied by the journalist Georg Gerster, was a passenger on the last tanker to go through the Suez Canal before it was closed off.
1957 Following a report on the Spanish Basque country, drives to Nîmes and finds Pablo Picasso in the hôtel du Cheval Blanc. Starts photographing the artist in the hotel, then at dinner and the next day during a bullfight. Works in West Germany (takes photographs of the architectural exhibition 'Interbau' featuring work by Le Corbusier and Oscar Niemeyer) and East Germany (e.g. 'Jugend in der DDR' ['Youth in the GDR'] for *Sie und Er*). Reports for *Life* magazine (25 November 1957) and *Jours de France* (no. 154, 26 October 1957) on the political uprising in San Marino.
1958 Has his first publication in *Du* magazine (July 1958). Designs the cover and provides several pages for the special issue 'Das lebendige Museum' ('The Living Museum'). Explores Gamal Abdel Nasser's Cairo. Photographs the Russian-led construction of the Aswan dam. Photographs the secret training camps of Algerian National Liberation Front (FLN) rebels. Documents the elections in Syria and the Syrian–Egyptian alliance. Sets off for Latin America for six months. Works on his legendary photo essay about the Argentinean gaucho. Travels by jeep through Bolivia, Peru, Brazil. Provides *Jours de France* with a portrait of the city Rio de Janeiro (no. 210, 22 November 1958).
1959 Becomes a full member of the Magnum agency. Publishes his photo essay about the life of the Argentinean gaucho in the March issue of *Du* ('El gaucho: 4 Farbaufnahmen und 28 Schwarzweissphotos aus Argentinien' ['The Gaucho: 4 Colour and 28 Black-and-White Photos from Argentina']). In the accompanying text he describes his attitude toward his chosen profession: 'The enormous social changes taking place in our age of technology – reflected in music, painting, literature and architecture – are casting a new face for humanity. Tracing these developments, and conveying my thoughts and images of them, is what I consider to be my job.' Reports from Cairo on the opening of the Hilton hotel, attended by Tito and Conrad Hilton, among others. On commission for *Life* magazine, is present at the funeral ceremony for Aga Khan in Aswan. Reports from Cyprus on the return of Archbishop

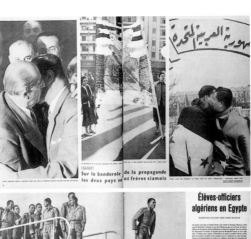

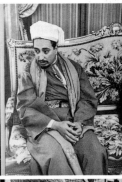
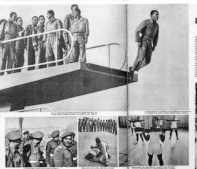

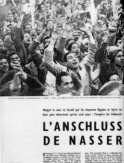

(1–2, 4) 'L'Anschluss de Nasser', *Paris-Match*, no. 462, 15 February 1958
(3) 'Élèves-officiers algériens en Égypte', *L'Illustré*, no. 13, 27 March 1958

1	2
3	4

Makarios. Continues his photographic essay on the work of Le Corbusier. Visits Picasso in his studio in the south of France as part of an assignment for *Du* magazine. In Germany, accompanies Eisenhower's state visit to Bonn and photographs the Berliner Ensemble in East Berlin, the famous theatre founded by Bertolt Brecht. Begins work on his book project *Die Deutschen*. Later reports on the oil industry in Iran, and on Baghdad, Iraq under Kassem.

1960 Continues work on his photo essay *Die Deutschen*. Collaborates on a series about Swiss artists living in Paris, including Alberto Giacometti, for *Schweizer Illustrierte*. Reports from Brazil on the construction and inauguration of the new capital city Brasília. Works for *Praline* on a portrait of the city São Paulo and on a reportage on industrialization in Brazil. Takes portraits of Robert Oppenheimer and other international nuclear physicists for the inauguration of the Conseil Européen pour la Recherche Nucléaire (CERN) in Geneva.

1961 Photographs buildings by Le Corbusier in Paris, Marseille, Poissy and Eveux for a portfolio in *Du* magazine. Visits the great Picasso retrospective in the Tate Gallery in London. Travels to Iran on the occasion of the publication of the Shah's memoirs for the German illustrated magazine *Revue*. Travels with Manuel Gasser to work on a special issue of *Du* magazine about Japan ('Japan bei der Arbeit' ['Japan at Work']). Takes portraits of film-maker Akira Kurosawa, actor Toshiro Mifune and architect Kenzo Tange. Travels through South Korea, Bangkok and Thailand. Meets the cellist Pablo Casals in Zermatt.

1962 Photographs at the annual meeting of the legendary German writers' association Group 47. Takes portraits of Ingeborg Bachmann, Hans Magnus Enzensberger, Günter Grass and Uwe Johnson. Travels to Egypt at the suggestion of Cornell Capa and reports on student life in Nasser's Egypt as part of a planned Magnum series called 'Students Around the World'. On assignment for the US magazine *Vogue*, he draws a portrait of high society in Beirut. Publishes his first book *Die Deutschen*, edited by Robert Delpire (German edition published by Fretz & Wasmuth, Zurich, 1962; French edition published by Delpire, Paris, 1963).

1963 Travels to Cuba for the magazine *Look*. Stays a total of twenty-three days on the island. Meets Fidel Castro, various revolutionary leaders and artists. Photographs Che Guevara in his office at the Ministry of Industry during a two-hour interview with *Look* journalist Laura Berquist. Burri begins his collaboration with Pakistan International Airlines (PIA). Works with Omar Kureishi, responsible for public relations, to develop a new image for the airline – and, by association, for Pakistan itself. Flies from Pakistan to Saigon, Vietnam, where as an accredited journalist he takes part in military operations led by US advisors. US Secretary of Defense Robert S. McNamara would soon urge a stronger

US military commitment in Vietnam. While in Zurich, learns of the assassination of John F. Kennedy and flies immediately via New York to Washington, DC, where he takes photographs of the funeral. In December he marries Rosellina Bischof (née Mandel), widow of Werner Bischof and mother of Marco and Daniel, in Zurich. Travels through Israel and Jordan for a reportage ('In Search of the Holy Land') commissioned by the magazine *Sun* in Tokyo.

1964 Publishes a twenty-two page reportage in *Paris-Match* entitled 'Sur les pas de Jésus' ('In the Footsteps of Jesus') on the occasion of Pope Paul VI's visit to the Holy Land, which had been announced on short notice (no. 770, 11 January 1964). Receives an entry permit for the United Arab Emirates, then almost inaccessible to Westerners. Reports there for the US business magazine *Fortune*. On assignment for English magazines, Burri documents the lighting of the Olympic fire in Greece prior to the Tokyo Olympic Games which takes place that summer. Flies on a PIA jet on its maiden voyage from Karachi to Shanghai. Invited to the May Day banquet in the Great Hall of the People where he is able to meet Zhou Enlai. Photographs the Great Wall and other sights in this long-inaccessible country. Flies back to Europe. Invited to New York by *Life* magazine to work on an extensive colour photo series. His daughter, Yasmine – a name inspired by the blossoms he saw in China – is born in July. Founds Magnum Films in New York together with Philip Gittelmann and other members of Magnum. Travels to China for a second time later in the year in order to prepare a film planned for 1965.

1965 Travels to Thailand with Manuel Gasser to photograph Koh Samui island, then still untouched by tourism, for a special issue of *Du* magazine. From 1 May he is in China with his wife Rosellina and shoots a three-part film portrait of the country. Produces a photo essay on Greece. Has his first one-man exhibition in the Zurich gallery Form. Edits his film about China in Elliott Erwitt's New York studio. Caught in the middle of a power cut that darkens Manhattan, he uses the incident to create an experimental photo series entitled *Blackout in New York*.

1966 Photographs a cultural festival in Dakar, Senegal. Produces a colour reportage on the newly opened Autostrada del Sole for Robert Delpire and his new magazine *Nouvel Adam*. Works with the writer Hugo Loetscher on a special issue of *Du* magazine about Salvador da Bahia (July 1967). Documents the preparations for the 1967 World's Fair in Montreal. Goes to Alaska and Hawaii with the famous Russian poet Yevgeny Yevtushenko.

1967 Visits the Expo in Canada, reporting for international magazines. Meets Jean Tinguely, who is installing one of his kinetic sculptures at the Swiss Pavilion. Shoots a film in Israel, Jordan and Egypt about the three major world religions (Judaism, Christianity and Islam). One-man

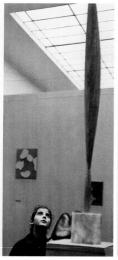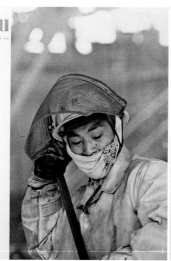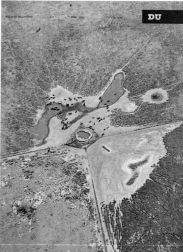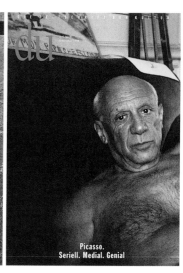

Picasso.
Seriell. Medial. Genial

exhibition held at the Chicago Art Institute, curated by Hugh Edwards. His son Olivier is born.

1968 Travels to South Africa on assignment for the magazine *Réalités* and reports on the country and apartheid. Becomes witness in Washington, DC to the civil rights protests of black Americans. Photographs the opening of the Olympic Games in Mexico. Produces a fifty-minute documentary *The Two Faces of China* in London.

1969 Begins a series about modern architecture for *The Daily Telegraph Magazine*; the series would run for many years. Documents modern architecture in Europe – Finland, Spain, France, Italy, the UK, Denmark – and also in Japan. Meets the Mexican architect Luis Barragán for the first time.

1970 Commissioned by various English magazines to photograph at the World Exhibition (Expo '70) in Osaka, Japan. Visits Le Corbusier's Chandigarh, India. Witnesses the independence of the Fiji Islands, as well as Nasser's funeral in Cairo. Documents the election of his successor Anwar Sadat for *Life* magazine. Receives the Zurich Film Prize in 1970 for his film *Braccia si, uomini no! (Hands yes, people no!)*.

1971 With Magnum Films/Philip Gittelmann produces a commercial film for Xerox describing the firm's worldwide business activities. The film is based on a black-and-white photo essay of the company.

1972 Works with writer Hugo Loetscher on a Chicago special issue of *Du* magazine, edited by Manuel Gasser and Peter Killer, and designed by Peter Jenny. Participates in the group exhibition 'Behind the Great Wall' in the Metropolitan Museum, New York, which also features works by Robert Capa, Henri Cartier-Bresson, Marc Riboud and Edgar Snow, among others. US President Nixon's meeting with Mao in China had made the subject very topical. Burri shows his film *The Two Faces of China* as part of the exhibition. Produces a film about Jean Tinguely for Swiss television to coincide with Tinguely's exhibition at the Kunsthalle in Basel.

1973 Returns to Vietnam taking photographs for himself.

1974 Travels to Cuba on assignment for *Time* and accompanies the state visit of Leonid Brezhnev. Documents for *Stern* and *Life*, among others, the mine-clearing operations in the Suez Canal led by the US following the Yom Kippur War. Photographs President Nixon's historic visit to Egypt. Works on a *Life* special issue entitled the 'New Kings of Oil' (January 1975), photographing in the United Arab Emirates, Kuwait, Saudi Arabia and Iran. His film *Braccia si, uomini no!* (made in collaboration with Peter Ammann) is featured in the series 'New Swiss Films' at the Museum of Modern Art, New York (19 December 1974 to 20 January 1975).

1975 Travels to Oman for *Stern* magazine. Photographs rubber production in Monrovia, Liberia as part of an industry assignment. Reports

for *Fortune* on the Pacific island of Nauru, known for its once rich phosphate resources.

1976 His highly acclaimed photo essay on oil-rich Das Island in the United Arab Emirates is published in *Geo*, *Schweizer Illustrierte* and elsewhere. Accompanies the election campaign of Jimmy Carter in his home town of Plains, Georgia.

1977 Journeys to Brazil on assignment for the Brazilian magazine *Manchete* and reports on Brasília seventeen years after its completion and the carnival in Rio. Produces a colour reportage on 'Fifth Avenue' in New York for *Geo* (US, no. 3, April 1981). In England, documents Queen Elizabeth II's silver jubilee for *The Sunday Times Magazine* under Michael Rand.

1978 Produces a reportage for *Stern* magazine on the influence of the military dictatorship in Argentina. Begins his examination of the US and Russian space programmes ('Ruins of the Future').

1979 Ten years after the first moon landing, takes portraits for *Life* of the twelve Apollo astronauts who had set foot on the moon ('Moon Astronauts – Where Are They Now?'). Begins documenting the Space Shuttle programme. Photographs a piece on 'car culture' in the US for *Stern* magazine. Produces a reportage on Palestinian training camps in Lebanon for *Life* and *Stern*.

1980 On assignment for *Schweizer Illustrierte*, photographs Germany on the eve of the elections (with writers Peter Bichsel and Hugo Loetscher). Takes a portrait of the dancer Rudolf Nureyev for *The New York Times Magazine*.

1981 Flies from New York to Cairo to photograph the memorial ceremonies held for assassinated Egyptian president Anwar Sadat. Documents the take-off and landing of the Space Shuttle Columbia. For the first time publishes examples of his collage work, which he began in the mid-1950s, in a special issue of *Du* magazine ('40 Jahre Du' ['40 years of *Du* Magazine'], no. 3, 1981).

1982 Elected president of Magnum Paris. Opens a photo gallery on the ground floor of the Magnum office on the rue des Grands Augustins. Its first exhibition, 'Terre de Guerre' ('Region of War'), focuses on the crisis in the Middle East (concept and catalogue by Burri). Takes the first photographs for an extensive photo essay on the fortieth anniversary of the Allied invasion of Normandy.

1983 Begins preparations for his large retrospective at the Kunsthaus Zürich.

1984 Opening of Burri's first major retrospective 'One World' in the Kunsthaus Zürich; the exhibition includes collage as well as photographic work. Exhibition subsequently moves to Paris (Centre National de la Photographie), Lausanne (Musée des Arts Décoratifs), among other cities and venues. Goes to Kenya to walk in the footsteps of the first

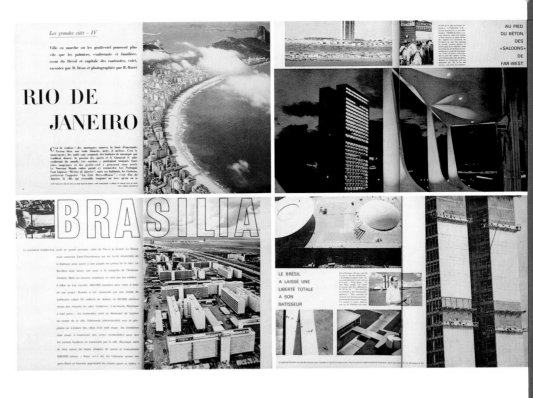

humans on assignment for the newspaper *Libération* (27 July to 31 August 1984). The subsequent reportage is entitled 'Un voyage de huit millions d'années sur les traces du premier homme' ('A Voyage of Eight Million Years on the Trail of the First Man').

1985 Learns that his wife Rosellina has cancer. At the end of the year, travels to China to do his long-planned reportage on the fiftieth anniversary of the Long March.

1986 Rosellina Burri dies in January. In September, works on a film entitled *The Nuclear Highway*, and completes a photo essay on the history of US space travel and nuclear programmes for the supplements of *Zürcher Tages-Anzeiger* and *Süddeutsche Zeitung*.

1987 Sees the architect Luis Barragán for the last time and takes his portrait. Follows student protests in South Korea in the run-up to the Olympic Games (for *Schweizer Illustrierte* and *Life*).

1988 Photographs the meeting between Mikhail Gorbachev and Ronald Reagan in Moscow. Takes portrait of writer Patricia Highsmith at her home in Tessin for *Schweizer Illustrierte*.

1989 Travels to Cairo where he takes the portrait of the Egyptian Nobel prize-winner for literature, Naguib Mahfouz, for *Schweizer Illustrierte*. Witnesses the fall of the Berlin Wall. Travels to China where he documents the student protests in Tiananmen Square. Travels through Poland on commission for *Du* magazine.

1990 With Marco Bischof, develops the concept for the book to accompany the touring exhibition 'Werner Bischof 1916–1954' (published by Benteli, Bern). Takes portraits of the film director Akira Kurosawa in Tokyo and the artist Anselm Kiefer in southern Germany for *SZ-Magazin*. Composes photo essay on the architect Mario Botta for the Japanese magazine *Approach*. Creates the concept for the illustrated book *À l'est de Magnum* (*East of Magnum*).

1991 Creates photo essay (together with Gabriele Basilico, Raymond Depardon, Fouad Elkoury, Robert Frank and Josef Koudelka) on the centre of Beirut, destroyed by civil war.

1993 Follows the re-election of Fidel Castro in Cuba. Goes on a second trip to Cuba, accompanied by his partner, Clotilde Blanc, and Marco Meier, deputy editor of *Du* magazine. Subsequently publishes a special issue on Cuba (no. 12, 1993, 'Los cubanos' ['The Cubans']).

1994 Birth of son Léon Ulysse.

1995 Photographs Fidel Castro's visit to the Elysée Palace, Paris.

1997 Russell Miller's book about Magnum – 'the unauthorized biography of a large, unruly and highly talented family which, by some miracle, has stayed together for fifty years' is published (Secker & Warburg, London); it becomes the subject of discussion within the agency. Part of Burri's 'Che' contact sheet features on the book jacket. Travels to Brazil where he and the author Jean Rolin create a photo essay about Brasília for the French magazine *l'architecture d'aujourd'hui* (no. 313, October 1997). Flies to Bolivia and photographs the scene of Che Guevara's execution in La Higuera thirty years earlier; the pictures are intended for use in an issue of *Photo Poche* devoted to the revolutionary.

1998 In September receives the Dr Erich Salomon Prize from the German Photographic Society. The prize, given every year since 1971, is awarded to individuals 'who have rendered services to photography in the media, but above all have done outstanding work in photo-journalism'. The award is presented to Burri in the Photokina in Cologne; the exhibition 'Die Deutschen' runs concurrently at the convention centre there. Marries Clotilde Blanc in Mosogno in Tessin.

1999 Burri's book *Le Corbusier* (edited by Arthur Rüegg and designed by Werner Jeker) is published by Birkäuser, Basel. The book represents the summation of Burri's decades-long experience of the architect and his work.

2000 Begins inspecting his archive in preparation for the retrospective monograph *René Burri Photographs* (Phaidon, 2004), as well as for an exhibition in the Maison Européenne de la Photographie in Paris and the Musée de l'Elysée in Lausanne, Switzerland. Picture edits *magnum°* (Phaidon, 2000) to accompany a highly acclaimed touring exhibition that starts in London and Paris.

2004 Retrospective exhibition 'René Burri – Rétrospective 1950–2000' held at the Maison Européenne in Paris from January–March, curated by Hans-Michael Koetzle (Munich) and William A. Ewing (Lausanne). Exhibited at the Musée de l'Elysée, Lausanne, June–October.

René Burri currently lives in Paris.

BOOKS AND SELECTED REPORTAGES

(1–2, 4) 'Red China – Spruced Up for Show', *Life*, November 1964
(3) 'Auf schmalem Pfad in die Zukunft', *Schweizer Illustrierte*, no. 18, 28 April 1986

440

Books by René Burri

Die Deutschen, texts selected by Hans Bender, Zurich: Fretz & Wasmuth Verlag AG, 1962. [Also published in French by Robert Delpire with texts selected and introduced by Jean Baudrillard]
The Gauchos, New York: Crown Publishers, Inc., 1967 [Also published in Spanish by Buenos Aires Muchnik Editores]
In Search of the Holy Land, text by H.V. Morton, London: London Editions Limited, 1979
The Lost Pony, text by George Mendoza, San Francisco: San Francisco Book Company, 1980
Die Deutschen: Eine Ausstellung von Photographien aus den sechziger Jahren [exh. cat.], Cologne: Galerie Rudolf Kicken, 1981
I Grandi Fotografi: René Burri, texts by Hans Koning and René Burri, Milan: Gruppo Editoriale Fabbri, 1983
One World: Photographien und Collagen 1950–1983, edited by Rosellina Burri-Bischof and Guido Magnaguagno, Bern: Benteli, 1984 [Also published in French by Benteli]
Ein amerikanischer Traum, text collages by Geritt Confurius, Delphi 1042, Nördlingen: Greno Verlagsgesellschaft m.b.h., 1986
Die Deutschen: Photographien 1957–1964, texts by Hans Magnus Enzensberger, Munich: Schirmer/Mosel, 1986 [Republished in 1990 with the subtitle *Photographien aus einem geteilten Land* (*Photographs from a Divided Land*)]
Dialogue avec Le Corbusier [exh. cat.], in collaboration with Daniel Schwartz, Hardhof-Basel: Espace Art et Culture Ebel, 1990
À L'Est de Magnum 1945–1990: Quarante-cinq ans de reportage derrière le rideau de fer, in collaboration with François Hébel, Paris: Les Éditions Arthaud, 1991
Cuba y Cuba, text by Marco Meier; poems by Miguel Barnet, Milan: Federica Motta Editore S.p.A., 1994
Gauchos: Photographs by René Burri, foreword by Jorge Luis Borges; text by José Luis Lanuza, New York: Takarajima Books, 1994 [Also published in Japanese by Takarajima Books]
Che Guevara: Photographies de René Burri, text by François Maspero, Collection Photo Poche Histoire 1, Paris: Éditions Nathan, 1997
René Burri, text by Hans-Michael Koetzle; edited by Robert Delpire, Collection Photo Poche 79, Paris: Editions Nathan, 1998
77 Strange Sensations, story by Barry Gifford, Zurich: Edition Dino Simonett, 1998
Le Corbusier: Moments in the Life of a Great Architect, Photographs by René Burri/Magnum, edited and with texts by Arthur Rüegg, Basel: Birkhäuser, 1999 [with supplemental brochure in German and French]

Die Deutschen: Photographien 1957–1997, introduction by Hans-Michael Koetzle; poems by Hans Magnus Enzensberger, Munich: Schirmer/Mosel, 1999
Luis Barragán, London: Phaidon, 2000 [Also published in French and German by Phaidon Press]
Berner Blitz, text by Guido Magnaguagno, edited by Dino Simonett, Zurich: Edition Dino Simonett, 2002 [Also published in English by Dino Simonett]

Selected Reportages by René Burri

1955 'Touch of Music for the Deaf', *Life*, June 1955, p. 95
1956 'René Burri', *Camera*, no. 7, July 1956, pp. 296–304
1957 'La Syrie sous les armes', *Jours de France*, no. 155, 2 November 1957, pp. 50–3
1958 'L'Anschluss de Nasser', *Paris-Match*, no. 462, 15 February 1958, pp. 30–5
'Monsieur 99%. A Damas, Mariage Egypte-Syrie', *Paris-Match*, no. 465, 8 March 1958, pp. 46–9
'Élèves-officiers algériens en Egypte', *L'Illustré*, no. 13, 27 March 1958, pp. 50–1
'Das lebendige Museum', *Du*, no. 7, July 1958, cover, pp. 5, 24–5
'Rio de Janeiro', *Jours de France*, no. 210, 22 November 1958, pp. 36–7
1959 'El gaucho', *Du*, no. 217, March 1959, pp. 7–76
1960 'Brasília', *Paris-Match*, no. 581, 28 May 1960, pp. 72–93
1961 'Le Corbusier', *Du*, no. 6, 1961, pp. 19–31
'Japan bei der Arbeit', *Du*, no. 246, August 1961, pp. 2–46
'Zen in Bildern', *Du*, no. 250, December 1961, pp. 49–63
1962 'In Deutschland', *Du*, no. 259, September 1962, pp. 22–31
1964 'Red China – Spruced Up for Show', *Life*, November 1964, no pagination
1965 'Koh Samui. Eine Insel im Golf von Siam', *Du*, no. 293, July 1965, pp. 496–548
1966 'Boxen in Thailand', *Du*, no. 306, August 1966, pp. 626–7
1967 'Bahia – Porträt einer Stadt', *Du*, no. 317, July 1967, pp. 502–64
'René Burri film in China', *Annabelle*, no. 433, 16 August 1967, pp. 84–5
1972 'Chicago', *Du*, no. 375, May 1972, pp. 316–376
1975 'Chinoiserie. China als Utopie', *Du*, April 1975, pp. 74–83
1979 'School for Terror', *Life*, June 1979, pp. 24–7
1981 'Space Chariot for the '80s', *Life*, March 1981, pp. 44–50
'Angst vorm Fliegen oder die Suche nach dem Gleichgewicht', *Du*, no. 3, March 1981, pp. 52–5

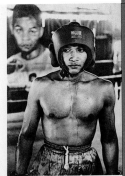

EXHIBITIONS

(1) 'René Burri filmt in China', *Annabelle*, no. 433, 16 August 1967
(2) 'Boxen in Thailand', *Du*, no. 306, August 1966

441

1986 'Auf schmalem Pfad in die Zukunft', *Schweizer Illustrierte*, no. 18, 28 April 1986, pp. 60–1

1987 'Krieg und Spiele', *Schweizer Illustrierte*, no. 22, 25 May 1987, pp. 18–19

1990 'Warschau. Der Anfang einer Geschichte', *Du*, no. 2, 1990; pp. 12–13, 16–25, 72–83
'Akira Kurosawa ...', *Du*, no. 8, August 1990; cover, pp. 28–9, 31, 34–5, 84–5, 97

1992 'Uwe Johnson ...', *Du*, no. 10, October 1992, pp. 56–7

1993 'Los Cubanos, Metamorphosen einer Revolution', *Du,* no. 12, December 1993; cover, pp. 24–35, 38–45, 48–55, 58–69, 73

1997 'Tango', *Du*, no. 11, November 1997, pp. 66–9

1998 'Picasso. Seriell. Medial. Genial.', *Du*, no. 1, September 1998; cover, pp. 30–1, 35–6, 46–52, 62–71, 74–9

1999 'Hans Magnus Enzensberger', *Du*, no. 699, September 1999; pp. 26–7, 29, 46–53

Solo Exhibitions

1966 'China', **Galerie Form**, Zurich

1967 'China', **Cafeteria am Sternacker**, St Gallen
'René Burri Retrospective', **Art Institute of Chicago**, Chicago

1971 '50 Photographies de René Burri', **Galerie Rencontre**, Paris

1972 'René Burri Retrospective', **Raffi Gallery**, New York
'René Burri Retrospective', **Il Diaframma**, Milan

1980 'Die Deutschen', **Museum Folkwang**, Essen

1981 'Die Deutschen', **Galerie Rudolf Kicken**, Cologne

1982 'Die Deutschen', **Galerie Nagel**, Berlin

1983 'Rovine del Futuro', **Galleria Fotografica**, Trieste
'Antologica', **Kunsthaus Zürich**, Zurich

1984 'One World', **Kunsthaus Zürich**, Zurich
'One World', **Berner Photo-Galerie**, Bern
'One World', **Centre National de la Photographie** and **Palais de Tokyo**, Paris

1985 'One World', **Musée des arts décoratifs**, Lausanne
'Un Mundo', **Casa de las Américas**, Havana

1987 'Dans la familiarité de Corbu', **Musée de l'Elysée**, Lausanne
'An American Dream', **International Center of Photography**, New York

1988 'One World – A Selection of Photographs', **Burden Gallery, Aperture Foundation**, New York
'One World – A Selection of Photographs', **Swiss Institute**, New York

1990 'Dialogue avec Le Corbusier', **Espace Art et Culture Ebel** (with Daniel Schwartz), Basel

'Jardin Zen/Made in Japan', **La Terrasse de Gutenberg/ Métamorphoses**, Paris

1991 'One World', **Indian Council for Cultural Relations**, New Dehli

1992 'Jordanie', **Fnac**, Paris

1993 'René Burri', **III International Photomeeting**, San Marino

1994 'Dialogue avec Le Corbusier', **Museo de arte moderno de Medellín**, Medellín
'Dialogue avec Le Corbusier', **Museu Theodoro de Bona**, Curitiba
'Dialogue avec Le Corbusier', **Museu da Casa Brasíleira**, São Paulo

1995 'Le Paris de René Burri', **Centre culturel suisse**, Paris
'One World', **Month of Photography**, Bratislava
'One World', **Institut Tvurcí Fotografie**, Ostrava
'Dialogue avec Le Corbusier', **Instituto dos Arquitetos do Brasil**, Rio de Janeiro
'Dialogue avec Le Corbusier', **Museu de Arte de Brasília**, Brasília
'Dialogue avec Le Corbusier', **Colegio de Arquitectos del Peru**, Lima

1996 'René Burri – Vintage Photographs', **Galerie zur Stockeregg**, Zurich

1997 'Paris, Berlin, Havanna: Pastis, Kalter Krieg und Cuba libre', **Argus Fotokunst**, Berlin
'Che', **Fnac**, Paris
'Che', **Galerie R. Mangisch**, Zurich
'Picasso', **Galerie R. Mangisch**, Zurich

1998 '77 Strange Sensations', **Villa Tobler**, Zurich
'Spezifisch deutsch', **Photokina/Messegelände**, Cologne
'Die Deutschen', **Fotografie Forum International**, Frankfurt am Main
'Che', **Fnac-El Triangle**, Barcelona

1999 'Die Deutschen', **Kunsthaus**, Kaufbeuren
'Die Deutschen', **Museum Schloß Hardenberg**, Velbert

2000 'Die Deutschen', **Galerie Municipale du Château d'Eau**, Toulouse
'Che', **Fnac**, Lille

2001 'Che', **Fnac**, Lisbon
'René Burri', **Toscana Foto Festival**, Massa Marittima
'René Burri', **Circolo Fotografico Sannita**, Benevento

2002 'Berner Blitz', **Galerie Karrer**, Zurich

2003 'Die Deutschen', **Haus der Fotografie/Dr. Robert-Gerlich-Museum**, Burghausen

2004 'René Burri – Rétrospective 1950–2000', **Maison Européenne de la Photographie**, Paris
'René Burri – Rétrospective 1950–2000', **Musée de l'Elysée**, Lausanne

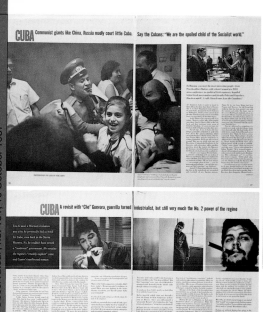
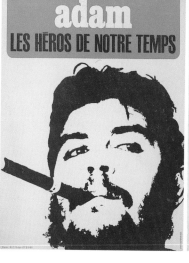
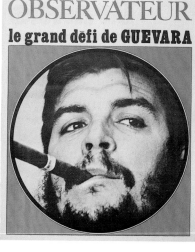

FILMOGRAPHY

(1–2) 'Cuba', Look, 9 April 1963; (3) 'Les Héros de notre temps', Adam, promotional poster, 1967
(4) 'Le grand défi de Guevara', Le Nouvel Observateur, no. 151, 10 October 1967

442

Group Exhibitions including René Burri's work

1956 'Magnum-Photos', **Photokina**, Cologne
1960 'Magnum Photographers', **Takashimaya Department Store**, Tokyo
'European Photography', **Museum of Modern Art**, New York
'Photography of the 20th Century', **George Eastman House**, Rochester
1965 Group Show, **Musée Réattu**, Arles
1966 'The Photographer's Eye', **The Museum of Modern Art**, New York
'6 fotografos extranjeros ven a Cuba', **Consejo Nacional de Cultura**, Havana
1967 'Photography in the 20th Century', **National Gallery of Canada**, Ottawa
1972 'Behind the Great Wall of China', **Metropolitan Museum of Art**, New York
1974 'Photographie in der Schweiz 1840 bis heute', **touring exhibition to 200 venues worldwide 1974–98**
1977 'Concerning Photography', **Photographers' Gallery**, London
1978 'Images des hommes', **Passage 44**, Brussels
1979 'Fleeting Gestures: Dance Photographs', **International Center of Photography**, New York
'Fleeting Gestures', **Venezia 79/La Fotografia**, Venice
'Fleeting Gestures', **Photographers' Gallery**, London
'This is Magnum', **Pacific Press Service**, Tokyo
1980 'Magnum Expo', **Kathedrale/Kreuzgang**, Saint-Ursanne
'Das Imaginäre Fotomuseum', **Kunsthalle**, Cologne
1981 'Magnum Paris', **Palais du Luxembourg**, Paris
1982 'Magnum Paris', **International Center of Photography**, New York
'Photojournalism 1960–80', **Stedelijk Museum**, Amsterdam
'Lichtbildnisse', **Rheinisches Landesmuseum**, Bonn
'Terre de guerre', **Magnum Galerie**, Paris
1984 'Sammlung Gruber', **Museum Ludwig**, Cologne
1988 'Magnum en Chine', **Galerie Municipale du Château d'Eau**, Toulouse
'Le Nu au Chiffon Blanc', **Galerie du Jour. Agnès B.**, Paris
'L'Amérique Latine vue par Magnum', **Galerie Magnum**, Paris
1989 'Magnum: 50 Ans de Photographies', **Centre National de la Photographie**, Paris
'América Latina', IV Mes de la Fotografía Iberoamericana, Huelva
1990 '40 Jahre Magnum', **Kunsthaus Zürich,** Zurich
'Ritratti d'autore', **Galleria Gottardo**, Lugano
1991 'Die Schweiz anders sehen', **Museum für Kunst und Geschichte**, Fribourg

1993 'Magnum. 50 Años de Fotografía', **Museo Nacional Centro de Arte Reina Sofia**, Madrid
'Imagina', **Photo-Visions**, Montpellier
1994 'Der Geduldige Planet', **Zementfabrik**, Holderbank
1995 'Die Sammlung Schweizer Photographie der Gotthard Bank', **Galleria Gottardo**, Lugano
'Die Sammlung Schweizer Photographie der Gotthard Bank', **Galleria Matasci**, Tenero
'Die Sammlung Schweizer Photographie der Gotthard Bank', **Centro d'arte contemporanea**, Bellinzona
1996 'Paysages de Magnum', **Bon Marché Rive Gauche**, Paris
1997 'Images de la Fondation suisse pour la photographie', **Musée Suisse de l'appareil photographique**, Vevey
1999 'magnum°', **Barbican Centre**, London
2000 'magnum°', **Bibliothèque nationale de France**, Paris
'magnum°', **Kunsthaus Zürich**, Zurich
2001 'Durchs Bild zur Welt gekommen. Hugo Loetscher und die Fotografie', **Kunsthaus Zürich**, Zurich
'Magnum. A Community of Thought', **Howard Greenberg Gallery**, New York
2003 'L'Étoile du Che à Paris', **Le Musée du Montparnasse**, Paris
'Les Choix d'Henri Cartier-Bresson', **Fondation Henri Cartier-Bresson**, Paris

Films by René Burri

1950 'Schulhaus-Umzug', produced by René Burri, Zurich, 10 mins, black-and-white (lost)
1952 'Exkursion der Fotoklasse nach Lascaux', produced by René Burri, Zurich, 10 mins, black-and-white (lost)
1952–3 'Edward Steichen in Zürich' (Steichen visited Hans Finsler's photography class together with Robert Frank while preparing for the 'Family of Man' exhibition), produced by René Burri, Zurich, 10 mins, black-and-white (lost)
1953 'Werner Bischof' (on the occasion of a school tour of the exhibition 'Menschen in Fernost' [People in the Far East]), produced by René Burri, Zurich, 8 mins, black-and-white
1953–4 'Kunstgewerbeschule Zürich', produced by René Burri, Zurich, 30 mins, black-and-white (lost)
1965–6 'The Physical Face of China', Magnum Films, New York/ Philip Gittelmann for *Encyclopedia Britannica*, Chicago, 15 mins, colour
'Three Villages of China', Magnum Films, New York/Philip Gittelmann for *Encyclopedia Britannica*, Chicago, 25 mins, colour

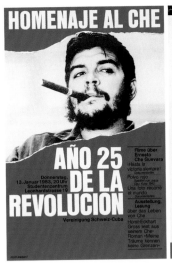
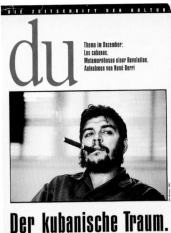
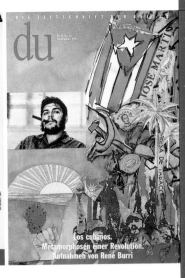

(1) 'Homenaje al Che, Año 25 de la Revolucion', poster, January 1983; (2) 'Der Kubanische Traum', Du, poster, December 1993; (3) 'Los Cubanos', Du, no. 12, December 1993

'What's it All About', Magnum Films, New York/Philip Gittelman for Xerox, 25 mins, colour

'The Industrial Revolution', Magnum Films, New York/Philip Gittelmann for *Encyclopedia Britannica*, Chicago, 15 mins, colour

1967–8 'Jerusalem', René Burri/Magnum Films, Zurich for Bavaria Film/WDR, 30 mins, colour

'The Biblical Zoo in Jerusalem', René Burri/Magnum Films, Zurich for Bavaria Film/WDR, 5 mins, colour

'Billy Rose Sculpture Garden, Jerusalem', René Burri/Magnum Films, Zurich for Bavaria Film/WDR, 5 mins, colour

1968 'The Two Faces of China', René Burri/Magnum Films, Zurich for the BBC, London, 50 mins, colour

1969 'The Big Team', René Burri/Magnum Films, Zurich for Sulzer Industries, Winterthur, 10 mins, colour

'It's What You Make It', Magnum Films, New York/Philip Gittelmann for IBM, 25 mins, colour

1970 'Braccia si, uomini no!', René Burri/Magnum Films, Zurich with Peter Ammann, 50 mins, colour (received the Zurich Film Prize, 1970; awarded a prize at the Nyons Film Festival, 1970)

1971 'Xerox in Concert', Xerox, 11 mins, colour

'Five: The Sculpture of Barbara Close Riboud', René Burri/Magnum Films, Zurich for The Museum of Modern Art, New York, 6 mins, colour

1972 'Jean Tinguely', René Burri/Magnum Films, Zurich for DSF, 10 mins, colour

'Wines of the World', René Burri/Magnum Films, Zurich and PPS/Robert Kirschenbaum for Suntori, Tokyo, 20 mins, colour

1973 'Indian Summer', produced by Philip Gittelmann, New York for the Ford Foundation, New York, 30 mins, colour

1986 'The Nuclear Highway', Little Magic Productions for Nippon TV, 10 mins, colour

Selected Bibliography

Emilio Ambasz, *The Architecture of Luis Barragán* [exh. cat.], New York: The Museum of Modern Art, 1976

Michèle and Michel Auer, *Encyclopédie internationale des photographes de 1839 à nos jours*, Genf: Éditions Camera Obscura, 1985

Dieter Bachmann and Daniel Schwartz, *Der Geduldige Planet. Eine Weltgeschichte: 255 Fotografien aus der Zeitschrift "Du"* [exh. cat.], touring exhibition, Pro Helvetia, Zurich: Schweizer Kulturstiftung, 1996

— , *So Many Worlds*, London: Thames & Hudson, 1996

Urs Bader, 'Weltgeschichte in Bildern: Fotos von René Burri im Kunsthaus Zürich', *Glarner Nachrichten*, 6 February 1984

Roland Barthes, *Mythen des Alltags*, Frankfurt/Main: Suhrkamp, 1964

Gabriel Bauret, *Color Photography*, Paris: Éditions Assouline, 2001

Alain Bergala, *Magnum Cinema: Photographs from 50 Years of Movie-Making*, London: Phaidon, 1998

Marco Bischof (ed.), *Werner Bischof 1916–1954: Leben und Werk*, Bern: Benteli, 1990

Werner Bischof, *After the War was Over ...*, London: Thames & Hudson, 1985

Bernd Busch, et al., *Fotovision: Projekt Fotografie nach 150 Jahren*, Hannover: Sprengel Museum, 1988

Jean-Philippe Breuille and Michel Guillemot, *Larousse Dictionnaire de la Photo*, Paris: Larousse, 1996

Turner Brown and Elaine Partnow, *Macmillan Biographical Encyclopedia of Photographic Artists & Innovators*, New York: Macmillan, 1983

Laura Bucciarelli, 'René Burri expose son yoga visuel', *Journal de Genève et Gazette de Lausanne,* October 1995

Hans Bütow, 'Sind wir wirklich so?', *Sonntagsblatt*, Hamburg, 24 February 1963

Alfred Catani, 'Die Deutschen', *Neue Zürcher Zeitung*, 4 January 1963

Jean Cormier and Danielle Pampuzac (eds), *Che Guevara par les photographes de la revolution cubaine* [exh. cat.], Musée du Montparnasse, Paris: Éditions du Rocher, 2003

Robert Delpire (ed.), *La Photo fait du Cinéma: René Burri, Francesco Maselli, Thierry Gérard*, Photogénies, no. 5, 1984

Robert Delpire and Dominique Eddé (eds), *Beyrouth*, Paris: Éditions du Cyprès, 1992

Jean Dieuzaide (ed.), *Magnum en Chine* [exh. cat.], Toulouse: Galerie Municipale du Château d'Eau, 1988

Magdalena Droste, *Bauhaus 1919–1933*, Cologne: Taschen, 2002

Sally Eauclaire, *The New Color Photography*, New York: Cross River Press, Ltd., 1981

Fritz Egger, 'Die Deutschen', *Wiener Zeitung*, no. 76, 1963

Ute Eskildesen, *Portraits aus Nachkriegsdeutschland: Fotos aus der Bundesrepublik Deutschland 1947–1980* [exh. cat.], Munich: Goethe-Institut, 1982

Martin Marix Evans and Amanda Hopkinson (eds), *Contemporary Photographers*, 3rd edition, Detroit: St James Press, 1995

Hans Finsler, 'Das Bild der Photographie', *Du*, no. 3, 1964

— , *Mein Weg zur Fotografie. 30 Aufnahmen aus den zwanziger Jahren*, Zurich: Pendo, 1971

Gisèle Freund, *Photography and Society*, London: David R. Godine Publisher, Inc., 1980

Marianne Fulton, *Eyes of Time: Photojournalism in America*, Boston: Little, Brown & Company, 1988

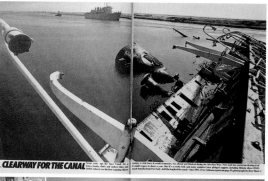

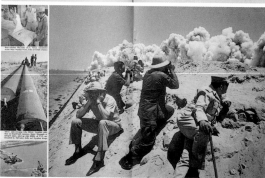

Klaus E. Göltz, Theo Immosch, Peter Romanus and Axel Wendelberger (eds), *Hans Finsler: Neue Wege der Photographie* [exh. cat.], Staatliche Galerie Moritzburg Halle, Leipzig: Edition Leipzig, 1991

Silvia González, *René Burris 'Che' Guevara-Porträt: Die mythische Überhöhung einer Fotografie*, Zurich: Lizensiatsarbeit der Philosophischen Fakultät der Universität Zürich, 1999

Michel Guerrin, 'Un photographe sous les feux de la guerre', *Le Monde*, no. 12258, 24–5 June 1984

— , 'The Life and Work of Photojournalist René Burri', *Guardian Weekly*, 12 August 1984

Hasselblad Foundation (eds), *The Hasselblad Award 1998: William Eggleston*, Göteborg: Hasselblad Foundation, 1999

François Hébel and René Burri (eds), *À L'Est de Magnum 1945–1990: Quarante-cinq ans de reportage derrière le rideau de fer*, Paris: Les Éditions Arthaud, 1991

Manfred Heiting (ed.), *Zwischen Wissenschaft und Kunst: 50 Jahre Deutsche Gesellschaft für Photographie*, Göttingen: Steidl, 2001

Martin Heller, 'Die Welt des Schweizer Fotografen René Burri. Verdienstvolle Ausstellung im Kunsthaus Zürich', *Vaterland*, Luzern, 3 February 1984

Mechthild Heuser, 'Photography meets Architecture: René Burri features Le Corbusier', *Archithese*, no. 4, 1999, p. 78

Gabriele Honnef-Harling and Karin Thomas (eds) *'Nichts als Kunst ...'. Schriften zu Kunst und Fotografie*, Cologne: Dumont, 1997

Alain d'Hooghe, *Les trois grandes Egyptiennes: Les Pyramides de Gizeh à travers l'histoire de la photographie*, Paris: Éditions Marval, 1996

Erika von Hornstein, *Flüchtlingsgeschichten*, Nördlingen: Greno Verlagsgesellschaft m.b.h., 1985

'**Bilder von Deutschen**', *Basler Volksblatt*, 6 April 1963

Albert Jacquard, *Dall' angoscia alla speranza: Una lezione di ecologia umana, Fotografie di René Burri*, Mendrisio: Università della Svizzera italiana Accademia di architettura, 1999

Peter Killer, *Du. Die Zeitschrift der Kultur 1941–2001*, Zurich: Du/Transmedia AG, 2000

Robert Kirschenbaum (ed.), *This is Magnum* [exh. cat.], Tokyo: Pacific Press Service/PPS Tsushinsha, 1979

Roberto Koch (ed.), *Americani: Dagli archivi Magnum le immagini degli States*, Mailand: Leonardo Arte, 1997

Thilo Koenig, Hans-Michael Koetzle and Christiane Wachsmann, *Objekt + Objektiv = Objektivität? Fotografie an der HfG Ulm 1953–1968*, Ulm: HfG-Archiv, 1991

Hans-Michael Koetzle, *Das Lexikon der Fotografen 1900 bis heute*, Munich: Droemersche Verlagsanstalt Th. Knaur Nachf., 2002

— , *Photo Icons II*, Cologne: Taschen, 2002

— , 'Deutsche West und Ost', *Photo Technik International*, no. 5, 1998, pp. 66–75

Jörg Krichbaum, *Lexikon der Fotografen*, Fischer Taschenbuch 6418, Frankfurt am Main: Fischer, 1981

Udo Kulterman (ed.), *Modern Masterpieces: The Best of Art, Architecture, Photography and Design since 1945*, Detroit: Visible Ink Press, 1998

'**Lässige Schwermut**', *Landbote*, Winterthur, 24 May 1963

Hugo Loetscher, *Durchs Bild zur Welt gekommen: Reportagen und Aufsätze zur Fotografie*, Zurich: Scheidegger & Spiess, 2001

Guido Magnaguagno, *Die Sammlung Schweizer Photographie der Gotthard Bank* [exh. cat.], Gallera Gottado, Lugano: Fondazione per la cultura della Banca del Gottardo, 1998

Magnum Photos, *1968: Magnum dans le Monde*, Paris: Magnum Photos, 1998

— , *50 Jahre Israel in Magnum Photographien*, Reinbek bei Hamburg: Rowohlt, 1998

— , *Arbres*, Paris: Éditions Pierre Terrail, 1998

— , *Couples*, Paris: Éditions Pierre Terrail, 1998

— , *magnum°*, introduction by Michael Ignatieff, London: Phaidon, 2000 [Also published in French, German and Italian by Phaidon Press]

— , *Magnum Football*, introduction by Simon Kuper, London: Phaidon, 2002 [Also published in French, German and Italian by Phaidon Press]

— , *Magnum Landscape*, foreword by Ian Jeffrey, London: Phaidon, 1996

— , *Magnum Photos*, introduction by Fred Ritchin; afterword by François Hébel, Collection Photo Poche 69, Paris: Éditions Nathan, 1997

— , *Terre de Guerre*, Charles-Henri Favrod, Paris: Collection La Mémoire de L'Oeil, Magnum Photos, 1982

William Manchester, *In Our Time*, New York: W.W. Norton & Company, 1989

Gloria S. McDarrah, Fred W. McDarrah and Timothy S. McDarrah, *The Photography Encyclopedia*, New York: Schirmer Books, 1999

Metropolitan Museum of Photography (ed.), *Photographers Who Created a New Age: 1960–70* [exh. cat.], Tokyo: Metropolitan Museum of Photography, 1993

Russell Miller, *Magnum: Fifty Years at the Front Line of History – The Story of the Legendary Photo Agency*, London: Secker & Warburg, 1997

Reinhold Mißelbeck (ed.), *Photographie des 20. Jahrhunderts: Museum Ludwig Köln*, Cologne: Taschen, 1996

— , (ed.), *Prestel-Lexikon der Fotografen*, Munich: Prestel, 2002

Stefan Moses, *Abschied und Anfang: Ostdeutsche Porträts 1989–1990*, Ostfildern bei Stuttgart: Hatje Cantz, 1991

— , *Deutsche*, Munich: Prestel, 1980

Josef Müller-Brockmann, *Raster-Systeme für die visuelle Gestaltung.*

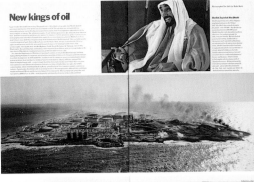

New kings of oil

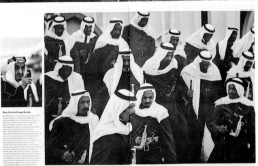

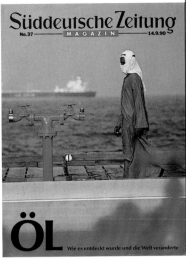

Süddeutsche Zeitung
MAGAZIN
No.37 14.9.90

ÖL Wie es entdeckt wurde und die Welt veränderte

(1–2) 'New Kings of Oil', *Life*, Special Report, Winter 1975
(3) 'Öl', *Süddeutsche Zeitung Magazine*, no. 37, 14 September 1990.

Ein Handbuch für Graphiker, Typographen und Ausstellungsgestalter, 3rd revised edition, Stuttgart/Heiden: Niggli, 1988
Raymond Naef, *Grock: Eine Wiederentdeckung des Clowns*, Wabern-Bern: Benteli, 2002
Carole Naggar, *Dictionnaire des photographes*, Paris: Éditions du Seuil, 1982
Colin Naylor, *Contemporary Photographers*, 2nd edition, Chicago: St James Press, 1988
Photographic Society of Japan (ed.), *54 Master Photographers of 1960–1979*, Tokyo: The Photographic Society of Japan, 1989
Jacques Poget, 'Un Oeil nommé Burri', *Illustré*, no. 6, February 1985, p. 56–7
Allan Porter, *Camera: Die 50er Jahre*, Munich: C.J. Bucher GmbH, 1982
Johann Georg Reißmueller, 'So häßlich sind wir nicht', *Frankfurter Allgemeine Zeitung*, 23 May 1963
Andrew Roth, *The Book of 101 Books: Seminal Photographic Books of the Twentieth Century*, New York: PPP Editions, 2001
Willy Rotzler, 'René Burri photographiert die Deutschen', *Weltwoche*, 11 January 1963
Arthur Rüegg, 'René Burri sieht Le Corbusier', *Basler Magazin*, no. 23, 19 June 1999, pp. 1–5
—, *Le Corbusier: Photographs by René Burri/Magnum*, Boston: Birkhauser, 1999
Saint-Ursanne (ed.), *Magnum Photos* [exh. cat.], introduction by Hugo Loetscher, Saint-Ursanne, 1980
Martin Schaub, 'Zeichen der Zeit: René Burri', *Tages-Anzeiger Magazin*, no. 2, 14 January 1984, pp. 18–20
— , 'Ein Traum von Weite und Einsamkeit', *Tages-Anzeiger*, 29 August 1994
Peter P. Schneider, 'René Burris vorbildliches Auge', *Tages-Anzeiger*, 18 September 1998
Robert Schneider, 'Fotografische Konturen unserer Epoche. "One World" im Kunsthaus Zürich: René Burris erste Werkübersicht', *Der Landbote*, Winterthur, 25 January 1984
Daniel Schwartz and René Burri (eds), *Dialogue avec Le Corbusier* [exh. cat.], Hardhof-Basel: Espace Art et Culture Ebel, 1990
Schweizerische Stiftung für die Photographie (eds.), *Photographie in der Schweiz: 1840 bis heute*, Teufen: Niggli, 1974
— , *Photographie in der Schweiz von 1840 bis heute*, Bern: Benteli, 1992
Agnès Sire, *Paysages de Magnum*, Paris: Éditions Plume, 1996
Urs Stahel and Martin Heller, *Wichtige Bilder: Fotografie in der Schweiz* [exh. cat.], Museum für Gestaltung, Zurich: Verlag der Alltag, 1990
John Szarkowski, *The Photographer's Eye* [exh. cat.], New York: The Museum of Modern Art, 1966

Jan Thorn-Prikker, *René Burri: One World*, Masch. Ms., WDR/Westdeutscher Rundfunk, Redaktion "Mosaik", 1984
Brigitte Ulmer, 'Der Fotograf ist meistens ein Clown', *Tages-Anzeiger*, 26 June 1999
— , 'Ich dachte, Burri, du spinnst', *Cash Extra*, no. 49, 5 December 1997, pp. 68–9
Hanne Weskott, 'Alltag in Kontrasten und extremen Ausschnitten', *Süddeutsche Zeitung* (supplement), 18 February 1999
Peter Zimmermann, 'Kein rasender Reporter. Zu René Burris Photographien', *Neue Zürcher Zeitung*, 15 January 1984

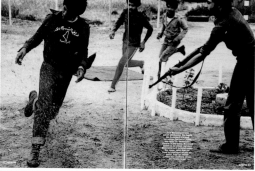
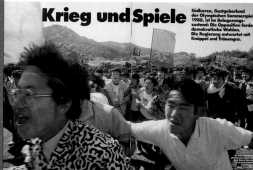
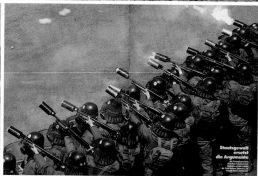

INDEX

(1–2) 'Die Schule des Terrors', *Stern*, no. 36, 30 August 1979
(3–4) 'Krieg und Spiele', *Schweizer Illustrierte*, no. 22, 25 May 1987

446

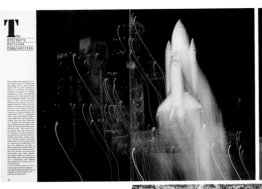

(1–2) 'Space Chariot for the '80s', *Life*, March 1981; **(3)** 'Death of a Superstar', *The Independent on Sunday*, 10 January 1993; **(4)** 'René Burri', *Zoom*, no. 12, 1984

ACKNOWLEDGEMENTS

left: René Burri in Fontvielle, France in 1997. Portrait by Charles Roff.
right: **Step Pyramid**, Giza Plateau, Cairo, 1970.

448

Remembering you with joy and sorrow

My family Clotilde Blanc-Burri and Léon Ulysse Burri, my parents Rudolf and Bertha Burri-Haas, my sister Véronique Burri-Winterfeld, my first wife, Rosellina Burri-Bischof, our children Marco, Daniel, Olivier and their wives, Yasmine Rebecca and Gina Sophia Lina, Anna Mandel, Jacques and Nicole Blanc Touvay, and to the Ambroise, Blanc-Levy and Gallois families.

To my friends and artists

Dieter and Ingeborg Bachmann, Luis Barragán, Walter and Andrée Binder, Werner Bischof, Walter Bosshard, Bob, Cornell and Edie Capa, Henri and Martine Cartier-Bresson, Le Corbusier, Victor and Mimi Cohen, Robert Delpire, Colette Delpire, Hans Magnus Enzensberger, William Ewing, Charles Henri Favrod, Edward Finnegan, Hans Finsler, Manuel Gasser, Alberto Giacometti, Hiroshi and Asa Hamaya, Jeane Hedstrom, Uwe Johnson, Hans-Michael and Michaela Koetzle, Hans and Kate Koning, Freddy and Franco Legler and their families, Guido Magnaguagno, Jean-Luc Monterosso, Sarah Moon, Annette Ringier and her family, George and Jinx Rodger, Ted Scapa, Martin and Maly Schaub, David (Chim) Seymour and Alfred Willimann.

To friends who helped me on this and many other projects

Peter Ammann, Sarah H. Boggs, Martine Borioli, Allen Brown, Norbert Bunge, Bixio and Nice Candolfi, Luc Chessex, Maurice Coriat, Jean Cormier, Florencia Costa, Benoît and Marie-Dina Deschamps, Richard Dindo, Diane Dufour, Joseph and Magi Estermann, Arno Fischer, Jimmy Fox, David and Nancy Friend, Paul and Betty Gauci, Dominik Geissbühler, Jean Genoud, Barry Gifford, Edie Gonseth, Theo and Sylvie Grimmeisen, François Hébel, John and Judith Hillelson, Helmut Hutter and his Orange film crew, Werner and Barbara Jeker, Lee Jones, Omar Kureishi, Sergio Larrain, Serge Libiszewski, John Loengard, Hugo Loetscher, Ernie Lofblad, Ramón López, Rudi Mangisch, René Martinet, Roméo Martinez, Richard Meier, Voja and Brigitte Mitrovič, John G. Morris, Arthur Rüegg, Bepe Savary, Lothar Schirmer, Laura Serani, Dino Simonett, Harald Szeeman, Jean Tinguely and Frank Wegner.

To Magnum

With thanks to my colleagues, friends all over the world, and photographers and staff at Magnum Photos Paris, New York, London and Tokyo.

To Phaidon

My special thanks to Richard Schlagman and his devoted team, Amanda Renshaw, Noel Daniel, Frances Johnson, Ellen Spalek, Amy Cilléy, Charlotte Garner and Karl Shanahan.

René Burri

Inside cover: (front) *Sir Winston Churchill, Zurich, 1946*. René Burri's first photograph; (back) *View from the offices of O Cruzeiro magazine, Rio de Janeiro, 1961*.

Phaidon Press Limited
Regent's Wharf
All Saints Street
London N1 9PA

Phaidon Press Inc.
180 Varick Street
New York, NY 10014

www.phaidon.com

First published 2004
© 2004 Phaidon Press Limited
Photographs © René Burri/Magnum Photos

ISBN 0 7148 4315 6

A CIP catalogue record for this book is available from the British Library.

Designed by Les Ateliers du Nord (Lausanne/CH), Werner Jeker with Benoît Deschamps and Ramón López
Translated from German by Matthew D. Gaskins
Printed in Italy

In addition to the standard edition, there also exist three Collector's Editions. Each Collector's Edition is specially bound and limited to 100 copies and contains one of the following original silver gelatin prints signed and numbered by the photographer: *Pablo Picasso, Villa La Californie, Cannes, 1957* (pp. 68–9); *Men on a Rooftop, São Paulo, 1960* (pp. 192–3); and *Che Guevara, Havana, 1963* (pp. 226–7). For more information, please contact Phaidon Press.

This book has been published simultaneously in English, German, French, Italian and Spanish.

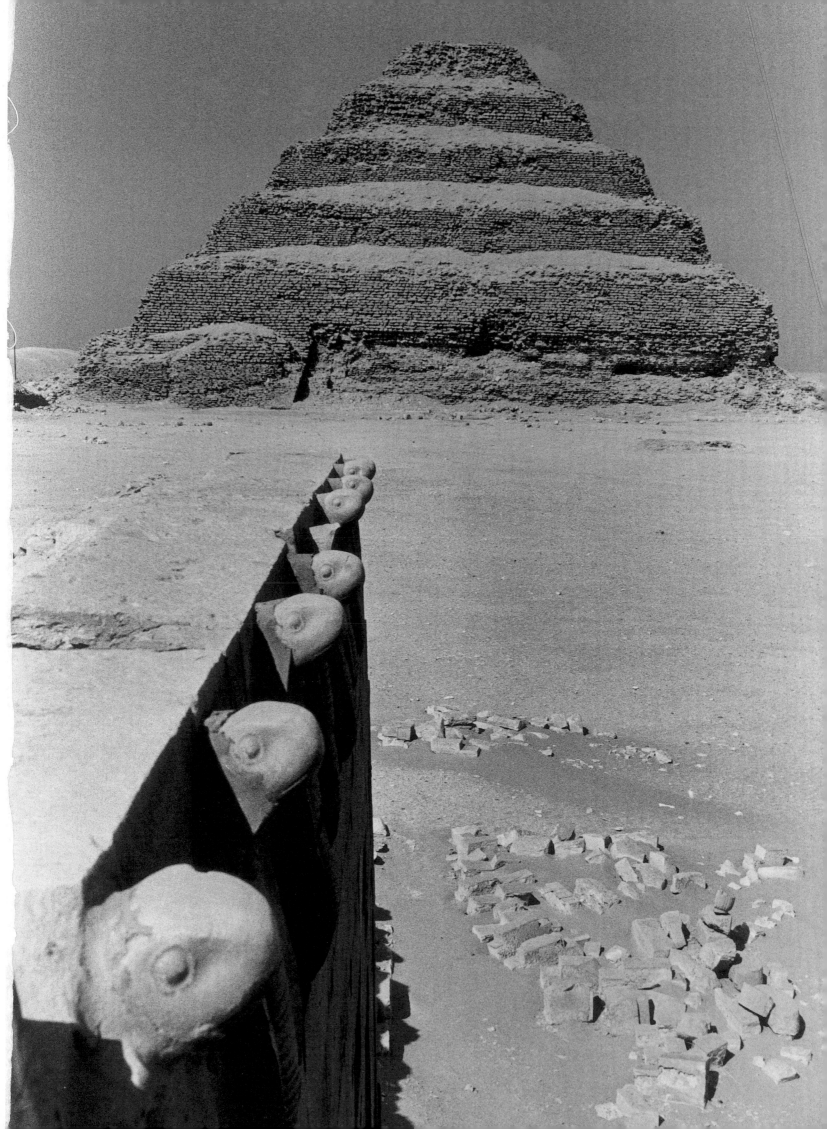

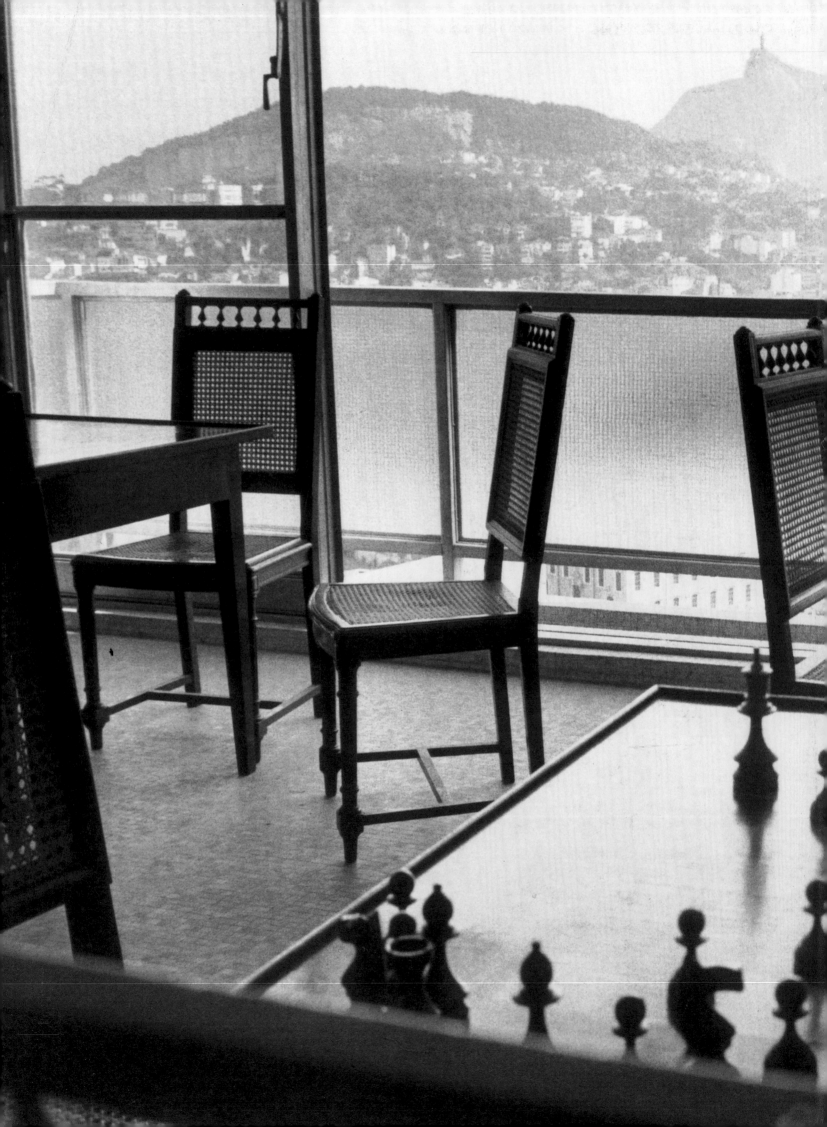